胡金銓
武藝新傳

King Hu:
the Renaissance Man

目錄
Contents

序文
Preface

【胡說：八道－胡金銓武藝新傳】
展出序文

石瑞仁 / 台北當代藝術館總監

曾被英國「國際電影指南」推舉為世界五大電影導演之一的胡金銓，堪稱華人藝術電影宗師，也是古裝動作片的先行者，他以歷史傳奇為本，融合東方美學內涵與現代藝術表現手法，於一九六〇、七〇年代開創出「武中有文、俠中有禪」的電影類型和獨特美學風格，影響甚鉅，至今仍為後學研究、參考、借鑑的典範。

今年適逢胡金銓導演八十冥壽，國際電影界紛紛推出胡氏電影作品的回顧展或學術探討活動，事實上，胡金銓除了蓋棺論定的電影成就之外，在其他領域如動畫、漫畫乃至生活美學面向，也有相當的興趣、投入和具體成果；目前收藏在國家電影資料館而未曾完整曝光的胡氏創作相關檔案，除了珍貴的文字筆記之外，圖像性的手稿不僅數量眾多，內容也相當精采，對於有興趣深入研究或完整瞭解胡金銓其人其藝者，這些創作筆記、手稿圖像都是不可錯漏的歷史檔案和文化資源。基於這樣的資源優勢，國家電影資料館和台北當代藝術館攜手合作，透過史料的整理再現加上後進的創作詮釋，於今年初夏推出以胡金銓導演為核心的【胡說：八道】主題策畫展，除了藉機表彰胡氏對台灣、華人、世界電影界的貢獻和影響，也希望提供民眾悠遊觀賞、涵詠胡氏多元藝術創作的不同門道。

本展由國家電影資料館和台北當代藝術館共同策劃，除了創意展出一系列涵蓋胡金銓導演的電影創作、書法、動畫、漫畫等珍貴手稿，也特邀葉錦添、黃文英、黃美清、陳昌仁、吳俊輝、葉怡利等六位藝術家，運用不同媒材創製新作，他們或有心與胡金銓特定作品神交對話，或各自萃取胡氏電影裡膾炙人口的客棧、竹林、雲霧……等意象元素重新發揮，或以新世代之眼再探戲中男儒女俠、文謀武鬥和禪意哲學等不同橋段情節…，雖從不同角度發想和實踐，但是共享了「向胡金銓致敬」的精神意義。

Preface
King Hu: the Renaissance Man

by J.J. Shih
Executive Director of
Museum of Contemporary Art, Taipei

King Hu was selected by *International Film Guide* in the UK as one of the top five international directors in 1978, and he was revered as a master of Chinese cinema. Also a pioneer of costume action films, Hu often based these films on historical legends and incorporated Asian aesthetics and modern artistic expression. In the 1950's and 60's, he developed a film genre described as having "culture within martial arts, and swordsman with Zen spirits." The influence of his unique aestheticism is profound and extensive, and is an exceptional example for later researches and references.

If King Hu were still alive, this year would mark his 80th birthday, and many film communities around the world are launching his retrospectives and also academic seminars. In addition to King Hu's undeniable motion picture accomplishments, he was also dedicated in the fields of animation, comics, and even living aesthetics. There are many never-before-seen King Hu creative works collected by the Chinese Taipei Film Archive, with many notes and manuscripts, and for people interested in studying or understanding King Hu's art, this collection is important historical document and cultural heritage that one should not miss.

With this resource, Chinese Taipei Film Archive and Museum of Contemporary Art, Taipei have come together for this exhibition, and have come up with creative ways to exhibit Hu's manuscripts of films, calligraphy, animations, and comics. Furthermore, six artists, Tim Yip, Wern Ying Hwarng, Meiching Huang, Leo Chanjen Chen, Tony Chunhui Wu, and Yili Yeh, have been invited to apply different media and artistic approaches to create artworks that connect with specific works by Hu, and some have based their works by extracting distinguished elements from Hu's films, such as the inn, bamboo forest, and misty clouds. There are also works inspired by the male literati and swordswomen, battles of kung-fu and wit, and sequences with Zen spirits from Hu's films, done with perspectives of the new generation. These artworks are created from diverse points of view with different approaches. However, they are all created to pay homage to King Hu.

策展論述
Exhibition Discourse

策展論述
找回 King Hu 應有的冠冕

策展人：張靚蓓／國家電影資料館館長

由國家電影資料館（電資館）、台北當代藝術館（當代館）共同主辦的「胡說：八道－－胡金銓武藝新傳」（King Hu: The Renaissance Man）展，於2012年7月3日至8月26日在台北當代藝術館展出。

這個展覽，網羅了各方名家。

當然，導演胡金銓是主角；至於配角，個個來頭不小。

各方名家來相挺

導演李安、徐克、徐楓、王童、葉錦添、黃建業、張艾嘉、華慧英等人，以言語與他溝通，聽他們談胡導、也談武俠。

文學家鍾玲、鍾阿城、舒國治、張錯、李歐梵、卜大中、中外策展人及影評人Roger Garcia、舒琪、黃建業、馮毓嵩、陳儒修、聞天祥、林文淇、江青、鄭佩佩等人，則以文字與之對話。

而在展覽場中，我們請來葉錦添、黃文英、黃美清、陳昌仁、吳俊輝、葉怡利六位藝術家，傾力形塑作品與之神交。

同時，導演徐克更應電資館之邀，特親筆揮毫，盡書他對胡導之情懷。今年四月底，當我們在北京見到依約前來受訪的徐導，正在籌備新片的他，百忙中，卻滿足了我們提出的所有要求，當他親自交給我們一幅字「俠氣古腸劍猶在，靈雨空山動江湖」，並拉展開來，唸出所書詩句；霎時間，在場諸位，似乎看到，老少兩代的武俠大師，天上人間，過往種種，在當下裡，均化為無限的思念及尊崇。事後我聽香港電影資料館的朋友告訴我，徐導以往從未深談過他與胡導的種種，聽聞之後，我只有感謝，徐導演把他對胡導演的第一次傾吐給了我們！

其實一路走來，我們碰到過許多「第一次」。打從2011年8月中動念要辦這個展覽起，即驚喜連連。無論是導演、演員、幕後工作者、影評人、文學家……，當電資館提出請求時，人人多異口同聲的應個「好」。

6+1位藝術家與胡導對話

葉錦添，是我首位邀請的藝術家，他一口答應，且立即發想，構想又多又好，雖然我們只有少少的預算、小小的空間，但他依然義氣相挺，只說：「這是一定要做的，應該的！」。就算經費拮据，他也堅持品質：「我不能給胡導演不好的東西啊！」之後自費來台，兩趟親赴電資館樹林片庫，檢視胡導當年留下的器物、服裝、海報、劇照等。他堅持看戲服的原件，有些服裝很脆弱，我們小心翼翼的拿出來，還不能架起來，得平鋪放好。葉老師看得非常仔細，甚至用尺來量領口、袖口，並翻開內裡檢視布料，他的心得是：「胡導演並非照本宣科、全依古畫上得來，他是依據他的需要所做的新設計。」上下兩代電影人的專業及態度，讓我們學到不少，之後我們加緊邀請相關的織品專家鑑定、整治這次展出的服裝。

後來聽王童導演說，胡導演對戲服考量周到，不但外衣布面、連內裡的色彩都照顧到。因為在銀幕上，當演員走動時，下襬微微擺動會掀起衣角，此時畫面上便窺見翻掀的內裡。張艾嘉導演也說，胡導演收集了好多日本的腰帶，都是質地上好講究的緞面；至於戲服的布料，就沒那麼講究了；而戲裡用的首飾，也都不是真的，張艾嘉轉述：「胡導曾說：『翰祥都用古董，不好看。』他還拖著我們去市集找首飾，說，這個銀幕效果好。」

此次葉錦添推出的作品是《空山靈雨》，當他近期創作的當然女主角莉莉置身在一個《空山靈雨》服裝道具與現代物件混搭的環境中，她的反應是什

麼？儘管胡導的世界豐富多元，但這一代人對其卻一無所知。他就像埋藏的寶藏，需要被挖掘，而那溝通兩代的頻率又是什麼？不然，只能像莉莉一樣，對之視而不見、聽而不聞，就算她始終被相關物件包覆著。有趣的是，這些古老物件到了葉錦添手裡，在燈光及環境的烘托下，居然產生一種奇異的現代時尚感，這還真是一個「物是人非」的世界！

黃文英答應，則是她剛從韓國為《聶隱娘》勘景回來時，當年胡導演到韓國拍攝《空山靈雨》、《山中傳奇》，引發她許多感觸，電影人的經歷真是奇妙：「為了尋找靈感，會鍥而不捨的追索。」她終於應允，加入，因為布料的質感引發她許多聯想，此次她從布料延伸，塑造一個古典的氛圍空間《平行時空－出發與探索的旅程》，展現她的創意，並向胡導致敬。我原本無法體會「布料」的魅力，就在黃文英帶我去看她辦公室那間擺放著她四處搜來的匹匹布料，霎時間，布料的花色、紋理、織法，把人帶到了另一個世界，太精緻、太美了。我終於理解她之前所言：「我為了找一匹布料，可以追到韓國、日本、甚而中東去。」她的那份執著，是對藝術的執著；一如胡導當年也曾為了布料「中國藍」，反覆尋找，直到找到，他才肯拍。

而黃美清則是早從2011年起，電資館專員薛惠玲就開始接觸，她先到片庫看了胡導演手繪的《張羽煮海》動畫圖稿，胡導的用色、筆觸，在在吸引著她。雖然工作滿檔，後來也首肯加入。她自此發想，找來聲音藝術家王福瑞建構起一個動態音場，用她的海底世界《翻轉－張羽煮海》來呼應胡導畫中的海底世界。原來黃美清在法國留學之初，曾在電影院打工，放映胡導演的《俠女》，當年就曾親見國外觀眾對胡導作品的驚嘆；那時的理解還很片面，就在她來到電資館片庫、遍覽胡導手稿後，當年的那顆種子終於萌發、滋長，對於胡導在建立角色人物上的功力，更是嘆服！

至於陳昌仁，更是個巧合。先是在台北光啟社巧遇多年不見的他，約他來電資館小敘時，方知他與館內同仁居然都是舊識，且都和胡導有關。原來陳昌仁是胡導的晚年小友，在洛城時經常和胡導擺龍門陣，還打算一起寫《滿漢全席》的劇本。UCLA收藏的一百二十多箱的胡導文物、手稿等，他均一一翻閱。知道我們要辦展覽，隨即加入。他和胡導情份不同，因為他是胡導過世後，洛城故居文物運來台北本館收藏時，最後一個去鎖門的人。這次他以《迎春閣之風波》為文本，創作了《陳昌仁的電影空間今詮》裝置藝術，這是個「內行看門道、外行看熱鬧」的作品。一進門、觀眾一坐下來就和銀幕畫面有所互動，自己就出現在銀幕上。之旁的「凝視輕觸」，19段的主題及構成畫面，均值得人一再的玩味。「旅人記憶」更帶你從不同角度觀看人生的不同風景，從這邊進去是風光明媚的江南，從另一邊進去則可管窺荒漠沙石一片。為了沙的肌理紋路，陳昌仁還在7月20日回台參加藝術家對談時，從日本帶回特製的耙子去展場梳理。

裝置藝術家吳俊輝，當年曾是電資館館員，入館的第一個工作，就是整理胡導的文物，如今學成歸國的他，在世新任教，並不時推出錄像裝置創作，這次他剪接胡導片中的畫面重新詮釋，以《迷霧傳說》述說他對胡導的情懷。每次坐在204展間裡，面對那些雲煙、飛瀑、樹影、陽光、山石、步行其間的人們……每每又有新發現，原來胡導的鏡頭裡還有這一段。吳俊輝不但善用胡導電影中的基本元素，同時也善用剪接、節奏感及中國山水畫中虛實相生的特質，好一個致敬！

至於當代館推薦的葉怡利，這位年輕、前衛的藝術創作者，從出道就以「武俠」為創作主題，此次的作品為《關於武俠》，她精選自己各個時期、跑遍世界駐村各地的作品，以影像與胡導對話，並於展場內設計一個俠女徐楓人型立牌的Kuso裝置與觀眾互動，觀眾在這裡，可扮俠女、可舞劍、可對打……。

其實以我們的預算，上述每一位大概誰都請不起，但每位藝術家都全力投入，這些人匯聚出一股強大的力量，與胡導擦出有趣多元的火花。

讓大家重新認識他的精彩

年輕人或許會問，胡金銓，何許人也？！

單從這些名家都願意為他跨刀、站台，你不好奇，不想一探究竟？

如今台灣四、五年級生熟悉胡金銓，因為那是他們的共同記憶，但年輕人卻對之陌生。所以在內容規劃、展品挑選及呈現方式上，兩館都做了種種考量，電資館深慶挑對了合作夥伴，不只因為當代館的場地，更因為他們的團隊。

記得第一次仔細走過當代館的各個展間，電資館的同仁們都有同感，這裡是展示影像的好所在。當代館熟稔「影、音」創作的各種展示方式，我們規劃六位藝術家與胡導對話、創作出全新視覺藝術的展覽方式，很符合當代館的調性。當代館原先最擔心的是胡導的作品如何對新生代產生吸引力、產生對話。我們提出的策略是，用他們所熟悉信賴的人（李安、徐克、葉錦添、舒國治、鍾阿城等）來帶領他們進入一個新世界；當代館的努力，則是設計出一些Kuso方式來呈現胡導的電影元素，譬如他們一聽胡導的音樂，方知周星馳的電影音樂源自於此，他們就從周星馳慢慢進入胡導的世界。

一如傳播原理所言，當一個訊息裡你所熟悉的元素佔80～85%，新元素的比例佔15～20%，這樣的組合較易為人接受；但考量到走進美術館的觀眾，多半已先有接受新事物挑戰的心理準備，所以我們大膽的加重份量，提議將201展間這個最大的空間全部展出胡導演的文物、手稿，畢竟那是電資館最珍貴的典藏品，也是我們舉辦這個展覽的初衷。其實

這次展覽的重心是倒過來的，從「完成的電影」出發，去看「電影的幕後」。如果電影有如冰山之一角，那麼我們這次是企圖將冰山揭露出一部份來給大家看看；那露出的一角，背後有哪些累積，才會創造出這些精彩的電影。在過程中，兩館工作人員經過多次討論、構思，才有了如今的內容。

譬如中英文展名的發想、產生。展名「胡說：八道」，是當代館館長石瑞仁及副館長林羽婕發想的，之後兩館一起討論，決定了中文展名「胡說：八道－－胡金銓‧武藝新傳」，雖是玩文字遊戲，但朗朗上口，容易吸引觀眾的注意，尤其是年輕人。有趣的是，名稱敲定之後，我有次翻閱胡導相關資料，發現他以前在報章雜誌上撰寫文章，還真有個「胡說」專欄。至於英文展名「King Hu: the Renaissance Man」，則是電資館資料組專員黃慧敏先草擬出幾個名稱，我與黃慧敏、林盈志討論之後，再請胡導演好友、南加大的張錯教授斧正；現在定案的英文展名，是我和黃慧敏從幾個名稱中所綜合出來，我做了最後的決定。

展覽中的「八道」，則由當代設計，電資館專員薛惠玲、黃庭輔等提供內容。這次推出的戲碼有：「客棧八道」及「俠女八道」。在客棧中，一定有打架必倒的脆弱欄杆、一定有盅毒酒、一定會碰上突發的暗器等等；至於「俠女八道」，則涵括了俠女的八種特質，必是忠良之後（彭雪芬）、定會男裝打扮（鄭佩佩）、還要身手不凡（上官靈鳳）、正氣凜然（上官靈鳳）、眼神冷峻（徐楓）、情感內斂（徐楓）、惜言如金（徐楓）、心思敏銳（胡錦）。此外，你還能應用胡導電影裡的元素，自行創造出你所發現的「八道」，如「暗器八道」、「竹林八道」或「佈陣八道」……端看你如何發揮想像力，拆解、活用胡導電影裡的元素。又如，胡金銓與徐克以書法對談，我們提供素材、想法，當代館構思如何落實，落實之後，又由電資館專員黃庭輔定名為「書劍恩仇錄」。

胡（導）說＋說胡（導）

除了以Kuso的方式串場外，整個展覽裡，我們還以「胡導說」及「說胡導」的兩種方式來統合所有的錄影訪問。如一開場，就是「胡說：八道」展區，剪輯胡導當年在公視接受訪問的錄影、來個「夫子自道」，這次呈現的是他的八個面向、搭配電影作品，讓大家對胡導有個初步認識，也讓人們再度重溫胡金銓當年叱吒國際影壇、與國際影壇人士往還的經歷。1975年，他在坎城影展奪得「高等技術大獎」；1978年，他被英國國際電影指南（International Film Guide）推舉為世界五大導演之一，胡金銓（King Hu）不但與克勞德・戈瑞塔（Claude Goretta）、文生・明尼利（Vincent Minnelli）、麥可・瑞契（Michael Ritchie）及卡羅斯・索拉（Carlos Saura）齊名；當時人們更將他與日本的黑澤明（Kurosawa Akira）、印度的薩耶哲・雷（Satyajit Ray）並列為東方三大導演。這些已被遺忘的當年盛事，不該消失的，所以我們準備了「說胡導」三部曲，經由名人專家的引介，一方面喚醒人們對胡導的記憶，一方面重塑人們對之的新體會。

第一部登場的是胡導的攝影師華慧英先生與他的兩位愛徒鄭佩佩、張艾嘉，從他們的述說中，讓觀眾建立起初步印象。這些錄影，都是電資館歷年訪談所累積的珍貴影像。第二部《聽他們說胡金銓》，則是為了此次展覽特別專訪六位電影工作者李安、徐克、徐楓、王童、葉錦添、黃建業的「說胡導」組曲，這些訪談經由電資館的黃庭輔、潘琇菱剪接、後製完成；再加上法國導演胡柏特・尼歐葛瑞（Hubert Niogret）的紀錄片《胡金銓》（King Hu），訪問了製片家焦雄屏，演員岳華、吳明才及明報月刊主編潘耀明等人。七部影片分別從各個角度來談胡導的電影美學、藝術特色、時代意義及後續影響。正忙於新片《少年Pi的奇幻漂流》後製的李安導演，四個月前在接到邀請後，一口答應錄製影帶寄來，雖因專心創作不受外界打擾，但他仍願為

胡導盡一份心；更因體恤本館經費拮据，李導演特在今年六月14日由美國國會錄下訪談，經美國在台協會（AIT）的協助，送來台灣給我們。還記得李安認為胡導電影裡所塑造的「文化中國」影像，對他的影響比武術還大：「胡導為明朝造型，一如李翰祥導演為清朝、為民初的形象定下基調。」曾跟隨胡導工作的王童，可算台灣至今唯一的胡金銓傳人了，聽王導現身說法談胡導，既充實又有趣，也讓前去訪問的電資館專員薛惠玲、黃庭輔過了個充實的下午。而徐克、葉錦添的訪問，則是今年四月底電資館團隊（張靚蓓、林盈志、黃慧敏、徐昌業、孫如杰、吳恬安及陳瑩潔）赴北京參加國際電影資料館聯盟（FIAF）年會時，趁空完成的。至於徐楓，趕在展前一週，我們特派林盈志、徐昌業飛到上海專訪的結果，在此特別感謝徐楓小姐贊助機票，我們方能成行。正如徐楓所言，她和胡導情份不同，胡導的事她一定會參與。果不其然，開幕時，她專程飛來台灣參加。

張艾嘉這位關門弟子則是一頭一尾的出現在展覽中，訴說她對胡導演的記憶，尤其第三部曲――「劇終」前的《無冕皇后》（又稱《維也納事件》），更是傳奇。2011年我們應金馬獎之邀，在其主辦的年度人物影展後，電資館也辦了個張艾嘉專題影展，請了張導演來館裡做訪問，言談間她提起胡導最後的影像作品應是《無冕皇后》，大家才知道還有這麼一部片子，當時誰也不知影片的下落。就在訪談後不久，有一天電資館資料組鍾國華組長在樹林片庫看到一盒沒有註記的影片，他心想，也許是這一部，沒想到一放映，真的就是！理所當然的，這段尋獲之影片就成了本次展覽的最佳結尾；而胡導演口中的兒子張艾嘉，也成了最好的解說者。

胡導下指導棋？

這種巧得令人驚訝的場景，在這次展覽中，屢屢發

生，讓人不禁懷疑，是否胡導在天上下指導棋？

記得第一次在電資館開籌備會時，當我們和顧問黃建業老師在本館七樓數位典藏中心開完會，下來四樓書庫找尋相關資料。不料進書庫之後，黃老師從書架上抽出的第一本書，正是我們要找的英國《國際電影指南》，評選胡導為世界五大導演的那一本；來到書庫另一端要找香港電影節出版的特刊《超前與跨越：胡金銓與張愛玲》，他伸手一拿，又是。大家邊笑邊說：「哇，神了，莫非胡導演顯靈？」

其實一路下來，奇蹟不時出現，譬如《華工血淚史》的部份英文劇本及全本中文劇本。這是胡導生前籌備已久，預定即將開拍、卻壯志未酬的電影，故事是關於華人在美國開鐵路、採礦的血淚過程。因為邀得影評人Roger Garcia寫稿，於是請他代詢《華工血淚史》的美國製片Sarah Pillsbury，是否有展出劇本的可能？沒想到對方不但同意展出七頁英文劇本，同時還為文回憶她與胡導相識的經過。

記得接到Sarah Pillsbury的回音時，我們正和當代館在討論劇本的展示方式；沒想到隔天北京中央電視台第六頻道（CCTV 6）來電資館參訪，名單中赫然出現「郎云」的名字，他是胡導的外甥，他二姐的公子。郎先生本身是影視編導，在大陸得獎甚多，我們一聽是他，就想見見。當郎云知道我們正在籌辦胡導演展時，當場問我們有沒有《華工血淚史》的中文劇本？他有，而且正帶在身邊，因為他已集資打算拍攝該片。他不但送給我們一本籌拍計畫書，隨之又爽快的說：「我這本影印劇本就留給你們。」還當場簽下授權書，同意展覽完整的中文劇本。當然，基於商業機密，我們不會展示內頁的相關內容。

有趣的是，一路下來，每當我們氣餒力窮之際，就有好事發生。後來想想，這一切都是因為胡導演吧！他生前與大家結緣，如今我們將這些緣份聚集在一起，但看展覽會有什麼結果了。

電資館責無旁貸

至於為什麼今年舉辦，我想，是時候到了！
一來今年是胡導演的80冥誕。二來從去年起，世界各地紛紛舉辦胡金銓導演影展，計有美國紐約林肯中心（《俠女》）、耶魯大學（《俠女》）、鹿特丹影展（《龍門客棧》）等；今年還有義大利波隆納電影資料館、法國電影藝術館、美國威斯康辛大學及北美地區的巡迴放映等。2011年金馬獎期間，更有歐洲發行片商前來館內希望洽談《龍門客棧》、《俠女》的歐洲代理權。當全球各地再度重視胡導演作品之際，作為全世界收藏胡金銓文物最齊全的我們，更是責無旁貸。因為電資館整理胡導演的影片、劇照、手稿、圖書等，已經二十多年了。

1989年，胡導演將香港金銓影業公司全部資料與個人藏書，捐贈給國家電影資料館收藏，當時整理後即舉辦記者會，胡導演曾親臨指導，看到電資館整理的成果，欣慰之餘，當下便決定將原存於美國鄭佩佩公司處的資料全數捐給電資館。這兩次的捐贈，包括演員造型、工作照、劇照、文獻資料及一些電影拷貝、配樂資料……。1997年胡導演辭世後，2000年美國胡金銓基金會將原存於美國加州大學洛杉磯分校（UCLA）的一批文物，包括藏書、手稿、文章、服裝、道具、私人藏品等運來台灣，交由本館整理。二十多年來，電資館投入無數的人力、經費，陸續完成整理、登錄、資料整飭、數位化等工作，如今已完成兩萬筆的文物數位化。這次我們展出胡導的電影創作、繪畫、書法、動畫、漫畫等部份手稿，一方面讓大眾分享電資館多年努力成果，同時也期待讓更多人瞭解胡金銓導演的藝術成就與多樣化創作，滋養下一代的電影及藝術工作者。

也許年輕一輩多不記得胡金銓導演了，但是不知道

他，就代表他不好、他不精彩、他不值得被認識？非也，這次是年輕人重新認識胡導的大好機會。我們為什麼不學學法國或歐美的時尚界、藝文界，他們珍視活用自己的文化累積，譬如這兩年的坎城影展海報，都是以老明星為主角，多迷人哪！

重看胡導的《龍門客棧》、《俠女》等片，你何不找找，為何當年大家會如此風靡？當年胡導演創造的許多人物「原型」，不但影響日後的許多導演；就連今天，你一打開電視，去到電影院，都還看到這個影響，只是大家不知道源出何處罷了，譬如電視不斷演出的《新龍門客棧》，譬如女俠們頭頂上的竹笠，抑或鶴髮的東廠公公⋯⋯。他是華人影史上非常重要的一位人物，而他最重要的兩部電影《龍門客棧》與《俠女》，都是在台灣拍攝，以台灣演員、資金為主所創造的作品。種種因素，讓我們決定辦胡金銓展。

胡金銓與藝術館

至於為何選在當代館展出？這又是另一個故事。「胡金銓走進美術館」這個想法，對我來說，是理所當然，因為這種做法在歐美早已是common sense(註)，沒想到會在台灣會引起一些話題，倒也是另一種收穫與刺激。本想，在台北如此國際化的都市，美術館與電影的邂逅，應該很平常啊！當巴黎羅浮宮（Musée du Louvre）都開始搶著當製片人，年年投資拍部電影時（第一部是蔡明亮的《臉》），我們思考的層面是否可以從「電影是否該走入美術館」，轉至「什麼樣的電影可以走入美術館」？美術館與電影的系譜我們並未深究，我們只問，當你面對這個作品的當下，你判斷，它值不值得放在美術館裡，供大家欣賞、思考、對話、學習⋯⋯。其實，在歐美藝術館舉辦影展或相關展覽早已不是新鮮事，幾乎著名的美術館都做過，筆者就在紐約的古根漢美術館（The Solomon R. Guggenheim Museum）看過「30年代中國電影展」，阮玲玉的《神女》也是在古根漢看的；紐約

現代美術館（MOMA）更是年年舉辦「新導演、新電影」，它還發掘過兩岸三地許多新導演；2000年筆者參加坎城影展之後，也在巴黎的龐畢度藝術中心(Centre Georges Pompidou)參觀了電影服裝展⋯⋯，美術館裡辦影展、辦電影文物展，光是隨機遇上，就已有這些；國內雖較少見，但也不是沒有。所以打從定下要辦胡金銓展後，我就構思，一定要在一個夠格的、好的場地，展出他的作品，因為不想再「委屈」他；所以從頭到尾，我們鎖定的就只是美術館。加上胡金銓早已經過世界影壇高標準的檢驗、認可，走入美術館，有何不可？尤其是瀏覽過電資館所搜藏及數位化的胡導作品後，在美術館展出胡導作品的決心更堅定了。

很高興的是，台北當代藝術館是個自由、開放的場域，所以才有今天的成果。不過最初徵詢時，場地幾乎滿檔，直到今年二月底，當代館才確定空檔，我們立刻敲下檔期，並與之合辦。當代館的石瑞仁館長及館員們非常投入幫忙，分工方面，電資館負責提供最熟悉的內容，展場則由擅長美術語言的當代館設計，彼此溝通討論。策展過程中，兩館團隊熱情參與，彼此提供專業所長，雖「一展數變」，經過許多成案、推翻、再成案，才有了今天的面貌。

全才金銓

他真是個全才，綜觀其作品，我看到我們熟知的胡導演，更驚訝的，是我們所不熟悉的胡金銓。譬如畫稿中出現的「天祥」素描、台灣南部鄉村的人物、車輛等⋯⋯。印象裡，胡導身在異地但心繫文化中國。這次遍覽其所有作品後，我發現，其實我們都錯了；他是到了哪裡，就融入那裡，同時吸收當地的精華，用他的方式來做表達。儘管後期無法再執導筒，但他一直創作不斷，以文字、書法、水墨、動畫、甚至諷刺時事的漫畫⋯⋯，等各種形式來表達自己的所思所感。

胡導的勘景，是一步一腳印、踏實的去走遍各地，找尋他心中的美景，再重塑成他電影中的畫面、傳達他的意境。如《空山靈雨》中的廟宇，電影裡呈現的是同一地點，又都是實景拍攝。但事實是，電影裡的這座廟宇，是韓國十幾座寺廟的組合。他走遍南韓各處，找到他需要的角度、畫面，透過拍攝、剪接，呈現在銀幕上的，是他的胸中丘壑、是他再造的真實，這不正是中國藝術的精髓？在郭熙、范寬等人的山水畫，在京劇舞台上的表演，不都是如此？看似真實，實則不然，它是藝術家的表達，由它帶著你進入一個你以為真實的世界，實則是藝術家所形塑的世界；而其中表達的情感，又如此真切。

此外，胡導電影裡所呈現的「順勢而為」，利用地理環境形成戲劇張力及結構的構思，在香港導演杜琪峰的作品裡亦見。影評人舒琪曾表示，杜琪峰是在都市、胡金銓是在山野或客棧，兩人都藉勢作戲，京劇的「三岔口」到了胡導手中，成了《怒》；到了杜琪峰手裡，則成了《鐵三角》。記得我第一次看《怒》時，曾想：「這不就是中國的默劇！」而胡導直接將京劇的舞台表演形式搬到曠野（如《龍門客棧》裡東廠番子在荒郊野外追殺忠良之後的那幕戲），陳昌仁認為，手法大膽前衛，至今無人敢再嘗試，若非胡導深諳京劇之骨髓，有著信手捻來的功力，誰人能如此運用？如今重看他的表演系統，之前有人曾謂，這是「臉譜式」的表演、沒什麼感情戲而忽略之。但京劇中的臉譜是融會貫通多少人生體驗所綜合出來的精準符號；綜觀胡導的電影，所有角色都是如此，這就是有意為之；此時不禁想問，他是否正在開創一個有別於西方表演體系的一種表演體系？而這個體系的表演方式是以東方戲劇的表達形式為主，在京劇、在日本的能劇、在泰國舞蹈、在印度舞蹈裡，處處可見交會之處。這方面的探索，仍有待開發；而這次展覽最大的收穫也在於此，每個人都有不同的觀察，重新切入新的角度，都覺得還有深究的必要。所以，這個展覽只是個開頭，對於胡導演的研究，還有好

多寶藏待挖！

至於胡導演電影裡的耳熟能詳的重要元素，客棧、竹林、暗器、人物造型等，也都是展出重點。這次在201展場中，我們展出十部電影的幕後元素，分別從不同的重點展示胡導創作的多樣性，觀眾可以看到分鏡表、當年的劇本、手稿、服裝設計圖、場景圖、工作照，甚至當年的海報、好玩的填字遊戲、《龍門客棧》的印戳……。

來到《張羽煮海》專區，則是胡導的動畫人物造型及場景，這是他當年在美國聖地牙哥水族館觀察各種海洋生物，先畫成素描，再一一轉化為《張羽煮海》裡擬人化的卡通 人物造型，可惜後來沒拍成電影。而在漫畫專區裡，當代館分解了胡導的四格漫畫及諷刺國際局勢的時事漫畫。如英國的查爾斯王子與情婦卡密拉戀情曝光後，英國人民反感，王子大驚的畫面。又如柯林頓掌政時期的美國稅務問題。還有美國柯林頓總統與北韓金正日談判核武。中共政局、兩岸關係。香港總督彭定康與中共總理鄧小平……。這一區我們特別邀請《聯合報》副總編輯、熟悉國際事務的郭崇倫先生，幫忙撰寫精簡的背景說明，幫助觀眾了解。

文化長河的中流砥柱

走筆至此，想起那天我和黃文英談起胡導：「這次有機會看了他這麼多作品，有很多感觸與啟發，原來我現在做的，他以前也做過！」就因為黃文英將她的創作與胡導留下的服裝、道具……融合得如此恰當，所以當石雋第一次看到黃文英的的作品時，恍如重回當年的韓國拍戲現場。這個「都是同道中人」的感觸，葉錦添、黃美清也有。不論生於何時，這些電影界的佼佼者，都相繼走在這條追求的道路上，為文化長河注入新活水。

胡導一生漂泊，先是從北京到香港、又自港來台，

之後移居美國，他是被迫；但到了這一代，走訪世界各地，成了自發。不論初衷為何，兩者都曾往西方取經。英文造詣極佳的胡導，生活裡早已是中西合璧，東西文化交流之痕跡在他身上、作品裡不時體現，而從胡導的「漂泊」軌跡中，我們也得見許多電影人的印記。葉錦添說：「胡導、李安、吳宇森、王家衛、徐克、我……，彼此或多或少都有著重疊，在某些階段中，你中有我，我中有你。」當年胡導演「厚積」多時，始終沒等到「薄發」的一刻，以致壯志未酬；如今風水輪流轉，東方又見抬頭，然斯人已逝。回顧上下幾代電影人的創作軌跡，雖因時代、機會不同，個人的發展及際遇有異；但放到文化的長河裡綜觀，在經歷時間的淬鍊後，胡導在文化創意上的貢獻及成就，益顯其真金不怕火鍊；這也是其作品至今不死、仍在世界各地放映流傳的原因之一；更是我們此次提出邀請，眾人多半一口應允之故。因為，大家都想為胡導演盡點心、做點事吧！尤其如今外在環境大好，華人電影及市場崛起，萬事俱備，只欠東風，獨缺人才，不禁越發讓人懷念這位「全才金銓」。我們還可以從他那裡發掘好多可學可用、可刺激我們想像之處……

以上所言，只是這次展覽起念之後所發生的種種，一切皆因胡導而起，許多事情還在進行中，這個展覽只是重啟這座智慧寶庫，他的影響正在逐漸發酵中。

註：見貧窮男「胡金銓.電影資料館@當代.美術館.tw」一文，國家電影資料館電子報，2012/8/4

2006年巴黎龐畢度中心，展出法國新浪潮導演高達的作品時，幾乎是以裝置藝術搭配高達的電影《電影史》，拼貼出非常高達風格的「烏托邦之旅，尚-盧．高達1946~2006，探尋失去的定理」。

而西班牙導演阿莫多瓦風格強烈色彩鮮明的電影場景，也成了美術館巡迴展的熱門主題，撇開這些導演自己參與的「展覽」。紐約古根漢美術館曾在費里尼逝世十週年時舉辦了大師的回顧展，展出的並不是費里尼的影片作品，而是他所畫的諷刺漫畫與素描等，讓觀眾了解大師創作的靈感來源。倫敦的巴比肯藝術中心在賈曼去世的隔年，展出賈曼生平的一切，他的繪畫，他的實驗電影，甚至搬來他最後的裝置作品，他家的「花園」，讓世人了解他的才華是全方位的，電影只是其中之一。

Exhibition Discourse
Retrieve King Hu the Crown He Deserved

by Jinnpei Chang
Curator / Director of
Chinese Taipei Film Archive
translated by Isabella Ho

King Hu: the Renaissance Man, an exhibition held by the Chinese Taipei Film Archive (CTFA)and the Museum of Contemporary Art (MOCA) opened on 3rd July 2012 and will continue until 26th August 2012.

A number of prominent artists are invited to take part in this project. It goes without saying that Director King Hu is the star of the exhibition but the supporting cast is so strong that each of them is a star of their own right.

Prominent Artists in All Fields of Arts

Directors including Ang Lee, Tsui Hark, Sylvia Chang and Tong Wang, others like producer and actress Feng Xu, art director Tim Yip, film critic Edmond Wong, and King Hu's cinematographer Huiying Hua are here to talk about King Hu as well as the martial arts films.

Writers including Ling Chung, Acheng Chong , Kouchih Shu, Dominic Cheung, professor Leo Oufan Lee, columnist Tachong Pu, actress Qing Jiang and Peipei Zheng have written articles for us in the memory of King Hu. Film festival programmers from Taiwan and abroad, critics such as Roger Garcia, Kei Su, Edmond Wong, Yusong Feng, Robert Rushou Chen, Tienxiang Wen, Wenchi Lin, have written articles to analyze King Hu's works, including his films and his drawings.

In this exhibition, we invited six artists to pay their tribute to King Hu through the art installations. These artists are Tim Yip, Wern Ying Hwarng, Meiching Huang, Leo Chanjen Chen, Tony Chunhui Wu and Yili Yeh.

Furthermore, requested from I and CTFA , director Hark Tsui wrote an poetry bestowed calligraphy scroll on us which he wrote himself. In April 2012, we visited Hark Tsui in Beijing. Although he was very busy with the pre-production of his new film, Tsui kindly agreed to all our requests. When he handed to me the scroll and read out the lines, "The integrity of swordsmanship remains as the spirited rain re-enervates the unpopulated mountain and the intertwining corners of society", everyone present seemed to have heard the dialogue between the old and new martial arts masters; all the memories of Master Hu were embodied in his reverence for Hu. After we made an interview with director Tsui, a researcher of the Hong Kong Film Archive told me that it was the first time Tsui talked about his work and friendship with Hu. When I heard it, all I felt was gratitude; I am so grateful to Tsui that he shared these stories for the first time with us.

In fact, ever since we decided to hold this exhibition in August 2011, we encountered so many nice "first-time" experiences. When we made the requests, it did not matter whether it was film directors, actors, crew members, critics or writers, almost everyone said "yes" to us straightway.

Dialogues between King Hu and Six+1 Artists

Tim Yip, art director of *Crouching Tiger, Hidden Dragon*, was the first artist I invited. He not only immediately agreed but came up with so many fantastic ideas. Although our budget and the venue were small, Yip did all his best to help us. He said,

"This is what I must do. It definitely should be done!" Despite the shoestring budget, he insisted on the best quality. "I can't give it to director Hu unless it's the best" Yip said to me. Later Yip came to Taiwan on his own expense. He went to our storage vault in Shulin to see the props, costumes, posters and stills Hu left to us. Yip insisted on examining the original costumes; some of them were so fragile that we could not hang them up but had to spread them flat on the table. Yip checked every detail of the clothes; he even measured the collars and the sleeves and inspected the inside. He came to the conclusion that director Hu did not exactly copy what was depicted in the Chinese paintings of National Palace Museum but designed the costumes according to his own needs. We had learned a lot from both Yip's and Hu's professionalism and attitude. Soon after that, we sought consult from a preservation expert on textile to restore the costumes which would be on display in the exhibition.

Later we heard from director Tong Wang that Hu cared so much about the costumes that he paid attention not only to the outer materials of the clothes but also the colors of lining. It was because when the actors moved, the lining would be revealed on the screen as the hem flapped. Director Sylvia Chang also told us that Hu had a large collection of kimono obi (sash); those were made of top-quality silk. Nevertheless, as to the fabrics of the costumes, he was not that fussy about them. Furthermore, the accessories used in the films was not authentic either. According to Chang, Hu once said to them, "Hanxiang (director Hanxiang Lee) always uses antiques. But they don't look good!" She also said, "He (Hu) then took us to the market to look for the accessories and found those pieces that would look good on the screen instead."

The installation Tim Yip presents is called *Raining in the Mountain*. When Lily, the lead character who also appeared in Yip's latest exhibition is put in a space full of not only the props and costumes from the film, *Raining in the Mountain*, but also mixed with modern things, how will she react to it? Although Hu's works are so diverse, the younger generation does not seem to know much about him. King Hu is like buried treasure that needs to be excavated, however, we need to find out what can be used to help the two generations communicate with each other. Otherwise, most people would react just like Lily; although she is surrounded by all those things related to the master, she cannot "focus" them with her eyes or "hear" them with her ears. The most interesting thing is in that elegantly designed space, Yip has transformed the old pieces into something modern or even fashionable. This truly reflects the world in which the objects remain eternal despite the change of their owners.

Wern Ying Hwarng agreed to take part after her location scouting for *Assassin* in Korea. She expressed that she had drawn so much inspiration from Hu's shooting of *Raining in the Mountain* and *Legend of the Mountain* in Korea. Working in the film industry was a really fascinating experience as Hwarng pointed out that she would go anywhere in the world to look for inspiration. The main reason she agreed to join the exhibition was that the fabrics had inspired so much imagination in her. This time she would begin with the fabrics and create a classical ambience in an installation titled *Parallel Space-Time: A Journey of Discovery and Exploration*. Through this she would not only demonstrate her creativity but pay homage to King Hu. I could not imagine the charm of fabrics until Hwarng showed me her collection in her studio. All of a sudden, the colours, the patterns, the

textures and the weaving techniques of the fabrics appeared to be so exquisite and beautiful that they immediately lured me into another culture. Finally, I came to understand why Hwarng's search for some fabric would take her to Korea or Japan or even to the Middle East. Her attitude towards art is reflected in her persistence demonstrated above. It was the similar with King Hu as he did not agree to begin shooting until he found the fabric, the "China Blue", he had been searching for.

As for Meiching Huang, one of our colleagues, Huiling Hsueh, contacted her for the first time back in 2011. Huang came to the vault to view Hu's hand-drawn sketches for *Zhang Yu Boils the Sea*, an aborted feature animation. She was attracted to the colours and the strokes Hu applied in the paintings. Despite her busy schedule, Huang was willing to participate in the exhibition. She came up with the idea of collaborating with the sound artist, Furui Wang, on constructing an interactive sound theatre. The final result, *Reversal – Till the Seas Run Dry*, echoes with Hu's portrayal of the sea world. We later learned that Huang had worked part-time in a cinema when she first arrived in France for her studies. Once when Hu's *A Touch of Zen* was shown in the cinema, she witnessed how the audiences were captivated by it. However, her understanding of Hu's films was rather fragmental at that time. Only when she came to the archive to look through Hu's manuscripts did she grasp the full picture of Hu's creativity. After that Huang was so deeply impressed by how Hu brought life to the characters on the screen.

Leo Chanjen Chen's participation was born out of a coincidence. Before I ran into him at the Kuangchi Program Service recently, I had not seen him for years. Later when I invited him to my office for a conversation, I knew that he not only knew several of my colleagues but had something to do with King Hu. It turned out that Chen befriended Hu at the late stage of Hu's life. They often met up and even planned to write the script *Han-Manchu Regale* (*manhanquanxi*) together. He had also gone through the over a hundred and twenty boxes full of Hu's manuscripts and other stuff stored at the UCLA. He joined us as soon as he heard about the exhibition. His relationship with Hu was different from the others since he was the one who locked up the door of Hu's apartment in Los Angeles when Hu's final donation was shipped to Taiwan from Los Angeles.

Inspired by *The Fate of Lee Khan*, Chen set up an art installation called, *"Aesthetic Precis"* of King Hu's cinema; it is a show that people who do not know much about cinema could enjoy while those who do would grasp its homage to Hu. As soon as you walk into the space, you could interact with the images and see yourself appear on the screen. The "Visual dialectics of the virtual and the physical" section shows nineteen clips; all of them are worth viewing over and over again. In the "Affiliation space- the transient home-making for Chinese journeyman" section, it shows you the different scenery from different points of view. From one end, you go into the warm pleasant world of Southern China, and from the other, you get to see the sand and rocks in the desert, symbolizing the good times and bad times in one's life. In order to create the patterns on the sand, Chen brought a special rake from Japan to work on it when he came back for the panel on July 20.

Tony Chunhui Wu had worked in the Chinese Taipei Film Archive before. His first job in the Archive was

to catalogue King Hu's donation. Now Wu has finished his studies abroad and is teaching at Shih Hsin University. He does video installations from time to time, and this time he not only re-edited but re-interpreted the images from Hu's films and turned them into an installation work titled *The Legend in the Mist* to express his admiration and respect for Hu. Every time when I sit in the room watching the images of the clouds, the mists, the waterfalls, the trees in their shadows, the sunshine, the mountain rocks and the people walking amongst them, I always find something new, something I didn't discover when I was watching Hu's films. Wu is so good at manipulating not only the important elements in Hu's films but the editing, the rhythm and the essences of the real and the unreal in Chinese painting. It is such a great work to give the respects to King Hu !

Yili Yeh was recommended to us by MOCA. She is a young and innovative artist who has been working on themes related to martial arts since her career began. In this exhibition, she came up with an art installation called *About Martial Arts*. Selected images from the works she did as the artist-in-residence in various organisations are used as the materials to strike a conversation between Hu and herself. In addition, modeled on the leading lady of *A Touch of Zen*, Feng Xu, the swordswoman, Yeh made a life-size cardboard sign in a comic style and uses it to interact with the viewers. In there people can act like a swordswoman; they can play the swords or fight with each other…

Actually, our shoestring budget could not afford any of the artists who participate in this exhibition. However, they have done their best and together they create such an interesting dialogues with Hu.

Rediscovering King Hu

Young people may ask who King Hu is, but just from these famous artists who come to pay tribute to him, wouldn't they be curious to learn who he is?

The reason people born in the 1950s and 1960s know about King Hu is their shared memories of his works. Nevertheless, the younger generations seem to have heard nothing about him. Therefore, when discussing the content, the selection of the materials, and the presentation of the exhibition, CTFA and MOCA had taken this into account. We are very happy that we chose the right partner, not only that MOCA proves to be a great venue but the team behind it is creative.

I remember the first time we went location scouting. When we walked through the rooms, my colleagues and I all agreed that MOCA was a suitable venue for the visual arts. MOCA has the experience in curating all kinds of audio-visual displays and it is a suitable place for the shows we and the six artists designed. MOCA's priority concern was whether the young audiences would be attracted to King Hu's works and how to draw them into the dialouge. The strategy we proposed was to invite celebrities whom young people were familiar with and trust (including Ang Lee, Hark Tsui, Tim Yip, Kouchih Shu and Acheng Chong) to lead them into the world of King Hu. The effort MOCA put in was to present some elements in Hu's films in a comic style. For instance, when the young viewers hear the soundtracks of Hu's films, they would know, in fact, this is where the music in Stephen Chow's films came from. Gradually, they would get to know King Hu through Stephen Chow.

The communication theory tells us that a message

which mixes eighty to eighty-five percent of elements one is familiar with and fifteen to twenty percent of new elements is the easiest for one to accept. Nonetheless, we assumed that most people who walk into the museum would be prepared to take the challenge from new things hence we planned to increase the proportion of the new elements. We suggested that we should turn Room 201, the largest room in the venue, into a display to show all Hu's manuscripts, sketches and drawings. After all, they were the most precious collection from our archive and what promoted us to hold this exhibition in the first place. In fact, we reversed the order of the production as we began with the finished film and then traced them back to behind the scenes. If the finished films are just a tip of the iceberg, we would like to reveal more of it and to let people understand how these great films were created. The exhibition people come to see today is the result of numerous discussions between the staff members of the Film Archive and MOCA.

For instance, it was the Director, J. J. Shih , and the Deputy Director of MOCA, Yujie Lin, who came up with the original name for the exhibition, *Hu Shuo: Ba Dao* (literally means King Hu speaks in eight different ways, and is a Chinese pun on talking nonsense). Then after the discussion between the Film Archive and MOCA, we settled on *Hu Shuo: Ba Dao – King Hu, the New Tale of Martial Arts* as the Chinese title for the exhibition. Although it was a word play, it was catchy and would easily attract the attention especially from young people. The most interesting thing is after we decided the name I found out that Hu had written a column for a paper called "*Hu Shuo*" (Hu says). As to the English title, my colleague, Teresa Huang, came up with a number of choices first. Then I discussed it with our colleagues Yingzhi Lin and Teresa Huang, and consulted Professor Dominic Cheung at the University of Southern California, who was a good friend of Hu's. Therefore the English name for the exhibition, *King Hu: the Renaissance Man*, is my decision.

MOCA designed the "Ba Dao" (meaning eight characteristics) section of the exhibition while my colleagues, Tingfu Huang and Huiling Hsueh , provided them with the materials. There are two parts in the section, "Eight Characteristics of the Inns in Hu's Films" and "Eight Characteristics of the Swordswoman". Those in the "Inn" included the banisters which are bound to be broken during the fight, a pot of poisonous wine and the assassination weapons. As to the swordswoman, she has to be the daughter of a loyal official (like Xuefeng Peng), dressed as man (Peipei Zheng), a kungfu master (Lingfeng Shangguan), a justice fighter (Lingfeng Shangguan), with killing eyesight (Feng Xu), emotionally reserved (Feng Xu), quiet (Feng Xu) and smart and reactive (Chin Hu). In addition, people are allowed to create their own "Eight Characteristics" based on those in Hu's films such as the "Eight Characteristics of Assassination Weapons", the "Eight Characteristics of Bamboo Forests" or the "Eight Characteristics of Fighting Formations". It all depends on how people use their imagination inspired by Hu's films and create something of their own. Moreover, we offered the materials and the original idea a dialogue between King Hu and Hark Tsui with calligraphy works, while MOCA put them into a concrete plan. After it had been materialised, my colleague, Tingfu Huang, named this part of exhibition, the "Analects of Calligraphy and Swords."

"King Hu Talks" and
"They Talk About King Hu"

In addition to stringing all the sections together in a kuso style, we divided the recorded interviews into two parts, "King Hu Talks" and "They Talk About King Hu". In the King Hu Talks room, we show the video clips edited from the footage of Hu's interview with the Public Television Service years ago. Here we show eight different aspects of him and his works as an introduction of King Hu by Hu's talks. Moreover, we hope this will remind people of Hu's great reputation on the international stage. In 1975, Hu won Grand Prix de la Commission Supérieure Technique du Cinéma Français at the Cannes. In 1978 Hu was praised by the International Film Guide as one of the five greatest directors in the world together with Claude Goretta, Vincent Minnelli, Michael Ritchie and Carlos Saura. In addition, ranking with Akira Kurosawa and Satyajit Ray, they were regarded as the three greatest masters in Asian cinema. These forgotten facts should not be erased from our memories therefore we prepared "They Talk About King Hu", a trilogy to introduce King Hu through the celebrities' interviews. On the one hand, we would like to evoke the memories of King Hu and on the other hand, we would like people to see him in a new light.

The protagonists in the first part of the trilogy are Huiying Hua, Hu's cinematographer, and Hu's two protégées, Peipei Zheng and Sylvia Chang. From what they talked about Hu, the audiences would gain the first impression of the master. It comes from the footage collected by the Film Archive. The second part is "They Talk About King Hu" which composes of the newly conducted interviews with six filmmakers specifically for this exhibition; they are

Ang Lee, Hark Tsui, Feng Xu, Tong Wang, Tim Yip and Edmond Wong. The interviews were conducted and edited by my colleagues, Tingfu Huang and Xiuling Pan. Moreover, there is a documentary made by the French director, Hubert Niogret, called King Hu, in which he interviewed Peggy Chiao (producer), Hua Yue (actor), Mingcai Wu and Yiuming Poon (director, Mingpao Monthly). In these seven short films, they talk about Hu's film aesthetics, characteristics, the significance of Hu's films and their impact on the films and filmmakers that followed. Ang Lee was occupied with the post-production of his new film, Life of Pi, but as soon as he received my request four months ago, he agreed to talk about King Hu. Because we didn't want to disturb his work, and Ang Lee understood our budget is limited, so the US Congress helped him to make an interview in LA at June 14 to answer our questions, then sent it to us via the American Institute in Taiwan.

Ang Lee regards the images of Chinese culture created by King Hu in his films have much greater influence on him than Hu's martial arts. He said "Director Hu sets the archetypes of Ming Dynasty just as director Hanxiang Lee sets the basic tones and images of Qing Dynasty and the 1910s period of China. Tong Wang who had worked with Hu is his only protégé living in Taiwan. Listening to Wang talking about Hu was such an interesting and satisfying experience for my colleagues, Huiling Hsueh and Tingfu Huang that they had a great afternoon together. The interviews with Hark Tsui and Tim Yip were done during our visit to Beijing for the annual FIAF congress by our team (including Yingzhi Lin, Teresa Huang, Changye Xu, Rujie Sun, Tianan Wu, Yingjie Chen and myself). As to the interview with Feng Xu, I assigned Yingzhi Lin and Changye Xu to Shanghai a week before the exhibition began.

Moreover, I would like to thank Feng Xu for her generosity that she sponsored the flight tickets; without that, we could never make it to Shanghai. As she said that she had a very special relationship with Hu, Feng Xu flew to Taipei just for the opening of the exhibition.

Sylvia Chang, Hu's last protégée, plays a role in the beginning and the end of the exhibition talking about her memories of Hu. The last part of the trilogy, *The Uncrowned Queen* (formerly called The Vienna Event in programme) sounds truly like a legend. In 2011, Sylvia Chang was invited to the Golden Horse Film Festival which held a retrospective of her films that year. After that, the Chinese Taipei Film Archive also ran a special programme on Sylvia Chang and I made an interview with her. She then mentioned that Hu's last film should be *The Uncrowned Queen*. At that time, none of us had heard about this film let alone knowing what happened to the print. However, soon after the interview, the head of Acquisition Dept., Guohua Chung, came across an unmarked reel in our storage vault and thought it might be the lost film. To everyone's surprise, it did turn out to be the long-lost film! Without any doubt, this film will be the perfect ending of this exhibition, and Sylvia Chang, to whom Hu often referred as "his son" will be the most suitable person to tell spectators the story.

Is Hu Directing Us from Heaven?

During the run-up to the opening, we encountered so many coincidences that we began to wonder if Hu was watching and directing us from Heaven.

I remember when we finished the first meeting for this exhibition I came to the library with Edmond Wong to look for some reference books. As soon as we walked into the library, the first book he randomly took from the shelves was *the International Film Guide* we were looking for. Then we walked to the other end of the shelves searching for the catalogue, *Transcending the Times: King Hu and Eileen Chang*, published by Hong Kong Film Festival and again Wong pulled something out by chance and it turned out to be exactly what we were searching for! We were joking that it got to be King Hu's spirit guiding us.

In fact, many miracles happened during the preparation, including the appearance of the English and Chinese scripts of *The Battle of Ono*. It was a film that Hu had been working on for so long, but the project fell through just before the shooting started. *The Battle of Ono* tells the story of the Chinese labourers who built the railway and worked as miners in America. Since Roger Garcia, the film critic, agreed to write an article for us, we asked him to get in touch with Sarah Pillsbury, the producer in US, to see if it was possible to put the script on display. To our surprise, Pillsbury agreed to not only loan seven pages of script but write a piece on how she met King Hu.

I remember that when we got the reply from Pillsbury, we were discussing how to present the show with MOCA. We did not expect the name, "Yun Lang" to appear on the list of the Chinese Central Television (CCTV 6)delegation who were due to visit us the next day. Yun Lang is King Hu's nephew. Lang is a scriptwriter and director with a string of awards under his belt. We wanted to meet him as soon as we heard about him. When he learned about the preparation for the exhibition, he asked us whether we had the Chinese script of *The Battle of Ono*. He

said he had a copy of it with him right now as he had not only raised the finance but got everything ready for the shooting. He gave us a copy of their production plan and left the copy of the script to us. He even signed the authorisation on the spot which allowed us to show the script in the exhibition. Nonetheless, due to the agreement, we will not disclose the content of the script.

The most interesting thing is during the process whenever we felt exhausted or frustrated, some miracle would happen. When we look back, we believe that it was the blessing from director Hu. He was a friend of ours and now he has brought everyone together again. We will wait and see the final result of the exhibition.

Responsibility of the Chinese Taipei Film Archive

Why should we hold the exhibition this year? The answer is that I believe it is the right time.

One of the reasons is that King Hu would be celebrating his 80th birthday this year if he was still with us. Secondly, since last year several King Hu's films had been presented around the world including the Lincoln Centre in New York (*A Touch of Zen*), the Yale University (*A Touch of Zen*), the Rotterdam Film Festival (*Dragon Inn*), Cineteca di Bologna, Cinémathèque française, the University of Wisconsin and the North America tour. During the 2011 Golden Horse Film Festival, one European distributor expressed interest in distributing films such as *Dragon Inn* and *A Touch of Zen*. Hu's works are enjoying a revival around the world and since the Chinese Taipei Film Archive is the organisation which holds the largest collection of Hu's heritage, it is time

for us to host the exhibition. Furthermore, the Film Archive has preserved, and continued cataloguing and documenting Hu's film prints, stills, manuscripts and books more than twenty years.

In 1989, King Hu donated all the company files and his personal collection to the Chinese Taipei Film Archive. A press conference was held after the lot had been catalogued. King Hu came to Taipei to supervise it in person and when he saw the result, he was so pleased that he decided to donate those stored in Peipei Zheng's company to the Archive. The content of these donations included the designs of the characters, photos taken in production, stills, documents, film prints and soundtrack. King Hu died in 1997 and in 2000 King Hu Foundation shipped the collection previously stored in the UCLA including books, manuscripts, documents, costumes, props and private items to the Film Archive in Taipei. During the past two decades, the Archive had put an enormous amount of time and effort into inventorying, cataloguing and digitizing these items, and so far we have digitized twenty thousand of them. In this exhibition, we show Hu's manuscripts of films and animations, comics, paintings and calligraphy. On the one hand, we would like to share the result of our hard work, and on the other hand, we hope we will show young people how diverse and great Hu's achievement is and to nurture the filmmakers of future generations.

Maybe most young people do not know who King Hu was, but this does not mean that he was not great or interesting or even not worth knowing. This is a fantastic opportunity for young people to know about Hu. Why can't we learn from the Europeans or Americans? They value their cultural heritage so much that they integrate it into their lives. For

example, the official posters of the Cannes Film Festival in the last couple of years both featured the old stars. How charming they look!

When watching *Dragon Inn* or *A Touch of Zen* today, why don't we try to understand why they captured the hearts of countless audiences? Hu had created so many archetypes of characters that they had very strong impact on the filmmakers of the next generation. Their influence can still be seen on the screen today such as the bamboo hat on the swordswoman's head, the white-haired eunuchs and so on. It is just that most people do not know the origins of these images and designs. King Hu is a very important figure in the history of the Chinese-language cinema and two of his master pieces, *Dragon Inn* and *A Touch of Zen* were shot in Taiwan, played by Taiwanese actors and produced with Taiwanese finance. For all the reasons mentioned above, we decided to hold an exhibition in Hu's honour.

King Hu and Art Museum

Why did we choose MOCA as the venue? Well, this is another story. The idea of showing King Hu in an art museum seems natural enough to me since it is very common in Europe and USA (1). At first, I did not expect it to raise controversy in Taiwan, but later I found it rewarding and stimulating. I thought that Taipei was such an international city that the encounter between cinema and the art museum would be taken for granted. Since Musée du Louver began producing films (*Face* by Ming-Liang Tsai was its first production), our question shifted from "whether cinema should be shown in the art museum" to "which films are suitable for the screenings in the art museum." We did not look into the history between cinema and art museum. We simply ask ourselves whether these films are worth being shown in the art museum for people to appreciate, to think, to have conversation with them and to learn from them. In fact, it is nothing new to host a film programme in an art museum in Europe or USA. Almost all the major galleries have done it. I had attended a 1930s Chinese film program in the Solomon R. Guggenheim Museum in New York and I watched *Goddess* starred Lingyu Ruan in Guggenheim as well. MOMA in New York even hosts the "New Directors / New Films" event every year and has discovered a number of talented filmmakers from China, Hong Kong and Taiwan. When I went to the Cannes Film Festival in 2000, I went to a film costume exhibition in Centre Georges Pompidou. I have attended a number of film festivals or film exhibitions in the art museums by chance. Although there aren't many similar events in Taiwan, it definitely had been done before. Therefore as soon as I decided to hold a King Hu exhibition, I was determined to look for a venue good enough to match his works because he truly deserves it. We considered only art museum as Hu's works had been highly praised all over the world; we could not see why they could not be shown in an art museum. I became even more determined after having inspected our collection and the digitized items.

I am so happy that MOCA Taipei proves to be such a free and open space; without it, we would not be enjoying the success today. However, when we first got in touch with them, the museum was almost fully booked. It was not until this February that MOCA was certain that the venue would be available. We immediately booked the place and began working with them. The Executive Director of MOCA Taipei,

J. J. Shih and his team had been working really hard and helpful. In terms of our collaboration, the Chinese Taipei Film Archive provided the content and MOCA Taipei and CTFA's team were in charge of designing the space together. The exhibition we see today is the result of countless discussions between the two teams and numerous revisions of our plans.

King Hu: the Renaissance Man

King Hu was truly a versatile talent. While going through all his works, I saw the King Hu I was familiar with, but what surprised me more was the King Hu that I did not know about. For instance, I saw Tienxiang (a place in Taiwan), the people and the vehicles in the Southern Taiwan drawn in his sketches··· I had the impression that it was China that Hu was emotionally attached to wherever he was. But now I find that I was wrong; he integrated himself into the place wherever he stayed. Moreover, he would learn the local culture and expressed it in his own way. Although later in his life, he could not make any more films, he kept working. Through his writing, calligraphy, ink washings, animation, even caricatures, Hu never gave up expressing his sense and sensibility.

When Hu went location scouting, he would walk everywhere. He was searching for the beautiful scenery he pictured in his mind before he turned the real location into his creation and used it to convey his vision on the screen. Take the temple in *Raining in the Mountain* for example, the temple looks like the same one on the screen and everything was shot on location. However, the temple we see in the film was a combination of more than a dozen temples in Korea. Hu had been to every place in South Korea just to look for his ideal locations. Through the different camera angles, cinematographical techniques and editing, what we see on the screen is the reality Hu created. Isn't it precisely the essence of the Chinese arts? Isn't it similar to the Chinese landscape paintings of Xi Guo and Kuan Fan and also in Peking opera? Everything looks real but in fact, it is created by the artist. It is used to lure you into the world that convinces you that it is real, but in fact, it is a pure creation of the artist; however the feelings expressed in it are yet real.

Moreover, Hu was an expert in making the best of the location to create the dramatic tension and to use it as the structure of the film. This trait is also seen in Jonnie To's films. Kei Su, the film critic, had once expressed that To made the best use of the city landscape while Hu was great with mountains and inns. Hu turned the Peking opera, *Three-Road Junction*, into *Anger* whereas Jonnie To turned it into *Triangle*. I remember when I saw *Anger* for the first time, I thought, "Isn't it the Chinese pantomime?!" Hu daringly shifted the Peking opera from the theatre to the deserted field, (for example, the scene in *Dragon Inn* in which the East Chamber guards chasing after the descendants of the loyal official), and Leo Chen thought it was such a daring attempt that no one had dared to repeated it. If Hu hadn't had a great knowledge of Peking opera, how could he have achieved such a success?

When looking back at his acting method, some claimed that it was a method based on the "opera masks" which could not express the characters' emotions deep enough. Nonetheless, the opera masks are such precise symbols of different characters born out of our forebears' life experience. Looking through the characters in Hu's films, we would find

that they all fit in this system. This makes me wonder if Hu was trying to create a different acting system from the western ones; a method based on the Asian theatre that can be seen in Noh in Japan and in the Thai and Indian dances. This is something that can be further explored. The best reward we get from this exhibition is that everyone has made one's observation from a different angle and we find that there is so much more worth looking into. Therefore this exhibition is just the beginning; there is so much about King Hu and there is the hidden treasure waiting to be discovered!

Moreover, the key elements in Hu's films such as the inns, the bamboo forests, the assassination weapons and the designs of the characters are essential in this exhibition. In Room 201, we show the behind-the-scenes of ten films to demonstrate the diversity of Hu's works from different points of view. The audience can see the storyboards, the shooting scripts, the manuscripts, the drawing of costume designs and the set designs, the photo shot in production, the posters, the promotion materials, like crosswords and the stamps from *Dragon Inn*.

When we arrive in *The Boiling Sea* section, we will see the characters and the sets Hu designed for this aborted animation. Inspired by his visits to the aquarium in San Diego, Hu made the sketches of these sea creatures and turned them into the characters in *The Boiling Sea*. It was a pity that it was never made into a film. In the caricatures and comics section, MOCA Taipei divided Hu's works into two parts; four-frame comic strips and the political caricatures. For instance, when the affair between Prince Charles with Camilla Parker Bowels was disclosed, it showed the British people's negative reaction and Prince Charles' astonishment. In addition, we see the tax issues during the Clinton administration, the negotiation between Bill Clinton and Kim Jong-il on nuclear weapons, the political situation in China, the cross-strait relations, Chris Patten and Xiaoping Deng… We invited Chen-Lung Kuo, Deputy Editor-in-chief, United Daily News to write the annotations in order to help the audiences understand them.

The Role Model in the World of Arts and Culture

By the time I finished writing the previous paragraphs, I remembered what Wern Ying Hwarng said about King Hu. She said, "This opportunity allowed me to see so many of Hu's works. I got so much inspiration and thoughts from them. After all, Hu had done exactly what I am doing now." Hwarng did a great job that she integrated her creation so perfectly into Hu's that when Jun Shi first saw her work, he felt as if he had gone back to the film set in Korea. Their thoughts of belonging to the filmmaking community are shared by Tim Yip and Meiching Huang. It does not matter in which periods they were born, these outstanding filmmakers keep working together and bringing new blood into the film art.

King Hu had been drifting from one place to another all his life. He left Beijing for Hong Kong and then moved to Taiwan and eventually immigrated to the United States. King Hu was forced to move around, but the film-makers of the next generation travelled around the world of their own free will. No matter what made them leave in the first place, they had all lived in the West. Hu's English was so fluent that the western culture had become inseparable from his life, and the combinations of the West and East

often appeared in Hu's films. From the trajectory of his move, we can spot the footprints of so many filmmakers. Tim Yip said, "King Hu, Ang Lee, John Woo, Karwai Wong, Hark Tsui and I have more or less overlapped with each other. At some stage, we exist in each other's lives." Back then, King Hu had been gearing up towards more ambitious projects, but in the end, he was never given the chance to realize them. Now we see that the East is rising again, yet King Hu was passed away. Looking back to the careers of generations of Chinese filmmakers, we could find that everyone was born and grew up in a different time and has his circumstance and chances in life. Nonetheless, when we put Hu's works in the historical context, his contribution and achievement can stand the tests of times. This is exactly why these films are still popular and appreciated by the audiences all over the world. This is also why everyone agreed to participate in this exhibition – they wanted to do something for King Hu and to pay his tribute. Now we miss King Hu, a multi-talented genius, even more since at this moment, the Chinese-language cinema is enjoying a renaissance that we have everything ready but brilliant filmmakers. There is still so much more we can learn and so much more inspiration we can get from his works···

All I wrote here is what happened to us after we decided to hold the exhibition. All of them happened because of King Hu and many things are still going. The exhibition is just a beginning to re-open this treasure of wisdom, his influences are spreading worldwide.

Jinn-Piei Chang

1. "King Hu, Chinese Taipei Film Archive @ MOCA Taipei," Guoping Tian, Weekly E-newsletter, August 4, 2012, Chinese Taipei Film Archive.

In 2006, Centre Georges Pompidou held the exhibition, Travel(s) in Utopia, Jean-Luc Godard 1946-2006 which was an art installation presented with Godard's works Histoire(s) du cinéma. The highly stylised sets from the films by Pedro Almodóvar have always been popular amongst the art museums around the world. In addition to these exhibitions in which the directors themselves were involved, Guggenheim Museum in New York held a retrospective of Federico Fellini at the 10th anniversary of his death. Instead of Fellini's films, they showed his caricatures and sketches so the viewers would understand the source of the master's inspiration. The Barbican Arts Centre in London held a Derek Jarman exhibition a year after his death. They displayed everything Jarman did in his life including his paintings, his experimental films and his last art installation, the garden of his home, to show the audiences that Jarman was a multi-talented artist and films were just part of his creation.

專文
Essays

論胡金銓的原型風格

黃建業 作

書劍江湖　武俠影史上成就一幢迎春閣
經史天下　文化底蘊中翻開多卷忠烈圖

從火燒傳統說起

在1920年代末年左右，中國揚起第一波的武俠電影浪潮，即《火燒紅蓮寺》連燒十八集的時代。

《火燒紅蓮寺》、《江湖奇俠傳》、《紅俠》、《關東大俠》、《荒江女俠》等作品，容或粗糙，藝術深度欠飽滿，但在類型發展上提供出一個活力鮮明的新世界，並且讓神怪武俠與傳統文藝／戲曲電影的拍攝路線，成為尚武崇文的兩條路線平分秋色，開展了1920年代末年興盛的民營電影企業，可謂是中國商業電影發展的最早期蓬勃模式。若不是1930年代初「九一八事變」的國家危難威脅，今日的電影形態，或許完全不同。

我們不妨從這歷史脈絡中重探，不少人對這波武俠電影的發展，認為是怪力亂神、荒誕不經，卻也暗示著一種非寫實元素，於武俠影片中尋找到它的雛型。在國家危難的強烈道德意識下，30年代後，一度中斷了它的發展。從近百年的中國電影史觀之，這未免不是一種可惜。

直到1950年代後的香港，才真的展開它重新發展的機會，再度把平江不肖生（向愷然）的《江湖奇俠傳》翻轉出來。可是真正重拾過去武俠電影的傳統餘緒，在殖民地的粵語影壇，產生有趣的變化。沒有太多「載道傳統」的務實商業發展趨向中，刀光劍影間再次舒展出它千奇百怪的想像魅力。《如來神掌》、《白髮魔女》、《白骨陰陽劍》、《武林聖火令》及《仙鶴神針》等奇幻世界，在粗糙的粵語片中，優先在商業票房上，吹號揚旗，甚至數十年後變成周星馳電影裡，窮街陋巷中的庶民記憶。

不過，香港電影工業發展到成熟的時期，才有足夠的電影產業製作分工，去支撐類型電影的發展，尤其是片廠系統的支撐。所以張徹跟胡金銓導演兩位深具企圖心的導演，才開始意識到現在的製作層面，可以讓他們在更寫實的路線中，尋找到更深刻的、更厚實的創作力。我覺得這是跟當時1960年代逐步形成的片廠作業系統有關，正是這個作業系統，支撐起一種中國傳統類型片的大爆發。胡導演因為他是對於歷史、考據，對於戲曲美學或人物創作，繪圖觀念與坊間小說等原創力的匯集，使他在單一的武俠電影系列中變成一個大師。而這套東西彙整到《龍門客棧》中時，已全面形成新的典範。胡導演把這些元素帶出來，非常有震撼力，從寫實的功夫深入下去，構成他獨特的視野和風格。

當然我們談胡導演一般都是談風格問題，可是這個風格問題又是建立在甚麼東西上面？其實很多人可能忽略了胡導演背後的那個寫實風格的驚人意義，他的寫實不是寫實的表面，是一種具有內在厚度和透視力的寫實風格，可是這個問題又是相當複雜的，因為一定要從原型人物、佈局、空間結構，以及影片中如何將明代歷史的黑暗時期嵌入所謂正邪兩面的觀念性對抗等等層面來談。他在這些地方，突然把一個很多人都覺得是娛樂或者不那麼重要的一個片型，提升到一個非常具有文化格局的一個全新狀況。《龍門客棧》有些時候讓人想到約翰・福特（John Ford）1939年拍的《驛馬車》（Stagecoach），在類型發展方面，已然像里程碑一樣，深具開創性，過了那麼多年，再看《龍門客棧》才驚見片中有一種莫可言狀的有機性。它的內在厚度並不能只從分析胡導演的某些元素，就能感覺它的重要意涵。

香港電影專家羅卡在〈民俗文化、民間藝術對胡金銓的啟導〉（2007）一文中，對胡導演的多元而豐富的雜學淵博，有相當詳細的論述：早在他第一個劇本《大地兒女》受老舍小說《火葬》及《四世同堂》啟發；《花田錯》即來自《水滸傳》「小霸王周通桃花莊搶親・花和尚魯智深仗義懲惡霸」一

節;《玉堂春》則來自京劇《蘇三起解》;《俠女》取自《聊齋誌異》;《畫皮之陰陽法王》也是來自《聊齋誌異》之《畫皮》;而《忠烈圖》導源於《明史》朱紈和俞大猷抗倭寇事件;《空山靈雨》則啟發於《蔣平撈印》一類的武俠小說;《怒》即改自京劇《三岔口》;《山中傳奇》來自宋人話本《西山一窟鬼》;《天下第一》雖為原創,但也依據五代十國周世宗的史實改寫。

以上的追本溯源,處處都看到胡導演的多元觸角,教人想到莎士比亞,他雖從希臘作家普魯塔克(Plutarch)、神話、異地傳說及羅馬、英國本土歷史中取材,但一旦被他寫成劇本後,數百年間也就只記得莎翁筆下所創造的人物原型。《龍門客棧》雖為原創,它的最初劇本題目卻是「起解」,歷史／戲曲的啟示,亦不言可喻。

原型與臉譜

在這個脈絡下,直到現在我們還是繼承胡導演這份原創的系統,只看《龍門客棧》的意義就已非常清楚了,因為它跟前作《大醉俠》不一樣,這些原型人物本身類型符碼的多樣性,是可以繼續開發的。當然,在《大醉俠》的金燕子也是很精彩的原創原型,可是那個原型裡面可能是單獨的一個傑出的原型;但在《龍門客棧》中卻有那麼多原型共構出一個宏大歷史空間,這就有點教人震驚。現在回頭看胡導演這部作品,就更顯出他是重要的。大部分人談他京派風格,都談到表面的視覺,某些華麗剪接等等,但卻是它的核心角色原型創造力,感動了那個時代,甚至後來的創作者。

《龍門客棧》對於武俠電影就像《驛馬車》之於西部片。《驛馬車》的偉大之處,是在整個西部旅途中,可以看到那麼多種後來不斷發展的西部典型人物。胡導演的《龍門客棧》的貢獻與重要性,也在於發展出《龍門客棧》這個明末歷史／江湖原型系統。或許從另一個角度來看,它們都是以精彩人物網絡來建構的古典「公路電影」。很多人把中國武俠電影跟西部電影做比較,因為其中有某些雷同性的手法和價值。《龍門客棧》裡的原型系統就很像西部片一般。《驛馬車》裡被社會所誤解的一個犯過罪、但有良心的英雄,所謂善心壞人,這是一種後來被西部電影所大力開發的重要角色,甚至早在默片時代也曾出現過;另外像很能了解孤獨英雄的風塵女子、嗜酒的醫師、過度正派的東部客,還有精神脆弱的東部淑女、野性的印第安人等等。這是一個典型的西部原型網絡,它不是某一角色獨特彰顯其個體色彩,而是以一個人物結構網,張羅開複雜的西部文明性格。

《龍門客棧》裡的原型系統就跟上述《驛馬車》很像,一個大不算大,小不算小的室內劇空間,進進出出的各色人等,都變成大社會中的黑暗小縮影。在《龍門客棧》之前沒有人看過這樣的太監群、這樣的書生,也沒有人創造出上官靈鳳那樣的俠女。這個原創力是直到目前,很多人談武俠電影都追本溯源,跟著胡導演所開發的範疇在走,這個範疇當然是影響深遠的。

我們說,如果沒有胡金銓的《龍門客棧》,怎麼可能有徐克、許鞍華這一代的《書劍恩仇錄》、《香香公主》、《新龍門客棧》、《龍門飛甲》?當然也就沒有李安的《臥虎藏龍》。胡導演為什麼具有那麼大的原創力,來創作出這些人物,雖然是匪夷所思,但古典傳統的雜學,確為他提供出精彩的創作思維底蘊。

正義凜然還是魔高一丈

不少當代的電影創作者,都輕忽古典敘事電影,但敘事電影厲害的地方,就在於創作角色跟佈局。莎士比亞是這方面的高手;延伸到電影,希區考克(Alfred Hitchcock)是高手;延伸到中國武俠電

影，胡導演在這方面亦是高手。

《龍門客棧》裡面的人物，被置放在一個虛構下的真實社會中，胡導演一拍太監之後，所有武俠電影幾乎跟著要拍太監。一個表面無能的人，武功卻極高；既深謀遠慮卻又有哮喘病等。是這黑暗勢力內在存有的脆弱和矛盾，從二檔頭到大檔頭，再到大太監，層層鋪墊，使他們越發精采。他創作出一個大可等著被開發的原型，這個原型還代表了黑暗的政治意義，最重要的是他代表了一層這樣的人物：外型上是那麼威風凜凜，而且是連正派人物都贏不了的。這樣的人物定位是跟以前的所謂反派的角色不太一樣。論武功高強，還是這個太監武功最高，這就可以看到胡導演怎麼在裡頭表現第一個反派英雄，把他設定成那麼厲害，於是他被殺之後觀眾會有另一種複雜心理：一個武功那麼高強的人，被一群所謂正義之士殺了，然後正義之士真的那麼無能嗎？

這個問題才是《龍門客棧》讓人震驚的地方：面對整個明代的黑暗歷史，正義在哪裡？正義的無能，如果正義之士那麼有能力，早就警惡鋤奸，這些反派人就沒有了，問題也就很容易解決。可是胡導演呈現出另一種黑暗史，所以他的原型力量，除了一方面，呈現出角色有豐沛生命力外，另一方面也在於他的原型背後，肯定了歷史中一個黑暗而悲觀的論點——歷史幽微中，魔高一丈，正義凜然，僥倖得勝。

戲曲美學滲透表演風格

演員出身的胡導演，在他指導演員時，無疑發揮了他的特長。這問題讓人想到：武俠電影哪些導演特別注重表演？胡導演可能是唯一的電影創作者，一以貫之地將表演變成風格，甚至所謂表演的風格化在很多電影表演的探討中，沒有人走得比胡導演遠，原因就是他因利乘便，在廣闊的武俠電影的類型化世界中，可以不用發展寫實表演，卻拿到一個大塊面中去融合，即傳統戲曲美學。傳統戲曲的戲劇是色彩豐富的表演系統，包括裡面的手、眼、身、法、步的技巧。這些劇曲系統加上背後的鑼鼓點音樂等，使得這些抽象化改變了武俠電影，這個改變是重要的。可惜的是那麼多後來拍武俠電影的人，包括徐克、李安，卻再看不到這樣的獨特的風格化表演。反而在黑澤明的《蜘蛛巢城》中，看到「能劇美學」，從山田五十鈴的表演，滲透到整部作品，成為莎劇最傑出的東方轉化。

和黑澤明一樣，胡導演並不看重心理真實，卻更重在寫意，寫觀念，寫原型。這是越來越鮮見的東方電影文化個性。

但更有趣的是如前所述，胡導演的角色原型，常被推向臉譜風格。這正是西部電影無法達到的，胡導演的角色多了傳統戲曲中的重要美學滲透，他大多數人物語言極有限，這批寡言之角色，大多以其形像姿態，行走坐臥的模樣，以及進行的動作，或許加上音樂鑼鼓點，來逐步界定他的戲劇意義。這種做法恰好讓胡導演的影片多一份戲曲美學的文化色彩，但更重要的是構成了人物的觀念化與抽象色彩，只要觀察一下《俠女》中的楊慧貞與顧省齋的空洞愛情，《忠烈圖》裡各俠客的形貌《龍門客棧》中蕭少鎡的冷穆《迎春閣風波》裡的眾女角（郡主李婉兒、萬人迷、水蜜桃、黑牡丹、小辣椒、夜來香）的定調，他在把人物推向觀念化臉譜風格，極為明顯。也是這種風格，使他跟張徹影片中的南方熱血，大異其趣。也使他的人物，在寡言中揮散著行動與影像的風格魅力。

殿堂級的透視力

楚浮（François Truffaut）、高達（Jean-Luc Godard）、侯麥（Eric Rohmer）他們所主張的「作者」，不是只談表面視覺的風格；當然視覺是其中

一個部分，但是這個視覺的本源、核心部分是什麼？他們是透過洞見來談導演風格，因為個性在那個風格裡面，作者看事物的態度在裡面。所以為什麼安德魯‧沙里斯（Andrew Sarris）說：作者批評的觀念最頂層，所謂殿堂導演層，是根據殿堂導演的人生觀而論斷的，其實就是檢視作者對世界的透視力，對人的透視力。我們如果今天將胡導演定位為真正傑出的武俠片大師導演，主要是著眼於此；而不是看他怎麼玩攝影機。這透視力才是一個導演對現實的真正態度的貢獻，一個具創見的思考家也是頂級藝術家的重要條件。

像馬丁‧史科西斯（Martin Scorsese）在談美國電影、談義大利電影時，他會細細分析某一個場段，真有那麼隱密的一種情調或者一種色彩處理存在其中。比如說他在看維斯康提（Luchino Visconti）的《戰國妖姬》（Senso）時，開場的歌劇段為例，他看維斯康提設計抗爭傳單色彩（綠色、紅色、白色），跟裡面不同族群的服裝、跟整個劇院的金色、白色的關係，是如此鮮明地對照著，單單看那個場景的色彩控制，看到維斯康堤那不凡的創造力。所以才發現那個開場是那麼出色地顯示義大利統一問題，正是山雨欲來風滿樓地與台上唱的歌劇相互輝映。這才看到這個導演在色彩元素上，用力至深，有那麼精華的觀點在裡面。

從另一角度，以胡導演的剪輯為例。他剪的是概念，他剪一個飛起來的概念，他剪一個倒掛衝下來的概念，所以才會發展出竹林段那樣精彩的剪輯。他不是剪動作，他是剪最有趣的、最具想像力的一個視覺觀。而且他也不要連戲的連續剪接，以致使得這個剪接點更凸顯出來。這並不是連戲剪接的觀念，所以從這些地方，可以看到胡導演在剪接美學也好，別的美學也好，這種非寫實性的觀念超越了同年代的中國影人的剪輯美學處理，沒有這麼大膽的藝術視野。剪輯像愛森斯坦（Sergei M. Eisenstein）所主張的，它不是技術而是思想！

增艷

胡導演尤其對美術擅長，他常為角色們設計的不同的衣服、配色或空間，似增強視覺風格，也為電影增艷。

上官靈鳳的帽子――不管是從日本還是考證來的――就是很有型。而且胡導演還有全新的裝備構想，非常精彩，像是石雋的傘。所有這些攜帶物的有趣變形運用，處處顯露胡導演的才華。

事實上胡導演的視覺設計，是他武俠電影中，極迷人的部分，《大醉俠》金燕子的竹紗帽、《迎春閣風波》的郡主裝扮，《忠烈圖》中徐楓苗族的頭巾、衣帶、長裙、配飾，《龍門客棧》中的錦衣衛服裝，《天下第一》的唐代美女、名醫、畫師、神偷等，都在考證之外延伸動人的戲劇美感。

其他像飛鏢、他的筷子、他的酒瓶，所有東西都可以轉型變成一個重新被創作的東西：他不是喝酒用的酒瓶，是用來放箭用的；他的銅板是用來展示功夫，或做通關暗號用的。這些東西我們可以看到一個導演在轉型現實的時候他的自由與才華，這並不是表面拍攝的視覺形式，而是看到一個導演對現實創作的透視態度。有些導演就是照本宣科，銅板就是銅板；胡導演的銅板自有不一樣的風情。就像他的客棧一樣。真正風格，是從獨特的內在透視力開始。

這就是我們所謂的「原創」。原創的意思就是：只有那個導演才會如此看待電影這個媒體，他如何看待現實，包括環繞在身邊的所有東西。這才是我們談剪接、談美學最核心的問題。所以當我們現在問誰拍武俠電影能真的把表演推到那麼風格化？大多導演沒辦法有這個能耐，可是胡導演有這個能耐，因為他像李翰祥一樣，兩人都是非常瞭解中國傳統文化中的這個塊面，然後在他們身上，變成一個有機而原創的資本。這才是個性與風格最重心的部分。

胡導演的藝術冒險

胡導演後來作品有趣的地方，是讓我們看到一個導演很清楚自己有的資本：國際名聲、票房，這是很實際的。是在有這些資本的前提下，他開始自己的藝術冒險。有一些藝術家他得到票房之後，他瞭解這些元素在觀眾是怎麼樣被接受，於是他可以不斷重複，對他來說也足夠了；但有一些創作者不斷把這塊東西深化，胡導演除了深化進去，更有趣的是，他開始尋求深化後的各種轉型。

從《俠女》一直延伸下來，其實都是胡導演的不同面向的一種冒險。其實他在拍《俠女》的時候，已經開始要借《俠女》裡的各個角色延伸發展，並開始轉型邁往更複雜的面向，或者說，他抱著非常大的野心，去把儒、釋、道——即中國的「文化性」三大支柱嵌進《俠女》之中。雖然有些地方不成功，可是就是這個意圖，讓人看到一個創作者突破過往的企圖心的堅定意志力。

一個藝術家在他名聲締造之後，看到他往後的發展其實是更重要的，就像我們看侯孝賢他會拍出《海上花》是驚人的。他拍出《戲夢人生》也是驚人的，因為這些都是一個藝術家在名聲締造之後，放棄某些東西重新冒險的成果。

類型的深化與轉向

胡導演一直有這種衝撞力，甚至到後來他想拍《華工血淚史》（當然他本來就一直想拍《華工血淚史》），可以看到他這些東西都是在願意放棄他現有的資本，重新建立另一個新的可能性。這就是藝術家的冒險探索精神，他對自我要求的企圖心是不同於一般導演的，在這個層面上，他一直都是這樣具突破性嘗試的藝術家。

有些導演不斷拷貝自己的過往，胡導演甚至在開發

所謂客棧原型，他都在變化，甚至從中可以看到他做了多麼精緻的節奏設計，去突破一個短片本身的結構，《喜怒哀樂》的《怒》本身就是短的，所以他會思考更有趣的另一種做短片的實驗性。他在節奏設計、在走位的區間觀念中去玩。他有他自己的元素，可能觀眾不太在意，可是作為一個電影藝術來說，很多人一看就了解，這是胡導演的節奏和元素試驗。我們也可以說那是他戲筆之作，可是這個戲筆之作，也是有他要完成的某一些實驗性。同一部合作片中，白景瑞也是這樣，我們看到有的導演拍分段體電影跟他拍長片是完全不同。胡導演是值得我們重新欣賞，他除了創作力很豐富外，更重要的是有藝術家的膽量，始能開發全新的局面。

電影產業與創作的永恆矛盾

姑且不論胡導演的國籍，他對台灣、香港甚至整個華語電影世界，影響意義很大。胡導演在台灣取景，讓我們開始發現東邊的山形地理景觀的趣味。煙樹雲林讓不少評論者，從宗白華申論到林年同的「鏡游美學」論述。事實上，一個導演會選景很重要。侯孝賢發現金瓜石，只有他點鐵成金！胡導演厲害就是，別的導演去勘那個景，也就是那個景而已；胡導演去勘那個景，那個景在他腦海中是另一種想像風格東西。一個山巒起伏的地形，在他心中，自有雲遮霧障。台灣聯邦的支持中，一方面提升了這種類型，因而後來聯邦有大量的武俠電影類型出現，但這些電影其實都是循這個資本去挖掘的，有些成功有些失敗。一個導演影響到電影公司；相對地，電影公司對胡導演的影響，除了足夠的專業支撐外，相對是比較有限的。

其時台灣的電影產業才開始定位它的產業，從1960年代初期，才看到國片慢慢有起來的狀況，差不多在1963、1964年之後，受《梁山伯與祝英台》和「國聯」的刺激，才開始有一些新的東西出來。包括中央電影公司的「健康寫實」。這些東西都直接

改變了台灣電影產業的教條稚嫩性格。改變之後我們看到包括很多民營企業，也開始有龐大一點的企圖心，電影產業才得以借經濟風向上昇而改變。

可是電影產業改變常要靠賣座電影的刺激，那就是像《龍門客棧》。這些旗艦型賣座電影，成功後才能讓老闆跟電影公司有信心，決定要發展這個類型系統。回顧為什麼1930年代華納兄弟公司大力發展盜匪片，電影公司看到，這剛好可以靠近不景氣時代的認同心理，了解這種黑道跟社會的不平等、鋌而走險的關係。1945年代亦有很多電影公司拿剩餘資本拍「黑色電影」，呼應著二戰後的保守冷戰氛圍。所以我們可以看到一種類型開發在電影產業中的微妙性，可是類型開發一定要有賣座電影跟賣座電影所帶來的原創性，證明它值得被開發，《龍門客棧》就完成了這個任務。

胡導演自己本身的視野跟他的企圖心遠比聯邦大，像這類超前的優質藝術家，沒有任何電影公司可以真的全面去支撐。所以他當然有一些創作上的不快，這是明顯的。可是商業產業跟藝術家的自由度永遠是永恆矛盾。這點好萊塢是很清楚的，畢竟得有這種藝術與自由的衝撞，對台灣電影來說才是非常有價值的。

風尚中有待揚帆

《龍門客棧》的很多原型，具有繼往開來的意義。但開發的同時，卻不能馬虎，胡導演的原型，包括衣服、道具運用、場景設計等，都不容任何專業性的要求，有所妥協。由李翰祥的國聯電影之後，連文藝愛情片，品質也不能太馬虎了，因為有人已經做出這樣水平，而且這個水準已經被大部分的觀眾所認知。電影產業才有重新往上提升，讓產業及藝術品質，有互動前進的可能性。

《龍門客棧》在票房上、在類型開發上、在原創力上或者視覺風格上，都具劃時代意義。其後，胡導演也在多次轉型中，尋找不同的漸進式變化，每一個年代的創作是否能善用他的文化遺產，也是每一個年代，開發古典傳統的寶藏鑰匙，是新世代創作者的重要遺產。只是有些有強烈的續航力，有些已隱埋在時代的新價值風尚中，等待再開發，或再度揚帆。

An Analysis of King Hu's Archetypal Style

by Edmond Wong
translated by Isabella Ho

Amidst literature and swords, "The Fate of Lee Kahn" is revealed in the history of martial arts.

In the world of history, "The Valiant Ones" are hidden underneath the culture.

From *Burning of Red Lotus Temple*

In the late 1920s, the first wave of martial arts films emerged in China beginning with the first *Burning Red Lotus Temple* which was followed by seventeen sequels.

The films including *Burning of Red Lotus Temple*, *Strange Swordsman Story*, *The Red Errant Knight*, and *Swordswoman of Huangjiang* might be far from refined works and lack artistic merits, but nevertheless they opened up a brand new world for a genre full of potential. Their success also enabled the fantasy films to rival the traditional dramas / opera films in the flourishing Chinese film industry in the 1920s. This could be regarded as the earliest bloom of Chinese commercial films. If there had not been the Manchurian Incident which happened in 1931 and consequently led to the long-standing war between China and Japan, we might have a completely different film industry today.

We shall re-examine the development of the genre in its historical context. These films are often regarded fantastic at best and immoral at worst. Nevertheless it implies that an element crucial to anti-realism had found its prototype in the martial arts films. It is a pity that as China was at war at that time, the strong moral sense permeating the country put an end to the genre development.

It was not until in the 1950s that the genre was revived in Hong Kong, a British colony back then. Writer Kairan Xiang's *Strange Swordsman Story* was re-enacted on the big screen; the ember of the previous wave of martial arts films was rekindled and triggered an interesting shift in the Hong Kong film industry. In a commercially-orientated environment free of moral burden, once again the film-makers were allowed to let their imagination run wild. Coming from the world of fantasy, kungfu quickies such as *The Young Swordsman Lung Kim-fei*, *White Haired Devil Lady*, *Ingenious Sword*, *The Holy Flame of Martial World*, and *Secret Book* dominated the box office. Furthermore, decades later they even transformed into the memories of the masses living the poor conditions presented in Stephen Chow's films.

It was only when the Hong Kong film industry reached its maturity could it support the development of genre films; the backing from the studios was particularly crucial in this respect. Therefore ambitious directors such as Che Zhang and King Hu began to realise that in terms of film production, they could look deeper and create more solid works in a realist style. I believe that the rising of the studio system in Hong Kong in the 1960s played an important role in this development and it was precisely this system that supported the surge of this traditional Chinese genre. King Hu was very interested in history, historical research and had a great knowledge of traditional Chinese operas, paint techniques and popular literature and this made him rise as a great master in a single genre. When he integrated his knowledge of different fields into *Dragon Inn*, a new paradigm was born. The elements King Hu demonstrated in the film were very powerful and by venturing deeper into realism, Hu had created his unique style and vision.

When people talk about King Hu, they tend to talk about his style. But upon what is the style built? In fact, many people may overlook the significant meaning hidden behind Hu's realist aesthetics. It is a realist style supported by depth and a penetrating vision. But this is a complicated question as it has to be analysed by the archetypal characters, the plot and the spatial structure and how the plight people faced in the Ming Dynasty is represented through the good and evil characters in the film. From here King Hu transformed a genre which was treated as entertainment or with less respect into one with artistic merits. *Dragon Inn* sometimes reminds people of *Stagecoach* (1939) directed by John Ford. In terms of the development of this genre, it had become the landmark which opened up a new dimension for the genre. When I watched *Dragon Inn* again years after my first viewing, I suddenly grasped how organically everything evolved in the film. One cannot understand its significance and depth by analysing some of the elements Hu infused in the film alone.

In his essay, 'From Folk Culture and Art to King Hu' (2007), Hong Kong film critic Kar Law has a thorough analysis of how Hu's broad knowledge about the traditional art forms inspired his films. As early as in Hu's first film script of *Sons of the Good Earth*, one can see that it was inspired by *Cremation* and *Four Generations under One Roof*, novels written by the Chinese writer, Lao She. *Bride Napping* was based on one of the chapters in *Water Margin* in which Zhou Yung tried to force a woman to marry him and met the monk Lu Zhishen. *The Story of Sue San* came from the famous Peking opera with the same title. Both *A Touch of Zen* and *Painted Skin* were stories from the Chinese classical novel, *Strange Stories from a Chinese Studio* whereas *The Valiant Ones* was based on a historical incident in the Ming Dynasty in which

Wan Zhu and Daiyou Yu fought against the Japanese. Furthermore, *Raining in the Mountain* was inspired by a martial arts novel called *Jiang Ping Retrieved the Seal* and *Anger*, a segment of *Four Moods* was adapted from the Peking opera, *Three-Road Junction*. *Legend of the Mountain* was based on *Ghosts in West Mountain*, a story written in the Song Dynasty. Although the script of *All the Kings Men* was original, it was inspired by Emperor Shizhong of Later Zhou in the Five Dynasties and Ten Kingdoms period.

From the analysis of the roots of Hu's films, one can see how widely Hu had read and learned. This reminds us of William Shakespeare. Although Shakespeare got the inspiration from Plutarch, the Greek mythology, the folklore and the histories of the Roman Empire and England, once he had turned the stories into his plays, the readers for generations to come remember only the archetypes of the characters in his plays. Despite the fact that the script of *Dragon Inn* was original, from its working title, "Qi Jie" (meaning "prisoners hit on the road for re-trial" in classical Chinese), the influence from the Chinese opera and history is far too obvious.

Archetypes and Faces

King Hu established a system which is being followed until today and the significance of *Dragon Inn* alone will make it clear enough. *Dragon Inn* is different from Hu's previous film, *Come Drink with Me* because in *Dragon Inn* the potential of these various archetypes could be explored further. Although Golden Swallow in *Come Drink with Me* is also a brilliant archetype, it is the one and only archetype in the film whereas in *Dragon Inn*, a huge historical space is constructed by so many different archetypes of characters. This

is a truly amazing achievement. Now when we look back at this film, it just shows how important King Hu is. When most people talk about Hu's Peking opera style, they talk about the visual aspect we see on the surface or the skillful editing, but it is the force in creating archetypes that has moved not only his contemporaries but filmmakers of the future generations.

What *Dragon Inn* means to the martial arts films is the same as what *Stagecoach* to the westerns. The greatest significance of *Stagecoach* is that so many archetypes of the characters seen in the following westerns are being established as the film unfolds. The contribution and the importance of *Dragon Inn* is that it established an archetype system of the martial arts world, set in the late Ming Dynasty. Maybe from another point of view, *Dragon Inn* could be seen as a classical "road movie" built upon a network of fantastic characters. Many people tend to compare the Chinese martial arts films with the westerns because the narratives adopted and values shown seem similar. The archetype system in *Dragon Inn* is very close to the one in the westerns. In *Stagecoach*, there is a kind-hearted hero who has committed a crime and is misunderstood by society; he is a bad guy with a tender heart, a character similar to him had also appeared in the silent cinema. It later became an important character in the genre and had been further developed in the westerns made afterwards. In addition, there is the prostitute who truly understand the lonely hero, the alcoholic doctor, the gentleman from the East coast who have overly strong sense of justice, the mentally fragile lady from the East coast and the wild Indians. They compose a typical archetype network in the westerns; neither of them stands out as a strong individual. Instead, it reveals the complex civilization of the westerns based on the connections between the characters.

The archetype system in *Dragon Inn* is very similar to the one in *Stagecoach* mentioned above. In a space of chamber drama, neither too big nor too small, people come and go and each of them is an embodiment of a type of people in society. Before *Dragon Inn*, no one had seen such a group of eunuchs or a scholar like that, and no one had created a swordswoman like Lingfeng Shangguan. When people discuss the martial arts films, they always trace everything back to the originality Hu demonstrates in this film; even until now filmmakers still follow Hu's guidance in this field, and his guidance remains extremely influential.

It is fair to say that if *Dragon Inn* had not been made, there would not be films such as *The Romance of Book and Sword*, *Princess Fragrance*, *Dragon Inn* (dir. Hark Tsui) and *The Flying Swords of Dragon Gate* and filmmakers such as Hark Tsui and Ann Hui. And of course Ang Lee's *Crouching Tiger, Hidden Dragon* would not exist either. The reason why King Hu had such creativity which enabled him to create all these characters is incredible and unfathomable, but his great knowledge of the classical arts definitely provided him with a rich source of inspiration.

Victory for Justice or the Dark Force?

Many contemporary filmmakers tend to overlook the classical narrative films. But what is great about the narrative films are the character creation and the plot development. Shakespeare is a master in this aspect; if we talk about cinema, Alfred Hitchcock is a master and if we talk about the Chinese martial arts films, King Hu is a master.

In *Dragon Inn*, these characters are put in a real society and yet set against a fictional backdrop. After Hu had introduced eunuchs to the martial arts film, eunuchs became an indispensable part of the genre. The Head Eunuch is a seemingly incompetent man, but in fact a great kungfu master; he is also an extremely calculating person but hampered by asthma. Weakness and contradiction exist in this dark force and the hierarchy within themselves makes the drama even more dramatic. Hu creates such a archetype that could be further explored and it also signifies the dark side of politics. Most importantly, it presents a villain who looks so confident and powerful that even good men cannot defeat him. This is a very different villain from the stereotype of a bad guy. In terms of fighting skills, the Head Eunuch is better than anyone. In other words, Hu has created the first heroic villain with excellent fighting skills, but when he gets killed, the audiences would have complicated feelings; they would ask that if it took a group of justice fighters to kill a villain, does it mean that the good men are so incompetent?

This is a shocking question *Dragon Inn* throws on its audiences. When facing the dark time in the Ming Dynasty, where is the justice? Justice is weak; if good people were powerful, they would have got rid of the evil and solved the problems long ago. But here Hu shows us the dark side of the history therefore, in addition to create the characters full of energy and potential in the archetype system, he reaches a sad and pessimistic conclusion – in the light of history, the dark force is stronger hence when justice is won it is won by chance.

Acting Styles Permeated with the Aesthetics of Traditional Chinese Theatre

Hu started his career as an actor therefore he was undoubtedly adept in instructing the actors. This question makes one think about which martial arts film directors pay much attention to the acting. In this respect, Hu might be the only one who turned acting into a style and insisted on the principle throughout his career. In some discussions on the stylised acting, it is believed that no one had pushed it as far as Hu. The reason is that he took advantages of Chinese drama. In a diverse genre such as martial arts films, Hu did not have to develop a naturalistic acting. Instead, he integrated the traditional Chinese theatre into the acting. In the traditional Chinese theatre, there is a complicated acting system involving the techniques of hands, eyes, bodies and feet. In addition to these techniques, music played by traditional instruments such as drums and gongs is applied. Together they make the films become abstract in terms of its aesthetics and brought a change into the genre. This is a very important change, but it is a pity that this change is not retained in the works of the next generation of martial arts filmmakers including Hark Tsui and Ang Lee. However, it is in Akira Kurosawa's *Throne of Blood* that we see the aesthetics of Noh permeating the film with the acting of Isuzu Yamada and it is the most successful adaptation of a Shakespeare's play in Asian cinema.

Like Kurosawa, Hu did not focus on the psychological realism but instead, he put in more efforts in the symbols, concepts and archetypes. This has become a feature we see less and less in Asian cinema.

But what is more interesting is that Hu's character archetype is often regarded as the Peking opera mask style and this is precisely what cannot be achieved in the westerns. The characters Hu creates in his films are permeated with the aesthetics of the traditional

Chinese theatre. Most of the characters speak very few words and they use their images, postures, moves and actions together with the music to define the meaning they represent on the screen. This adds a cultural touch of the traditional Chinese theatre to it and more importantly, through this the characters are conceptualised and become abstract. If we look closely into the empty love between Huizhen Yang and Xingzhai Ku in *A Touch of Zen*, the swordsmen in *The Valiant Ones*, the coldness Shaoze Xiao shows in *Dragon Inn* and the women in *The Fate of Lee Khan*, it is very obvious that Hu has turned these characters into conceptualised Peking opera masks. It makes Hu's films feel so different from the boisterousness commonly seen in tropical cultures shown in Che Zhang's films. Furthermore, it compensates the reticence and makes his characters enchanting with their images and actions alone.

Penetrating Vision at Pantheon Level

In the "auteur theory" Francois Truffaut, Jean-Luc Godard and Eric Rohmer advocated, they discussed more than the superficial visual style although it is part of it; but what are the origin and the core of the visual style? They talked about a director's style through his penetrating vision because his personality was embedded in the style and so was his attitude towards the world. This is why Andrew Sarris said that the auteurs of the top layer, i.e. the pantheon-level directors, were assessed by how they viewed life; in other words, it was based on the auteurs' penetrating insight into the world and people. Today if we regarded Hu as a master of martial arts films, it is based on this theory, not on how he played with the camera. The penetrating vision is a director's

contribution to the reality; original thinking is required for becoming a world-class artist.

For instance, when Martin Scorsese talked about the American or Italian films, he analysed a sequence in such detail and revealed a hidden ambience or a take on colour scheme in these films. Take the beginning sequence in *Senso* by Luchino Visconti for example, Scorsese noticed that the clear contrast of the colours Visconti applied to the political flyers (green, red and white), the costumes worn by different ethnic groups, and the colour scheme in the theatre (gold and white). From the manipulation of colours alone, one can see Visconti's incredible creativity. Then one would realize how brilliantly the opening sequence summarises the problems in the unification of Italy and how it echoes the opera performing on the stage. This fully demonstrates Visconti's great talent in conveying his views through colours.

From another point of view, take Hu's editing for example, when he was editing flying up in the air, and plunging down, what he edited was the concept. This explains how he could compose such a brilliant fighting sequence in the bamboo forest. It is not the moves that Hu edited but the most interesting and imaginative visual elements. Moreover, he did not want continuity editing and this makes him even more unique. Hu's editing aesthetics, his idea of anti-realism and his daring vision made him surpass his Chinese contemporary filmmakers. His editing is like what Sergei Eisenstein advocated - editing is not a skill but a way of thinking.

Colour Enhancement

Production and costume design was definitely Hu's

forte. He often designed costumes in different colours for the characters in order to enhance the visual impact.

As for the hat of Lingfeng Shangguan wore in the film, it did not matter whether it got the inspiration from Japan or the research, it was just so stylish. Furthermore, Hu often had great ideas of creating paraphernalia that went with the characters; Jun Shi's umbrella was a good example. The clever use of the paraphernalia in the films fully demonstrates Hu's talent in the visual design.

In fact, the visual design is an extremely charming element in Hu's martial arts films. The bamboo hat with a veil worn by Golden Swallow in *Come Drink with Me*, the princess' outfit in *The Fate of Lee Khan*, the traditional Miao headscarf, belts, long skirt and the accessories Feng Xu wore in *The Valiant Ones*, the uniforms of the Royal Guards in *Dragon Inn* and the clothes of the women, the doctor, the painter and the thief in Tang Dynasty in *All the King's Men* were not only re-created based on the research but became part of Hu's aesthetics.

Other things such as the darts, chopsticks and wine bottles are transformed into something new. The wine bottle is no longer for drinking but is used as a quiver; the coins are used to show off kungfu or served as passwords. From these we see how a director uses his talent and the creative freedom to transform the reality. Moreover, this is not just a superficial visual style but a penetrating vision the director holds when facing the reality. Some directors see the facts as they are, so coins are used as coins, but the coins in Hu's hands are turned into something different; it is just like the inn he created. The real style begins with a penetrating insight.

This is what we call "originality". What "originality" means is that only that particular director would view cinema in that particular way; it means how he sees the reality including everything around him. This is the core when we talk about editing and aesthetics. Therefore when we ask which martial arts film director could push the acting to such a stylised extent, the answer is that most directors cannot but Hu. Like Hanxiang Li, they both had a great knowledge of the traditional Chinese culture, and then it became the resource which enabled them to create something organic and original from it. This is, in fact, the most important thing in their personalities and styles.

King Hu's Adventure in the Arts

What is really interesting about Hu's later works is that they reveal a director who knew very well of the resource he owned including his international reputation and the box office records and this is something very practical. It was under these conditions that Hu began his adventures. For some artists, after they have made the films that did well at the box office, they would understand how some elements work for the audiences so they would, and it is enough for them to, repeat these elements over and over again. However, for some creators they keep digging deeper and deeper into these elements. On top of looking deeper into these elements, what is more interesting about Hu is what he later transformed them into.

From *A Touch of Zen* onwards, the following films could be regarded as Hu's adventures. In fact, when he was making *A Touch of Zen*, he had already planned to develop these characters further and explore them in a more complicated way. In

other words, he already had the ambition to bring Confucianism, Buddhism and Taoism, the three pillars in the Chinese culture, into *A Touch of Zen*. Although he might not have succeeded in some aspects, his intention demonstrated a strong will of an artist who wanted to make a breakthrough.

It is more important to see how an artist develops his career after he has become famous. It is amazing to see Hsiao Hsien Hou making films like *Flowers of Shanghai* and *The Puppetmaster*; they are the results of an artist who gave up something after he has made his name and ventured into new realms.

Deepening the Depth and Transformation of the Genre

Hu had always had such energy. In the later stage of his career, he wanted to make *The Battle of Ono* (although he had always wanted to make it), and from there one can see that he was willing to give up what he had gained and to explore other possibilities. This is the adventurous spirit of an artist; the ambition Hu demanded on himself was different from other directors. In this respect, Hu had been an artist who always wanted to make a breakthrough.

Some directors keep recreating his past but for Hu, he kept changing. He even changed the archetype of the inn and from there we see how he brought in a new rhythm and design in order to make a breakthrough in the structure of the short film, *Anger*, one of the segments of *Four Moods*. In this film, he experimented with the rhythm and mise-en-sense. His signature elements are there; maybe the audiences would not recognise them, but other filmmakers can spot his experiments straightaway. We

may say that it was a rather unintended creation, but there was still some experiment being carried out. In Hu's collaboration with Jingrui Bai, it was the same for Bai. We see that some directors make segments of a film in a very different way from how they make feature films. Hu is a director worth our renewed appreciation; apart from his great creativity, the more important thing is that he always had the courage to explore new fields.

The Everlasting Contradiction between Creativity and Film Industry

Regardless of Hu's nationality, he is tremendously influential in not only the film communities in Taiwan and Hong Kong but all over the Chinese cultural world. Hu's films shot in Taiwan show us the beautiful mountains in Eastern Taiwan. The woods shrouded with clouds and mists in his films provided the critics with a rich source for their writings, from Baihua Zong's analysis to Nin Tung Lam's discourse on the aesthetics on the movement in cinematography in Chinese cinema. In fact, it is very important for a director to choose the right locations. Hsiao Hsien Hou discovered Jiangguashi and only he could turn a stone into gold. What is the greatest about Hu is that when other directors go to the same location, they just see the plain view of it, but Hu would see something totally different in his head. A mountain seen in his eyes was already surrounded by clouds and mists. With the support from Union Motion Picture Company, the genre was flourished and a large amount of martial arts films were made subsequently. But all of them followed Hu's steps; some were successful whereas some failed. A great director could have a great influence on a film company, but on the

other hand, apart from some professional support, the company's influence on Hu was relatively limited.

At that time, the Taiwan film industry was in its infancy. It was not until the 1960s that people began to see the rise of Taiwan films. It was around 1963 or 1964 and only after the success of *The Love Eterne* and the establishment of Grand Motion Pictures Company that the new ideas began to emerge including the "Healthy Realism" promoted by the Central Motion Pictures Corporation. They had a direct impact on how the film industry was run and liberated it from the strict Government's doctrine. After that, many private companies with bigger ambitions were set up. Relying on the improved economic environment, the film industry began to change.

Changes taking place in the industry often have to be stimulated by box office hits like *Dragon Inn*. These smash hits would boost the confidence of the film companies and encourage them to be committed to developing the genre. Looking back in the 1930s, why did the Warner Brothers devote themselves to making gangster films? It was because the company spotted that this genre would echo how the audiences felt in a time of depression and they understood why the gangsters would risk their lives as injustice permeated society. It was the same for the companies which invested their remaining capital into film noir as the genre echoed the conservative cold-war ambience in the mid-1940s. Therefore we can see the interesting role the genre development played in the film industry. Nevertheless, the genre development had to rely on box office successes in order to prove that they were worth developing. *Dragon Inn* undoubtedly succeeded in its mission in this aspect.

Hu's ambition was bigger than that of Union Motion Picture Company; in fact, none of the companies could support such a talented pioneer like Hu. Hence it was not surprising that he had some unpleasant work experience. Nonetheless, the contradiction between creative freedom and commercial concern has always existed and it is well understood in Hollywood. Nevertheless, we need the collision between different forces as it could be very valuable to the Taiwan film industry.

Sails To Be Filled by the Wind

Many archetypes in *Dragon Inn* were worth further development. However, when they were being developed, it had to be done with attention to detail as Hu would not allow any compromise on the costumes, the use of the props and the set design. After Hanxiang Lee established Grand Motion Pictures Company, even melodramas had to be quality films since someone had set the standards high and they were already accepted by the mass audience. It was only under such circumstances that the quality of the film production could improve with artistic merits.

Dragon Inn has proved to be the landmark in terms of box office, genre development, originality and visual style. After that, Hu kept looking for gradual changes in each transformation and kept examining if he had made the best use of his knowledge of the traditional culture. Each transformation was a key to the exploration of the traditions and each is an important legacy to filmmakers of the future generations. It is just that parts of legacy are still going in full sail while some are buried underneath the new fads waiting to be re-discovered and to set sail again.

也談胡金銓

舒國治 作

胡金銓，說來有趣，我這一代的小孩是看著他電影長大的。先是他以「金銓」藝名演的《畸人豔婦》、《神仙老虎狗》、《江山美人》（飾那個唱「你要帶她走，我就跟你把命拚」的大牛）、《一樹桃花千朵紅》，我們原本就熟悉得很他那張有點胖嘟嘟卻兩眼又有點嚴厲兮兮的面孔，更別說他更早演的《金鳳》（改編自沈從文的《邊城》乎？）、與《長巷》（改編自沙千夢的同名小說）。

故而我自幼即對這個人算是不陌生。

後來的他，開始自己導演電影了，這時候的胡金銓，竟然與前面的人生稍微有點變化了。

可以說三十歲以前的胡金銓，是一個多難時代的產物。自他所演影片看來，他是個「孩子」，要不就是個幫工或跟班，顯示時代在凌亂未整前每個人能嵌在哪個位置就暫時嵌在哪個位置之處境。且看《江山美人》中的大牛，竟找了個快三十歲的他來演。再自他的人生經歷去看，似乎他隻身離開故鄉，算是避開紅禍，南渡至香港，遂不得不做上一些學徒的工作，這一段「多能鄙事」的少時，為他日後打下了「更要爭氣」的基礎。

三十歲以後的胡金銓，又幾乎是一個微顯犬儒、影片氣勢不凡、評論界常以學術角度論他的嚴謹君子了。

這麼樣的一縷生命路數，倒是頗奇特的。同時，也可能頗辛勞。

香港50年代國語片會將他選角為「孩子」，一來或許編導者自手邊現成的同事朋友提取，二來或是他的長相有一股童稚氣。這種社會上認定的習慣，或許對他的成長模式，有了某些影響。也就是孩子的那一時段不易跳進青年的那一時段。後來甚至青年的時段完全模糊，直接進入中年時段。

故而後來胡金銓的電影題材，很顯然不環繞在青春愛情、男女思慕上，甚至也不著墨在家庭倫理上。哪怕家庭這一概念，在他十多歲離家前，是極深極濃的影響著他（他生活在三代同堂、四合院式的北京大家庭中）。

胡氏開始拍片時，完全不呈露當時香港的風貌，而進入自己最喜造就的歷史世界，並且其中含蘊著他出身的華北風土。即說一點，他電影中角色的語言，完全與所有國片的用語不一樣，是胡氏自己敲錘過的北方話。他對十八歲以前在家鄉北平記憶中所聽所講的尋常百姓語言，深深懷念卻又有些淡忘與隨著時日流逝後的不確定，於是在讀老舍小說時偶可重溫一點，卻又未必全面；也不時在台北的停留期間最樂意與北平出來的推行國語最力的何容（1903～1990）老先生多所相談與請益，往往將好些個字眼早年家鄉是怎麼說的，一一給鉤索了出來。此一刻也，是他最快樂的學術之行，亦是溯源之旅。

猶記70年代末，某次在台北聽他聊天，他言及香港港英政府的政策，是希望港人使用粵語，而不是國語。如此一來，香港的華人比較能掌控於英人手中。胡氏謂，他早知這種陰謀，雖會說粵語，但他盡量讓自己說國語。

胡氏的故國（或說故園）觀念，算是濃重的。他的離開赤化中國，有很長（甚至終其一生）的時間極不認同共產黨，尤以5、60年代他的大伯一家被鬥得甚悽慘，他道來很是沉痛。

這樣的他，很長一段時日，既不可能依歸中共，又未必欣賞國民黨，再加上對港英政府亦不盡滿意，稱得上是一個天涯漂泊人。正好寄情於古裝電影，更好是武打片。

80年代中期，胡金銓旅居洛杉磯東郊的San Marino時，自己讀讀書、查查圖書館資料，算是逍遙自在，偶至Monterey Park華人餐館林立之地吃一盤

「王家餃子館」的炒餅，便已是最慰藉他北方脾胃的上等享受了。

60年代港產的武俠片，造型早濫，即胡氏的《大醉俠》在造型與裝具上也沒法與別的片子差異太大，只不過他的轉場與剪接比較俐落罷了；然自聯邦的《龍門客棧》起，胡氏的片子便有一股「正宗」味，凜然有一襲尊貴氣。這時，人們可隱隱知道國片中的武俠片開始有講求考據的人出來矣。

胡金銓正因為有孤身一人流亡至港、參與不甚製作精良國片的配角演出等經驗，或許益發激勵他人生後來的志氣，遂在「香港時期」的奠基工程（編導《大地兒女》、《大醉俠》）後，於「台灣聯邦時期」完成了他作為「風格家」的大師地位。也就是拍了《龍門客棧》、《俠女》二片。

《龍門客棧》是1967年最賣座的國片，然它不僅叫座，亦叫好，乃《龍》片充分顯現出胡氏的場面調度。且看一場戲，蕭少鎡（石雋飾）第一次抵客棧，沒遇上吳掌櫃（曹健飾），與東廠爪牙打了一架，結果受大檔頭（苗天飾）勸停，出得門來，走至荒遼沙地，結果遠處一人拱手站立，正是吳掌櫃孤立風中，似在相待。這一場戲，饒有味道，便是胡氏的場面調度也。

《龍門客棧》之廣受歡迎，尚有一原因，便是其類型可稱作「召集眾好漢完成一使命」片。吳掌櫃為了救于氏姊弟（忠臣于謙的遺孤），不但找了石雋，找了薛漢、上官靈鳳兄妹，後來還加入了曾遭東廠嚴罰下過蠶室、反正來歸的萬重山兄弟二人；終虧有那麼多人，最後才殺了白鷹。這種「召集好漢」片，好萊塢最有名的就是《決死突擊隊》（The Dirty Dozen），日本黑澤明的《七武士》是影史上最經典的例子。但始作俑者，當是1950年約翰‧休斯頓（John Huston，1906~1987）的《夜闌人未靜》（The Asphalt Jungle）一片也。這種志士集結一堂，然後出生入死為了完成一椿大事，最能扣緊

觀眾心弦。

《龍門客棧》是一部充滿打戲的片子，於是「如何安排打鬥」、「為何打」最是重要。當年胡氏妙手偶得，弄出這樣一部充滿打鬥意趣的經典武俠片，遂成就他的武打片大師之聲望。

三年後的《俠女》，更幽邈了，更上一層樓了；卻不知是少了股生猛氣還是什麼，當時並不賣座。然知音卻更讚賞此片，終於在1975年的坎城影展奪得委員會最高技術大獎，這對國片來說，是破天荒的殊榮。

《龍門客棧》一片的編寫模式，其實最適合胡金銓；簡單、乾脆、人物鮮明、陸續登場、最後要完成一使命。這樣的片子，最不用講太多的主題或哲理，卻是結結棍棍的純粹視覺享受。我遇過不少影迷，大夥皆這麼認為。

稍後的《三叉口》（《喜怒哀樂》中的《怒》）、《迎春閣之風波》、《忠烈圖》皆是打片，也皆不令人討厭。

尤其規模愈小、場景愈單純，愈能拍出豐富的打戲。《忠烈圖》一共沒幾堂景，有時在樹林，有時在海灘，有時在村屋，亦偶在衙門（即有屠光啟飾朱紈的部分），簡單之極，卻照樣能打出好戲。但看你想不想只拍打戲而已。

《迎春閣之風波》一片，最具魅力處，是田豐所飾的一個人物李察罕。這雖然是一打片，卻增添了一些韻味，尤以片尾韓英傑彈三絃唱關漢卿小曲，這段在刺李前的鋪排尤其動人。

《忠烈圖》中亦有一妙韻，即飾伍繼園夫人的徐楓，從頭至尾不說一語，卻叫人愈看愈覺著美、愈覺著英氣過人，真是好筆。讓她穿苗服，亦絕妙安排也。

大夥似乎不約而同有一種見解，便是胡金銓有太多可以拍出給世人看的東西，卻似乎只呈現了極少，這是最教人嘆息的。已故的遠景出版社老闆沈登恩，當年一直希望出版胡金銓各類的雜項著作，卻也倉促間只湊上了一本《山客集》。他的才能太多，畫他畫得好，明史他讀得好，老舍的文章他研究得好，太多太多，這造成拍電影亦可能分神嗎？不知道。

他應該專注於把劇本編寫得更完善，或覓得更適宜的合寫者，或找到更好的製片替他先張羅寫故事之人……等等之或許。然而誰是這樣的合編者？誰是這樣夠意思又體恤他的製片？

胡導演其實一路走來遇著的貴人並不少，像早期的夏維堂、沙榮峰，或後期的胡樹儒，皆在他的拍片生涯裡起了很重要的作用。再就是，有太多敬重他、視他為恩師的終生好友，像鄭佩佩、石雋、徐楓、張艾嘉等，總是人前人後為胡導演解釋外人不夠理解的片中瑣節、為胡導演找尋更優厚的拍片機會、為胡導演張羅新片可能徵召的人才與錢財。這些年輕時跟著他演戲的人，本身已然蘊涵了俠士俠女的義風，這是國片中最了不起的道德倫理。

他應該可以找到相當說得過去的資金（即使不必太多），他也應該可以找到相當有陣容的大牌為他擔綱演出，甚至他還可以隨你想怎麼拍就怎麼拍、事後別人再來埋單，皆可能也。其實哪有這麼困難呢？只要你胡導演自己審時度勢、找到最可發揮的時機與最稱意的合作夥伴，便何事不能成？

當然，人生如戲，拍出怎樣的好電影與怎樣籌拍電影，有時後者更難。誰能人生像電影每場戲皆調度得既高低有致又圓融沉厚、渾然天成呢？

作品現場裝置圖
Artworks in MOCA

On King Hu

by Kuochih Shu
translated by Yihsuan Chen

People of my generation grew up watching King Hu's movies. He first appeared under the stage name of "Jin Quan" in such films as *The Deformed*, *The Fair Sex*, *The Kingdom and the Beauty* (he was the heroine's brother who sang the famous trio in the film), and *When the Peach Blossoms Bloom*. We were already familiar with his chubby face with somewhat serious eyes, not to mention his earlier performances in *Golden Phoenix* (presumably an adaption of Congwen Shen's *Border Town*) and *The Long Lane* (adapted from the novel of the same name by Qianmeng Sha).

Therefore I had known King Hu since I was very young.

Later he began directing his own films. From then on, King Hu became a slightly different person than before.

It can be said that before he was thirty years old, King Hu was under the impact of a restless age. In the films he played, he often played the role of a "child," either a hired help or an attendant, which shows that in the time of uncertainty, people cannot choose their places in the world but can only pause at the positions temporarily imposed to them. In *The Kingdom and the Beauty*, King Hu, who was nearly thirty at that time, was cast in the role of Da Niu (a very young boy works in the tavern). In real life, he left his hometown on his own when he was just in his teens; escaping from Communist China, Hu came to Hong Kong and could only find work as an apprentice. This humble experience in youth served to drive him towards greater goals in the latter days.

After he turned thirty, King Hu became a slightly cynical man; at the same time, he made grand-scale, visually impressive films. Critics even often talk about him and his works from an academic point of view.

His journey of life was quite unusual indeed. At the same time, it could be quite difficult.

He was often cast in some teenage roles in Hong Kong Mandarin films of the 1950s. First of all, the filmmakers might have cast him simply because he was an available crew member. Secondly, there was indeed something childish about his looks. Such recognition might have influenced his growth and maturity to a certain degree. When he was young, he was considered a child and had difficulty in making people recognize him as a grown man. Therefore he went from being a teenage directly to a middle-aged man, completely skipping over the period of youth.

Consequently, in King Hu's later films the themes obviously do not revolve around youth, love, and romantic relationship, not even the family ties. Even if the concept of family had influenced him significantly before he left his family when he was a teenager (the three generations of his family lived under the same roof in a traditional Beijing quadrangle).

As Hu began making films, he virtually ignored contemporary Hong Kong in his films and favored the ancient world of Chinese history, especially the environment of North China, where he was born. That is to say, the language used in his films is vastly different from the common Mandarin heard in most Chinese films, but the kind of northern dialect that Hu himself polished and refined. The common people's language that he heard in his hometown of Peiping (also known as Peking, now called Beijing) before he was eighteen years old was dearly missed

but somewhat lost in the course of time. Hu got to relive it a little when reading Lao She's novels, but that was not comprehensive enough. During his stay in Taipei, he constantly conferred with Rong He (1903 - 1990), an avid advocate of Peking Mandarin, and learned from the older man many words of the vocabulary used in his hometown. This was his happiest moment in terms of academic research and a trip down memory lane.

I remember once in Taipei in the late 1970s, hearing him remark on the language policy of the British Hong Kong Government. He said that the Hong Kong government wanted the people to speak Cantonese instead of Mandarin, in the hope of subjecting the Chinese population of Hong Kong to the control of the British government. Hu said he was fully aware of such a conspiracy; therefore, although he could speak Cantonese, he still chose to speak Mandarin.

Hu had a strong nostalgia for his native country (or rather, hometown). His departure from Communist China resulted in his lifelong distrust in the Chinese Communist Party; especially in the 1960s, his uncle's family took a severe beating from the struggle sessions and purges, which Hu remembered with grave sorrow.

For a very long time, Hu could neither identify with the Communist China nor appreciate the ways of the Kuomintang; he was not even entirely satisfied with the British Hong Kong Government. Therefore, he was genuinely a drifter of the world. He could only pour his feelings into the period films, especially the martial arts genre.

In the mid-1980s, King Hu's lived in San Marino on the eastern suburb of Los Angeles. He read books,

went to the library, and was indeed a free man. Occasionally he would go to Monterey Park where there were many Chinese restaurants and dine at the Wang's Dumpling House, finding comfort for his northern stomach.

The Hong Kong produced martial arts films of the 1960s mostly feature costumes and makeup in cliché. Even Hu's own *Come Drink With Me* could not make much differences; the film was only saved by its neat transitions and editing. However, following *Dragon Inn*, produced by Union Motion Picture Company, Hu's films began taking on an "authentic" aura, a kind of awe-inspiring nobility. Starting with Hu, people began to notice the authenticity of historical accuracy in the martial arts films.

Perhaps it was exactly King Hu's lone exile in Hong Kong and his participation in those less well-made films as supporting actors, inspired his later cinematic ambition. Following the foundations he laid in the Hong Kong period (with films such as *Sons of Good Earth* and *Come Drink with Me* that he directed and wrote scripts), Hu was later able to achieve his status as a master of cinematic styles in the Union period in Taiwan (with the two films *Dragon Inn* and *A Touch of Zen*).

Dragon Inn was Taiwan highest grossing domestic film in 1967 and the film was also critically acclaimed for Hu's mise-en-scène. Let's take a look at one particular scene, in which Xiao (played by Jun Shi) first arrived at the inn, and instead of meeting the innkeeper Wu (played by Jian Cao), Xiao gets into a fight with East Chamber minions. The fight is stopped by the chief of East Chamber (Tien Miao), and Xiao steps out of the inn, only to find that the innkeeper is greeting him, standing alone in the distance. This

scene, rich in suggestions, is characteristic of Hu's mise-en-scène.

Dragon Inn has been popular for various reasons: this film belongs to the genre in which an ensemble of heroes join hands to complete a common mission. In order to save the Yus (the orphans of the loyal minister Qian Yu), the innkeeper not only brings together Jun Shi, Han Xue, and Lingfeng Shangguan, but also requests the help of those victimized by East Chamber. It takes all these people to finally kill the villain played by Ying Bai. *The Dirty Dozen* is Hollywood's most notable equivalent of such "hero ensemble" films. Akira Kurosawa's *Seven Samurai* is probably the classic of this genre in film history. But the honor of being the film that started it all must be attributed to *The Asphalt Jungle* (1950) directed by John Houston (1906 - 1987). People of different backgrounds come together to complete a mission against all odds, the moviegoers simply love this kind of story.

Dragon Inn is a film defined by its fight scenes, so it is most important to determine how to arrange a fight sequence and why to engage in a fight. It was Hu's creativity to come up with such brilliant and meaningful fight sequences in this martial arts classic, led to his reputation as a master of martial arts films.

A Touch of Zen of three years later was even more spiritual and took the genre to a higher level. However, it was less popular at the box office probably due to the lack of some sort of raw and ferocious vigor. Still, those admirers showed even more appreciation for this film than the previous one, and the film claimed the award, Grand Prix de la Commission Supérieure Technique du Cinéma Français, at the 1975 Cannes Film Festival, an unprecedented honor for a Taiwan film.

The script of *Dragon Inn* is in fact the most suitable for King Hu: simple, clean-cut, filled with distinctive characters who take the stage in turn and eventually complete a mission. This kind of film has no use for too many themes or philosophical thoughts but is a pure and solid visual experience. I have come across a lot of movie fans who all share the same feeling.

The subsequent films *Anger* (an episode of *Four Moods*), *The Fate of Lee Khan*, and *The Valiant Ones*, all are films focusing on fight scenes and all make for quite pleasant viewing.

In particular, the smaller the scale, the simpler the scene, the more splendid a fight sequence can get. *The Valiant Ones* is almost minimalist in this sense, its scenes consisting of no more than the woods, the beach, a village house, and occasionally in the courthouse (featuring Wan Zhu played by Guangqi Tu). It is as simple as it can get, but it still makes for good drama. It just depends on whether or not you merely want to shoot the fight scenes.

The most attractive part of *The Fate of Lee Khan* is arguably the character Lee Khan played by Feng Tien. Although this is a martial arts film, it carries some rarely seen touches in this genre, especially in the scene when Yingjie Han sings the ditty written by Hanqing Guan (a poet of Yuan Dynasty) towards the end, which is especially moving, placed right before the assassination of Lee Khan.

The Valiant Ones also has a touch of magic with the character of Jiyuan Wu's wife, played by Feng Xu. She does not utter a word from start to end, but she exudes a kind of extraordinary beauty and valiancy

this way. The fact that she wears the costume of the Miao people is also a brilliant arrangement.

Everyone seems to agree that King Hu had too much to show to the world, but only managed to deliver too little, which is really a pity. Dengen Shen, the former owner of Vista Publishing, had a plan to publish all of King Hu's miscellaneous writings, but he just published one, *Visiting Mountains* (*Shan Ke Ji*). He had a variety of talents: drawing and painting, historical research of the Ming Dynasty, and research on Lao She's works. Was he simply too talented and otherwise occupied to produce more films? This remains an unanswered question.

He should have been more focused on perfecting the script or collaborated with a more suitable co-writer or found a better producer who could hire a scriptwriter for him, and so on. But who could have been such an ideal co-writer? What producer could have been so generous and sympathetic?

Director Hu met some important people, who had played an instrumental role in his career, along the way: such as Weitang Xia, Yungfong Sha, and Shuru Hu. Furthermore, he had some lifelong friends who had much respect for him and regarded him as their mentor, such as Peipei Zheng , Jun Shi, Feng Xu, and Sylvia Chang; they have been eager to explain the obscure details in Hu's films to the outsiders, find better opportunities and conditions for his film projects, and raise money and recruit people to meet his demand. These actors took part in Hu's films when they were young and have inherited from him the righteous spirit of swordsmen and swordsmwomen. They have set the best moral example in the history of Chinese language cinema.

He should have been able to find enough funding (which did not have to be much), and he should have been able to secure a lineup of big names to star in his film: he could even shoot the film any way he wanted, and afterwards there would be people willing to cover the expenses for him. In fact, there could not have been much difficulty. Should Hu have been able to assess the situation and find the most opportune time and cooperate with the most suitable partners, he could achieve anything.

Of course, life is like a drama, and sometimes it is more difficult to plan a film project than actually make a decent film out of it. After all, who can live life like a movie, in which every scene can be arranged, organized, and executed to perfection?

作品闡述
Artworks

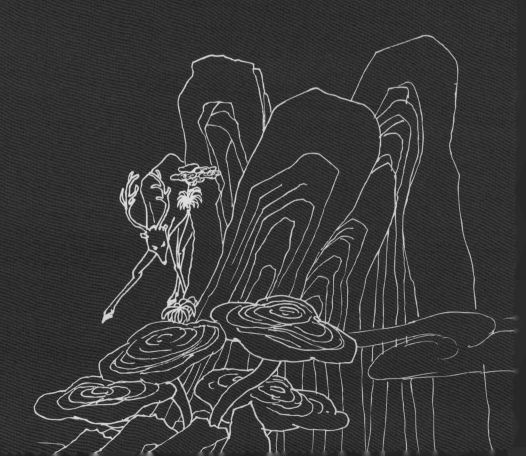

入口形象區
Entrance

此區以前景的竹林裝置結合後景現有的椰林步道，在當代館有限的入口室中，模擬再現胡金銓電影中常見的自然空間山林意象，然後利用一個現場拍片及監看的靜態裝置，以及現場環境和監視畫面之間虛實交替的內容變化，營造一個懸疑的閱讀情境，以導出胡金銓擅長將自然空間環境、歷史人文故事結合成為引人入勝的電影美學的藝術成就。

In the entrance of the exhibition hall, the foreground of bamboo forest installation is connected with the background, the passage with coconut trees on the side. In this small foyer of MOCA, the imagery of the nature, mountains and forests in King Hu's films is simulated. The installation of shooting on location with a camera and a monitor creates a change of the real-the installation, and the fictional- the images on the monitor. This creates a suspense environment, and introduces the artistic achievement of King Hu, he is an expert in combining the story, culture, and history and accomplished his enchanting films.

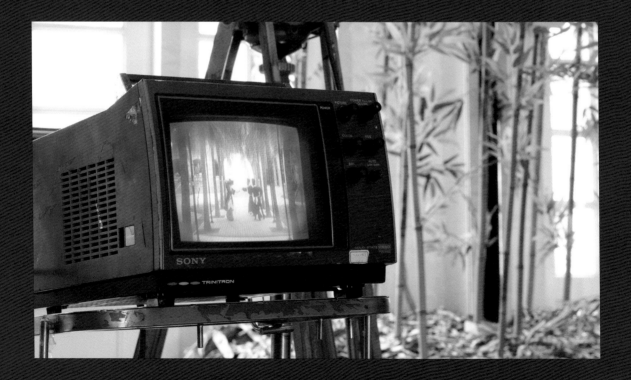

上圖 above
作品現場裝置圖
Artworks in MOCA

左圖 left
作品局部圖
detail

胡說八道 · 胡語錄
King Hu Talks

「我是誰？我是一個怎樣的導演？」走進105展間，首先看到八部短片中，胡金銓導演用戲謔的言詞從八個面向剖析自己，直心而率性的自白——他對於愛情的觀感、對「俠義」的定義……乃至於他畢生中的最愛。

"Who am I? What kind of a director am I?" In the first of eight short films screened in gallery 105, director King Hu uses witty banter to analyze himself from eight perspectives. He openly confesses his views on love, definition of "swordsman" and even the greatest love of his life.

胡說一：我是誰

我既不是出身豪門，又不是三代「老貧農」，根不正，苗不紅，一開頭就洩氣。在電影界混了幾十年，倒是熱鬧過一陣子。可是有些電影學者老想把那段「淹」掉，以突出現在電影藝術輝煌的成就。這種「薄古厚今」的想法，倒也無可厚非。把別人踩下去，自己爬上去確是所謂「後現代」的一種手法。（摘自〈癡人說夢－開市大吉〉手稿）

Who am I?

I was not born in prestigious family and I am not a proletariat. So my background is not favorable. I have worked in film industry for decades and had my golden years. So some film scholars try to ignore my background, to emphasize my achievement in film art. This thought of forgetting the past is not unusual. To step on others and climb up is a surviving strategy in contemporary society.

【胡說八道・胡語錄】單頻道錄像，共八件
King Hu Talks / Single Channel Video, eight pieces

胡說二：我的電影論

我覺得對電影而言，主題不要緊，故事也不要緊，故事的好壞與主題都不足以影響一部電影，電影最重要的仍是表現的技巧。（摘自《胡金銓談電影》〈胡金銓與王敬羲對話〉）

About Film Direction

I think to make a film, the theme is not important, the story is not important, either. The story and theme could not determine the final result, the most important thing about filmmaking is "the strategy" to tell the story. (*King Hu on Filmmaking*)

胡說三：我的歷史考據觀

「⋯又查到了明朝萬曆年間毛筆一枝銀子一錢，茶葉一兩銀子一斤（指當時河北，南方也許便宜些）。皂隸每年工食銀三兩二錢（如不貪污，很難維持起碼生活）。但是問題又來了，茶葉一兩銀子一斤，是香片還是龍井？想一想，算了，再這麼追究下去，六年也拍不成一部電影！」（摘自《胡金銓談電影》〈從拍古裝電影找資料談起〉，88頁）

About Art Design

I found information about the price in the reign of Wanli Emperor, Ming Dynasty, an ink brush is worth of 3.72 grams of silver, 40 grams tea is worthy of 500 grams of silver. This was the living standard in Hebei, maybe it's less expensive in the south. The annual salary of the zaoli (the officer worked in the local government, similar to contemporary policeman) was 119 grams of silver. So if you are not corrupted, it's hard to survive. Then there comes another problem, what kind of tea is meant to be, it's jasmine tea or Longjing tea ? Another thought, if I research all the details, it will take me more than 6 years to make a movie. ("Research of the Costume Drama," *King Hu Talks About Film*, p. 88)

胡說四：我的客棧想像

用客棧主要是因為這種公共的場所，會對設計劇情有利。將客棧和酒館的內部設計成二層建築，這樣做，雖然是將空間限定在一個地方，但卻利用垂直的結構去立體的表現出動作的運動。但也不是僅僅為此而用客棧。以前，在這種人與人相遇的地方，容易引起吵架是必然的，特別是酒館，例如看一看《水滸傳》就明白，常常都是在這種地方引發騷動的（笑）。（《胡金銓武俠電影作法》，83頁）

The "Inn" in My Films

The reason I use the inn as the setting is because it's a public area, and convenient to tell the story. I designed the interior of the inn in two-storey, so the space is limited in one setting and I could use the vertical structure to design the movement of action in full dimensions. But this is not the only reason to use the inn. People easily get into fights in the places where people meet, especially in the bars. If you read *Water Margin* (*Shuihu Zhuan*), you'll understand all conflicts take place in this kind of space. (*King Hu on Filmmaking*, p.83)

胡說五：我的情愛美學

問：有人對你的電影人物有個不太客氣的批評，就是每個人物好像沒有感情的，冷冰冰的……
胡：其實，我覺得這是沒注意看，像《龍門客棧》裏的愛情，你看到了沒有？像石隽在戲裡告訴上官靈鳳說，「妳先走吧，現在很危險，他們要射箭了。」女的走到樓梯邊，回頭來，欲言又止的，這些細膩的描寫，我覺得會比西方影片那些「哇」的一聲就抱在一起來得好（哄堂大笑），因為，東方人畢竟比較含蓄一點，如果這在西方處理就不同，起碼也得拉一下啦什麼的才成吶（笑聲）。（摘自《風過群山》〈深夜的對話－夜訪導演胡金銓〉）

About Love

Q: Someone criticizes your characters, it seems none of them has emotions, really cold......
HU: I think it's someone who does not pay close attention to my films. There is love in *Dragon Inn*, do you catch that? In the sequence Jun Shi tells Lingfeng Shangguan "You should leave now. They are going to shoot the arrows, it's dangerous." The woman walks to the stairs and turns her head. She seems want to say something but doesn't speak up finally. All these subtle movements are much better than the protagonists in the western movies, they just hug after saying "wow." It's because the Orientals are more conservative. The films made by the westerns are different. They have to take one's hands or do something else, at least. (interview of King Hu)

胡說六：我的古裝動作片

常有人問我：「你是不是『武俠』片導演？」每次我總要辯駁一番：「不是。我只能算是個古裝動作片導演。」因為在中國古代記載上，「俠」字，或「遊俠」到是常見。「武俠」兩個字聯在一塊兒，起碼我沒見過。「武俠」這個名詞是寫小說的人發明的。最早的武俠小說大概是平江不肖生（向愷然）寫的「江湖奇俠傳」。後來拍成電影《火燒紅蓮寺》，很受觀眾歡迎，連拍了十八集，可惜余生也晚，沒看過。我拍的古裝動作片，其中人物都有職業。就算是「大盜」，也算是一種謀生的辦法。這些人不會拿著單刀或板斧逛街，上茶館。他們即使攜帶武器，也要藏好，或著用布包起來，否則「地保」或「衙差」一定把他抓起來。（摘自《偏見集三》〈武俠一〉）

About Martial Art

The question I was asked often is "are you a martial art director?". I had to argued it every time, "no, I am not. I am just a director of costume action drama." It's because the term "xia" (swordsman) or "you xia" (wandering swordsman) is often seen in ancient Chinese books. But I have never seen the two characters "wu xia" were used as a term. "Wuxia" was invented by novelists. The earliest wuxia novel is *The Tale of the Extraordinary Swordsman* (*Jianghu Qixia Zhuan*) written by Pingjiang Buxiao Sheng. It was adapted to *The Burning of the Red Lotus Temple* film series. It was popular and the series has 18 films. It's a pity that I could not see these films. The characters have occupations in the costume action films I made. Even a thief is a way of earning a living. They don't just take a knife or an axe and walk on the streets or visit the tea house. They'll hide their weapons or wrap them with cloths. Otherwise they will be arrested by the policemen or officials. (from King Hu's writing)

胡說七：我的俠女

「俠」這個字，是指一種行為方式，英語就是behavior，是武士和戰士的行為模式、生存方式。但是，我的電影指的並非這個東西，並不是指為正義而戰的女人。她是個被追殺的女人；是個被通緝的女人。徐楓演的俠女不是站在政府那邊的，她是逃亡的犯人。她的父親是個非常著名的大官，卻給殺了。而她本來也差點被殺的，但僥倖逃脫，逃到和尚寺中去投靠一個和尚。和尚收了她為徒弟，教她武功。

在她的對白中，有一句「天下之大，我已無處容身」。即是說，她不論去到哪兒，都會給追捕者找到。因此，她對她所愛的人說：「你離開我吧，和我在一起會有麻煩，因為不知甚麼時候會給抓住。」她彈琴和唱歌給他聽。那首歌的意思是：「來我這邊吧，我要和你一起睡。我要為你生孩子，但你不可以愛我。」因為「不知道甚麼時候會給他們殺死，快抱孩子逃吧！」這其實是男主角的母親的終生期望，因為兒子沒有錢，沒有能力娶媳婦，沒有子孫繼承香火。女主角聽到這番話，為了報答那對母子的相救，就為他而生孩子了。那首詩是從李白的「月下獨酌」來的。（《胡金銓武俠電影作法》，96頁）

About Swordswoman, Xia Nu

The character "Xia" (swordsman) means a kind of "behavior," the behavior modes and the ways of surviving of warriors and fighters. But this is not what I wanted to depict in my films. My female protagonist is not fighting for justice. She is a woman being chased, and wanted. The swordswoman (Feng Xu) is not submissive to the government. She is a convict on the run. Her father is a famous high rank official, but is killed. She is nearly being killed herself, but escapes by luck. Then she hides in a monastery and a monk takes her as disciple and teaches her Kung Fu.

She says in the film, "There is no place for me in this world." That means she'll be chased and found by her enemy wherever she goes. So she speaks to her lover "Leave me, you'll get into trouble with me. I've no idea when I'll be caught." She plays guzheng (the zither) and sings for him. The hidden meaning of the song is "come to me, I want to sleep with you and have a child with you, but you could not love me, because I don't know when I'll be killed. So just take the baby with you and run." This is what the mother of the male protagonist hopes for all her life. Her son has no money and could not afford to get marry, and the family has no heirs. The female protagonist hears that and to thank them for saving her life, she gives him a child. The poem she sings is titled *"Drinking Alone by Moonlight"* by Bai Li. (*King Hu on Filmmaking*, p.96)

胡說八：我的最愛

我愛看書，可不願意讓書管著，不論是世界名著，還是專家推薦，有些書翻了幾頁，只要覺得乏味，就放下。老舍說過：有一類書，最好給判了無期徒刑的人看，反正活著也沒什麼意思。對我來說：「開卷」不一定「有益」。（摘自〈學藝、賣藝〉手稿）

About My Favorite

I love reading, but I won't be stuck in books. Whether it's canons or recommended by experts, if I read few pages and I'm bored, I'll just leave it. She Lou said "There is one kind of book, it's better for the prisoner who serves life sentence to read, because there is not much meaning in their life." For me, reading is not really beneficial all the time. (from King Hu's writing)

作品現場裝置圖
Artworks in MOCA

書劍恩仇錄 徐克
King Hu Talks and Hark Tsui Writes

透過105展間隔牆上的開口向內望去，觀眾將會發現，胡金銓的話語變成了書法文字，背對著觀眾卻出現在眼前的牆面上，正以遠處鏡像的方式和眼前導演徐克龍飛鳳舞的書法原作，進行著一場虛與實、往者與今人的對話。剛拍完武俠片《龍門飛甲》的名導徐克，針對本次展出於百忙中特別書寫了【俠氣古腸劍猶在，靈雨空山動江湖】的詩句，並撰寫了「書法胡金銓」的專文（如後）來詮釋胡金銓對他個人的啟發，以及對諸多電影後進的影響。

Setting connected to the room of "King Hu Talks," is Hark Tsui Writes. The audience could look through a hole in the wall and discover the words of Hu King transforming into calligraphic text. The words come from behind the audience, yet appear on the wall in front of them, this is achieved by the mirror image, to reflect expressive calligraphy written by Hark Tsui himself. It creates a dialogue between the virtual and the real, engaging both the previous and contemporary generations. Just after finishing the filming of the martial art movie, *The Flying Swords*, the famous director Hark Tsui wrote the calligraphy work himself. The verses could be translated as "The integrity of swordsmanship remains as the spirited rain re-enervates the unpopulated mountain and the intertwining corners of society." This reveals how King Hu had inspired him, and has greatly influenced the next generation of filmmakers.

【書劍恩仇錄】裝置 / 2012年
King Hu Talks and Hark Tsui Writes / Installation / 2012

書劍恩仇錄

徐克 作

胡金銓的不同

記得《大醉俠》有一場在客棧大堂，金燕子對上土匪的戲，感覺很不一樣，造型上特別深刻，那些影像、氣氛和電影手法，現在還不斷地在我們的電影裡出現，原因是，我們就是跟著他的作品、跟著他給我們的很多思維一起長大的，至今我們還使用他作品裡留下來的各種形象，這些印象都成為我們創作時的營養，是從他那裡來的。

胡導演的作品在這麼多年以前就創造出來了，可是現在我們要再找回那個效果，就是感覺不對，也不知道是什麼原因，是不是我們的氣質沒有他當時的修養？他那麼原創，我們卻怎麼樣都是在他的基礎上再去創作。所以在這點上，比如有些衣服造型，我覺得我們很想去把當時我們看胡導演的一些感覺，透過銀幕呈現出來，可是一出來就感覺不對。我最近拍《龍門飛甲》，想用《龍門客棧》的音樂，我們希望把音樂能重新再做出這個效果，胡導演留給我們的作品一再影響我們，但分別很大很大，我一直覺得很可惜。

拍電影時，沒有多少人知道他拍電影的方法是怎樣，所以他有時候會花很多精力去告訴別人，這些該怎麼拍。就算這樣，我覺得可能許多人在現場時也不知道他在做什麼；到最後看他電影，才看出來原來是這樣子。

《新龍門客棧》裡面的世界，就是胡導演的世界，我們闖入他的世界，當時覺得像是學生跑到一個禁區，禁區裡都是我們在唸書時候看到的那個世界。理所當然，我們放了一些我們很想在他世界裡面添加的人物，所以金鑲玉就出現在這個世界裡了。金鑲玉像是對胡導演的某種致敬。因為金鑲玉是我們在闖入到他世界裡某種行為的寫照，我們就是在這個世界裡特別不規矩，不依照某種江湖規矩去做事情。我們用了一個方法進去了胡導演打造的世界，就希望把胡導演的人物再重新打造出來；可是沒有

可能，我覺得沒有人能夠代替胡導演的人物，沒有人能代替上官靈鳳，沒有人能代替白鷹，其實這些人物都已經變成經典了；也只有再回去看胡金銓導演的《龍門客棧》，才能夠看到這些人物，其他地方看不到。

無論是《倩女幽魂》、《黃飛鴻》，都是講一個人在某個年代的改變，他要面對一些很不同的、新事物的挑戰，他的無奈；同時他要肩負使命和任務的壓力，他得做出很多違反他自己性格的東西。胡導演的電影人物常常是為了這些事，必須要去面對一些壓力較大、做出超乎其能力範圍的事。

從《龍門客棧》到《俠女》，裡面眾多的俠女、俠士，我們可以感覺到，他的英雄都會面臨很多大的挑戰；在《忠烈圖》裡，他處理將士們對抗倭寇的挑戰，我們當然看得很緊張，因為不能讓倭寇給贏了，確實是他的電影才有一些讓我們緊張萬分的場面。所以之後在塑造武俠世界時，我們常會給反派增強、增多威力，因為以前武俠電影裡的反派角色，都沒有《龍門客棧》裡曹少欽的威力那麼大，看了《龍門客棧》之後我才知道，原來反派可以製造出這麼大的魅力，他的反派比他的正派還更精采。

以筆書寫思維

每次我拿毛筆，就覺得，我們現代人怎麼不用毛筆了呢？這毛筆在我手上一直都不聽話，寫字最難的是在每一次蘸墨的時候，當你下筆寫字時，要不然就墨太多，要不然就墨不夠，寫完一個字，墨就沒有了。我覺得在控制筆跟紙、筆跟墨的關係上很奇妙。

還有一個很有趣的感受，寫書法常會寫一些詩詞歌賦，我們唸李白、宋詞，往往就只是去唸，沒有去寫；當你去寫的時候，突然間，你跟它的作者好像有了某種精神上的連繫。你寫這個字，這個字的感覺，在這首詩裡，他想表達這個字的意思。你用你

的筆墨去表現字的情緒，它應該從你身上被翻譯出來，你對這個字所要表現的特點在哪裡，就在這點上，突然間，你會覺得你和詩人有了某種關係。

我一直很想做一些跟中國有關係的東西。書法很方便，只要有筆、有墨、有紙，就可以寫了。寫的時候你會很欣賞自己的精神狀態，覺得寫完一張書法之後，自己就優雅了一點。我也嘗試把書法寫得很狂亂，這個狂亂不容易，因為我試過寫一些很狂亂的字，寫過之後，沒法再重複。我看過一些相關記載，寫書法時要集中精神；有人認為，寫書法是人練氣的一個過程，能夠寫好書法，對壽命也有延長的功能。我還沒有感覺到這點，不過至少我覺得做這件事情是很享受。

書法可以帶給我們對現代社會的某種對比、某種眼光，因為現在很多都是設定好的系統字，電腦、印刷都是。書法恰恰相反，它預料不到，我們自己寫的人都意料不到，每次寫，都覺得這枝筆自己會走到一個地方去，覺得很精采。所以寫出來的字不一定好看，但至少這剎那，覺得這是自己所控制的東西；跟現代社會我們設定好的一些規範相比，書法是可以讓一個人在剎那間感到自由的一種載體。

我喜歡很多書法家的字，他們寫的字，整個空間佈局、結構都很精采，不論筆法和各方面的技術，控制畫面的美學，真的是要學也學不來。書法還有一個很精采的地方，是你看一個字跟看一篇字，跟看一筆字，是很不一樣的。近看、遠看，都有不同的感觸。

在這裡，我寫了兩句話給胡導演：「俠氣古腸劍猶在，靈雨空山動江湖。」

我覺得胡導演的作品給我感覺是「俠氣古腸」，他留給我們的作品，直到現在都仍有力度在，所以說「劍猶在」，他的劍還在我們的身邊出現。他的精神是很高雅的一種氣質文化，但他說的是江湖事。這兩句話，是我盡我最大的力量來描寫胡導演。

Recreate King Hu's World

by Hark Tsui
translated by Yichuan Chen

The King Hu Difference

I still remember a scene from *Come Drink with Me*, where Golden Swallow faces down a bandit gang in the foyer of an inn. I felt there was something different about it, and the style particularly affected me. The images, atmosphere, and cinematic techniques used there continue to be used in our films today, because they are works that we grew up with, and that influenced how we think. Even today, we continue to use images from them, images that were part of our cinematic diet, from which we took creative nutrition.

But even though King Hu's works were created all those years ago, whenever we try to go back and recapture that effect, something doesn't feel quite right. I don't know why, either - could it be that we just haven't reached the level of cultivation and inherent sophistication that Hu had back then? It is his original works that form the foundation upon which so much of what we create today rests. And so, I think, much of what we do in terms of, say, costuming, is an effort to try and recreate that feeling we had watching King Hu's films, but as soon as our work appears on screens, we can immediately feel that something isn't right. When I was making *The Flying Swords of Dragon Gate*, I wanted to use music from *Dragon Inn* (dir. King Hu); we hoped that using that music might help recreate some of its original effect, that we could once again feel the influence of King Hu through our work, but the gap between the two works was just too big, something I always feel is a pity.

There are few filmmakers who really understand even their own process of filmmaking. So when trying to tell other people "this is how you should do it," they end up expending a huge amount of energy. In all honesty, I think a lot of people on-set don't really understand what they're doing either. It's only when looking at the finished product that they can really see, "oh, so that's how it worked!"

The world of *Dragon Inn* (dir. Hark Tsui) is King Hu's world. As we enter that world, we feel like students trespassing on forbidden ground, and within that ground is the world we saw while we were studying. Naturally, we added in a few characters we would have liked to see in his world, hence Jade's appearance there. Jade is something of a tribute to

Hu. As Jade is our intrusion into Hu's world, we made a particular effort to not adhere to the usual rules of his world, to do things that don't follow the usual rules of jianghu. By using this method to try and enter the world King Hu had created, we hoped to recreate the characters he had created as well, but it was not to be. No one can replace King Hu's characters, no one can replace Lingfeng Shangguan, no one can replace Ying Bai. These people and characters have become icons, classics; only by going back to King Hu's original *Dragon Inn* can we truly see these people and characters, nowhere else.

From *A Chinese Ghost Story* to *Once Upon a Time in China*, my films tell stories of people in a given era having to face how things change, how new challenges must be confronted, and how they can feel helpless in the face of these. At the same time, though, they must continue to shoulder the burden of their missions and duties, often having to do things that run counter to their own personalities. Often, the figures in King Hu's films would have to face even greater pressures in the face of such realities, and do things seemingly beyond their abilities.

From *Dragon Inn* (1967) to *A Touch of Zen*, many of the warriors featured, we sense, all his heroes face their many tremendous challenges. In *The Valiant Ones*, he showed warriors facing down the challenges of Japanese pirates, and naturally we feel nervous. We don't want the pirates to win, but the film nonetheless features scenes that are rife with tension. And so, in creating later wuxia worlds, we give the villains greater strength, make them a greater threat, because in such films before *Dragon Inn*, the opposition lacked the great menace of Shaoqing Cao. After seeing that film, I finally understood just how entrancing the villains could be made to be, and how Hu's villains could be just as impressive as his heroes, if not more so.

Committing Thought to Paper

Every time I pick up a calligraphy brush, I wonder why we modern folk don't use them anymore. The brush in my hand never does what I tell it, and the hardest part of writing with it is trying to avoid getting too much or too little ink on it as I dip it into the inkwell. What I need is just enough

ink so that as I finish a character, the ink runs out. I find the matter of controlling how brush and paper, and brush and ink, interact fascinating.

There is another interesting sensation that comes with calligraphy. When doing calligraphy, I often write out poetry or songs; usually, we only read or recite the works of Bai Li or Song-era poems, but not write them. When writing them, though, you suddenly feel a kind of spiritual connection with their authors. The characters you write, the feelings the characters give you, what the poets try to express within the poems. The emotions expressed by brush and ink should be translated from your physical motions, and suddenly, as you try to express what you feel about these characters, you feel connected with the poets.

I have always strived to do things with a connection to China, and calligraphy is a convenient option - all you need is a brush, ink, and paper. When writing, you gain an appreciation of your own spiritual status, and that, when you finish, you will be that little bit more refined. I have also tried my hand at more free form, chaotic calligraphy. That, too, is not easy, because when I finish, there is no way to repeat what I have done. I have read writings on the subject that say that one should focus one's energies when writing calligraphy; some people believe that calligraphy is a way of training one's *qi*, and that good calligraphy can help prolong one's life. While I don't really experience that yet, but I can at least enjoy the process.

Calligraphy offers a contrast, a different perspective for us in modern society, because so much writing today is standardized in computers and prints. Calligraphy is different. It cannot be predicted, not even by those of us actually doing it. Every time we write, we feel that the brush is travelling its own path, and that feeling can be amazing. Sometimes the characters don't come out all that good looking, but in that moment, we feel that this is something that we can control; in contrast to the formalized regulation of modern society, calligraphy can give us a momentary sense of freedom.

I love the work of many calligraphers. What they write, the way they work with space, the way they structure their works, it is all incredible. Regardless of the style or technique used, their aesthetic control is

something that I want to learn, but which cannot be learned. There is something else incredible about calligraphy - that how you see an individual work, an individual character, and an individual stroke all vary dramatically. Viewing them from afar or up close both also produce different sensations.

Here, I have written two lines dedicated to King Hu, which could be translated thus: "The integrity of swordsmanship remains as the spirited rain re-enervates the unpopulated mountain and the intertwining corners of society."

I believe that the "spirit and heart of a swordsman" are the essence of that feeling that King Hu's films gave me, and that their power, their "sword," remains with us today. The spirit of his works was that of elegance and refinement, even as the stories he told were of the swordsmen of the jianghu. In these two lines, I have done all in my power to try and describe the great director King Hu.

下圖 below
【龍門客棧首映】單頻道錄像 / 1分45秒 / 1967年
The Premiere of Dragon Inn / Single Channel Video / 1 m 45 s / 1967

右圖 right
作品現場裝置圖
Artworks in MOCA

龍門客棧首映 紀錄片
Premiere of Dragon Inn Documentary

本區放映的是，胡金銓導演成名作《龍門客棧》1967 年於台北首映時的珍貴紀錄片。由影片中觀眾大排長龍爭購門票的情景，不難想像當年的轟動盛況。《龍門客棧》是胡導演於台灣拍攝的首部電影，由台灣聯邦公司出品，首映不僅刷新了台灣有史以來國片首日賣座最高記錄，之後於紐約、舊金山、北海道、東京、漢城、馬尼拉、曼谷、香港等地放映，也大受歡迎，屢傳捷報和佳績。這種成就於今來看仍屬不易，堪稱台灣藝術文化史的一次奇蹟。

In this area, a rare documentary footage of 1967 premiere of *Dragon Inn*, the first box office hit of King Hu, will be shown. It captures people standing in long queues jostling to get hold of tickets, bringing to image scenes of this yesteryear movie sensation. *Dragon Inn* was the first film King Hu made in Taiwan; it was produced by Union Motion Picture Company of Taiwan. The premier not only broke the Taiwan domestic film box office record for first day ticket sales, it was also a hit in New York, San Francisco, Hokkaido, Tokyo, Seoul, Manila, Bangkok, and Hong Kong. It attained such success is by no means easy, even by the standards of today. This truly can be called a miracle in the art and culture history of Taiwan.

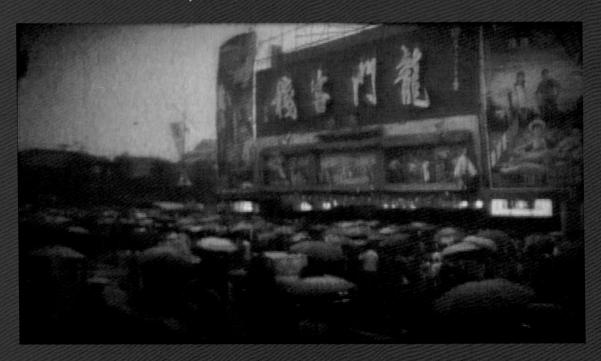

俠女八道
The Eight Characteristics of the Swordswoman

胡金銓的古裝動作片中，俠女的角色往往帶有極重的份量，而他所塑造的俠女，有別於傳統父權社會中備受保護的柔弱女性，流露出堅定、內斂、獨立自主的氣質，甚至可以反過來保護男性。而胡金銓在選角方面也獨具慧眼，發掘了許多出色的新人演員加以栽培，最後都成為著名的優秀演員。如《俠女》的女主角徐楓，十五歲即被胡金銓發掘，受到胡金銓大力栽培，將飛賊、鬼狐、烈士、異族女子等不同特性的女性角色皆詮釋得栩栩如生。另外主演《大醉俠》與《龍門客棧》的鄭佩佩與上官靈鳳，則同樣以中性的裝扮、矯健的手腳突破傳統女性角色形象。此外著名的演員張艾嘉、胡錦、彭雪芬等在胡金銓的電影故事中皆塑造了獨特的女性形象，令人印象深刻。

關於胡金銓電影中的俠女，策展團隊特別歸納出「俠女八道」的重點，搭配精彩劇照輸出，訴說胡金銓電影世界中八種不能取代的女性特質。

The character of a swordswoman often bears a heavy burden in the costume action films of King Hu. All of the swordswomen he created are unlike the closely protected delicate women of traditional patriarchal societies. They are resolute, introspective, independent in nature, and even protect the men. In the casting, King Hu had great insight. He unearthed and cultivated many new talents, who became outstanding actors, such as Feng Xu, the leading actress of *A Touch of Zen*. She was discovered by King Hu at fifteen, and he spared no effort in cultivating her to play the characters of the cat burglar, the fox spirit, the martyr in various ethnicities, and other diverse roles. She succeeded in convincingly bringing all these characters to life. There are Peipei Zheng in *Come Drink with Me* and Lingfeng Shangguan in *Dragon Inn*. They also broke the traditional image of female roles with their unisex clothing, excellent kung-fu skills. Additionally, famous actresses featuring in the films of King Hu, such as Sylvia Chang, Jin Hu and Xuefen Peng have created unique and impressive female personas.

Regarding the swordswomen from the films of King Hu, the curatorial team has specially summarized 'the eight characteristics of the swordswoman' with matching stills.

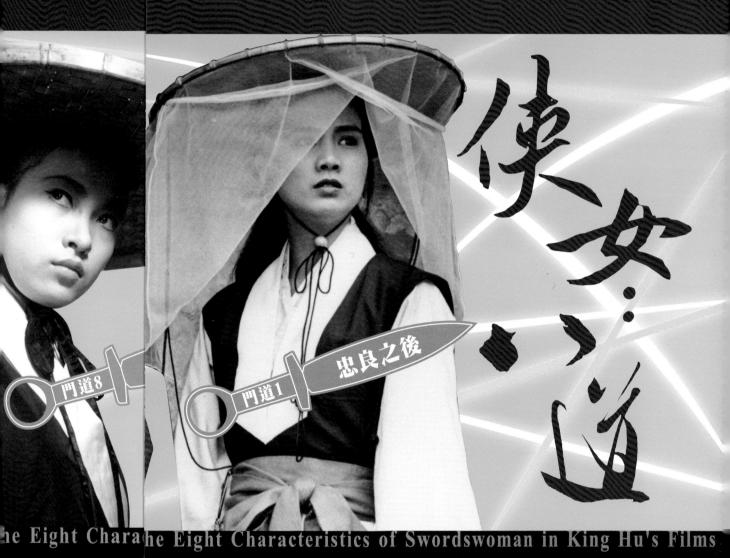

俠女之道

門道8

門道1 忠良之後

The Eight Charac The Eight Characteristics of Swordswoman in King Hu's Films

With sharp and

片名：俠女

角色：楊慧貞（

Feng Xu in *A T*

Must be descendants of loyal officials

片名：大輪迴

角色：韓雪梅（彭雪芬 飾）

Xuefeng Peng in *The Wheel of Life*

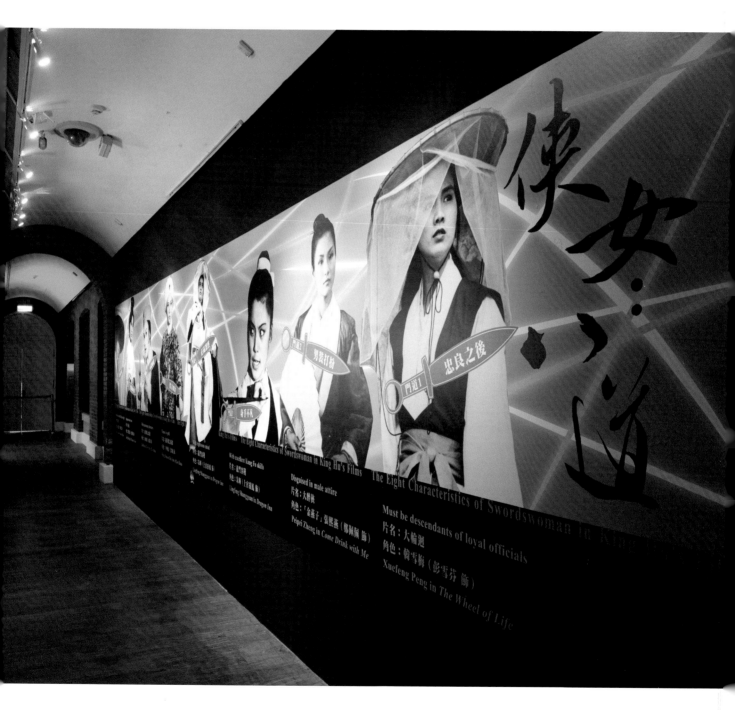

【俠女八道】作品現場裝置圖
The Eight Characteristics of the Swordswoman in MOCA

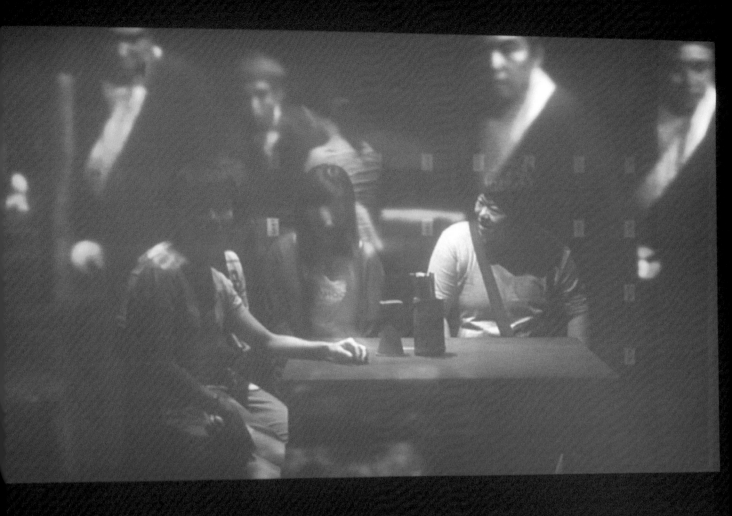

陳昌仁的電影空間今詮：
凝視輕觸－旅人記憶－時間實相
"Aesthetic Précis" of King Hu's Cinema
Leo Chanjen Chen

走進106 展間，首先映入眼簾的是一組樣式復古的客棧桌椅；觀者腳步移動，彷彿穿越時空隧道，置身於某處的荒郊野店。就在這個當下，藝術家陳昌仁的互動裝置瞬間啟動，將觀者的身影拍攝融入胡金銓的古裝動作片《迎春閣之風波》中，並當場投映在展場牆面。在現場另一面牆上同步投影的則是胡導演著名電影中最經典的人物神情演出。

《迎春閣之風波》與《大醉俠》、《龍門客棧》同列客棧三部曲。時代背景為元末明初，故事內容充滿正邪對立、文謀武鬥，集胡導演喜愛的武俠元素於一身；同時，胡導演以獨特的電影剪輯技術來詮釋和表達武藝的美學，令人驚嘆佩服。陳昌仁以《迎春閣之風波》為文本，利用數位科技和多媒體互動裝置，引領對傳統武俠文學與電影陌生的新世代觀眾，輕鬆進入充滿神祕傳奇的俠義世界，就地體驗胡金銓風格獨特的電影美學。

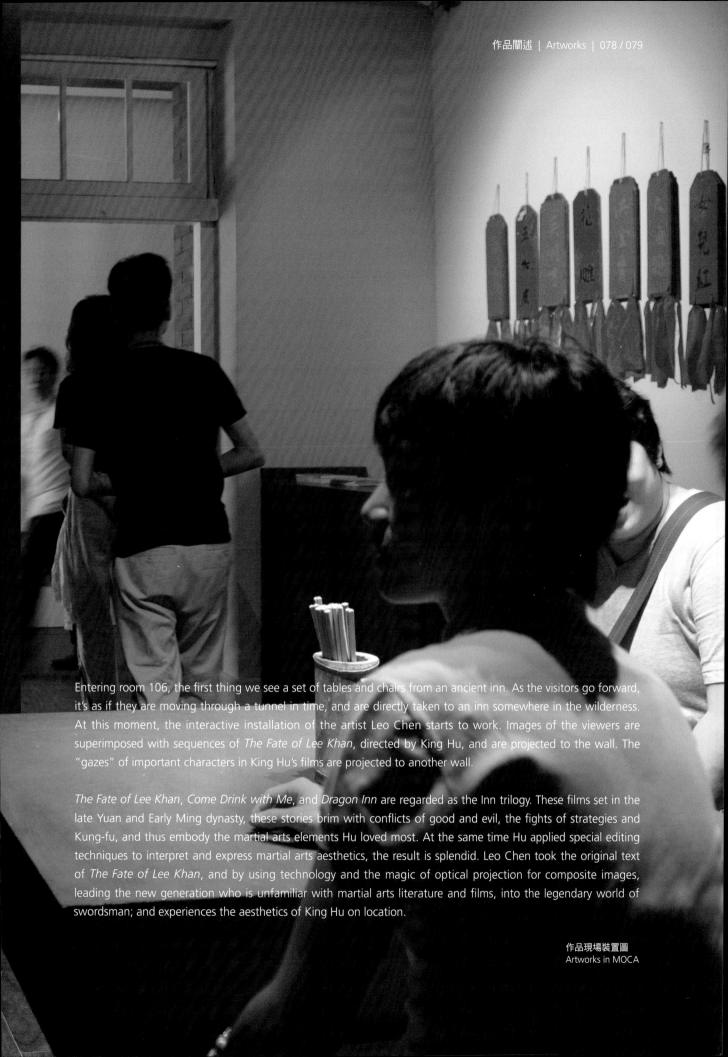

Entering room 106, the first thing we see a set of tables and chairs from an ancient inn. As the visitors go forward, it's as if they are moving through a tunnel in time, and are directly taken to an inn somewhere in the wilderness. At this moment, the interactive installation of the artist Leo Chen starts to work. Images of the viewers are superimposed with sequences of *The Fate of Lee Khan*, directed by King Hu, and are projected to the wall. The "gazes" of important characters in King Hu's films are projected to another wall.

The Fate of Lee Khan, Come Drink with Me, and *Dragon Inn* are regarded as the Inn trilogy. These films set in the late Yuan and Early Ming dynasty, these stories brim with conflicts of good and evil, the fights of strategies and Kung-fu, and thus embody the martial arts elements Hu loved most. At the same time Hu applied special editing techniques to interpret and express martial arts aesthetics, the result is splendid. Leo Chen took the original text of *The Fate of Lee Khan*, and by using technology and the magic of optical projection for composite images, leading the new generation who is unfamiliar with martial arts literature and films, into the legendary world of swordsman; and experiences the aesthetics of King Hu on location.

作品現場裝置圖
Artworks in MOCA

陳昌仁的電影空間今詮

陳昌仁 作

武俠電影宗師胡金銓過世十五年之後由國家電影資料館在台北當代美術館舉辦回顧展這個事件本身是一個大膽有趣的美學宣言。先不提行政及票房的共榮互利，把武俠經典當作當代藝術重新呈現，有機結合大眾媒體的類型電影與小眾媒體趣味的當代藝術，不啻是對兩種媒體藝術的挑戰但也同樣是各自開展的契機。

106展間佈置成客棧的樣子主要在營造一種真實的氛圍，如同園林造景雖由人來造景，但園林景觀也會反過來影響改變人的心情甚至想法。邀請人們進入環境空間，其實就是氣氛（mood）的主要意義，而德文stimmung根據海德格（Heidegger）的說法，就是指人與環境其實一直不停地在不自覺的情形下互相影響著。所以欄杆跟樓梯不僅以實木具體呈現客棧氛圍，由樓梯與欄杆指向而延伸客棧的空間更擴充形成心理空間，於是酒甕中生出枯枝，破題且寫意；掌櫃台上方的菜單，以人名入菜，說明治片（製片）有如烹小鮮；狀似藥櫃的百寶櫃，暗含萬物相生相剋之意，比喻一山還有一山高，並以有限蘊含無窮；細心的訪客還可把掛在牆上燈籠取下，用可移動之光源探照搜索空間每一個角落。有了可掌控的光源於是就產生主動性，主動性會使觀眾坐在板凳觀看牆上的投影，這時對比比較兩邊投影就會使觀眾發現差別——內牆投影娓娓道來胡金銓電影中的諸多情愫，如說不出的愛情、筷意眼神較勁……等，十九種情緒片段。這些片段各自獨立，完整表達胡金銓電影的美感，而且每段都有獨特的象徵意義。此時觀眾轉身往外牆看，會發現自己已被邀請進入到胡金銓的電影當中，於是具融合投入性的戲劇性藝術遊戲開始，觀眾的愉悅與收穫正來自於自己對自己的誠懇。

整個光學影像的合成，是在磨坊中以簡單的光學原理結合實相與虛像。磨坊左側有間看似倉庫的「間關蒼房」，打開簾幕會看到自己的反影被投射在蒼房之中，房中牆上反映著江南湖光山色的綺麗風光，同時耳中

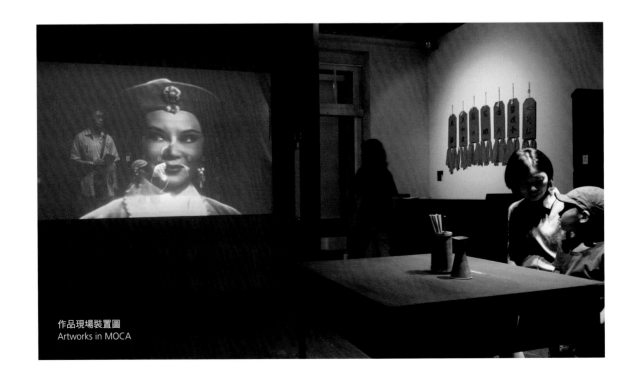

作品現場裝置圖
Artworks in MOCA

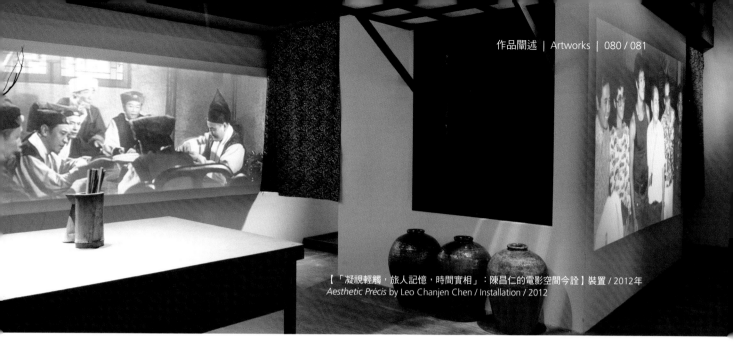

【「凝視輕觸，旅人記憶，時間實相」：陳昌仁的電影空間今詮】裝置 / 2012年
Aesthetic Précis by Leo Chanjen Chen / Installation / 2012

傳來間關鳥語，地上的竹笈表達對取經及知識的渴望，於是在一派鳥語花香的風情中，整裝待發充滿希望進京趕考的形象躍然浮現。但低頭一看，由蒼房滿溢出來的白沙，透露出路途迢迢的未知，枯山水指射山水終將枯竭，滿溢出來的白沙遂賦予「間關蒼房」歷史的深度。繞過磨坊可到「間關蒼房」的另一處入口，如同城門的拱型門上貼著『陽關』二字，影射西出無故人的典故，打開簾幕先是一片漆黑，但從手指挖出的兩道孔洞望進蒼房，卻驀然驚見一片蒼涼景象，夕陽血染的荒漠，擱置地上的竹笈依舊，旁邊卻多出一縷早生白髮。如同生年不滿百卻常懷千歲憂的書生心路歷程。這時聽著風沙吹襲的聲音，從一片蒼涼的景觀裡，卻竟然還可以看到由另一頭「間關蒼房」裏反射出來正在「夢遊江南」的他人影像，形成強烈對比，觸動人心，回想起自己也曾經在明亮且充滿希望的那一頭，如今卻只能咀嚼他人青春的投影，吞噬老去的年華。

離開了「間關蒼房」，可見到一面由名為「心像儀」投影出的連續馬賽克影像——「凝視的眾面相」，其中由視覺邏輯自行說故事的趣味來自胡金銓電影中剪出的凝視鏡頭，因其具有各自獨立的美感，在重新隨機組合之後，影像之間開始會互相交談，人們的想像也會填補敘事的空間。正如尼采所說的，當你注視迴旋下流的山泉瀑布，時間一久，山泉瀑布也會回頭來凝視著你。「凝視的眾面相」的影像起始自每個人一生懸命的凝視，夾雜與自然的回顧交錯，以螺旋輪迴的結構貫連之，形成永恆的重複與延續。

依據茅思（Marcel Mauss）所建言的禮物經濟活動 (gift economy)來調適資本主義經濟，電影空間今詮以實體的禮物贈與觀眾來交換並延伸經驗。在看完前述影像之後，觀眾可以從百寶櫃中得到兩樣禮物：「電影本事」及一秒鐘的電影膠捲「時間實相」。「電影本事」語帶雙關，既指胡金銓拍電影有本事，形式上又復刻七〇年代觀影經驗中的電影本事，懷舊並復古。中英文版的四張選圖，以影像作為對比，強調胡金銓構圖之深意，包括動作凝結的瞬間感，寫意如中國山水畫的山陰對照嶙峋古松，營造出魔山的氛圍，整個構圖以對比為原則，相反的意像造成特殊的美感。

「時間的實相」是送給觀眾胡金銓電影裡面的一秒鐘，讓數位年代成長的觀眾有機會體驗從前電影以膠片存在的時代。每24格的膠捲長度就是電影裡的一秒鐘，時間是有實體的，摸的到，聞的到，有重量，可以反覆玩味。而這個「時間的實相」剪自胡金銓的電影，不僅顯示胡金銓的誠懇，更重要的是，在當代藝術抽象當道，「時間的實相」或許更有承先啟後的創新意義。總體而言，這許多設計旨在整合傳統與創新的觀影經驗。在解構的年代化整為零容易，但化零為整困難。電影空間今詮的觀影過程如同是一個人生學習的縮影，因為經驗來自與實物互動，累積經驗歸納抽象化後變成知識，但進一步如何從抽象的知識概念再應用回到實物，以回歸經驗，卻彌足珍貴。電影空間今詮試圖把諸多電影、文化及藝術理論以實體藝術呈現並延伸為觀眾的自身實際體驗，應該是向胡金銓致意之餘並能與觀眾分享的美感經驗。

Aesthetic Précis and Praxis of Cinema

by Leo Chanjen Chen

The first major retrospective exhibition of King Hu fifteen years after his untimely death in 1997 is an event of aesthetic significance in both cinematic and contemporary arts. To claim King Hu's martial art films as contemporary art, most of Hu's famous films were made before 1980s, is a daring and visionary statement in the art exhibition – "King Hu: the Renaissance Man" on display at the Museum of Contemporary Art Taipei, initiated and organized by Chinese Taipei Film Archive. The question to what extent does King Hu's cinema fit in the category of contemporary art lingers. There is also considerable worry about the outdatedness and slow tempo of King Hu's gracefully choreographed fight scenes that might pale in comparison against the CG special effects and high strung wired works rampant in today's global martial art movies. Can repackaging of King Hu's films as contemporary art generate enough interests, particularly from younger generation, to justify such brave move? In another word, from the perspectives of art and film theories, how can one integrate mass entertainment of genre cinema with contemporary art so often deemed as elite and opaque hence appealing to a smaller audience?

The core issues center around audience responses and/or spectatorship. Mere viewership alone can not justify the value of art works as most of the popular movies are not considered masterpiece displayed in art museum. On the other end of the spectrum, many contemporary art works on display today in gallery and museum are not easily accessible to general viewer in terms of both its meaning and beauty. What is a viewer to do when he/she faces an artwork by claim only and can not understand nor appreciate its beauty? Since Duchamp, the regime of abstract conceptual art has dominated 20th century art often at the expense of beauty. Consequently, contemporary art is often too cerebral, abstract and most of them are not even beautiful in common sense! However, for another raison d'etre, there simply have not been enough wolf-crying to unveil many Emperors' new clothes.

Tackling the problem of value judgment in modern art, aesthetician Michael Fried suggests sincerity as a gauge in his paradigm of art value judgment consisting of Absorption and Theatricality. Defined as the two polarity modes for evaluation between which art works can be judged according to the artist's attitude towards viewer/audience: art of absorption engaged in self expression without concerning the viewer's reaction, such as Van Gogh; while art of theatricality are always aware of the viewer/audience responses and adjust accordingly, such as Las Vegas. Lamenting the theatricalization tendency of modern art has been a persistent trend in western art criticism since Diderot onwards. And yet, more arts today based on media material are inevitably and structurally turning towards the mode of theatricality.

It is in this sense that King Hu's cinema become relevant in contemporary art, for King Hu is sincere in authenticating period film experiences and his films are beautiful to look at. As a filmmaker who creates films as an art with the utmost sincerity integrating two aesthetic systems of Chinese and cinematic conventions, King Hu is perhaps too sincere as to become a nuisance in the eyes of money-clenching commercial producers. But sincerity and beauty alone may not warrant a justification to recontextualize King Hu in the camp of contemporary arts. In fact, to bring King Hu into the context of art in general and contemporary art in particular seems at first complicating Michael Fried's model. While King Hu's filmic characters are absorptive in their incandescent gazes, a performance merit rarely seen today, their actions are always motivated within a genre full of old world ideologies

necessarily theatricalized.

Re-contextualizing King Hu's cinema as contemporary art, however, we learn a reciprocal enlightenments for both. On the one hand, the effort to accommodate King Hu as contemporary art help clarify the need for contextualization in the value judgment of arts, including material-based skills, something contemporary art need in order to outgrow its own perplexity. On the other hand, the re-situation of King Hu's cinema as avant-garde art help solve the perennial structural problems of Chinese cinema trying to sinologize western cinema techniques.

Unlike many precedent examples in adapting Chinese theater onto screen, conspicuous failures include Fei Mu's *Remorse at Death* (1948) in which formal experimentation run into incongruity problem when adapted onto screen the symbolic acting in a relatively realistic set. King Hu solves the problem by pushing even further the experimentation in breaking genre conventions altogether with the border of realism in his innovative integration of sound. Using Peking Opera stage sound to accompany movements in exterior landscape of swordsmen running out of breath, King Hu thus creates a new cinematic space and a new language. The audacity and vision qualify King Hu not only as an innovative creation in world cinema but also as exemplar in contemporary art.

Aesthetic Précis is an installation artwork set in Room 106 MOCA Taipei, designed to pay homage to director King Hu and invite participating appreciation of his cinematic aesthetics. Among a few renowned Chinese film directors who had made indelible imprints in world cinema, King Hu not only established a distinctive film style closest to Chinese aesthetics. King Hu also invented a film language that has been influencing and inspiring generations of filmmakers, not to mention the many archetypes he created, images such as white-hair eunuch and the lone scholar in landscape with a backpack, in martial art genre that have been recycled and promulgated ever since.

In designing "Aesthetic Précis" of King Hu's Cinema, I assign myself a double mission. On the one hand, I have to succinctly present King Hu's cinematic aesthetics in an interestingly familiar yet serendipitously provocative way for people who knew his films to savor; on the other hand, I also would like to introduce and rejuvenate interests of King Hu's films to the new generations who can learn to appreciate and understand cinematic aesthetics by interacting with King Hu's cinematic design, and then learn from the master's lessons. To accomplish such ambitious aspirations, therefore, my design of "Aesthetic Précis" has three intentional layers, each layer corresponds to specific cinematic aesthetics and each invites visitor's participation.

The First layer presents the idea of an "Affiliation space the transient home-making for Chinese journeyman" by showing how one can and always has to turn an indifferent space into a meaningful place for one to dwell in. The abstract space of room 106 is set up to recreate the mood of a tavern as a concrete place, an ad hoc temporary home for the perpetual homeless generations of Chinese people in constant migration, exile and diaspora. Tavern is a recurring theme and place in King Hu's cinema and an image immortalized by filmmakers like Ang Lee and Hark Tsui among others. Traces of King Hu's favorite footsteps reminiscent of transience and affiliation, such as Kyoto's garden landscaping art, are also hinted.

The Second layer invites visitors to enter King Hu's cinematic space, thereby embodying/reifying a "Visual dialectics of the virtual and the physical". By filming curiously interested visitors through optical projections of virtual images and then project the optical (read "no computer") composite images onto tavern's wall, viewers as live actors are invited to interact with the virtual images for physical as well as scopophilic pleasures. 19 emblematic episodes of King Hu's films expressing aesthetic autonomy and visual rendition of emotion are projected in a loop to form a mandala with synecdoche unity. They are each annunciated with succinct yet suggestive titles for audience to interact with and to dwell in. New images of participants engaging in multi-layer compositing are encouraged for instant feedback, check-in on twitter, web consumption and immediate recollection.

The Third layer de-signs the place as consisting of a series of riddled drawers, labyrinthine rooms and Chinese boxes. Highly suggestive physical exploration, as suggested by a portable lantern, will lead visitors to discover a hidden Diorama with apocalyptic yet poetic messages tucked inside the Deposit Room (a.k.a. Desolation room) located in the corner, which in turn is wrapped within the larger Milling Room (a.k.a. Magical room) outside, with separate entrances and different views. Viewer will see himself/herself reflected inside the Deposit room amidst beautiful garden scenery in reflection and hearing the birds cheerfully chipping. The bamboo-made backpack on the floor refers to the pursuit of knowledge as the necessary path for Chinese intellectual hence the image of hope and aspiration for every young man and woman. Look down on the ground, however, the overflowing white sand exuding through glass to cover the floor outside points to an elsewhere perpetually extending that may never be reached. The dry gardening is a hint of futile hopes and even a death chronicle foretold. On the other side of the Milling Room, one can get the second view of the same Deposit room through a darkened corridor tucked behind. Entering the hidden corridor, one is at once blinded by darkness and intrigued by the two peeping holes emitting light. By looking through the finger-drilled peeping holes, one will see a scene of desolation shaded by bleeding sunset and hearing the howling wind blowing against the invisible and long since vanished journeyman whose only trace is the bleached white hair left on the sand dune.

Coming back into the tavern space, one is greeted by a mental image generator designed to reveal the invisible working of organic mental unity through multiplicity of gazes— projecting mosaic image consisting of variety of gazes for pure visual pleasure. The constantly changing images also showcases King Hu's cinematic/aesthetic précis which includes: mise-en-scene in pictorial composition incorporating Chinese painting aesthetics, visualization of the instantaneity of action, and the pre-lingual cognitive beauty of cinematic images. Tavern's menu includes actors' names as cuisines suggest King Hu's interest in exquisite culinary art that is comparable to his careful ways of filmmaking. Completing the exploration of "Aesthetic Précis" will transform for participant visitor/player the room beyond a meaningful place thus established, into a "Thinking room" (Denkraum) with live interactions, spiritual rewards, intellectual gains and material gifts (pace Étant donnés) to take home as souvenirs. And as souvenir exists only when it has emotional value attached to it, thus a practice of gift economy is in place.

The Gift Economy analyzed by anthropologist Marcel Mauss provides an alternative to the economy of Capitalism

because, for one thing, in gift economy the value of material object is not solely determined by money. Before leaving the room, visitors are clued to locate two designated souvenirs to take home with which will not only complete the nostalgic adventure in the "Aesthetic Précis" but also, as memento vivere, will continue to rekindle one's interest and rediscovery of King Hu. The first souvenir is a "Film Précis", brochure of "aesthetic précis" pages printed on nostalgic pulp paper imitating the movie house hand-out/flyer in 1970s with movie poster in the front and plot summary in the back. Four film stills from King Hu's cinema highlight the beauty of composition based on contrast: they are beauty of the intensified instants of look (augenblick), beauty from frozen movements contrasting mobile stasis, and the beauty of a transformed nature with shading mountain flanked by corrugated pine tree and human torso suggesting a magic mountain.

The second souvenir is "Material Time"- celluloid film frames cut directly from King Hu's film as a reminder of the physical form and materiality of time. "Material Time" is not only designed as a tutorial souvenir to challenge our common conception of "time" as intangible abstraction. As a heuristic and pedagogical tool, "Material Time" also urges one to re-learn about time differently through film, to measure TIME by its physicality in terms of material length, weight, smell, and sound. Ideally, every visitor can bring home a second of King Hu's film and let the material TIME continues to rekindle one's senses of beauty, even though fragile, it is the impression of beauty that will last for good, as Keats once odes.

Ultimately "Aesthetic Précis" is designed to integrate different modes of viewing experiences and revitalize a classic genre cinematic art through installation art. More than integrating the arts of viewing, through film and installation art, the aesthetic précis is also a praxis of cinema in which theories and concepts from art and cinema histories are put into practical test through viewers' interactive responses. In other word, in order to emphasize the importance of being earnest (and physically beautiful) in art, I transform several theoretical concepts and abstract thoughts into a materialized set up for corporeal interaction. By actualizing abstraction and return knowledge back to the physicality of its original being, the aesthetic précis functions also as aesthetic praxis that literally puts knowledge into work, and the art work only rewards those who use their hands and body to play with their vision and imagination, with sincerity. To experience in person both the virtual and the physical existence of art and film is itself an aesthetic experience that should last a long time.

作品現場裝置圖
Artworks in MOCA

關於武俠 / 葉怡利
About Martial Art / Yili Yeh

受到胡金銓導演武俠美學的啟發，藝術家葉怡利從2004年的創作《橘花花》，到2011年發表的《啦~啦~啦~小島》，都有意將東方傳奇的武俠元素融入作品中。在這次特意向胡導演致敬的新作中，葉怡利重新剪接了她2004~09之間與武俠美學有關的幾件行為錄像作品，包括：在中國桂林山水場景中，用掌風推送彩虹和鮮花的「橘花花」；在韓國山林古剎中，儀式性地表演武功的「紅衣」與「春雪」；古裝人物「彩虹七仙子」和當代卡漫「蠕人」在樹林裡的遭遇互動；美俠女 也黃花」與痞子男「一片藍」無聊對打的情節等，另外一件全新之作是2011年於非洲小島留尼旺駐村時，邀請當地黑人共同演出創作的《啦~啦~啦~小島》，這些作品，都有意無意地呼應了胡導演電影美學裡的人物、情景、詩性與禪意。

本次展出，葉怡利也特別設計了一個互動遊戲裝置，一來呼應電影《俠女》應戰的經典場面；二來讓觀眾用扮演加上想像，虛擬一場與俠女並肩抗敵的戲劇情節，進而領略胡氏電影中俠女角色的獨特性格和處境。

作品現場裝置圖
Artworks in MOCA

Inspired by the martial arts aesthetics of director King Hu, artist Yili Yeh has integrated legendary martial art elements of the Oriental in her works, *Orange Flower* (2004), and *La~La~La~An Island* (2011). In this new work, which specifically pays tribute to director King Hu, Yili Yeh re-edited several of her performance art videos of 2004-09, related to martial art. The works include: scenery from the Guilin in China, where Orange Flower moving the rainbows and flowers with the "qi" of her palms. In the ancient temples of the mountains of Korea, Red Robe and Spring Snow perform the martial art like a ritual. The characters in costume, Seven Rainbow Fairies and the modern kuso character, Creeping, fight with each other in the woods. The beautiful swordswoman, Yellow Flower, and the hooligan, Blue Piece, engage in a rather boring fighting scene. Another completely new work made in 2011, takes place in the villages of the small island of Reunion, off the east coast of Africa, where Yeh was the resident artist. The local people were invited to co-perform

【啦~啦~啦~小島】三頻道錄像裝置 /
5分33秒 / 2011年
La~La~La~An Island /
Three Channel Video Installation /
5 m 33 s / 2011

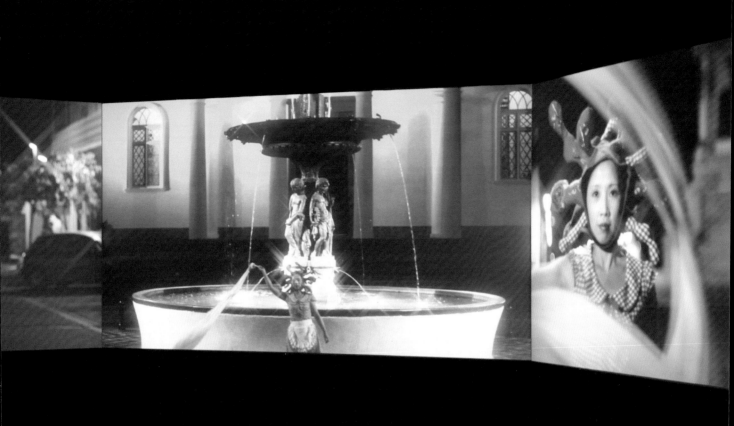

in the creation of *La~La~La~An Island*. Whether intentionally or not this work echoes with the characters, scenes, poetic elements and a touch of Zen in King Hu's films.

Yili Yeh has also designed an interactive installation of the forest, which pays homage to the classical bamboo duel scene in *A Touch of Zen*, and allows viewers to let their imaginations run free, by virtually fighting side by side with the swordswoman. This gives the viewers the chance to explore the personality, and experience the circumstance faced by the swordswoman created by Hu.

關於武俠

葉怡利 作

我總是游移於真實與非真實之間，因此我喜歡看電影，因為電影故事情節的敘事性，總能讓我瞬間脫離現實、情境轉移，所以我也時常在錄像作品中，曖昧不明地敘述了某些情境氛圍。然而電影中我卻特別鍾愛武俠片，武俠片第一大導演胡金銓所開創的武俠美學，影響了後世的電影至今不僅是武俠片而已，對我雖非直接卻也間接得深刻，其中我最感到興趣的莫過於高手對打的招式、在竹林或樹林間飛來飛去的輕功，配合武俠片慣有蓄勢待發的鼓聲和國樂，有一種虛實挪移的情境轉換，還有那些講究的古裝及古代建築場景，讓我這個成長於對文化認同薄弱年代的人，產生了莫名的好奇。

就因為我從小到大喜歡看武俠片，因此讓我直覺且慣性地在我的錄像作品裡加入了武俠的蹤跡。偶然接到這個展覽，問我如何向武俠大導胡金銓致敬？我想我無需刻意，因為打從我2004年的《橘花花》到2011年的《啦~啦~啦~小島》，胡導所影響的後世武俠觀，自然而然在我作品裡若隱若現。

我重新剪接了我2004～2009年的錄像作品：《橘花花》在中國桂林山水噴洒彩虹與花、紅衣與春雪在韓國寺廟祭祀的儀式性（《春雪、巧克力遇紅衣》）、《彩虹七仙子》的古裝人物與《蠟人》在樹林裡對打、也黃花與一片藍對戰（《反正明日也黃花獵殺昨日一片藍》）等等橋段，來呼應胡導武俠美學裡的中國山水、人物情境的詩意與禪意和最著名的竹林對決的部份，並將此影片放置在一個樹林的場景裡，而觀眾也可以拿著竹劍與場景裡的俠女對決，和我一起向武俠大導胡金銓致敬。

就因為中了武俠的毒太深，所以2011年在非洲小島「留尼旺」駐村所創作的「啦~啦~啦~小島」，很本能的邀請兩位當地的黑人跟我一起在作品中，武俠了一番。

啦~啦~啦~小島

我的斷裂故事情境總處於真實與非真實之間，訴說著我對環境空間與時間流逝的無力抵抗。

而身體就是最方便在空間與時間中移動的媒介物，2004年開始我時常穿著蠟人服裝，周遊各地拍作品，透過我的身體轉化成不同的角色，我時常裝扮成有魔力的怪獸、仙子、惡女等角色，在文明的城市或是幽然的大自然中，透過現場行為的藝術形式，猶如小孩嬉戲的原始本能，再以錄像藝術或互動裝置呈現作品。

所以藉由調侃自身的經驗，內化成一個輕鬆自在的遊戲性，作品裡經常有一些像童話故事的角色，這些角色都像是成人倒帶到幼童的原型，透過遊戲的過程在嬉戲中藉由原始的本能反應創作，「遊戲中」就像藝術之於我的「創作中」，是我作為一個藝術家最重要的部份。

我出生在亞洲東部、太平洋西北側、面積約3.6萬平方公里的島嶼「台灣」，因為住在島嶼，對於海洋有著一種歸屬感，大概是因為島國人的特性作祟，總是喜歡旅行，就像一艘船在遼闊的海上飄來盪去，我總喜愛處在起點與終點之間的狀態，最有趣的莫過於過程中的一些偶然發生！

而《啦~啦~啦~小島》是我2011駐村在印度洋西側的馬達加斯加群島之一的南島「留尼旺」的作品，「留尼旺」跟台灣一樣有著殖民時代的歷史是法國海外省，也有著南島的特色多元文化，島上有穆斯林的阿拉伯人、印度人、法國人、中國客家人、克里奧爾人（Creole people）等多種族。所以作品裡我和一個當地克里奧爾人（Creole people）與印度人在最後的聖地卡拉利對打一番，象徵殖民時代的戰爭，我分別又在法國建築與穆斯林廟玩中國的彩帶，意味著多文化的混血。我延續慣有的創作風格，以行為、錄像的方式創作這一次的《啦~啦~啦~小島》的計畫。

左圖及上圖 left & above
【關於武俠】雙頻道錄像、互動裝置 / 7分26秒 / 2012年
on *Martial Arts* / Double Channel Video, Interactive Installation / 7 m 26 s / 2012

About Martial Art

by Yili Yeh
translated by Geof Aberhart

I have always wondered between the real and the unreal, and so film has always appealed to me, because the narrative nature of film has given me a way to momentarily escape reality. As such, my own video works have often strived to present narratives scenes and atmospheres with their own particular ambiguity. While I love film, I have a particular love for martial arts films, and the aesthetic of the leading director of such films, King Hu, continues to influence not only the martial arts genre, but other genres as well. His influence on me has been an indirect, yet deep one, particularly in the form of the combat between martial artists that interests me so and the acrobatic qinggong used by them to flit through forests of bamboo and of trees, and through the drums and traditional Chinese music that accompanies the films. These give the films a sense of unreality as scenes change and transition. The ancient costumes and architecture, too, helped me form an idea of my cultural identity in a time where that identity was weak, as well as producing a sense of wonder.

Growing up with a love of martial arts films, elements of those films intuitively and pervasively informed my own works. When I happened upon this exhibition, I asked myself how I could pay my tribute to the great director King Hu. I did not have to think too hard, though, as my works - from 2004's *Orange Flower* to 2011's *La~La~La~An Island* - have all naturally incorporated elements of Hu's influential works.

I recut recordings from 2004 through 2009: *Orange Flower* erupts in glorious colors and flowers amidst the spectacular scenery of Guilin, China; Red and Spring Snow perform ritualized motions in Korean temples in *Kuso-Spring Snow*, *Chocolate and Red*; in *Kuso-Rainbow Fairies and Creeping*, with battles in the forests; and in *Kill the Rabbit*, Yellow Flower and Blue Piece have duel scenes. All of these call to mind the martial art aesthetic of King Hu, the landscape (shanshui) style, the poetry and Zen of the characters and scenes, and the renowned bamboo forest duels that feature in Hu's films. The resulting piece is set in a forest, with the audience able to pick up a wooden sword and do combat for themselves with the swordswoman in the scene, paying tribute to Hu alongside me.

And, having caught the wuxia bug as badly as I have, in 2011 I was resident artist in the small African island of Réunion and I have created *La~La~La~An Island*, inviting two local Africans to participate in some martial arts themselves in the piece.

La~La~La~An Island

My fragmented tales are always a mix of the real and the unreal, telling the story of my own powerlessness to resist the march of time and the reality of the environment.

With my body being the easiest medium for traversing space and time, in 2004 I began traveling around dressed as Creeping and filming, transforming myself physically into other characters: mystical monsters, fantastic immortals, villainous women, etc. Through my acting on the sites, whether in civilized cities or secluded wildernesses, I used

the childlike, primal instinct of play to create happening art works, and display the works in the form of video art or interactive installation.

Through physical ridiculousness, I internalized a sense of playful comfort, and my pieces often feature characters with a fairytale quality. These characters appear as a grown adult acting as a child, and through the process of play they tap into and reflect basic instincts; "play" is an essential element of my "creativity," and is the most fundamental part of my existence as an artist.

I was born on an island in the East, situated at the northwest of the Pacific Ocean, with an area of some 36 thousand square kilometers, and known as "Taiwan." Living on an island, I have a particular affinity for the ocean, possibly because it is something of an object of worship for people of an island nation. And so I have also developed a love of travel, becoming like a raft adrift on the high seas. It is the journey, rather than the destination, that I love, and in particular I love seeing what happens along the way.

La~La~La~An Island is the product of my time as residence artist on an island to the east of Madagascar, at the western side of the Indian Ocean, called Réunion. Like Taiwan, Réunion is an island with a colonial history - they are an overseas region of France - but also with a distinctively diverse culture, including Indians, Frenchmen, Hakka, Creoles, Arab Muslims, and indigenous Malagasy. And so, the piece includes a duel between an Indian and a Malagasy, symbolizing the fighting of the colonial era. I also cavorted around French architecture and mosques with Chinese ribbons, symbolizing the multicultural, multiethnic nature of the island. This piece is a continuation of my creative style, using the forms of happening and video art to create the La~La~La~An Island project.

作品現場裝置圖
Artworks in MOCA

空山靈雨 / 葉錦添
Raining in the Mountain / Tim Yip

葉錦添參與李安導演電影《臥虎藏龍》的拍攝時，曾用心回看並大力肯
定胡金銓的武俠電影「成為一個取之不盡的寶藏，中國元素的精神面不
斷被發現，卻不拘泥於形式，在各種結構中製造了特殊的氛圍，特殊的
說故事的方法……」。本次展出，他在108展間特意搭設了一個可三面
觀看的透明房間，內部擺設的茶几、電視、音響、矮櫃、掛衣架等，營
造了懷舊的時空氛圍，當代的時空氛圍，有別於其他展間。胡氏電影的
影像結構作為佈局，這裡卻把視覺放在年輕一代的無憂世界裡，使胡氏
可以在一個截然不同的時空中，與藝術裝置的年輕主角Lili相遇，兩者同
時分享了這裡的每一瞬間。

針對這個氣氛懸疑的空間場景，葉錦添提道：「胡金銓的創造力縱然豐
富，博學多聞，卻很難在當今的新世代產生廣泛的溝通，我想從這個不
容易發生的邂逅上進入。」一方面，他自身相當肯定胡氏電影美學和文
化傳承之間的聯結關係，另一方面，他卻想突顯不同世代之間無可避免
的精神疏離與情感隔閡，因而構設了眼前這個默劇：「兩種存在體都是
帶有非常強烈的不確定性，隨時會離開這個房間，但是至少在這一些時
間裡，在某個關節點上，他們同時互看著對方，她也開始在審視這個前
輩的智慧，對比著自己的美感經驗，但他們沒有多大的接觸，就像《空
山靈雨》一樣，各自空在。」

註：《空山靈雨》是胡金銓1978年的作品，故事內容一反過去常見的政
治性，以佛教傳位與盜寶為主題，探討人性的貪婪與執著。全片在韓國
寺院實景拍攝，作品意境深遠，對於人性內在的剖析精闢深入。

During the shooting of *Crouching Tiger, Hidden Dragon*, Tim Yip watched
King Hu's martial art films again and paid close attention. He regards
these works are "an inexhaustible treasure, re-discovering of the spiritual
aspects of Chinese elements, yet without being confined by forms, and
creating peculiar ambience in various structures, and presenting a unique
way of telling stories."

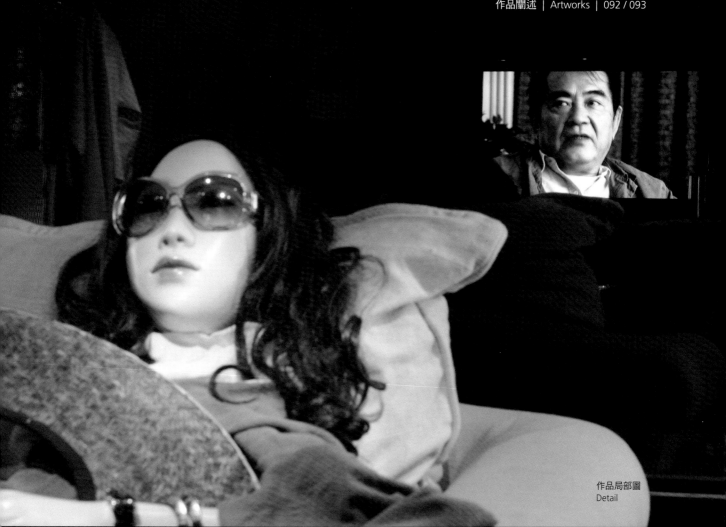

Tim Yip designed room 108 as a three-sided transparent space. It was furnished with a coffee table, television, hi-fi, cabinet, clothes stands, and so on. However, its atmosphere, spatially and temporally, is nostalgic. Lili, the beauty imagined by Tim Yip, sits alone in front of the television. She is fashionably dressed and looks silent in a very 'Waiting for Godot' manner. Lili gazes at the television which constantly plays interviews of King Hu. Yip said of this suspenseful space: "King Hu was highly creative and knowledgeable but it's hard for the new generation to understand his works extensively. I wanted my entry point to be this hard-to-come-by encounter." On the one hand he really affirms the connection between Hu's film aesthetics and passing on of the culture, while on the other he wants to highlight the unavoidable spiritual alienation and emotional gap between different generations, and thus created this mime. Yip says "both entities carry a strong sense of uncertainty and may leave the room at any moment. However, at least in this time and space, they look at each other. She also tries to examine the wisdom of this veteran director, which is contrast to her own experience. But there was little connection between the two, just like raining in the mountain, they both exist separately and in the mean time they really do not exist."

Note: *Raining in the Mountain* is King Hu's film made in 1978. The subject is not about the politics as his previous films, but about the transference of the authority and stealing of the Buddhist treasure. It explores the greed and obsession of human nature. The film was shot on location in monasteries in Korea and is profound and has an insightful criticism of human nature.

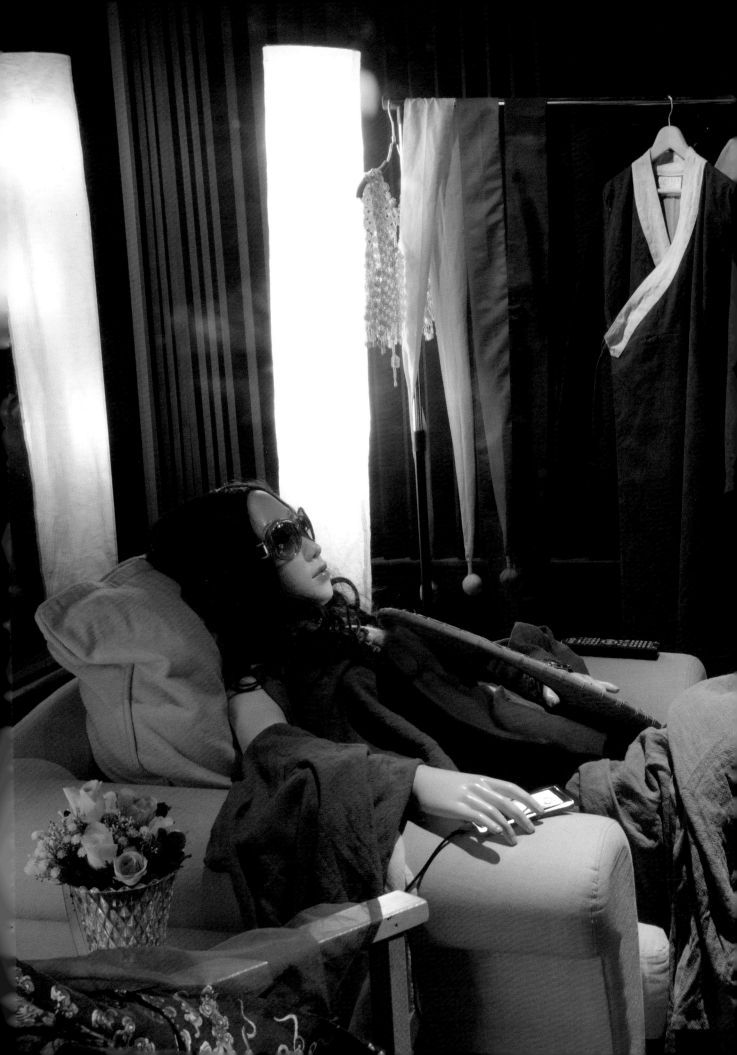

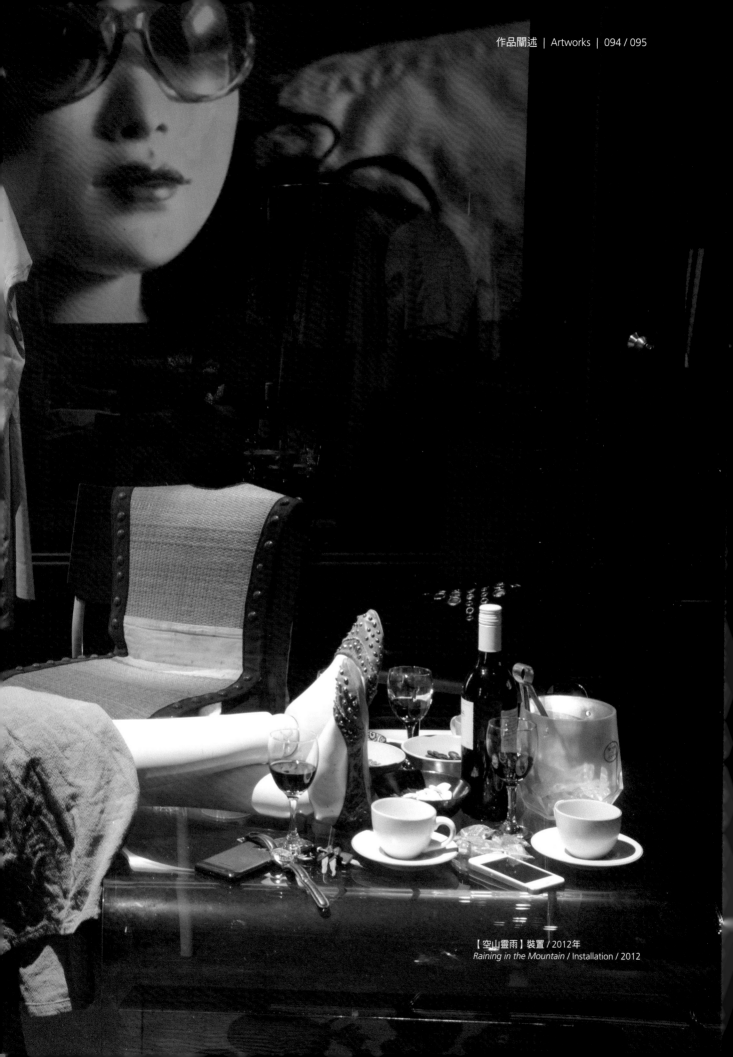

【空山靈雨】裝置 / 2012年
Raining in the Mountain / Installation / 2012

空山靈雨

葉錦添 作

作品現場裝置圖
Artworks in MOCA

當初接到台灣電影資料館的館長張靚蓓女士的邀請，很自然又進入了胡金銓的狀態，胡金銓在中國電影史上早已成為某種象徵性的精神素質，拍攝《臥虎藏龍》的時候，胡金銓的電影成為一個取之不盡的寶藏，中國元素的精神面不斷被發現，卻不拘泥於形式，在各種結構中製造了特殊的氛圍，特殊的說故事的方法，是一種類似舞蹈語言的電影節奏。他如何運用京劇，滲入他說故事的經驗裡。他的世界觀使他先從空間進入，通過時間去帶出人物，空間一直存在在那邊，卻一直催促著裡面的人物不斷地移動，不斷地找尋戲劇的線索與答案。從而空間的移動成為他影像精神的一個重要部分。

讓我想起了黑澤明、小津安二郎，很多時候，空間就成為主要的角色，也是觀眾可參與的橋梁，觀眾從空間的意識與人的行為中參照他所表達的「道」，他講述形而上的道，卻體驗在他電影藝術所散發的畫面上，營造出一種詩意的美感，特別是在《空山靈雨》最後的竹林大戰裡，這種漸進的營造方法，使一切都變成裡面的進行式，通過劇場的結構與行進，產生了戲劇的懸念，同時又推進了故事的脈絡，這種大整體的掌握，把期間的人物鑲嵌在時間裡，裡面有巧合、有碰撞、有突發、有潛伏、有推理、有神怪，這樣構成了一個多面向的、屬於古老中國的多維體現，使他在形象上大刀闊斧，去刪減、補缺、不斷深化，漸漸建構了他的敘事風格。

明朝是他的一個戲劇場域，理由是它的複雜性。在宦官橫行的年代中，產生了東西廠，有如秘密警察的組織，控制人們思想，結果是令朝廷內外的元氣大傷。這時候朝廷裡面不同的勢力，各自的爭相擴張，產生了不少刺客、間諜。表裡不一的存在狀態，把他們這些各有潛藏動機的勢力，擺放在一個流動的載體上，一個不存有實際存在性的場域——客棧，那裡龍蛇混雜，產生很多曲折離奇的碰撞，人物帶有無限的神秘感，又能呈現那個時候的江湖形態的細節。在一種精密的推理中，做出一個迷離的世界，潛伏著武功的強與弱，滲入京劇的風格化層面，使這些場景又帶有人文文化的色彩，使戲劇的力量更行深入，在流動中京劇板眼的節奏中不斷提示著與現實保持間離的效果，不落入俗套。

在當代藝術館所展出的有關已故武俠大導演胡金銓的展覽，追求一種現代感，讓大師的創造能量能與廣泛的年輕人有所接觸，這時候我腦海裡就出現了一些畫面，因為很多哪怕是90後的年輕人，沒有多少人會真正認識胡金銓，在浮躁卻充滿動感變化無窮的多維思想的現代年輕人心中，他們追逐的是世界上最新潮的事物，這種需要漫長時間所琢磨出來的美學，很難讓他們能持久的關注，更難說理解個中的玄妙。胡金銓的

創造力縱然豐富，博學多聞，卻很難在當今的新世代產生廣泛的溝通，我想從這個不容易發生的邂逅上進入。

在一個場域內，兩個不同的世界互相散發出來的氣息，在一個靜止的空間內交流，一個故事的場景，迎合了一個空間的結構，空間不大，卻可以三面的觀賞，看到裡面枝微末節的細節，一邊是胡金銓本人在電視裡講話的片段，他就如往常一樣暢談人生，他的理念、他的想法，我們可以直接聽到他親切爽朗的聲音，迴盪在空間內，牆上掛著《空山靈雨》的海報。在他前面，坐著一個在等待中顯得不安的個體，她身上穿著時尚的衣服，又披上了戲衣，但是我們無從在這裡知道她所穿的衣服，是她的選擇，還是被指定的，好像暫時又忘記了一切，而開始專注地與電視中的人物交流，甚至她好玩地戴著古代的斗笠，用獨特的眼光在審視著，並審美著這些服裝的美感，她的心思空懸在這個空間之內，沒有想法，等待著不知名電話的回音，手中不斷發著短信，證明她等待了已經很久，身旁還有一個臨時的衣架，掛著不同角色的衣服。

兩種存在體都是帶有非常強烈的不確定性，隨時會離開這個房間，但是至少在這一些時間裡，在某個關節點上，他們同時互看著對方，她也開始在審美這個前輩的智慧，對比著自己的美感經驗，他們沒有多大的接觸，就像《空山靈雨》一樣，各自空在。

Raining in the Mountain

by Tim Yip
translated by Yichuan Chen

When I was first approached by Ms. Jinn-Pei Chang of the Chinese Taipei Film Archive for this project, I was immediately thrown back into the world of King Hu. King Hu has become a sort of symbolic mentality in the history of Chinese cinema. When we were shooting *Crouching Tiger, Hidden Dragon*, King Hu's films were an inexhaustible source of inspiration, where we constantly discovered the spiritual side of the Chinese elements. He was uninhibited by forms and was able to create a special ambience in a variety of structures; his unique method of storytelling constitutes a kind of cinematic rhythm similar to the language of dance. The use of Peking Opera permeates his story-telling techniques. His unique worldview made him start first with space and bring out the characters in time; the space always remains there, urging the characters inside to constantly take action, looking for the clues and answers to the drama. Therefore the spatial movement has become an important element of his imagery.

This reminds me of Akira Kurosawa and Yasujiro Ozu. Oftentimes space has become a major role, a bridge for the audience to participate in the film, reflecting on the Tao (way) the director seeks to express through spatial awareness and human behavior. Hu's metaphysical Tao has to be experienced in the imagery of his cinematic art, which creates a kind of poetic beauty, especially so in the climactic fight in the bamboo grove in *Raining in the Mountain*. Such a gradual process of development renders everything in the present continuous tense, creating a dramatic suspense by means of theatrical structure and progress while propelling the storyline along. The overarching manipulation embeds the characters in the mosaic of time, featuring coincidences, collisions, twists and turns, mysteries, and fantasies, thereby constituting a multidimensional manifestation of ancient China. In this way, Hu was able to make bold attempts with his cinematic images, deleting, adding, and deepening, and establish his narrative style in the process.

The Ming Dynasty is his favorite dramatic background due to its complexity. In an era when the powerful eunuchs actually rule the country with the help of spies and secret agents, just like the organization of secret police, seeking to control people's minds, therefore turning the entire imperial court upside-down. Different forces inside the court fight each other to gain the upper hand, resulting in the rampant activities of assassins and spies. The duplicity of existence puts the differing forces, each with their own agenda, on the same volatile vehicle, a place of no actual existence: the inn, where all walks of life mingle, generating a lot of collisions and twists and turns, where the characters are imbued with infinite mystery while conveying the details of the underworld at that time. By means of sophisticated reasoning, a world of unnamable mystery comes into being, where the martial arts are put to test and the stylization of Peking Opera infiltrates every details, so that these scenes are imbued with the color of humanistic culture and the drama is pushed to its limit. The flowing rhythm of the Peking Opera percussion maintains a sort of alienation effect from reality, keeping the film from falling into the trap of clichés.

The exhibition *King Hu: The Renaissance Man* at the Museum of Contemporary Art is all about modernity, seeking to extend the reach of the master's creative energy with a wider young population. At this point a vision appeared in my mind. For many of the young people born in the 1990s and after, they are not really familiar with King Hu. The young people nowadays are impetuous but at the same time full of infinitely dynamic and multidimensional

thinking. They are after the latest and trendiest things in the world. It is difficult to inspire in them interest in this kind of time-consuming aesthetics, let alone understanding the mystery therein. Even though King Hu has been known for his diverse creativity and rich knowledge, it is relatively difficult to convey them to today's young generation. Therefore, I would like to make an entry point right at this seemingly impossible encounter.

 In the same location, the atmospheres of two different worlds interact with each other in a still space. The scene of a story is fitted inside the structure of a space; the space is not large but allows viewing from three sides, enabling the viewer to see into the nuances of details. On the one side we can see the fragments of King Hu's speeches on TV; as usual, he talks about life, his philosophy, and his ideas, and we can hear directly his cordial and hearty voice echoed inside the space. On the wall is the posters of *Raining in the Mountain*. In front of him sits a person, uneasy as she is in waiting. She is wearing some fashionable outfit, yet also in costume at the same time. We have no way to determine whether the clothes she wears is her choice or an assignment. As if temporarily oblivious to the world, she begins focusing on her interaction with the characters on TV. She is even wearing an ancient bamboo hat simply for fun; she is contemplating through her eyes, appreciating the beauty of these garments. Her vacant mind is being suspended within this space; she is not thinking at all, waiting for an unknown phone call while continuously texting messages, which insinuates that she has been waiting for a long time. There is also a temporary clothes stand nearby, hanging the costumes of different film characters.

The two existences all carry with them a very strong sense of uncertainty, as they will leave the room at any time, but at least in the time being, at a joint point, they are looking at each other: she is also beginning to appreciate the wisdom of the director, comparing it with her own aesthetic experience. Still, they do not have much contact, just like *Raining in the Mountain*, exist by themselves in emptiness.

胡金銓現身說法紀錄片
King Hu: the Renaissance Man

影片剪輯 / 黃庭輔
documentary, editor / Tinghu Huang

本紀錄片由黃庭輔剪輯，以胡金銓活靈活現的自道生平為經，穿插其不同時期、不同角色的演出畫面為緯，呼應其人生各個階段的發展與心境，讓觀眾更易了解其個性、創作生涯及處世哲學；片中可以看出，胡金銓早在1958年青少時代開始演出《吃耳光的人》時，其生動促狹的演技，即已深入人心，並成為當年票房賣點之一。這三十分鐘的紀錄片，有助於我們理解，胡金銓如何從一個意氣風發的電影演員，逐步發展出自己的藝術觀點和電影美學，進而躍升為國際知名的電影導演。在其遺作試拍片《無冕皇后》（又稱《維也納事件》）中，我們看到了他客串演出老畫家角色的一瞥身影，但在現實生活中，胡金銓對美術的投入與熱情，其實從小時啟蒙到後來的生活事業，都一直相當緊密，而這也是本次豐盛的展出內容中，觀眾在他為人熟知的電影事業之外，另外可以感知和延伸探索的。

This documentary shows King Hu talking about his life, intercut with his performances in different periods, playing various characters, echoing what he experienced and his moods in different stages of life. The viewers can capture his personality, career and views of the world by watching this documentary.

The film starts with his young and promising images in Hong Kong and ends with Hu playing the painter in his test film, *The Uncrowned Queen*. This short film invites the viewers to be part of this "unfinished project," which seems still continue......

【胡說八道—胡金銓武藝新傳】單頻道錄像 / 30分10秒
Documentary of King Hu / Single Channel Video / 30m 10s

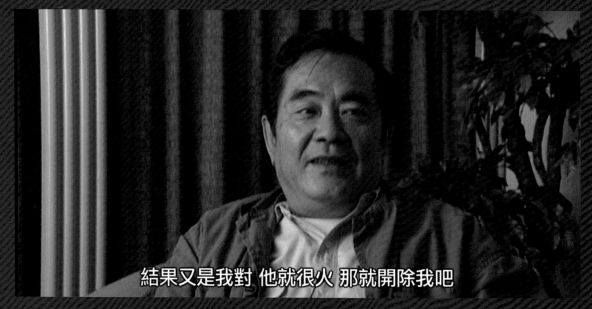

結果又是我對 他就很火 那就開除我吧

《聽他們說胡金銓》

李安、徐克、葉錦添、王童、徐楓、黃建業

They talk about King Hu

Ang Lee, Hark Tsui, Tim Yip, Tong Wang,

Feng Xu, Edmond Wong

《聽他們說胡金銓》是由國家電影資料館為本展特別製作，邀請李安、徐克、王童、徐楓、黃建業、葉錦添六人現身說法，談胡金銓、談武俠，也談文化傳承；六位傑出的電影創作者及評論家，分別從各自專業的立場或經驗記憶，析論胡金銓電影創作的貢獻與成就。這些精彩的言論，配合珍貴罕見的歷史畫面和許多人記憶猶新的胡金銓作品片段，相當有助於今日觀眾全方位地了解，胡金銓源自東方傳統美學而又富有現代獨創精神的電影藝術成就。

They talk about King Hu has been specially produced by the Chinese Taipei Film Archive for this exhibition. It features: Ang Lee, Hark Tsui, Tim Yip, Tong Wang, Feng Xu, and Edmond Wong. They were invited to talk about King Hu, his martial art films, and his impact and cultural heritage. These six outstanding film makers and critic analyze the contribution and achievements of King Hu from their professional standpoints and experiences. These wonderful accounts match the precious, rarely seen historic images and sequences of King Hu's films, still fresh in the mind of many. These interviews significantly contribute to the overall understanding of viewers today. And they also reveal that King Hu's film art is based on the traditional Oriental aesthetics, with its own innovative and contemporary sense.

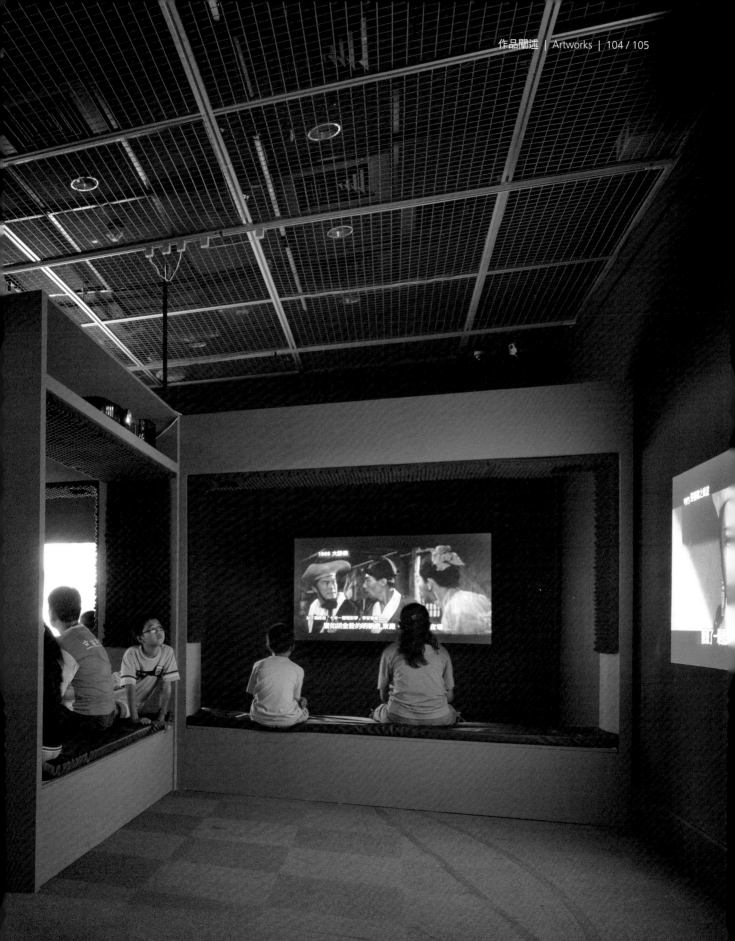

【李安：具現文化形象的先驅者】單頻道錄像 / 23 分 58 秒
Ang Lee: King Hu, a Pioneer Representing Chinese Culture / Single Channel Video / 23 m 58 s

【葉錦添：純粹的藝術追尋者】單頻道錄像 / 25 分 07 秒
Tim Yip: King Hu, a Searcher for Pure Art Form / Single Channel Video / 25 m 07 s

【徐楓：沒有他，就沒有今天的我】單頻道錄像 / 27 分 39 秒
Feng Xu: King Hu, My Mentor / Single Channel Video / 27 m 39 s

【徐克：追隨胡導演的腳步前行】單頻道錄像 / 16 分 04 秒
Hark Tsui: Following the Steps of King Hu / Single Channel Video / 16 m 04 s

【王童：從心心相印到惺惺相惜】單頻道錄像 / 21 分 48 秒
Tong Wang: King Hu, a Master and a Friend / Single Channel Video / 21 m 48 s

【黃建業：原型的創造者】單頻道錄像 / 32 分 32 秒
Edmond Wong: King Hu, the Creator of the Archetypes / Single Channel Video / 32 m 32 s

客棧八道
The Eight Characteristics of Inns
in King Hu's Films

客棧是華人動作片中不可或缺的元素，它是一個匯聚四面八方各路人馬的場所，同時也是各種衝突碰撞角力的舞台。胡金銓的古裝片幾乎都有客棧場景，其中的《大醉俠》、《龍門客棧》與《迎春閣之風波》甚至被稱為「客棧三部曲」。胡金銓擅長以俠士與盜賊之間的你追我逐、算計埋伏，以及客棧內不同人馬的互別苗頭、明爭暗鬥……等情節來營造衝突氣氛，以此凝聚「暴風雨來臨前」的一種緊張危機感，並將戲劇性推向高潮。本次展出，策展團隊從胡氏歷年作品中概要歸納出「客棧八道」，並剪輯一些代表性的精彩片段以為佐證，希望透過「客棧八道」的提點，讓民眾見識和理解，胡金銓透過一個濃縮了社會戰場的客棧空間來鋪陳人間故事，及架構其電影美學的開創意義。

"The Inn" is an indispensable element of Chinese action movies. It is place of convergence for people coming from all places, as well as a stage for all sorts of conflicts. Pretty much all of King Hu's films are with scenes setting in the inn. *Come Drink with Me, Dragon Inn*, and *The Fate of Lee Khan* are called 'The Inn Trilogy'. King Hu is particularly skilled in using the chases between the swordsmen and gangsters, planned ambushes, the interactions and infighting among the visitors of the inns, and other plots to create conflicts. He uses such plots to create tension and crisis, and then building up a dramatic climax. For this exhibition, the curatorial team has gone through the works of Hu to summarize 'the eight characteristics of the inn', and have edited the related sequences. Hopefully, with 'the eight characteristics of the inn,' the viewers could understand how King Hu used the "inn" space as a microcosm of human beings and as a framework for his film art.

門道4
小二難纏
片名：迎春閣之風波

With a best boy, *The Fate of Lee Khan*

【客棧八道】作品現場裝置圖
The Eight Characteristics of the Inns in King Hu's Film in MOCA

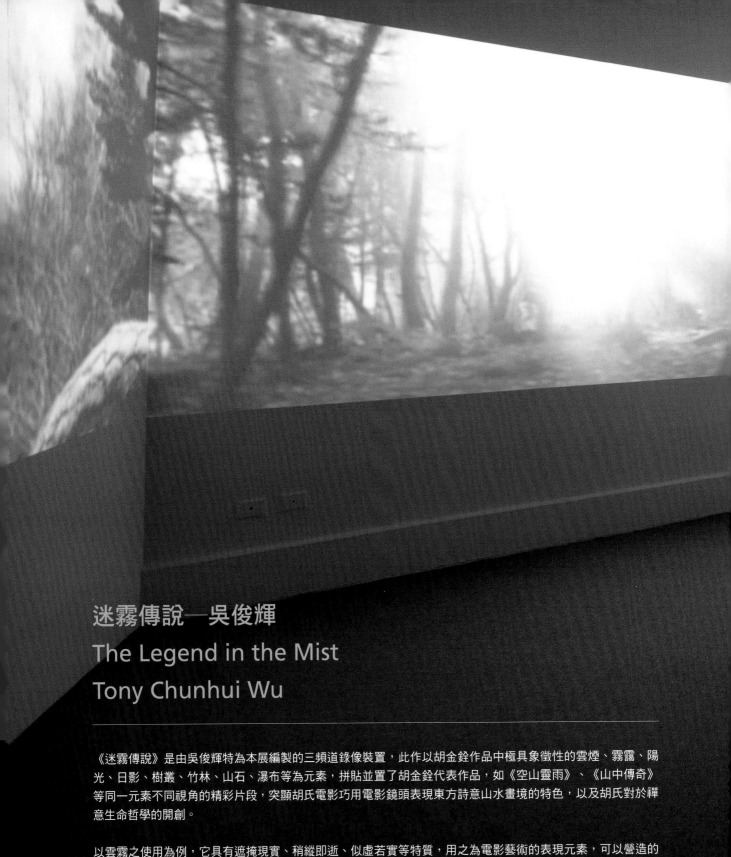

迷霧傳說─吳俊輝
The Legend in the Mist
Tony Chunhui Wu

《迷霧傳說》是由吳俊輝特為本展編製的三頻道錄像裝置，此作以胡金銓作品中極具象徵性的雲煙、霧靄、陽光、日影、樹叢、竹林、山石、瀑布等為元素，拼貼並置了胡金銓代表作品，如《空山靈雨》、《山中傳奇》等同一元素不同視角的精彩片段，突顯胡氏電影巧用電影鏡頭表現東方詩意山水畫境的特色，以及胡氏對於禪意生命哲學的開創。

以雲霧之使用為例，它具有遮掩現實、稍縱即逝、似虛若實等特質，用之為電影藝術的表現元素，可以營造的氛圍，從詩意浪漫到不安、不確定、不存在等兩極意象。胡金銓偏好將此種視覺元素轉換為營造或加強氣氛的電影語言，不論是真相未明前的懸疑氣息、俠客間爭奪勝負的纏鬥場面、或是敵我間一決生死的殘酷對決，常可看到雲煙繚繞或霧氣蒸騰的場景應用，以及因之而被凝聚或放大的一種影像美感與戲劇張力。

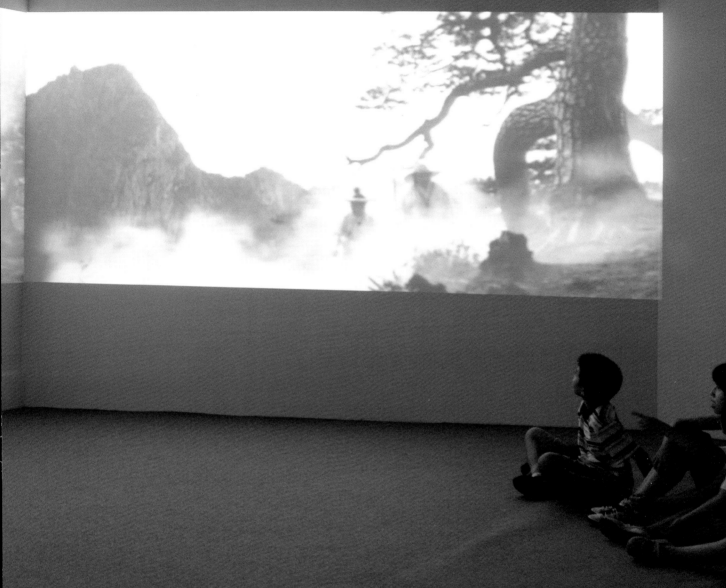

The Legend in the Mist is a newly created three-screen video installation by the artist Tony Wu. This work is inspired by the highly symbolic 'mist', which is often used by King Hu. The work is a montage of sequences from *Raining in the Mountain* and *Legend of the Mountain*. The assemblage of various misty scenes highlights the ever-present theme of the Eastern poetic landscapes, similar to ink washing paintings, in Hu's films, as well as the creation of a Zen philosophy of life.

Mist is transient by nature. It can distort our perception of reality. It paradoxically seems devoid of form and yet real, and because of these characteristics it is used as an element in King Hu's films. Mist can create atmospheres which are poles apart, from the poetic and romantic, to the unsafe, precarious, and empty. King Hu likes to use the mist as visual element to create or intensify the moods. This can be seen in *Dragon Inn*, *A Touch of Zen*, *Raining in the Mountain*, *Legend of the Mountain* and other films. We could see the coiling mists and rising vapors in the fighting scenes or the cruel duel scenes of the swordsmen. This creates the tension, suspense and the poetic ambience.

霧中之謎－關於《迷霧傳說》

吳俊輝 作

在創作《迷霧傳說》的過程中，不斷地思索與回溯個人的電影經驗中很重要的兩個階段，第一個階段是1990年在電影資料館第一次接觸到電影資料的整理工作。當時第一次著手整理的電影資料就是胡金銓導演捐贈的電影資料文物。當親手接觸到這批珍貴的電影史料，做為一位從小熱愛電影，在電影院觀看電影成長的影迷，這是第一次電影超越了只有觀影的電影經驗，進而與電影有了更親密關係。這一次接觸電影資料整理的經驗也引發了我對台灣電影史與電影影像資料與材質性的高度興趣。第二個階段是1996年開始實驗電影的創作。進入實驗電影重鎮舊金山藝術學院修習實驗電影，第一部電影大量使用超八釐米翻拍VHS播放在電視銀幕上法斯賓達電影《霧港水手》的影像開啟了對現有影像重製（Found-Footage）類實驗電影創作的開端。

持續至今，幾乎創作的每一部作品都是現有影像重製的實驗探索與實踐，利用舊有的電影膠卷、影像資料檔案，使其重新省思自我與檢視影像媒體與媒材的關係，並進而改變劇情片中的敘事系統運作，顛覆原始影像的意涵，延伸再創造被遺棄影像的新生命。因為這樣持續的實驗電影創作實踐將胡金銓導演的電影、電影史、當代藝術與實驗電影連結起來。

創作《迷霧傳說》不同於過往創作現有影像重製的實驗探索，幾乎過去的每部作品都是透過跨媒體與跨材質的方式，使敘事在不斷複製的過程中遠離影像的原貌，終至敘事徹底消失無法運作為止，再產生新結構的可能，轉換成純粹的視覺經驗。這一次創作《迷霧傳說》則是思考如何能夠開啟既顛覆同時又能達到向胡金銓導演致敬，使胡金銓導演的電影與電影史脈絡在場的這件作品中都有強烈的存在感與糾纏。

《迷霧傳說》選擇三銀幕投影的影像裝置形式，是從四部胡金銓導演的經典電影《山中傳奇》、《空山靈雨》、《俠女》與《龍門客棧》中的影像發展而成，顛覆從敘事的改變與消失著手，先截取單部電影中的敘事片段，再混合與重組四部電影的敘事關係，使其產生新的結構及使原來的敘事在深山的迷霧，以及俠客飛躍翻滾、互鬥砍殺中逐漸轉變。三銀幕投影的空間打破原來電影中線性敘事關係，原來的線性敘事被並置同時放在三個銀幕中，使四部不同的電影中的敘事片段與角色在三銀幕中交匯、錯置、對應與對話。

在創作的策略與結構上，首先從觀看胡金銓導演的電影記憶中，喚起胡金銓導演中期的兩部電影《山中傳奇》與《空山靈雨》中瀰漫的霧氣來作為主要的視覺意象，在這件作品中迷霧始終以不同的速率不斷地擴散、蔓延與消逝在深山中，貫穿整件作品，一直循環不已。處理迷霧，也是處理山中景緻，這些景緻有壯麗的山川地理形貌，以及各種多樣的動植物生態的空鏡，也成為作品的影像主軸。同時也處理人與自然環境的關係：山水風景之後，是俠客穿越山谷、涉水入山，與其他不同電影中的俠客與書生交匯，從三人到一人，在迷霧的山中不斷地行走，彷彿走不出迷霧的山中，有如迷失在迷宮中，貫穿頭尾，風景空鏡與行走的重覆性產生在山中迷途狀態，持續循環。

從《俠女》與《龍門客棧》兩部電影中截取俠客快速的身影與武俠動作的局部特寫，不論是飛躍、疾行，或是互鬥刀劍砍殺，透過速度的改變、快速的剪接、三銀幕的交錯並置，使這些俠客在山中忽隱忽現，稍縱即逝。而被飛鏢射中、刀箭飛過與中箭等鏡頭與風景空鏡穿插並置於三銀幕，因為無射箭來源的對應鏡頭，無法得知迷霧的山中真正發生了什麼事，成為一陣陣謎團。忽隱忽現的俠客如同山中鬼魅是胡金銓電影的糾纏。

電影的空間透過三個銀幕投影延展開來，讓這些不同電影的俠客與書生遊走在三個不同的影像空間中，時而飛

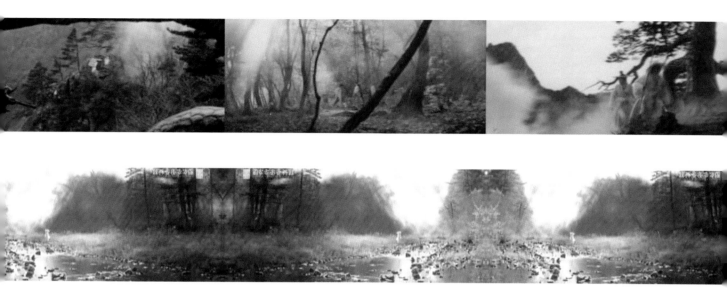

【迷霧傳說】三頻道錄像裝置 / 10分 / 2012年
The Legend in the Mist / Three Channel Video Installation / 10m / 2012

躍穿梭其間；時而展現動線的對稱性與變化。不論是俠客一人飛躍翻滾穿越三個銀幕到眾人同時在三個銀幕中飛躍翻滾，胡金銓導演電影中的攝影表現及鏡頭已經是電影的極致表現，將所有出神入化的武俠動作集合起來，不但令人感到讚嘆，同時也呈現出一種無比的荒謬感。這些神出鬼沒的俠客身影與山中的風景空鏡正干預著原有電影敘事的進行，原有的敘事被迷霧改變而逐漸消逝的過程正呼應著《山中傳奇》與《空山靈雨》兩部電影裡呈現的一種空的禪意，同時達到向胡金銓導演致敬。

《迷霧傳說》的剪接工作先是數量龐雜的鏡頭分類，然後是追求少於一秒影像速率的精準度，透過剪接師李俊宏的神奇功力使整件作品的概念與策略得以精準完美地執行出來。配樂與聲音製作再度邀請到長期合作的前衛音樂家李婉菁擔任，聲音使用被剪接過的原來電影中的原始聲軌，將刀劍聲與對白，結合風景與生態空鏡，營造出俠客人影不在，人聲口白的回音在山中迴盪不已。原有電影的配樂被重新混音，不論能夠辨識與否，不斷地引領觀者進入胡金銓導演的電影，再被前衛的電子聲響帶離，進入另一種時空想像，形成流動迴盪在山中自然環境中的層層交錯感，這也是一種胡金銓導演的電影精神無處不在的存在。

《迷霧傳說》的創作與觀看過程彷彿置身在胡金銓導演電影的霧中，霧中充滿了謎團。《迷霧傳說》不在解謎，也不在造傳奇，四部胡金銓導演電影中的傳奇與敘事在影音的混搭、改變與消逝中成為名副其實在霧中的謎中之謎。

Lost in the Mists -
On *The Legend in the Mist*

by Tony Chunhui Wu
translated by Geof Aberhart

The creation of *The Legend in the Mist* was a process of constant reflecting on and retracing my personal experience with cinema, particularly on two major stages in that experience. The first of these began in 1990, when I was first worked in the Chinese Taipei Film Archive. It was then that I had my first experience working on documentation of film-related material, working specifically on a donation by director King Hu. I had already been a lifelong film buff, growing up watching films in the theater, but handling the precious heritage of cinema was the first time films went beyond just something I watched, and brought me another step closer to cinema. The experience of working with these items sparked in me a powerful interest in Taiwan cinema history, the archival images and physical materials of it. The second stage started in 1996, when I began creating experimental films. I joined the home of experimental cinema, the San Francisco Art Institute, to study the subject. My first film largely used super 8mm film to shoot a VHS copy of Rainer Fassbinder's *Querelle* playing on a television, marking the start of my work in experimental "found footage" film.

Even today, virtually all of my works experiment and explore new ideas of found footage, using existing celluloid and archival images to make me rethink myself and explore my relationship with media and materials, while also fostering changes in feature film narrative systems, subverting the meanings of original images and extending and giving new life to the abandoned images. It was my continuing experimentation with cinematic creation that led to this integration of the works of King Hu, cinema history, modern art, and experimental cinema.

The Legend in the Mist, though, is unlike my past work; most of that work was cross-media and use diverse materials, the narrative departing from the original images through constant duplication until it was ultimately lost entirely, producing the possibility of a new structure and transforming into a pure visual experience. *The Legend in the Mist*, though, is a meditation on how to creating something that is subversive, but yet still respectful of the legacy of King Hu. In this piece, both the films of King Hu and their places within cinema history both have a strong sense of presence and inter-entanglement.

For *The Legend in the Mist*, I chose to create an installation of three-

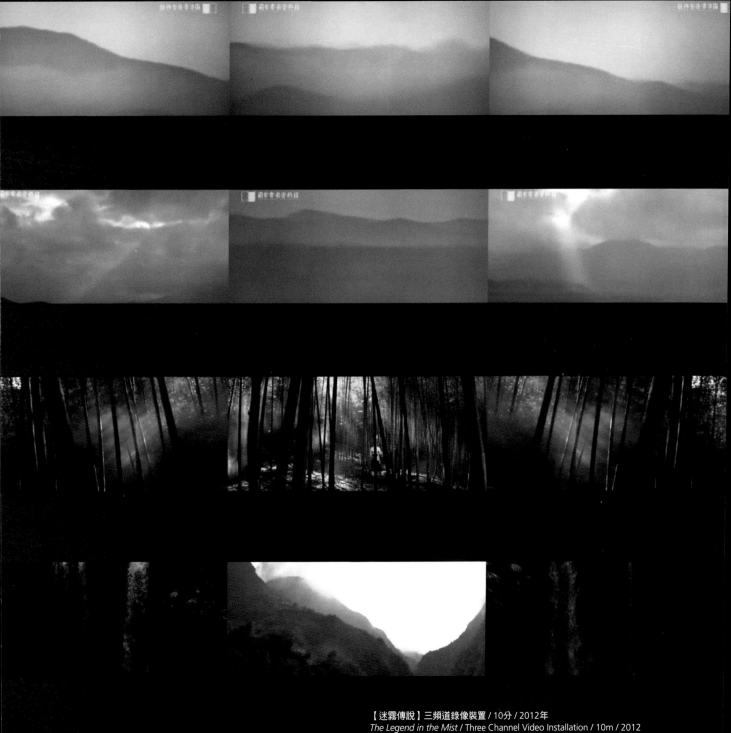

【迷霧傳說】三頻道錄像裝置 / 10分 / 2012年
The Legend in the Mist / Three Channel Video Installation / 10m / 2012

screen projection, showing images from four of Hu's films, namely *Legend of the Mountain*, *Raining in the Mountain*, *A Touch of Zen*, and *Dragon Inn*, subverting through changing the narrative and make it disappear. First, I chose sequences of each film, then remixed and reconstructed the narrative relationships between the four, creating a new structure. So there are gradual changes through the mountain mists, acrobatic swordplay, and heated battles in the original narratives. The three-screen space breaks down the linear narratives of the original films, and these are juxtaposed with each other on three screens. The narrative sequences and characters of four different films intersect, displace, interact and engage in a dialogue.

In terms of creative strategy and structure, the piece first summons forth two of Hu's later films, *Legend of the Mountain* and *Raining in the Mountain*, and the pervasive mists that were such a prominent visual motif, and in the piece itself these mists spread and disperse into the mountains at various speeds, pervading the entire piece, constantly circulating. To manipulate the mists is to manipulate the landscape of the mountains, a landscape rich in magnificent mountains, rivers, and a multiplicity of scenes of flora and fauna; this in turn serves as the crux of the piece. At the same time, it creates a manipulation of man's relationship with nature; beyond the natural scenery, swordsmen and -women weave through the mountain valleys, intersecting with swordspeople and scholars from other films, from three people to solitary ones, constantly voyaging amidst the mists, seeming unable to escape, as if lost in a labyrinth. Throughout, scenic empty shots and the repetition of walking create a sense of being lost in the mountains in a constant loop.

Shots of the rapid forms and actions of swordspeople from *A Touch of Zen* and *Dragon Inn*, whether walking, soaring, or in heated battle, are, through changes in speed and fast editing, interwoven and juxtaposed across the three screens, making them seem to appear and disappear suddenly amongst the mountains, leaving no trace behind. Images of arrows, darts, and knives with no discernible source and shots of characters being hurt whip through the scenery of all three screens, leaving the view with no way of knowing what exactly is happening in those mists, creating mystery after mystery. The flashes of swordspeople, like spirits haunting the mountains, are entangled with the films of King Hu.

The cinematic space is expanded by the three-screen projector setup, giving these various scholars and swordsmen the ability to wander through three different spaces, sometimes soaring through spaces, and sometimes their moving is symmetrical and in constant changing. Whether it is a solo swordsman or a group of people acrobatically soaring through the three screens, the cinematography and shots of King Hu are the pinnacle of cinematic expression, and the collection of these entrancing martial arts sequences not only astonishes, but reveals a peerless sense of the absurd. These mysterious images of swordsmen interrupt the original progress of the narrative, the mists obscuring, altering, and dissolving the narrative in a way that recalls the Zen imagery of *Legend of the Mountain* and *Raining in the Mountain*, while also serving as a tribute to the great director.

The editing of *The Legend in the Mist* first demanded a large, complicated categorization of scenes, followed by a pursuit of cuts to sequences as short as one second. Through the formidable editing talents of Junhong Li, the

concept and strategy of the piece began to take precise, perfect shape. For the score and sound effects, I invited long-time collaborator and avant-garde musician Wanjing Li to edit the original scores and soundtracks of the films, remixing dialogues and sound effects of swords, tying together the empty shots of the landscapes and ecological scenes, and creating constant echoes of human speech reverberating through the mountains while the characters disappear already. The original scores of the films have been remixed, sometimes distinguishable, sometimes not, but always drawing the audience into the world of King Hu's films, while at the same time drawing them away with avant-garde electronic sounds and into another imagination of space and time, creating a flow and reverberation in the nature and in the mountains that overlap and intersect. This, too, is an existence of the cinematic spirits of King Hu is everywhere.

The Legend in the Mist, in both its process of creation and viewing, seems to inject us into the mists of King Hu's films, mists that are full of mystery. *The Legend in the Mist* does not solve those mysteries, nor does it recreate any particular legends. Scenes, sounds, and narratives in four films of King Hu are remixed, revised in sound and image, and dissolved to mysteries within mysteries in the mists.

作品現場裝置圖
Artworks in MOCA

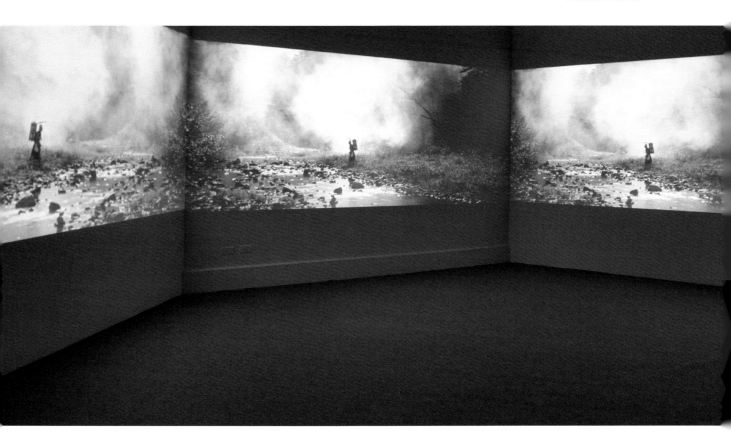

平行時空—出發與探索的旅程—黃文英
Parallel Space-Time :
A Journey of Discovery and Exploration
Wern Ying Hwarng

黃文英為美國卡內基梅隆大學藝術碩士,與匹茲堡大學戲劇製作碩士。於1993 年膺選為美國舞台美術設計工會會員。1990～1996年間於美國紐約從事歌劇、百老匯劇場服裝設計與美術設計工作,曾獲金馬獎、台北電影節、亞太影展等最佳美術指導獎,自1996年起擔任侯孝賢電影社美術指導,目前正在籌拍侯導的電影《聶隱娘》。

黃文英本次應邀創作的空間裝置,以「平行時空」的概念為出發點,並置了胡金銓在「東京夜談」中,對於中國紙張近乎學術的研究考證,以及個人忙裡偷閒的文人遣興字畫創作;加上從胡氏電影中所截取的空景畫面影像,將之置放於她所構思的一處空間。這個空間尚涵括了十來種文人清玩仿古器物,以及黃文英為設計影劇服裝而大量收集的各國特色布料等。兩代藝術家,在美學探尋的路途中,時有交會,時而共鳴;黃文英在創作的同時,也以此向胡金銓致敬。

Graduated from MFA, Carnegie Mellon University and MA, University of Pittsburgh, Wern Ying Hwarng had worked at opera houses and Broadway theatres as set & costume designer in New York from 1990 to 1996. She has received Best Art Director awards of Golden Horse Awards, Taipei Film Awards, and Asian Pacific Film Festival. Since 1996 she has collaborated with Hsiao Hsien Hou as artistic director. She is currently in preproduction of Hou's upcoming film, *Assassin*.

The inspiration for the work of Hwarng is the idea of "parallel space-time." She chose King Hu's manuscript about the Chinese paper, which demonstrates his meticulous historical research approach. There are also King Hu's paintings and writings of brush and two sequences of empty shots from Hu's films. All these are placed in a space designed by the artist. This space also features over a dozen faked Qing antique objects and the special fabrics that Hwarng collected around the world. Two artists of two different generations sometimes share the same thoughts yet sometimes their creations resonate with each other. With this work, Hwarng pays homage to King Hu.

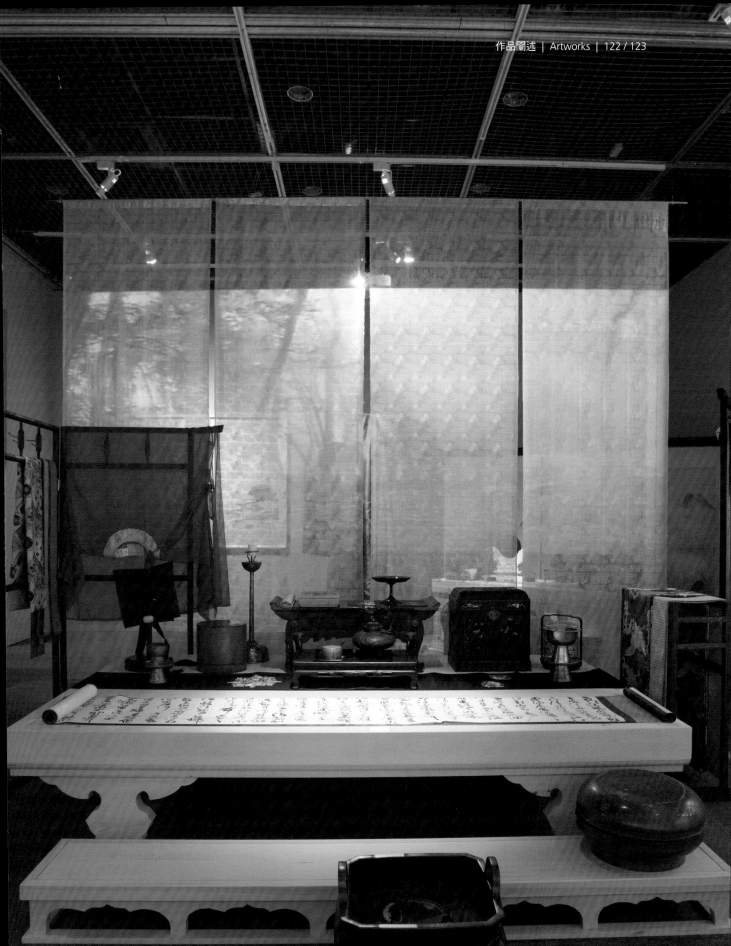

平行時空——「出發」與「探索」的旅程

黃文英 作

主辦單位來電
希望將胡金銓導演拍片多年所累積的文物
構思出多元的呈現方式
主角當然還是導演— Mr. King Hu.

年輕時在電影院看過《空山靈雨》、《山中傳奇》等電影
喜歡電影中特殊的生活氛圍
一種人文與自然交織的意境
電影導演擅長結構／解構時空情境
在歷史軌跡中想像出異世界裡的「平行時空」
不管是遙遠的從前或未知的未來

在當代館的 203 室裏
我想藉由一些基本的「元素」佈展：「布料」、「文字」（胡的書寫）
元素也意謂著細節
不同的細節　結構出不同的時空內容與訊息

做為電影從業人員
每一部電影幾乎都是一個「出發」與「探索」的旅程
在 70 年代胡金銓導演前往韓國取景尋找新的視覺突破
做電影美術設計
也想在限制中尋找符合劇情時空的新刺激
更具體說　電影中每一個時空都是獨一無二的
亟欲尋覓一些新鮮有趣的質材
建構出與眾不同的氛圍或情境
有點像人想找出讓生命長生不老的方法　讓創作得以自我突破、穿越

最近參與侯孝賢導演的武俠新作
有機會到韓國、烏茲別克、印度、日本、中國大陸等地找布料
布料的織紋、圖騰、顏色、觸感、質地、造型……透露角色時代生活的存在感
胡導演因電影而生的各類書寫字跡：
書法、筆記、手繪……保留拍片當下部分的訊息
透過這些文字　彷彿穿越時空取得拍片「第一現場」的連結
聆聽導演的「身教」
在文字與布料之間
似相關　非相關　並不必然一致
希望可以產生另類的時空軌跡與記憶
向大師致敬

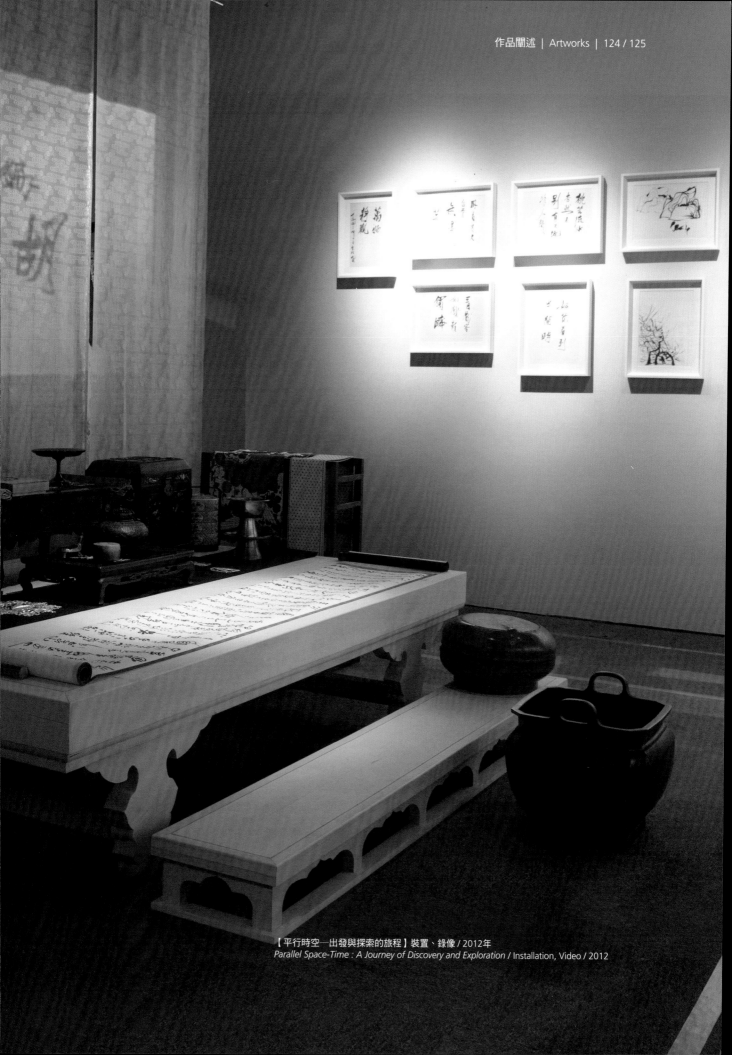

【平行時空─出發與探索的旅程】裝置、錄像 / 2012年
Parallel Space-Time : A Journey of Discovery and Exploration / Installation, Video / 2012

Parallel Space-Time:
A Journey of Discovery and Exploration

by Wern Ying Hwarng
translated by Geof Aberhart

The director of the Chinese Taipei Film Archive called,
in the hopes of bringing together the relics of King Hu's years of directing,
and plotting out a multifaceted means of displaying them,
of course focused around our protagonist, the great director, King Hu, himself.

During my youth, I sat in theaters,
witnessing movies such as *Raining in the Mountain* and *Legend of the Mountain*,
falling in love with the unique atmospheres and lifestyles portrayed therein,
a kind of interweaving of culture and nature.
The film director is a master of construction and deconstruction of space and time,
imagining the "parallel space-times" from the traces of history
whether in the distant past or the unknowable future.

In Room 203 of the Museum of Contemporary Art,
I aspired to use a few basic elements - fabrics, words written in the hand of Hu himself -
to symbolize meanings and details.
Different details create different space-times, different messages.

作品現場裝置圖
Artworks in MOCA

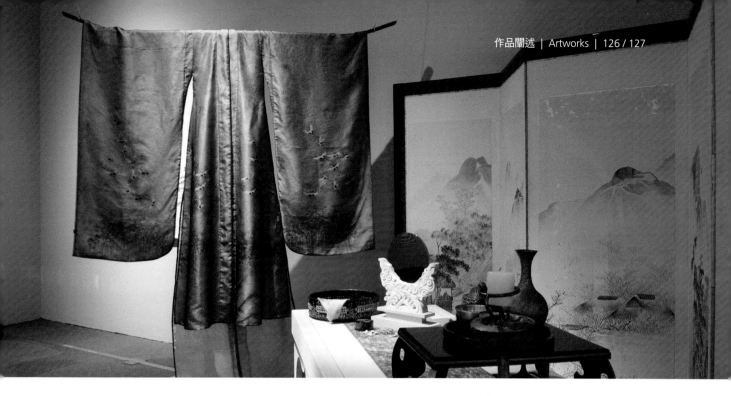

【平行時空—出發與探索的旅程】裝置、錄像 / 2012年
Parallel Space-Time : A Journey of Discovery and Exploration / Installation, Video / 2012

To someone in the cinema industry,
every film can seem to be a journey of discovery and exploration.
In the 1970s, King Hu traveled to Korea in search of visual breakthroughs,
and as a cinematic artist and designer myself,
I seek out new, stimulating space-times that fit within the restrictions of the diegesis.
To be more precise, in cinema, every space-time is unique,
and we search for fresh, interesting material and texture
from which to construct atmospheres and scenes that differs from others.
Somewhat like the mankind seeking out the secret to immortality,
we strive to create that which transcends ourselves and make breakthroughs.

Recently I took part in Hsiao Hsien Hou's production of his new martial arts piece,
enjoying the opportunity to travel to Korea, Uzbekistan, India, Japan, and China in search of fabrics,
fabrics that through their patterns, totems, colors, textures,
and forms create a sense of the era and lifestyle of the characters.
As a director, King Hu created a variety of writings for films,
and he leaves behind him – calligraphy works, notes, sketches -
that preserve some part of the time when the film was being made.
Through these writings, we can almost travel through space and time to be "on the scene,"
listening to the director's instructions.
Amidst the writings and fabrics,
the faux-relevant and the irrelevant may not always be the same thing.
It is my hope that between them, we can create an alternative space-time, alternative memories,
a tribute to a great master.

【平行時空—出發與探索的旅程】裝置、錄像 / 2012年
Parallel Space-Time: A Journey of Discovery and Exploration / Installation, Video / 2012

翻轉，張羽煮海—黃美清
Reversal – Till the Seas Run Dry
Meiching Huang

《張羽煮海》典出元代雜劇，描述一個書生克服萬難與龍王千金相戀成功的愛情喜劇。1984 年，胡金銓以此故事為文本，與宏廣動畫公司簽約合作，負責這部動畫影片的籌畫與拍攝。可惜此計畫因故無法實現，成為胡導演生平憾事之一。針對這個令人期待惜未完成的創作計畫，藝術家黃美清從胡導演留下的一張小小手稿開始，以小中現大的方式，以微型劇場的概念，於202展間構築了一個結合動態音場（由聲音藝術家王福瑞製作）與炫麗景觀的奇幻深海王國。

觀眾步入展間，人體感應的動態音場隨之啟動，伴隨著音響漫流造成的空間晃動錯覺，觀看場中央由半球狀穹頂和方型展台建構而成的小型裝置。象徵宇宙的穹頂，內部圖像來自胡金銓手繪的金黃色調龍宮圖稿，與之感應和對話的是，正下方的展台上，由黃美清另行創造的一個深藍意象海洋峽谷。穹頂之內藏著壯闊的海洋、海洋之中包覆著深邃地谷，藝術家以鏡射原理試圖翻轉海陸界，並以此呼應張羽突破天人隔閡追求圓滿愛情的浪漫傳奇。

Zhang Yu Boils the Sea is a story of zaju, a form of poetry from Yuan dynasty. It is a romantic comedy telling the tale of a scholar who overcomes extreme difficulties, successfully courted with the daughter of the Dragon King. In 1984, King Hu used this story as an original text, and signed a contract with Wang Film Productions to be responsible for the planning and shooting of this film. Unfortunately, for some reason this plan could not be realized, and this became one of the unaccomplished project of King Hu. Artist Meiching Huang starts from a drawing of King Hu, using a micro theater concept to build a dynamic sound field in room 202 (created by sound artist Fujui Wang) and a fantasy deep sea kingdom with mysterious soundscape and dazzling visuals.

As the audience steps into the room, the interactive installation begins, flowing sound immediately fills the empty space. This small work standing in the middle of the room is constructed with a hemispherical dome and a square stand. The dome symbolizes the universe, with images of Dragon Palace inside, taken from King Hu's sketches. In contrast, Huang created a deep blue image of an ocean trench beneath the golden dome. The artist uses the reflection, attempting to reverse the sea and land, and with this design, the work echoes with the romantic legend of Zhang Yu overcoming the barrier of heaven and earth in pursuit of perfect love.

【翻轉・張羽煮海】FRP、聲音裝置 / 2012年
Reversal – Till the Seas Run Dry / FRP, Sound Installation / 2012

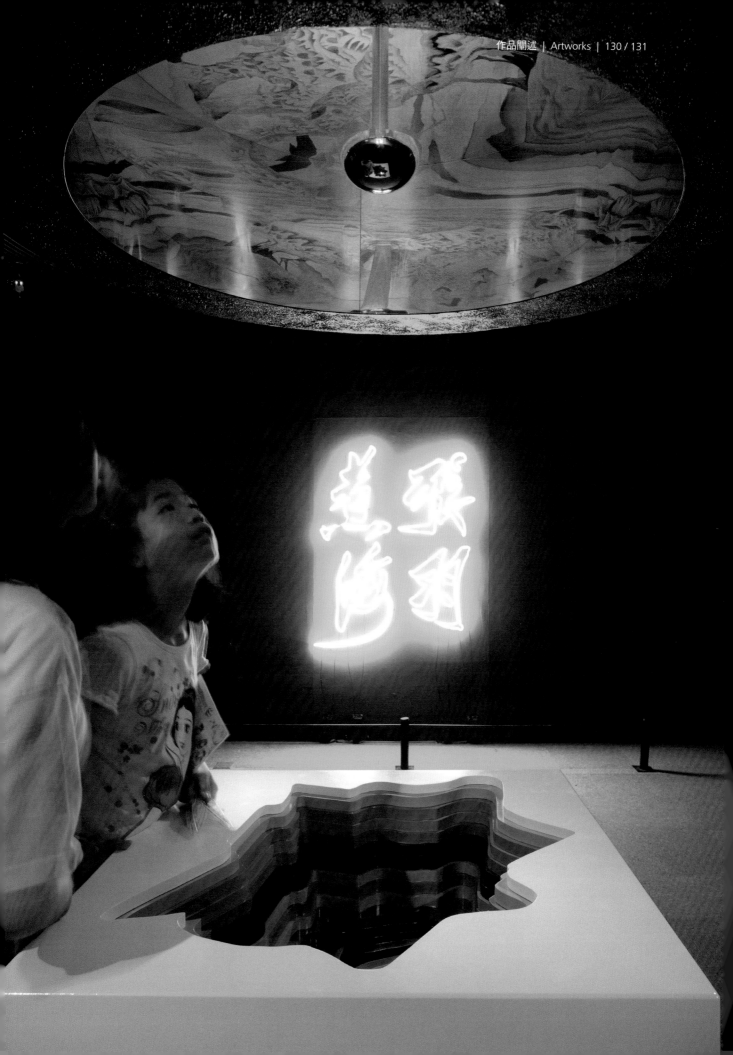

張羽煮海

黃美清 作

《張羽煮海》是胡金銓導演於1986年開始與宏廣公司籌劃的動畫長片，90年代胡導演又將這個計畫發展成西洋版動畫《深海的戰爭與和平》，完成了眾多的角色設計，場景手稿與概念氛圍圖，數年後礙於當時的技術規格與龐大的資金需求而未實現。

我從一張畫着微小紅色天空的手稿被帶入廣大卻只見鉛筆線條的海洋，胡導演引領我進入了一個始於元雜劇的華麗想像：以亙古不變的愛情主題建構儒生為追求幸福不惜挑戰皇權的自由之歌，顛覆陸地與海洋的場域界定，神話與道教的形式成為角色形變的超自然連結。看著一幅幅完成與未盡完成的創作，心中浮現了「翻轉」的意圖。

在當代藝術館的空間裡，聲音以線性的結構成為敘事體，環繞東方深海裡平靜、涉入、薄膜、回聲與崩解。半球狀天頂透過鏡射與看到翻轉近似真實的海陸地界正火紅地燃燒，莫不是放火光，直逼太陽，燒得火焰騰騰滾波翻浪。純白冰冷的海底基石鑿開一道深邃的海溝，彷彿指引進入弱水三千里，只要無私自可航。

既是抽象的物質轉換又是具體的情感投射，運用聲音與裝置勾勒出心中對張羽煮海無限想象的漫射端點，遊戲於時空波動之中。

作品現場裝置圖
Artworks in MOCA

Reversal-Till the Seas Run Dry

by Meiching Huang

translated by Geof Aberhart

King Hu began work on *Zhang Yu Boils the Sea* in cooperation with Wang Film Productions in 1986, aiming to translate the ancient story into an animated feature film. Later, in the 1990s, Hu returned to the project, developing it into a Western-style animated film by the name of *The Boiling Sea*, even completing work on many character designs, drawings of sets, and creating concepts about the overall ambience. However, after years of trying, the project remained unrealized due to its tremendous technical and financial scale.

Starting from a sketch of a small, red sky and a broad, pencil-drawn ocean, Hu drew me into a gorgeous reimagining of a story that began as Yuan-dynasty zaju; building on the time-honored theme of love eternal, Hu constructed a song of freedom sung by a scholar willing to challenge even the power of royalty in the pursuit of happiness. As well as subverting the usual territorial distinction between land and sea, using mythology and Taoism to create transformational characters with ties to the supernatural. Observing piece after piece of complete, yet not entirely complete, creation, an idea for "reversal" sprang to mind.

Within the space of the Museum of Contemporary Art, sound, through its linear structure, becomes a storytelling device, surrounding visitors with the tranquility of the eastern ocean, drawing them in as it reverberates and disintegrates. The image on the semi-dome on the top is projected on the mirror surrounded, and is reversed to an almost realistic image of the horizon between land and sea, appearing to burn red with flame, rivaling the sun in intensity and bringing the waves to a boil. At the bottom of the sea, pure and white, the bedrock splits open to create a deep sea trench, seeming to draw in waters for thousands of miles that only the unselfish may navigate.

Whether it is the transformation of object in abstract or the projection of emotion, the use of sound and installation reflects and diffuses our infinite imagination to "*Zhang Yu Boils the Sea*" and creating a game played amongst the fluctuations of space and time.

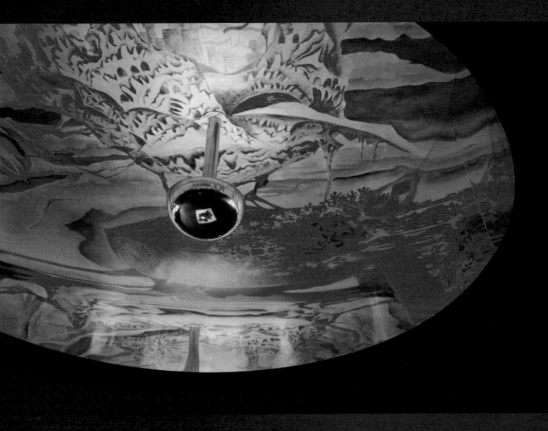

看他們畫胡金銓
Portraits of King Hu

R201 樓梯間展出的三幅畫像原作和循環播放的人物影像，註記了胡金銓導演不同人生階段的容顏和精神狀態，其中一幅為1991年農曆除夕前三天，他對著鏡子完成的鉛筆自畫像，當時正辛苦籌拍《畫皮之陰陽法王》的胡金銓，表情嚴肅而眼神堅毅，流動的線條同時刻劃出了臉部的特徵表情和心靈的波動。另一幅為席德進畫的胡金銓側面像，時為1979年，胡金銓的《山中傳奇》一舉奪下第十六屆金馬獎最佳導演、最佳美術設計、最佳攝影和最佳配樂四大獎項，席德進筆下的胡金銓畫像，也具現了一種英姿煥發、神定氣閒的精神特質。

另外幾幅胡金銓畫像，年份最早而未簽名的一張推測為李翰祥任美工時之作，其餘分別出自名畫家黃永玉、漫畫家李敬祖（李費蒙之弟，曾任星島周刊主編）、以及插畫名家林崇漢等人手筆。

Here presents three portraits and a series of continuous images of Hu's portraits. These demonstrate his appearance and spiritual states at different stages of his life. One of the three framed pieces is a self-portrait he drew in pencil while looking in the mirror three days before Chinese New Year's Eve in 1991. At the time he was toiling on the planning of *Painted Skin*; he wears a serious expression and his eyes have a determined look. The flowing lines depict both his features and his fluctuating emotions. Another is drawn by Dejin Xi, painted in 1979, not long after Hu's *Legend of the Mountain* won the awards of best director, best artistic director, best cinematography and best film score of Golden Horse Awards in 1979. Hu looks dashing, spirited and totally at ease in the portrait.

There are several other portraits of Hu. It is speculated that the earliest one without signature is by Hanxiang Li, when Hu was working in the art department in Li's film. Others were painted by famous painter Yongyu Huang, comic artist Jinzu Li (Feimeng Li's younger brother, former chief editor of the Sing Tao Daily) and famous illustrator, Chonghan Lin, and others.

作品現場裝置圖
Artworks in MOCA

胡金銓畫像 / 林崇漢 作
King Hu's potrait by Chonghan Lin

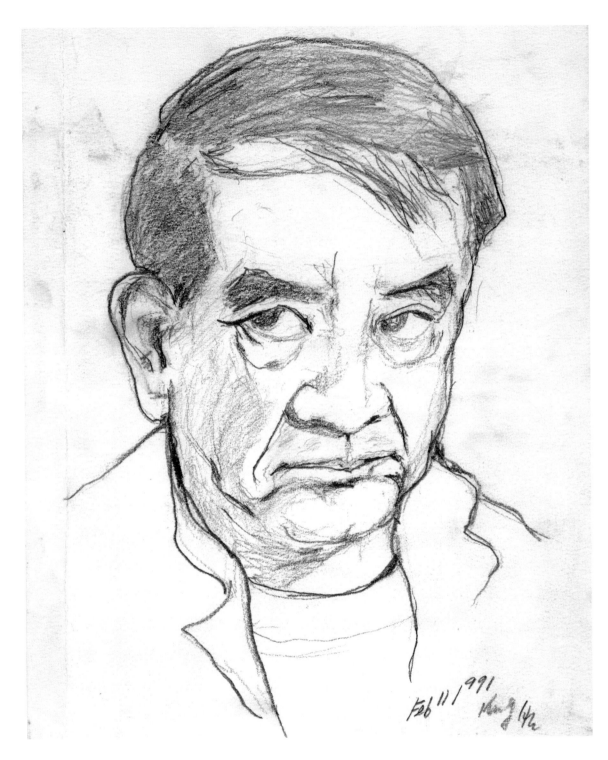

胡金銓自畫像
King Hu's Self-Potrait

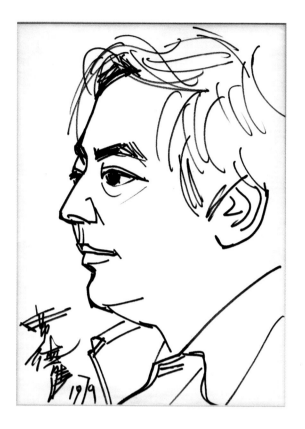

胡金銓畫像 / 席德進 作
King Hu's potrait by Dejin Xi

胡金銓畫像 / 黃永玉 作
King Hu's potrait by Yongyu Huang

胡金銓畫像 / 李敬祖 作
King Hu's potrait by Jinzu Li

胡金銓畫像 / 推測為李翰祥 作
King Hu's potrait probably by Hanxiang Li

胡金銓作品展區
Gallery of King Hu's works

本展區分為三大部分 —— 電影檔案區、動畫手稿區、漫畫再現區，所有素材都來自於胡金銓導演所留下來的檔案資料，再由策展團隊藉由當代裝置手法重現部分精采內容，胡導生前創作豐沛，本展雖無法將所其所有作品完全展出，但藉由主題系統式的展出，梳理出胡導前衛當代隱藏在電影背後的藝術深刻面。電影檔案區以胡導膾炙人口的十部電影為主，從電影海報、電影菁華片段、劇本、分鏡腳本、定裝照、工作照，到勘景速寫、設計手稿等，一窺胡導在電影幕後的細心、貼心與天才型的藝術本能；動畫手稿區首度揭開胡導的動畫夢，將胡導赴美國水族館寫生採集素材的手稿分層次裝置手法呈現，並讓觀眾有機會以最簡單的方式瞭解動畫原理；漫畫再現區主要呈現胡導在美國的社會觀察角色與針砭時事的犀利角度，以趣味的立體裝置再現胡導的平面插畫、漫畫作品。

This exhibition space is divided into three sections: CineFiles, Animation Drawings, and Caricatures and Comics. All material is from the King Hu collection, with the curatorial team transforming some works into contemporary installation artworks. Hu was quite prolific in his lifetime, and this exhibition is unable to showcase all of his creations. But with the arrangement by themes, King Hu's profound artistic significance hidden behind his films is revealed. The CineFiles Area showcased the most celebrated ten films. With film posters, sequences, scripts, storyboards, costume fitting photos, photos of production, site-survey sketches and design drawings, Hu's meticulousness, attentiveness to details, and masterful artistic sense are revealed. Animation Drawings Area showcased for the first time Hu's creations of animation. His drawings in an aquarium in the U.S. are exhibited in multiple installation layers, and the viewers could understand how animation works in a simple way. Moreover, the Caricatures and Comics area shows Hu's caricatures, display his social observations and critiques in his days in the U.S. These are presented through a three-dimensional installation incorporating the director's two-dimensional illustrations and comics.

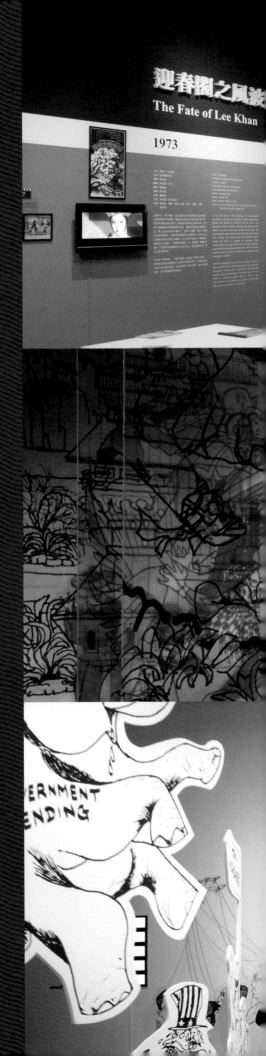

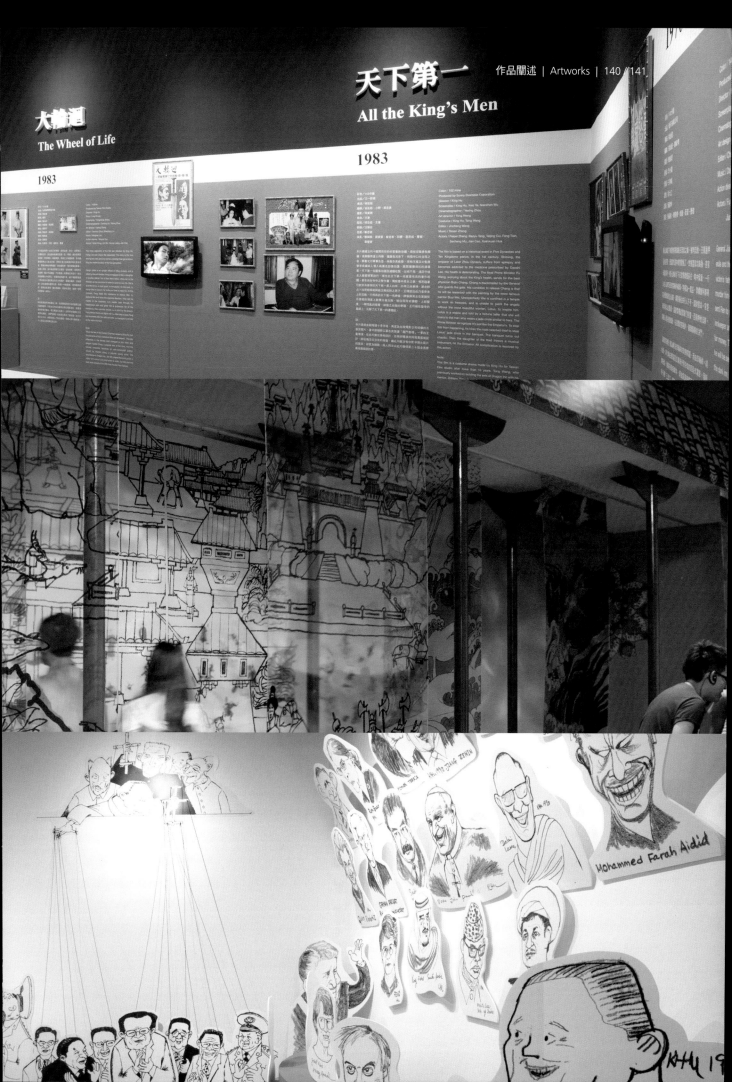

電影檔案區
CineFiles

進入201 大展間，迎面而來是局部模擬重現的《龍門客棧》正面景觀，以及當年胡金銓拍攝這部鉅作的某個角落現場。《龍門客棧》是胡金銓在台灣拍攝的第一部電影，客棧建築場景搭設在苗栗火燄山下廣闊乾枯的河床中，建材簡陋而形象鮮明，看似樸素寧靜卻充滿殺機，不同角色人物在此進進出出，故事情節不斷演繹高潮迭起……。從這個門面開始，我們進入了胡金銓導演揚名國際的電影作品回顧區，展出內容包括胡氏十部經典作品的電影海報、定裝照、文宣品、劇情介紹和菁華剪輯，以及難得一見的電影分鏡表、工作照、場記表、及場景設計稿等。

身為開創華語電影新時代的重要導演之一，胡金銓的作品產量雖不算多，正式發行的十三部作品中，著名而被視為經典的代表就有：《龍門客棧》、《俠女》、《大醉俠》、《空山靈雨》、《山中傳奇》及《迎春閣之風波》等十部。他雖以武俠電影名聞國際，實則他的電影美學並不賣弄表面的打鬥招式，而比較著墨於一種「胸中丘壑」的文儒俠義；他特別關注的是源自中國文化傳統的俠義哲學與含蓄美學。在塑造與呈現戲中角色人物時，除了對相關的服裝、道具、場景、對白等各方面很重視歷史考證，為了具現不同時代的人文精神特徵，他對古典文學如元代雜劇、宋人話本及清朝小說也都做過深入研究。也因此，他的作品明顯有別於當時市面的華語片，而能深刻詮釋中國文化意涵，開創有別於西方主流的東方電影美學。

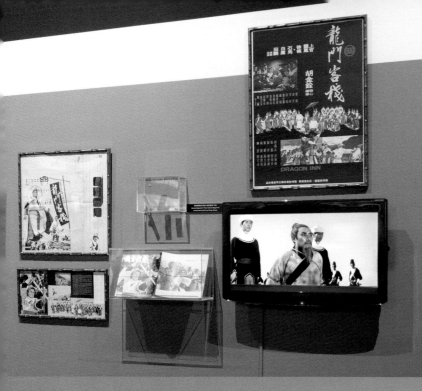

彩色 ／112分鐘
出品／聯邦影業有限公司
編導／胡金銓
攝影／華慧英
佈景／鄭志良
剪輯／陳洪民
音樂／周藍萍
武術／韓英傑
演員／上官靈鳳、石雋、苗天、白鷹、薛漢、曹健

Color ／ 112mins
Produced by Union Motion
Director & screenplay / Kin
Cinematographor / Huiying
Production design / Zhilian
Editor / Hongmin Chen
Music / Lanping Zhou
Action director / Yingjie Ha
Actors / Lingfeng Shanggu
Han Xue, Jian Cae

明朝中葉，東廠太監曹少欽權傾一時，在迫害兵部尚書于謙
之後，更欲斬草除根，派出手下，層層截殺發配龍門充軍的
于家子女。因奸計未遂，曹公公再派東廠殺手前往龍門客棧
埋伏。俠士蕭少鎡風聞東廠陰謀，親往龍門客棧，遇于謙舊
部朱驥和其妹朱輝亦入住客棧，眾志士會同客棧掌櫃吳寧，
同謀搭救忠良之後。于家子女起解抵達客棧，因其手下終非
蕭少鎡等人對手，曹公公於是親率東廠人馬前來，雙方展開
一場生死惡鬥，最後曹公公死於亂劍，忠良之後化險為夷。

本片是胡金銓來台拍攝的第一部影片，也是其最賣座的電
影。勘景時他跑遍全台，親選外景。如屏東墾丁的原始森
林、苗栗火焰山的斷崖絕壁、中橫梨山的漫天雲海等，讓全
片氣勢更為遼闊。龍門客棧內、外搭景更是經典場景，太監
曹公公、俠士、俠女、忠良之後等角色元素，延用至今。

In the mid-Ming dynasty,
accused and killed by the
Yu's children are sentence
Gate. Tsao sends several
their way, yet failed. Tsao t
the espionage agency. Th
Yu's former staffs come
children. The two groups I
eunuch Tsao himself com
and others. Tsao dies and

This is the first film made
does best in box office. T
over the island for locatie

Entering room 201, visitors are greeted by a partial reproduction of the set of *Dragon Inn*, including a corner showing the location shooting of the masterpiece. *Dragon Inn* is the first film King Hu made in Taiwan. The inn setting was constructed on a vast dried up riverbed in Huoyan Mountain, Miaoli. The simple and crude materials give us a visual impact, creating austere and serene sense but also filled with deadly tension. As the various characters enter and leave, the plot continuously shifts from one climax to the next. After the facade, visitors enter an area featuring the films made King Hu internationally famous. There is material of ten classics, include posters, costume fitting photos, promotional materials, synopsis, and sequences. Furthermore, this exhibition also presents the rarely seen storyboards, photos of production, production notes, and drawings of sets.

Considering that King Hu was one of the key directors created a new era in Chinese film history, he did not make many films. Out of the thirteen officially released works of Hu, and ten are regarded as classics: *Dragon Inn*, *A Touch of Zen*, *Come Drink with Me*, *Raining in the Mountain*, *Legend of the Mountain* and *The Fate of Lee Khan*, etc. Through martial art films made Hu internationally renowned, but his films do not merely parade showy feats of martial arts, they tend to dwell more on his 'inner notion' of the chivalrous literati. In particular, he concerned with the philosophy of swordsman and sense of aesthetics stemming from traditional Chinese culture. When shaping and presenting characters, apart from the related costumes, props, scenes, dialogue and various aspects, he also attaches great importance to historic research, so as to gain an understanding of the spirit of humanity throughout the ages. He intensely researched classic literature such as Yuan Dynasty opera, Song Dynasty story script and Qing Dynasty novels. These considerations set his work apart from other Chinese films of the time, making the conveyance of the inner meaning of Chinese culture possible, and creating an eastern film aesthetic different from that of the western mainstream.

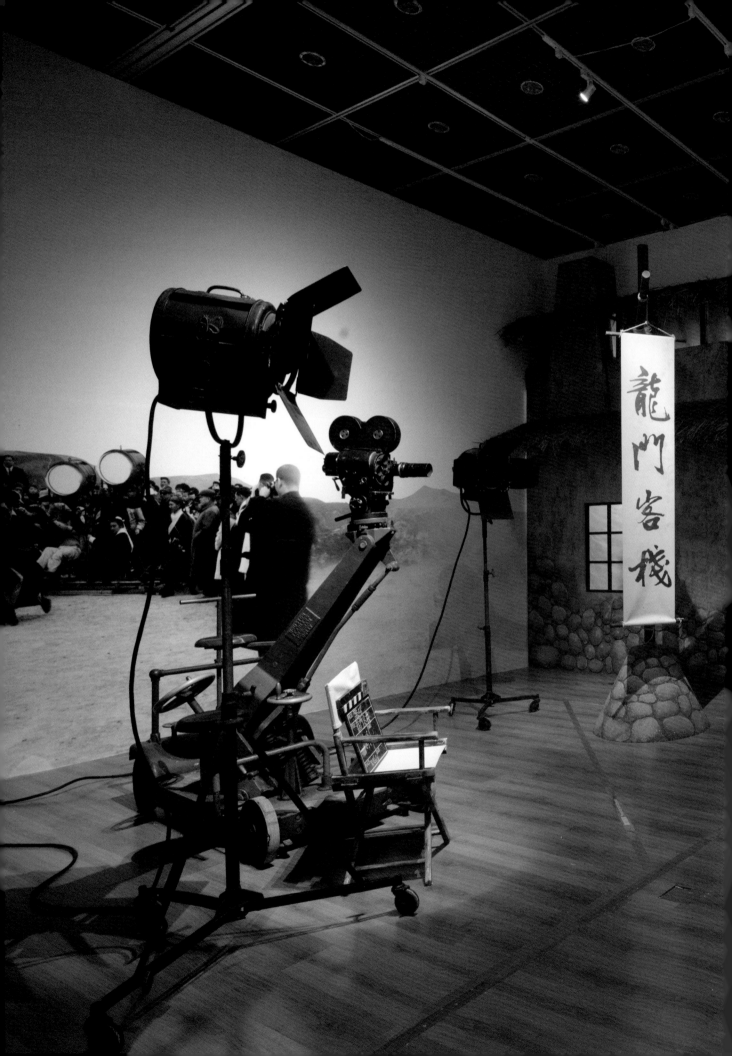

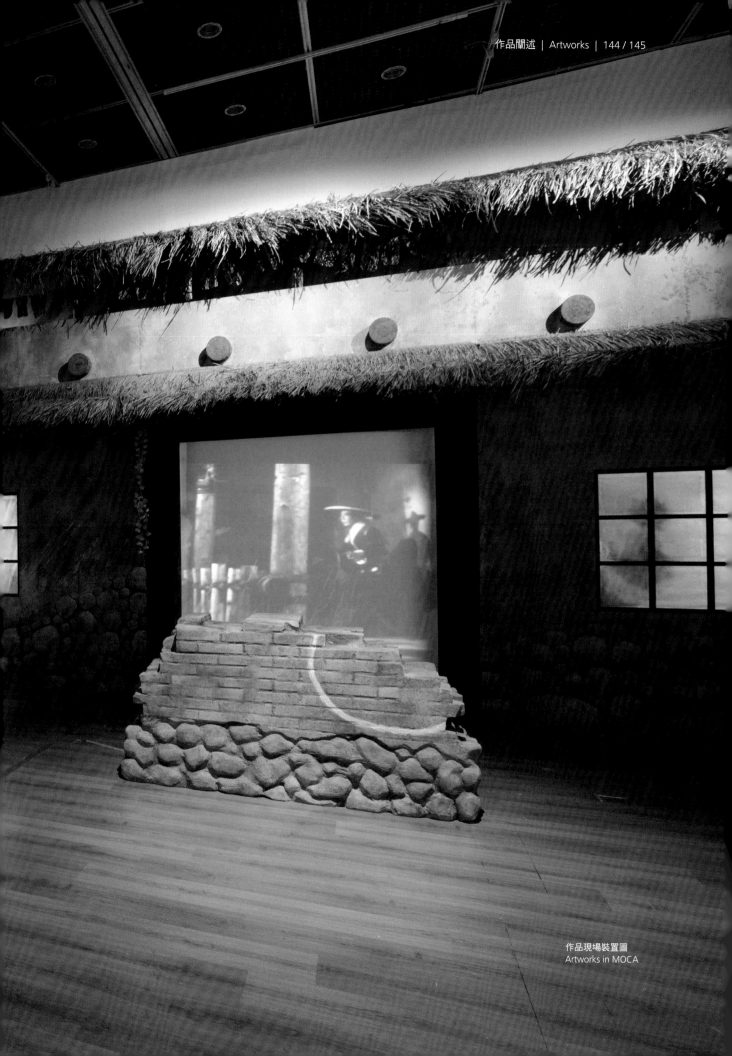

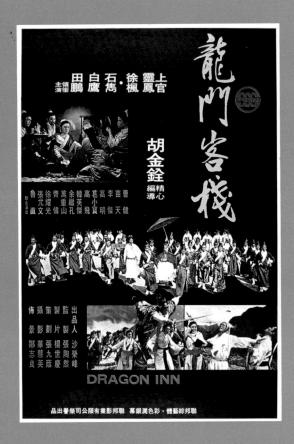

龍門客棧

1967／彩色／112 分鐘
出品／聯邦影業有限公司
編導／胡金銓
演員／上官靈鳳、石雋、苗天、白鷹、薛漢、曹健
攝影／華慧英
佈景／鄒志良
剪輯／陳洪民
音樂／周藍萍
武術／韓英傑

劇情摘要：
明朝中葉，東廠太監曹少欽迫害兵部尚書于謙之
後，更欲斬草除根，試圖截殺發配龍門充軍的于家
子女。因奸計未逞，曹公公派出東廠殺手前往龍門
客棧埋伏。俠士蕭少鎡風聞東廠陰謀，親往龍門客
棧營救忠良之後。適遇于謙舊部朱驥和其妹朱輝亦
入住客棧，眾志士會同客棧掌櫃吳寧，共商抗敵之
策。于家子女起解抵達客棧，曹公公悉其手下並非
蕭少鎡等人對手，於是親率東廠人馬前來，雙方展
開一場生死決鬥。最後曹公公死於亂劍，忠良之後
化險為夷。

註：
本片是胡金銓來台拍攝的第一部影片，也是其最賣
座的電影。除了龍門客棧的搭建，成為台灣電影史
上的經典場景，劇中人物如太監、俠士、俠女、忠
良後代等角色類型，也被延用至今。為了拍攝本
片，胡金銓跑遍全台親自勘選外景，將屏東墾丁的
原始森林、苗栗火焰山的斷崖絕壁、中橫梨山的漫
天雲海等點選入鏡，為影片添加了多變的情景和氣
氛。

Dragon Inn

1967 / color / 112mins
produced by Union Motion Picture Company
director screenplay / King Hu
actors / Lingfeng Shangguan, Jun Shi, Tian Miao, Ying Bai, Han Xue,
 Jian Cao
cinematographer / Huiying Hua
production design / Zhiliang Zou
editor / Hongmin Chen
music / Lanping Zhou
action director / Yingjie Han

In the mid-Ming dynasty, a loyal and upright Minister Yu is accused and killed by the evil and powerful eunuch Cao. Yu's children are sentenced to exile to the border Dragon Gate. Cao sends several assassins to kill Yu's children on their way, yet failed. Cao then sends killers of East Chamber, the espionage agency. The righteous swordsman Xiao and Yu's former staffs come to Dragon Inn to rescue Yu's children. The two groups have many fights there. Then Cao himself comes and has fierce fights with Xiao and others. In the end, Cao dies and Yu's children are saved.

Note:
This is the first film made by King Hu in Taiwan and the one did best in box office. To make this film, Hu travelled all over the island for location hunting. The film was shot in various locations: the forest in Pingtong, the semi-desert and the cliffs in Houyen Shan and a sea of clouds in Lishan. Hu has created visionary scenes of these locations. And the production design of Dragon Inn has become classical. The characters: the eunuch, the swordsman, the swordswoman, and the descendants of the loyal officials are still used in contemporary martial art genre.

《龍門客棧》影片服裝道具參考資料，根據攝影師華慧英轉述，當年他與胡導演、製片楊世慶至故宮博物院參閱明朝書畫，並以手繪記錄明式服裝、道具。此展品是由張舒眉所謄寫的。

These pages are references for costume and prop design of *Dragon Inn*. According to the cinematographer, Huiying Hua; King Hu, the producer Zhiqing Yang and himself went to the National Palace Museum to research books and paintings of Ming Dynasty. They took notes and drew clothes and accessories. This is copied by Shumei Zhang.

(1)國立故宮博物院蔣館長復璁與該院圖書畫組那志良組長均謂拍攝歷史古裝片關於服裝道具等項考證工作殊非易事，但是導演此種求真的態度甚實在值得讚佩。要想使"龍"片中設計製作的服裝與現今相去甚遠那朝代的當時服裝完全符合是不太可能的，但我們能力求其接近，即屬不易，故他們均認為國片觀眾有福了

(2)報端上指摘"龍"片的造型照有日本武士風味，則可用以下之理由加以辯駁。

首先應該瞭解日本文化之淵源：

明太祖即位初年決上詔復唐、宋"復陝官威儀"，為固五胡元魏有此方 多行漢化，遼金亦未強令漢人改其習。元朝則以胡俗變易中國之制。故明太祖之民族政策即右

其禁辮髮椎髻，士民仍行束髮。

壹、禁胡服。衣冠悉如溏制 註：官吏，寬袍束帶，黑靴。人民寬衣。帽有六瓣合縫。下綴以簷，蓋平頂方中。

三禁胡姓胡語。

四禁蒙古礼俗。

隋唐以漢莫基礎 故隋、漢二代實同一體。

日本在東漢光武帝時即開始來貢，當時稱做倭奴

孔家牌

文武官常服：烏紗帽，圓領衫束帶為公服。

一品至四品緋袍，五品至七品青袍，八九品綠袍。

註：文武官公服補子之花樣，一品、大獨科花，二品，小獨科花三品，散荅花，無枝葉，四五品小雜花紋

梁冠圖

上衣圖

中單圖

大帶圖

調玉圖

綬圖

草履圖

褘頭圖

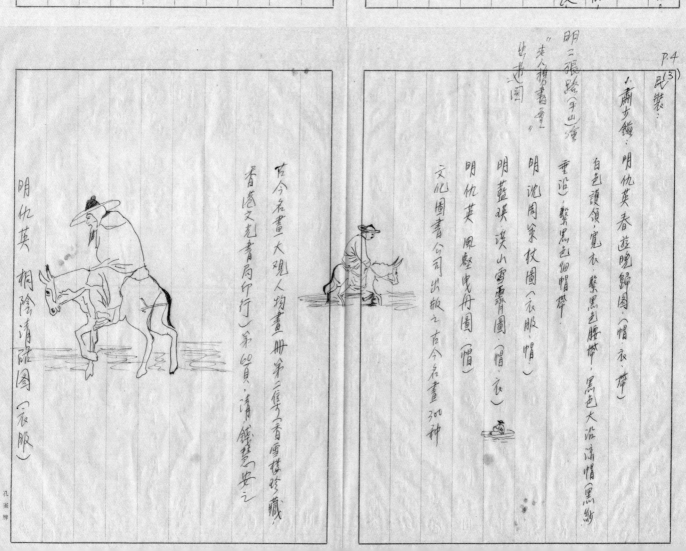

P.4　民裝(3)

六、肅步鎖：明仇英春遊晚歸圖（帽、衣、帶）

白色護領，寬衣，繫黑色腰帶，黑色大沿涼帽（黑紗）

明仇英春夜宴桃李園圖（衣服、帽）

"夹人指巾畫意"

明二張路（于山灣）

重沿，繫黑色細帽帶

明說周案秋苑圖（衣服、帽）

明藍瑛洗山雪霽圖（帽、衣）

明仇英風塵戈丹圖（帽）

文化圖書公司出版之 古今名畫 300 神

明仇英 桐陰清話圖（衣服）

古今名畫大觀人物畫冊第二集之"香雪樓珍藏"

香港文光書局印行）第64頁，清，錢慧安之

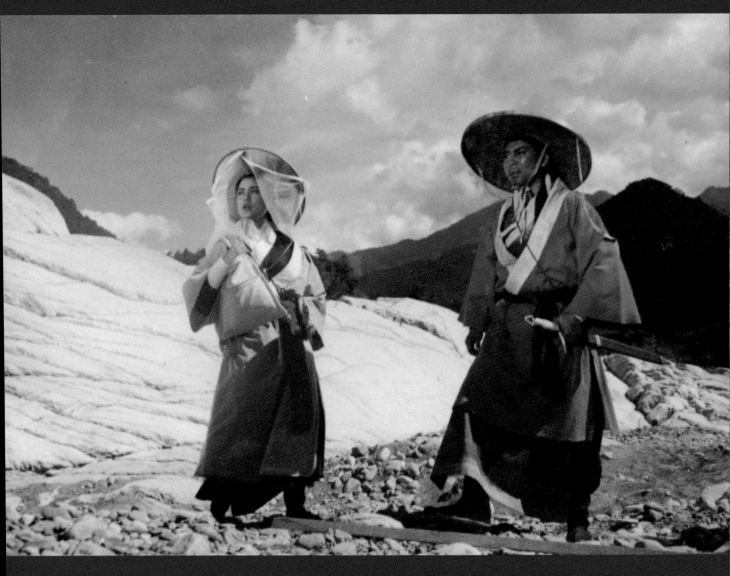

《龍門客棧》劇照
Stills of *Dragon Inn*

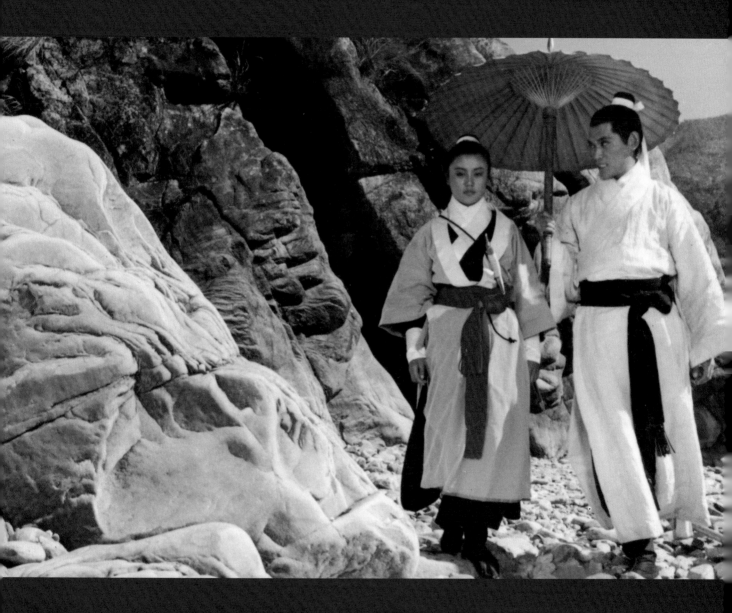

聯邦公司招募演員試鏡珍貴畫面，拍攝現場為當年該公司位於桃園縣八德鄉大湳的國際電影製片廠。
The audition photos of Union Motion Picture Company, shot when the company recruited actors at its film studio located at Danan, Touyuan County.

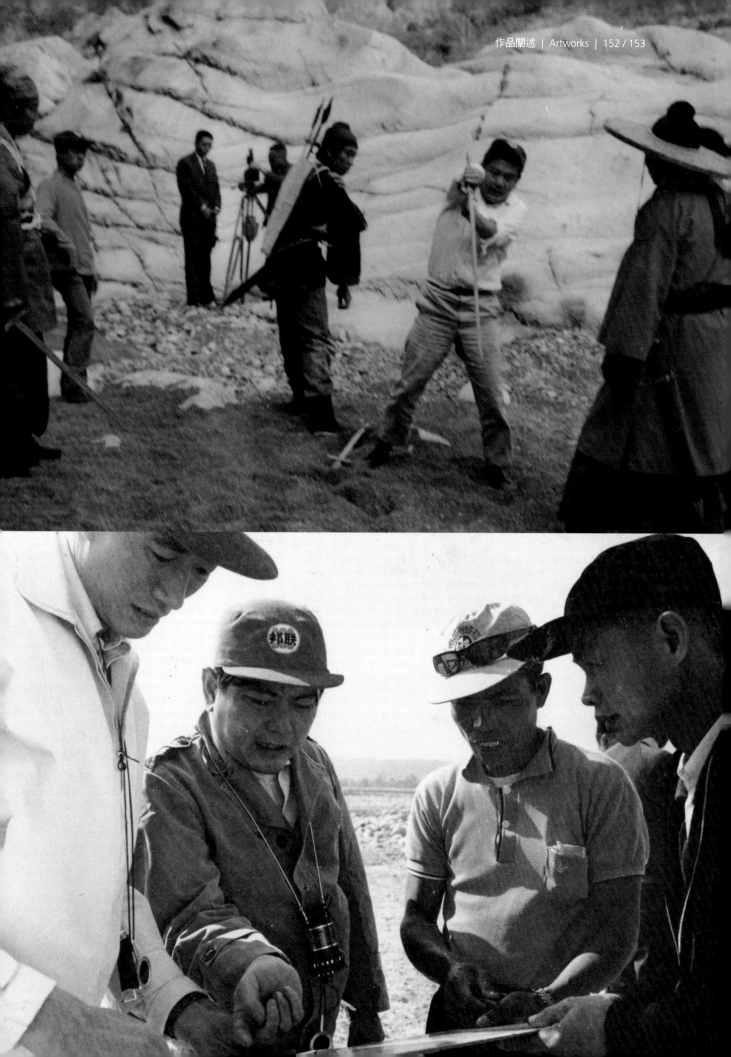

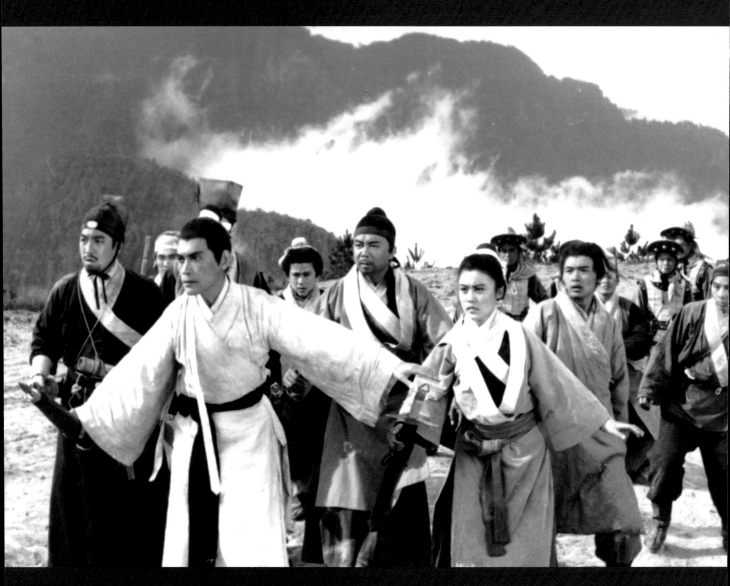

《龍門客棧》劇照
Stills of *Dragon Inn*

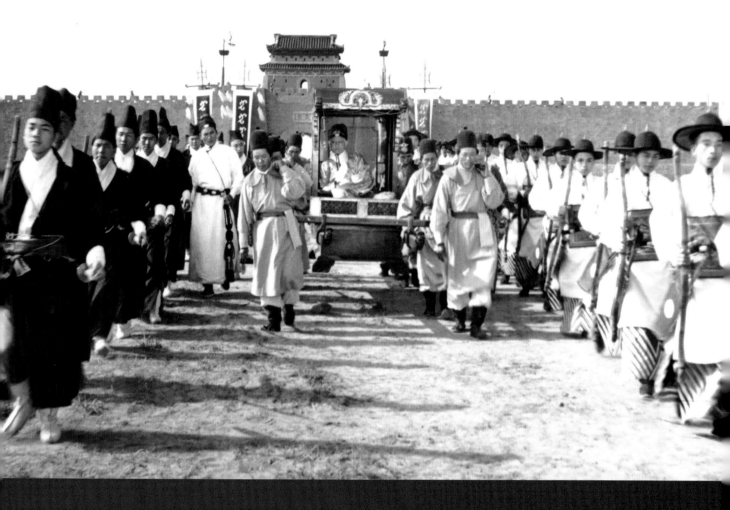

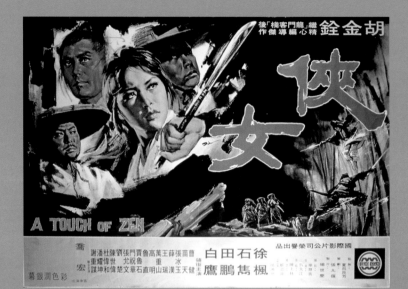

俠女

1970／彩色／200 分鐘
出品／聯邦影業有限公司
編導／胡金銓
演員／徐楓、石雋、白鷹、喬宏、田鵬、張冰玉
攝影／華慧英
佈景／鄒志良
剪輯／汪晉臣
音樂／吳大江
武術／韓英傑、潘耀坤

劇情摘要：
本片改編自蒲松齡的《聊齋誌異》。明代書生顧省齋靠著賣字鬻畫維生，放棄科舉功名，而以諸葛亮的「苟全性命於亂世，不求聞達於諸侯」來自明心志。顧家旁傳聞鬧鬼的靖虜屯堡中，躲居著一對逃難母女。顧省齋與女主角楊慧貞有了一夜情緣後，發現楊女為朝廷重臣楊漣之後，顧生以智巧機關和鬼神傳言，協助楊女擊潰夜間來襲的兇敵人馬。翌日乍見遍地屍野而楊慧貞已離此他去，顧省齋為了情緣循跡追尋，楊女避見而託僧人交付新生嬰兒，本身決定遁入空門，法師以其俗緣未盡，囑其和同夥石將軍下山營救顧生父子，與東廠殺手難分勝負的交鋒對決，倖因法師前來相助而讓惡人伏法，但法師本身也因此犧牲圓寂入聖。

註：
本片以徐楓及白鷹等四人在竹林中激戰的場面蔚為經典，胡金銓剪接影片時，首創以短鏡頭畫面的快速銜接來推衍劇情，並營造出在螺旋空間中飛躍的震撼視覺和臨場感，他也因此榮獲1975 年坎城影展高等電影技術委員會大獎。

A Touch of Zen

1970 / color / 200mins
produced by Union Motion Picture Company
director / screenplay / King Hu
actors / Feng Xu, Jun Shi, Ying Bai, Roy Chiao, Peng Tien, Bingyu Zhang
cinematographer / Huiying Hua
production design / Zhiliang Zou
editor / Jinchen Wang
music / Dajiang Wu
action director / Yingjie Han, Yaokun Pan

The film is adapted from *Strange Stories from a Chinese Studio*. Gu is an intellectual who paints and writes for living, having no interest in taking the imperial examination and fame, like Geliang Zhu said "I merely managed to survive in times of turbulence and had no intention of seeking fame and position from princes." He and his mother live by a deserted mansion, which is rumored haunted. One day a woman, Yang, and her mother, who are refugees, are found hiding in the mansion. Yang's father is a loyal official and killed by the evil eunuch of East Chamber. Yang and other loyal generals are chased by the guards sent by East Chamber. Then the guards attack the mansion and Gu designs traps and uses the haunted rumor to scare off the enemy, along with Yang's fighting. Gu and Yang falls for each other before the attack. After the carnage, Yang leaves Gu and gives birth of their child, then gives it to Gu. Yang then follows her master, Huiyuan, the monk, to be a nun. The guards re-appear and have fierce fights with the righteous ones, Yang is badly injured. Master Huiyuan appears and teaches the guards lessons. In the end, he is injured by the scheming enemy, yet he struggles to kill the evil guy and dies.

Note:
The fight scene in the bamboos in *A Touch of Zen* becomes classical. King Hu edited 4 frames of several short shots to achieve spiral spinning images of the jumps. He received the "Grand Prix de la Commission Supérieure Technique du Cinéma Français" in Cannes for this.

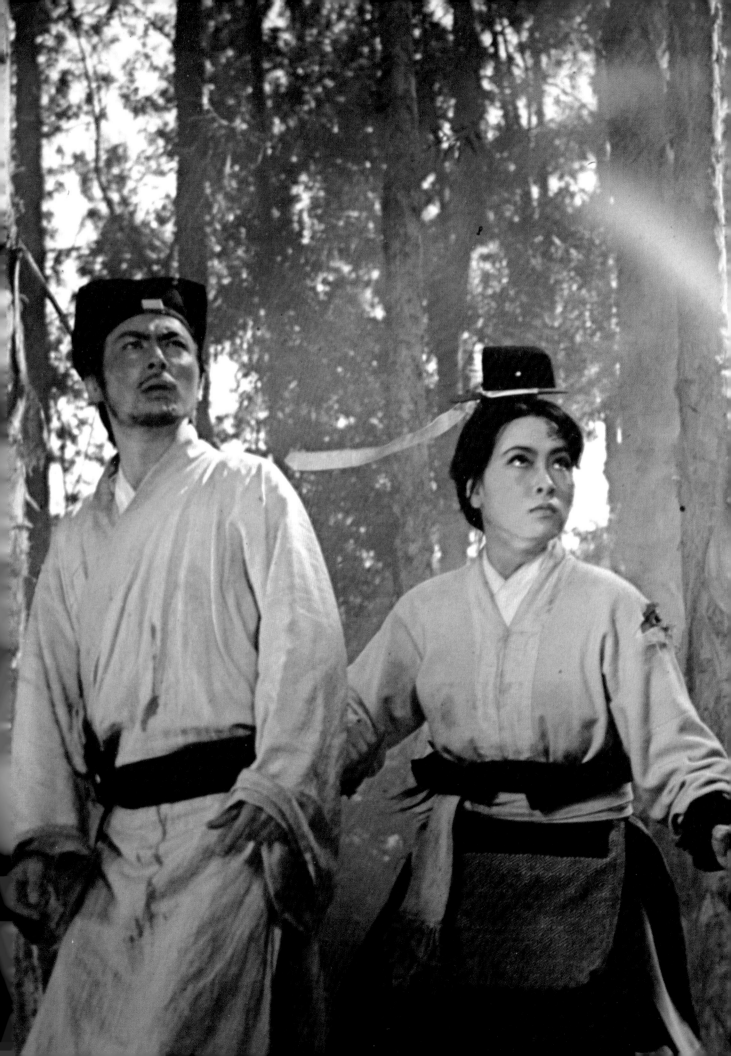

《俠女》劇照
Still of *A Touch of Zen*

《俠女》定裝照
Costume Fitting Photos of *A Touch of Zen*

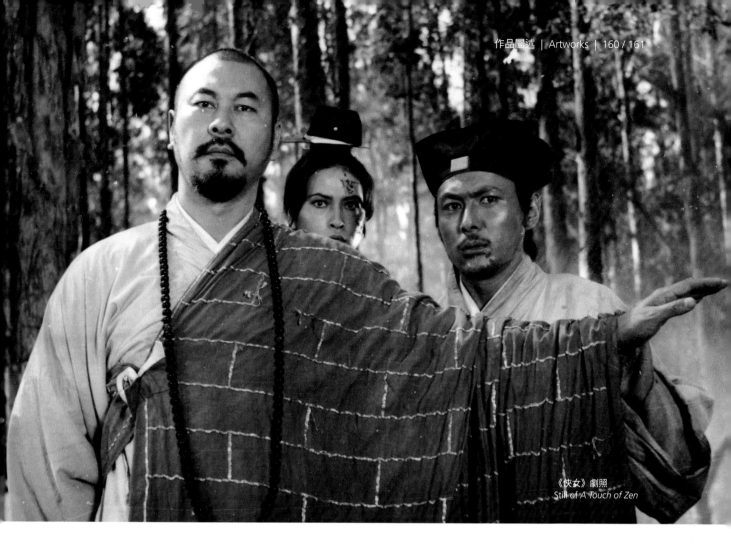

《俠女》劇照
Still of *A Touch of Zen*

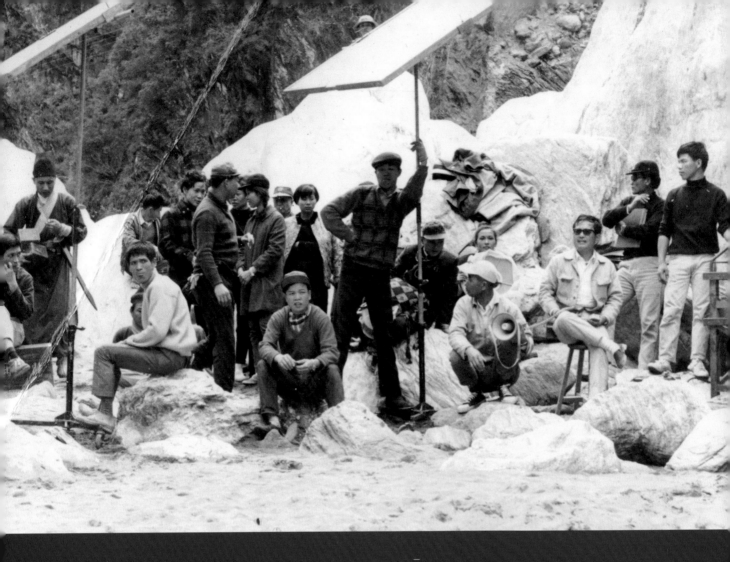

因為《龍門客棧》非常賣座，聯邦公司決定投入鉅資建立自己的片廠，委任胡導演為製片經理，一手規劃聯邦大湳片廠，並著手拍攝《俠女》，該片拍攝歷時五年，橫跨台港兩地。拍攝地點包括台灣大湳片廠外搭景靖虜屯堡、將軍府、街道等，外景包括中部橫貫公路、天祥、溪頭、日月潭、故宮及香港城門水塘等地。

Due to the excellent box office of *Dragon Inn*, Union Motion Picture Company decided to invest in building its studio. They hired King Hu as the manager of production to build Danan studio. In the mean time, King Hu also prepared the shooting of *A Touch of Zen*. It took Hu five years to complete the shooting and the locations are in both Taiwan and Hong Kong. The setting was built just beside Danan studio, including the deserted mansion, the general's mansion, and streets. The film was shot in various locations: Central Cross-Island Highway, Tianxiang, Xitou, Sun Moon Lake, National Palace Museum in Taiwan, and Shing Mun Reservoir in Hong Kong.

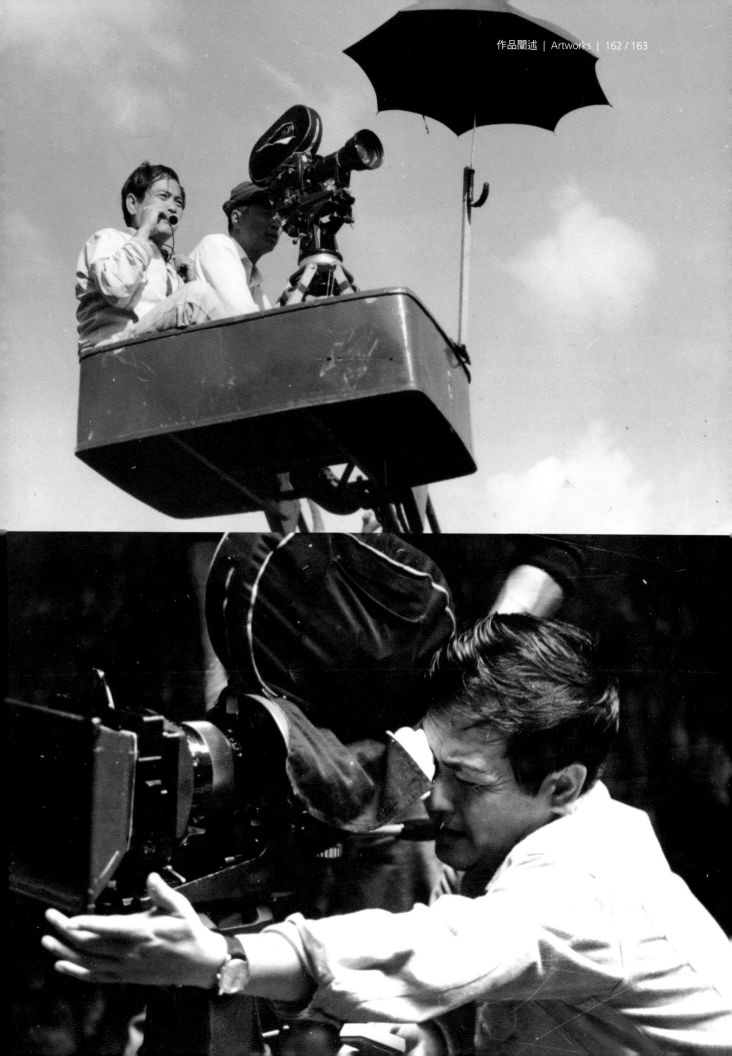

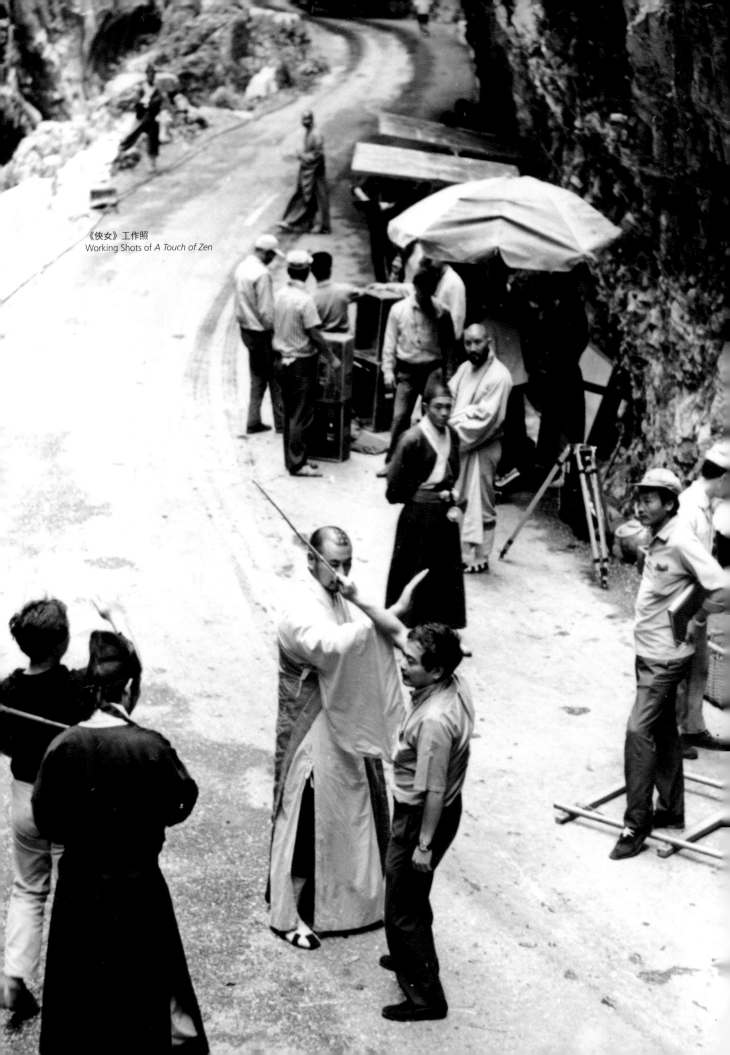

《俠女》工作照
Working Shots of *A Touch of Zen*

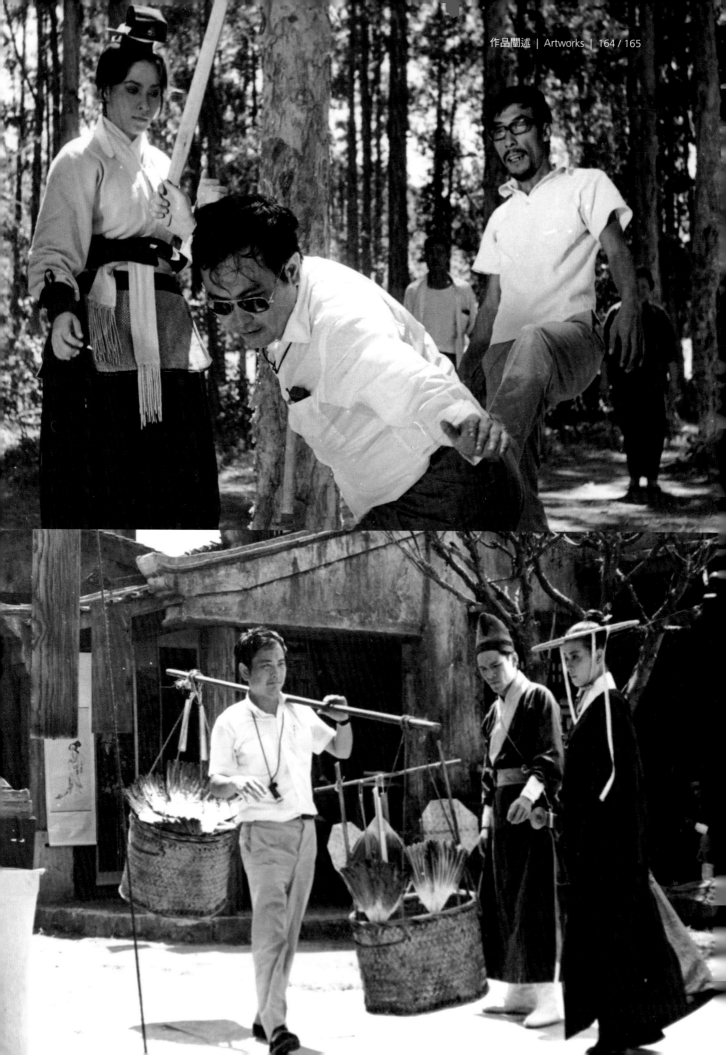

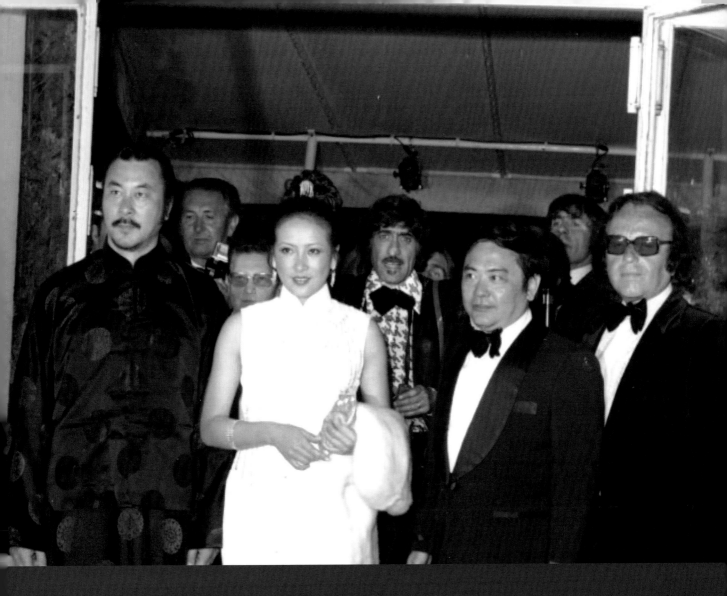

胡金銓把較少格數的膠卷接起來（抽格），觀眾就會因為視網膜的殘像現象，而看到螺旋式的躍起。這個剪接技巧，是他獲得坎城影展頒發「法國電影最高技術委員會大獎」的原因。竹林大戰整場戲長度約5分49秒，共用了115個鏡頭，分割為22個小單元時間，每個小單元時間在銀幕上從幾秒到一秒，二分之一秒，三分之一秒，甚至更短的六分之一秒，打破一般傳統剪輯不少於三分之一秒及八格的規則。（註：電影標準放映速度為每秒24格）

In the action scenes, King Hu cut down some frames and edited with fewer frames. Then the viewers see spiral leaps due to the persistence of vision. He received the "Grand Prix de la Commission Supérieure Technique du Cinéma Français" in Cannes for this technique.

The total length of fighting in bamboos is 5 minutes 49 seconds. There are 115 shots in total, divided to 22 units, from few seconds to 1, 0.5, 0.3, even 0.15 seconds. This breaks the traditional rules of editing, that is, a cut should not be less than 0.3 seconds or eight frames. (The standard rate of film projection is 24 frames per second.)

XXVIIIᵉ FESTIVAL
INTERNATIONAL DU FILM
CANNES 1975

GRAND PRIX
DE LA
COMMISSION SUPÉRIEURE TECHNIQUE
DU
CINÉMA FRANÇAIS
CATÉGORIE LONG MÉTRAGE
DECERNE A
TOUCH OF ZEN

HONG-KONG

RÉALISÉ PAR
King HU

LE PRÉSIDENT

LE DELEGUE GENERAL

《大醉俠》

1966／彩色／95 分鐘
出品／邵氏兄弟（香港）有限公司
導演／胡金銓
編劇／胡金銓、爾羊
演員／鄭佩佩、岳華、楊志卿、陳鴻烈、韓英傑
攝影／賀蘭山（即西本正）
剪輯／姜興隆
音樂／周藍萍
武術／韓英傑
©版權由天映娛樂有限公司全部擁有

劇情摘要：
兩江總督之子張步青押解人犯，途中遇襲受到劫
持，成為賊人殷中玉用來交換獄中老大的人質，步
青之妹「金燕子」前來營救兄長。金燕子雖身手不
凡，卻無謀略機智，幾次為終日飲酒賣傻的「醉
俠」點化相救。醉俠和金燕子以交換人質為計，共
謀營救步青，面對賊黨匪人之際，偽善的法師了空
中途介入，在隱姓埋名的醉俠與了空法師之間，一
場有關於掌門接班人選以及權力信物青竹杖的爭戰
同時展開。

註：
《大醉俠》的拍攝，雖受限於邵氏片廠既有格局，
但也給了胡金銓開展武俠新路的契機，影片賣座成
功，也同時捧紅了一代俠女鄭佩佩及俠客岳華。本
片拍攝過程，胡金銓與北京「富連成」戲班出身的
京戲演員韓英傑合作愉快，此後韓英傑也一直擔任
胡金銓的武術指導。

Come Drink With Me

1966 / color / 95min
produced by Shaw Brothers Studio
director / King Hu
screenplay / King Hu, Yang Er
actors / Peipei Zheng, Hua Yue, Zhiqing Yang, Honglie Chen, Yingjie Han
cinematographer / Tadashi Nishimoto
editor / Xinlong Jiang
music / Lanping Zhou
action director / Yingjie Han
©Licensed by Celestial Pictures Limited. All rights reserved.

A young official, Buqing Zhang, is in a mission to guard prisoners. He is ambushed and kidnapped by a bunch of bandits, who demands to exchange him with their imprisoned leader. Zhang's sister, Golden Swallow, comes to rescue her brother. She is good at Kung Fu, but is inexperienced to fight with bandits. She is rescued several times by Drunken Cat, a monk in disguise. Drunken Cat has a feud with his superior. They have been fighting for the green bamboo stick, an object symbolized the leadership of the monastery. Drunken Cat and Golden Swallow plan to rescue Buquing by exchanging the hostage. The fight starts.

Note:
Come Drink With Me is successful in box office, but its style is still like the genre films by Shaw Brothers Studio. Yet it opened a new door of martial art for King Hu, and made the swordswoman, Peipei Zheng, and the swordsman Hua Yue famous stars. King Hu started his cooperation with Yingjie Han, an actor of the famous Beijing opera troupe "Fu Lian Cheng." Han has worked as King Hu's action director ever since.

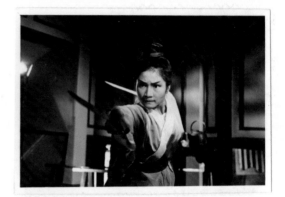

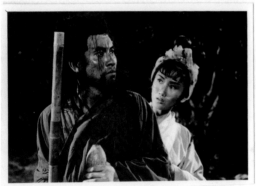

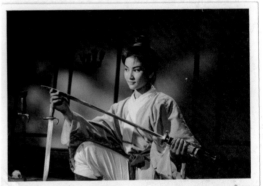

當時胡導演想起用新人，塑造新武俠風格，特意安排試鏡來決定人選，安排已成名演員唐菁與蕭湘，新人岳華、鄭佩佩與趙心妍共同試鏡。 最後由岳華、鄭佩佩勝出，成為男女主角。

King Hu wanted to use new talents for this film, in order to create new martial art style. So he intentionally arranged auditions to decide the casting. The famous actors Jing Tang and Xiang Xiao and new talents Hua Yue, Peipei Zheng and Xinyan Zhao took the auditions at the same time. Finally Hua Yue and Peipei Zheng were chosen as the leads.

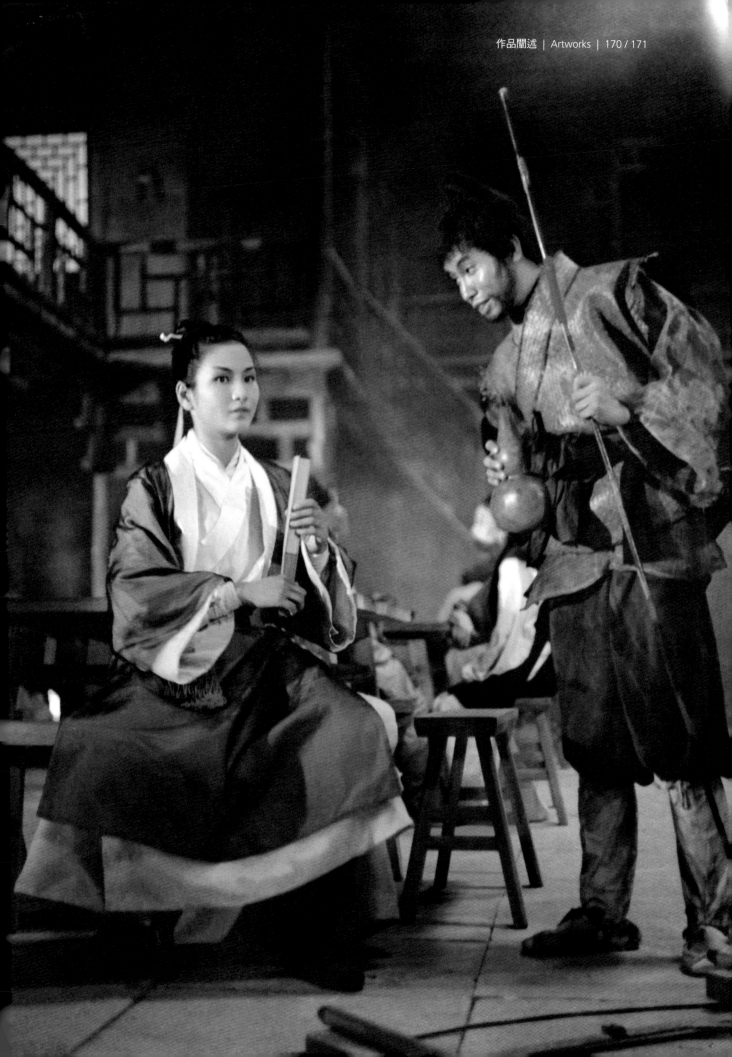

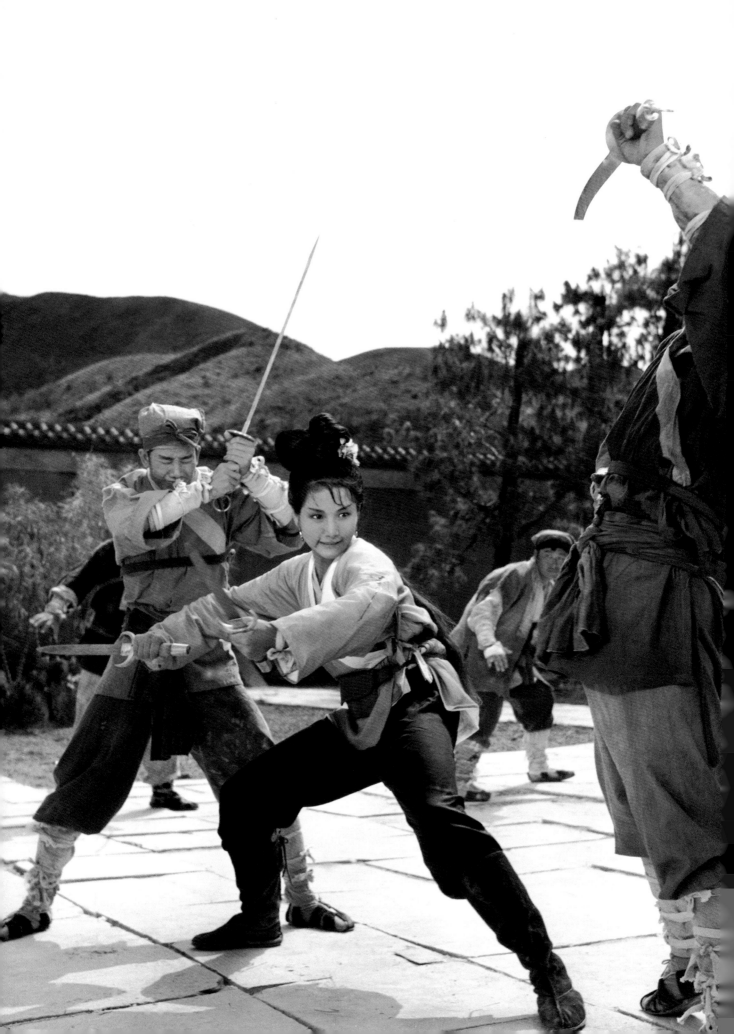

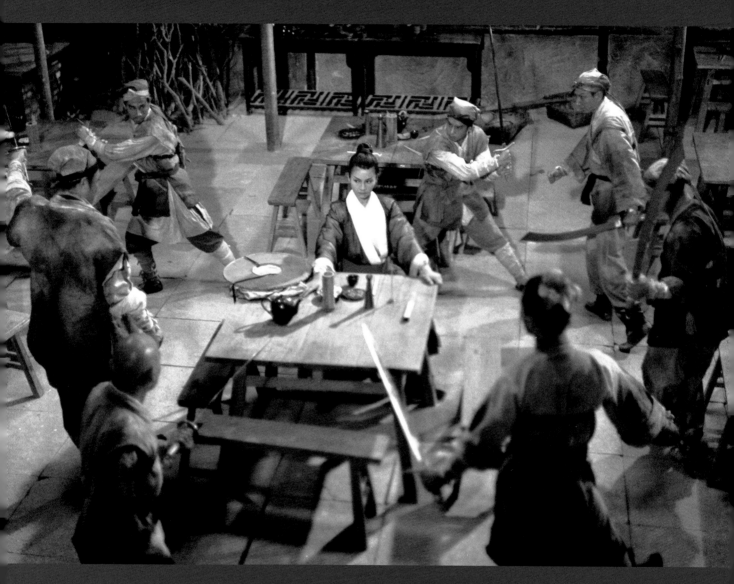

《大醉俠》劇照
Stills of *Come Drink with Me*

迎春閣之風波
The Fate of Lee Khan

1973

大輪迴
The Wheel of

1983

天下第一
All the King's Men

1983

作品現場裝置圖
Artworks in MOCA

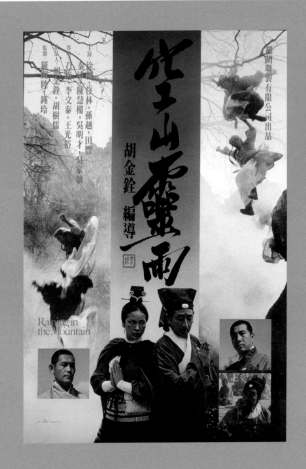

空山靈雨

1979／彩色／122分鐘

出品／羅胡聯製有限公司

導演／胡金銓

編劇／胡金銓

演員／徐楓、孫越、佟林、田豐、陳慧樓、秦沛、
　　　吳家驤、吳明才

攝影／陳俊傑

美術／胡金銓

剪輯／胡金銓、蕭南

音樂／吳大江

武術／吳明才

劇情摘要：

三寶寺住持智嚴為傳位問題，請來大地主文安、王將軍以及由眾女弟子服侍、不戒葷素的物外法師共同商議見證。文安與王將軍另有所圖，假扮文安之妻的女飛賊白狐和副官張誠，暗謀盜取傳聞中三藏法師留下的「大乘起信論」。眾人爾虞我詐之際，老住持卻另有盤算，出人意料地將法位傳給正在寺內修行的流犯邱明，並賜封法號慧明後，一場盜經攪局的行動從此正式展開。文安、白狐及張誠分別潛入藏經閣及主持室房盜經，你爭我奪接著變成了林中的刀劍往來，張誠死於劍下，文安摔落山崖，白狐則在被制伏後，剃度出家。慧明繼位，當眾燒掉經書原稿秘本，並將抄本大方送人流傳，點出了經典重在內文而不在卷本的精神意涵。

註：

本片跳脫在片廠中搭景拍片的模式，全部為實景拍攝，自1977年8月到韓國出外景，一直拍到隔年4月，走訪了韓國許多大小寺院攝成。胡金銓表示韓國的寺院和中國的寺院形式與格局相似，且韓國的寺院不大，建築物集中，對拍攝電影來說較為便利。片中盜賊潛入藏經閣的情節，寺院管理者以國寶及重典為由拒絕開放拍攝，胡氏團隊被迫私下買通寺內僧侶，偷偷進入拍攝完成，平添了戲裡戲外相互呼應的緊張氣氛和精神趣味。

Raining in the Mountain

1979 / color / 122mins
produced by Luo Hu Productions
director / King Hu
screenplay / King Hu
actors / Feng Xu, Yue Sun, Lin Tong, Feng Tian, Huilou Chen, Pei Quin, Jiaxiang Wu, Mingcai Wu
cinematographor / Junjie Chen
art director / King Hu
editor / King Hu, Nan Xiao
music / Dajiang Wu
action director / Mingcai Wu

San Po monastery is famous for its Mahayana Sutra scroll, handcopied by the monk Tripitaka of the 7th century. The old abbot calls a meeting to decide his successor. He invites General Wang, a wealthy patron, Wen Ann, and Master Wuwai, who is served by many female followers and eats meat, to the meeting. Wang and Wen both covet for the priceless scroll, and each has his plans. Wen brings a female thief, White Fox, disguised as his concubine. Both parties tried to steal the scroll. The abbot chooses the convict, Qiu Ming, as the new abbot, and conferring Qiu as Master Huiming. Wen and White Fox steals the box of the scroll and gets away, but is chased by the General's staff, and they have vicious fights. Later Wen falls from the cliff and White Fox decides to become a nun. The new abbot burns the original scroll in public and then gives the copied scroll to the public. All that happens point out what is most important in the classics is the spirit, not the scroll.

Note:
The film was shot in many monasteries in Korea. King Hu thinks the monasteries of China and Korea are similar and the Korean ones are less scattered and more convenient for shooting. When the crew asked to shoot the scenes of the library of scriptures in a monastery, they were refused, due to the fact the precious scrolls are kept there. Yet the crew shot secretly in it by buying off the monks. It's an interesting fact echoing with its story.

據徐楓回憶，到了韓國一切正式進入軌道後，第一件事是拍定裝照，胡導演很細心，演員身上的每一個配件都是他安排的。和胡導演拍戲，你永遠聽不到甚麼是苦、甚麼是累、甚麼是難、甚麼是做不到的。他像有用不完的精力和心思，永遠為影片設計到盡善盡美。圖片中可見，無論是肢體動作、道具擺設、服裝穿戴、鏡頭位置等等，胡導演皆一一確認。

According to Feng Xu, "after we arrived in Korea and everything was settled, the first thing was to take the costume fitting shots. Hu was really meticulous, he chose all accessories himself. So if you make films with King Hu, you would never hear him saying: it's so difficult, he is so tired or something is impossible. It seems he is always energetic and thinking, tries to make the film perfect." These photos show King Hu giving direction on movement, setting the props, how to wear the costume, and positions of camera.

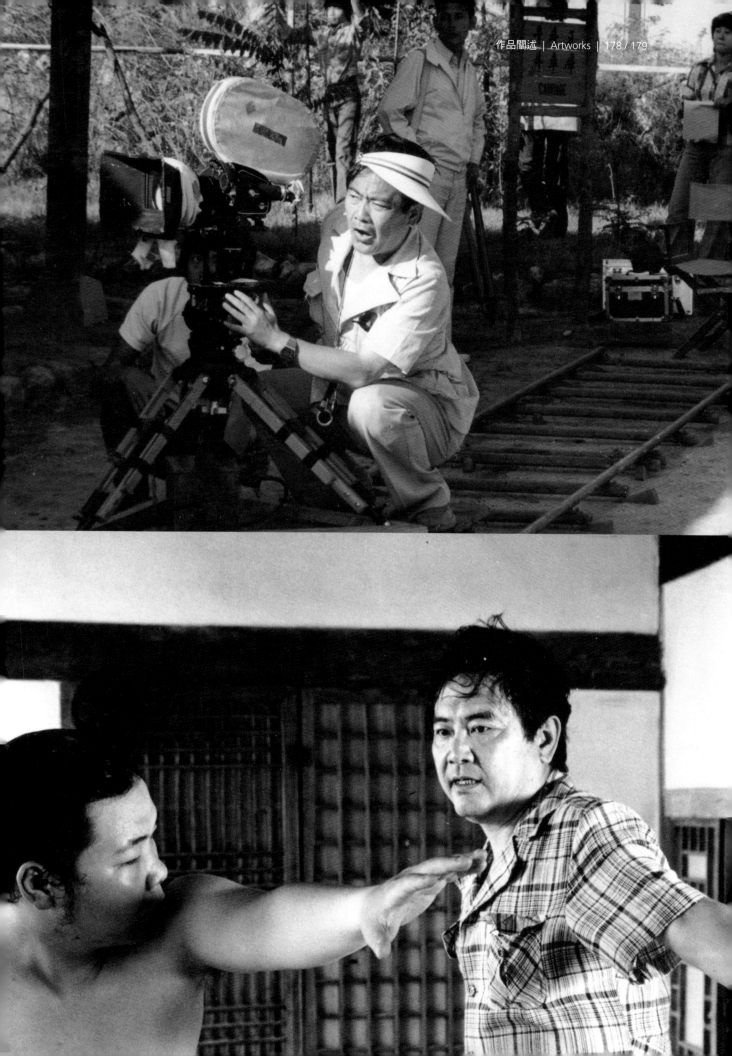

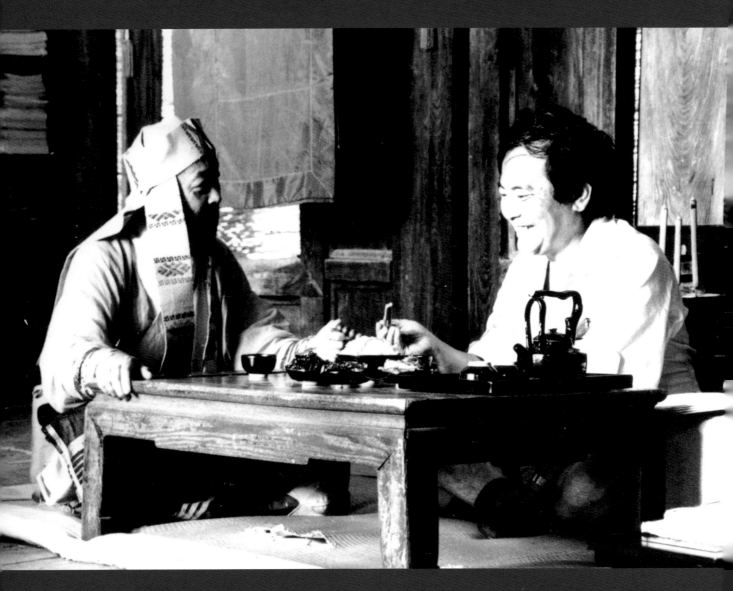

《空山靈雨》工作照
Working Shots of *Raining in the Moutain*

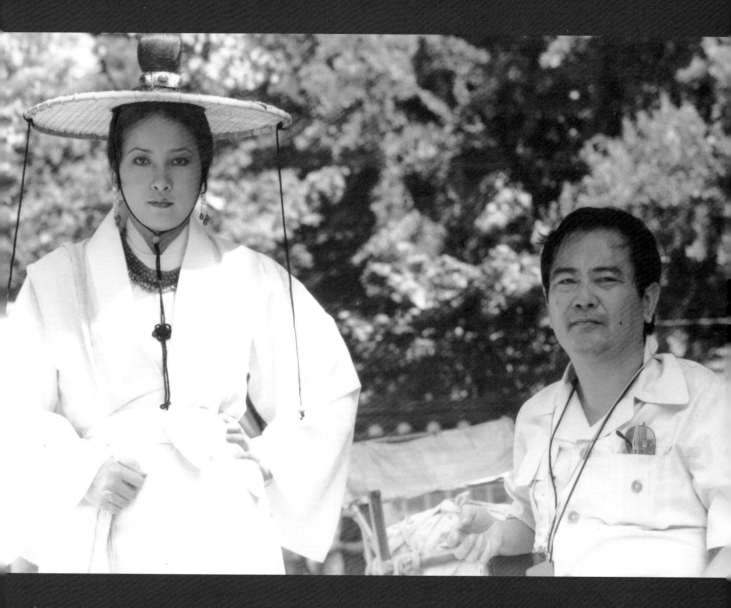

為了《空山靈雨》和《山中傳奇》兩部戲的外景，胡導演在韓國連
跑十七天，從漢城沿公路南下，一直到半島的南端——三千浦，再
坐船到三鶴島，然後經釜山沿海岸線北上，爬上雪嶽山，下山後西
行回到漢城。旅程中全靠坐小巴和步行，平均每天坐五小時車，走
十公里的山路。

King Hu spent 17 days traveling all over Korea for location hunting
of *Raining in the Mountain* and *Legend of the Mountain*. He started
from Seoul and went south to the south tip of the peninsula. The
he took boat to Samhakdo and went to north from the coast line
via Busan, climbed Seoraksan and went west back to Seoul. He took
minibuses and also walked during the journey. In average, he took
five hours on bus and walked 10 kilometers everyday.

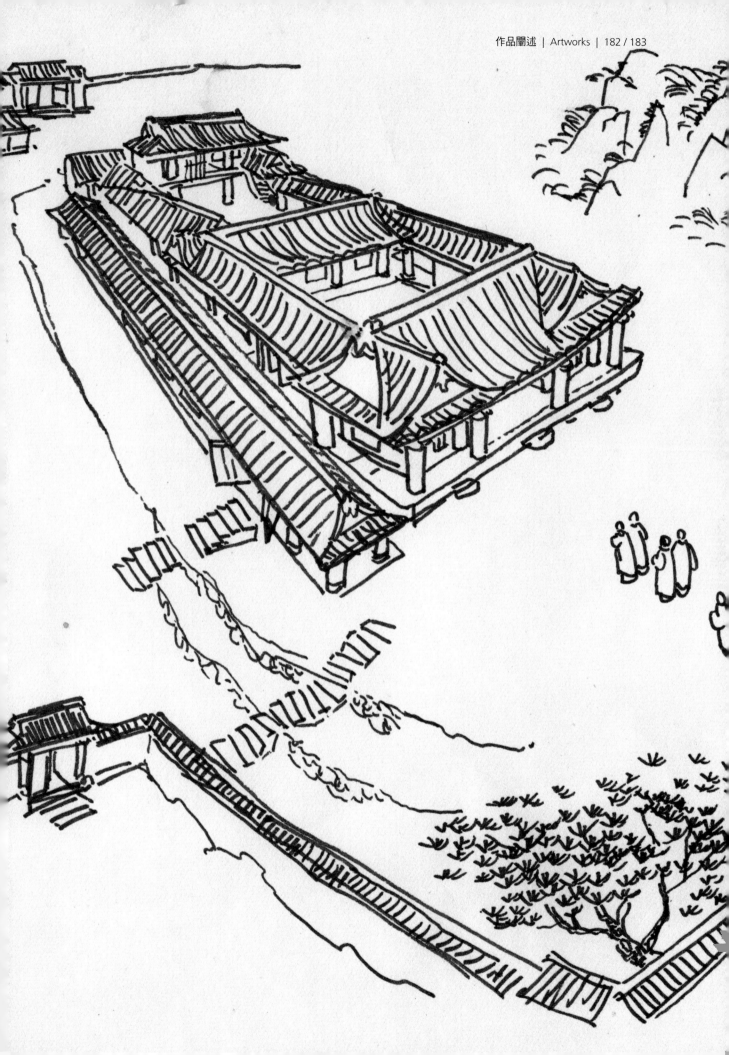

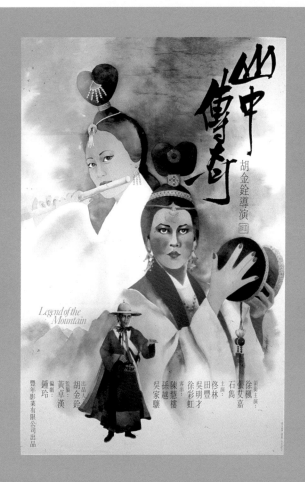

山中傳奇

1979／彩色／184 分鐘
出品／豐年影業有限公司
導演／胡金銓
編劇／鍾玲
演員／徐楓、張艾嘉、石雋、佟林、田豐、
　　　吳明才、徐彩虹
攝影／陳俊傑
美術／胡金銓
剪輯／胡金銓、蕭南
音樂／吳大江
武術／吳明才

劇情摘要：
由「宋人話本」中的「西山一窟鬼」改編而成。
《山中傳奇》與《空山靈雨》同時期拍攝，多數演
員兩邊軋戲，但張艾嘉只主演本片。

書生何雲青受海印寺法圓上人之託，抄寫「大手
印」經以超度亡靈。因為抄寫佛經需要清幽靜心的
環境，和尚推介雲青至其好友崔鴻至居住的邊城工
作，抵達目的地後怪事接連發生，熱心鄰人王媽媽
設宴洗塵，安排女兒樂娘拜雲青為師並演出樂曲；
一夜宿醉醒來，雲青發現樂娘同處房中，泣訴兩人
已非尋常關係，於是答應娶其為妻。原來王氏母女
乃陰間厲鬼，等著偷取何雲青抄完的經書，當地番
僧試圖阻撓，但不敵樂娘妖術，於是與道長聯手。
何雲青與崔鴻至趕集途中結識另一對鬼母女莊夫人
及依雲後，從此夾陷在僧道與鬼魂的角力鬥法、人
鬼之間的愛戀迷情、厲鬼與善鬼之間的忌妒爭執等
多角關係之中，劇情發展到最後，一切夢幻泡影終
歸煙消雲散，原來所有多情種種，竟是西山一窟鬼
罷了。

Legend of the Mountain

1979 / color / 184mins
produced by Prosperity Film Company
director / King Hu
screenplay / Ling Chung
actors / Feng Xu, Sylvia Chang, Jun Shi, Lin Tong, Feng Tian, Mingcai Wu,
 Caihong Xu
cinematographer / Junjie Chen
art director / King Hu
editor / King Hu, Nan Xiao
music / Dajiang Wu
action director / Mingcai Wu

The film is adapted from a ghost story written in Song Dynasty. *Legend of the Mountain* and *Raining in the Mountain* were shot at the same time. Most of the cast play in both films, but for the leading characters, Sylvia Chang only plays in this film.

A young scholar, He, visits an old monk in the mountain and is asked to copy a sutra to redeem the wandering souls. On his way of traveling to a friend's residence, he falls asleep. When he arrives, he meets a woman, Melody, and her mother. He is fascinated by Melody and marries her. It turns out Melody and her mother are ghosts, trying to steal the hand-copied sutra. A lama comes to rescue He, yet he is defeated by Melody's black magic, Then He meets another beautiful girl, Cloud. After that he becomes involved in several conflicts, the magic power struggle between the monk and ghost, the love and infatuation between man and ghost; and the jealously and struggle between good ghost and bad ghost. In the end, everything disappears. It turns out all women and his friends are ghosts.

胡導演自十八歲開始演戲，演過許多膾炙人口的電影，如《金鳳》裡的小癩子、《雪裡紅》裡的小麒麟、《長巷》裡的敗家子、《江山美人》裡的大牛等，一演成癮，導戲時經常犯「戲癮」。拍攝本片時，剛新婚的胡導，對片中演夫婦的石雋、徐楓的「抱抱」不甚滿意，特別示範胡氏的「給我抱抱」。

King Hu started his acting career since he was 18. He played characters in many famous films, like *Golden Phoenix*, *Blood in the Snow*, *The Long Lane*, and *The Kingdom and the Beauty*, etc. So when he was directing, he would often showed actors how to act. During shooting of *Legend of the Mountain*, King Hu was newlywed. It seems he was not satisfied with the hugging of Jun Shi and Feng Xu, so he demonstrated the hugging in these photos.

右圖 right
《山中傳奇》工作照
Working Shots of *Legend of the Moutain*

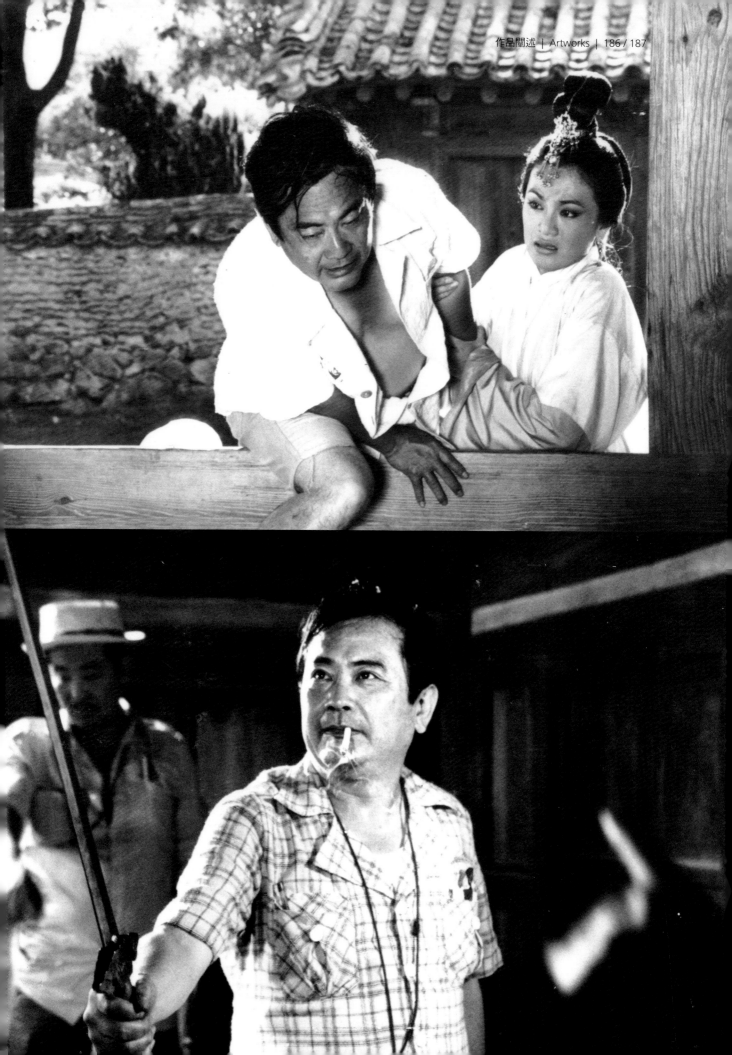

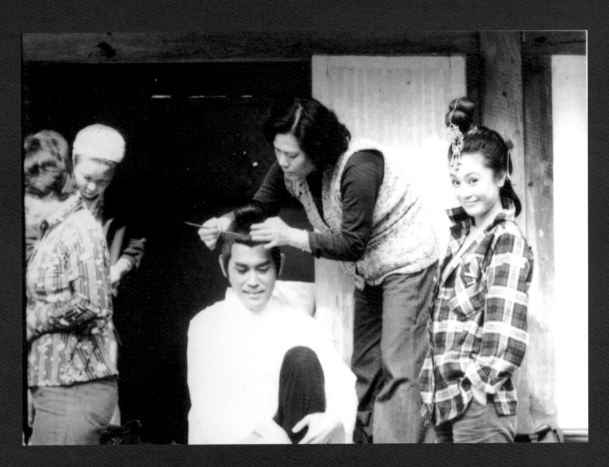

《山中傳奇》工作照
Working Shots of *Legend of the Moutain*

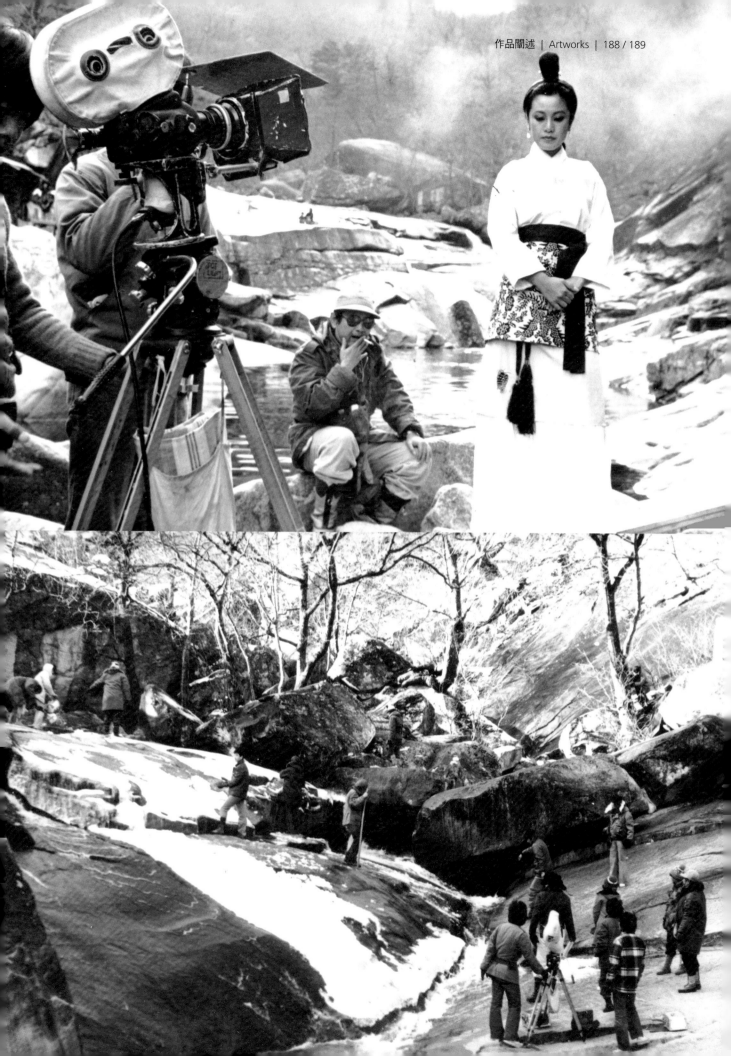

喜怒哀樂 之 怒

1970／彩色／41分鐘
出品／藍天有限公司
導演／胡金銓
編劇／胡金銓、謝家孝
演員／張福根、陳慧樓、胡錦、薛漢、曹健
攝影／陳清渠
美術／李小鏡
剪輯／王朝曦
音樂／吳大江
武術／潘耀坤

劇情摘要：
楊元帥的部下焦贊將軍誤殺了王若青的女婿，被判
流放，王若青買通押送焦贊的差官，希望在押送途
中將他處以私刑，然而焦贊武功高強，差官未能得
手。楊元帥命任惠堂微服前往，暗中予以保護。一
行人在人跡罕至的客棧內會了頭，而原來此客棧為
一黑店，掌櫃劉利華和其妻子聚集附近的山賊，專
對停歇客棧或過路的行人下手，謀財害命，官差知
悉後以此作為交易，要劉利華趁夜殺了焦贊，否則
押他法辦。四路人馬各懷鬼胎，就在漆黑的客棧內
展開靜靜的決鬥，任惠堂與焦贊亦接上了頭，聯手
制敵，一場廝殺終在黎明前劉妻擲出的長劍錯中劉
利華的背頸結束。

註
《喜怒哀樂》原為解決李翰祥的財務問題，而由李
翰祥、胡金銓、李行與白景瑞四位導演分別完成的
四段式電影。因時間短促，無餘裕發展劇本，胡金
銓直接將京劇中著名的武打折子戲「三岔口」電影
化，即片中《怒》段，並再次以客棧為背景，於封
閉空間內開展出精彩的打鬥畫面，場面調度尤為出
色。

Anger in Four Moods

1970 / color / 41mins
produced by Lan Tian Limited.co.
director / King Hu
screenplay / King Hu, Jiaxiao Xie
actors / Fugen Zhang, Huilou Chen, Jin Hu, Han Xue, Jian Cao
cinematographer / Qingqu Chen
art design / Xiaojing Li
editor / Chaoxi Wang
music / Dajiang Wu
action director / Yaokun Pan

General Jiao kills a man by mistake. Jiao is sentenced to exile and there are guards send him to the destination. The victim's father-in-law buys off the guards and intends to murder him on the road. Jiao's superior, General Yang, has sent Ren to protect him. All characters gather in a remote inn. The innkeeper and his wife are outlaws and they murder clients for money. The guards threaten the innkeeper to kill Jiao or he will be sent to the prison. Then all of them fight quietly in the dark inn. Ren and Jiao join forces to fight the enemy, the vicious fight ending just before dawn when Liu's wife throws a sword and accidentally hits Lihua Liu in the neck.

Note:
The film was made to solve the financial problem of Hanxiang Li. The four sequences are directed by Hanxiang Li, King Hu, Hsing Lee and Jingrui Bai separately. Each directed one sequence dedicated to one mood. Due the short time for preproduction, King Hu uses the story of a famous action sequence *Three-Road Junction* (*San Cha Kou*) of Beijing opera. Once again Hu uses the inn as the setting and the wonderful fighting scenes are shot in the closed space. His mise-en-scene technique is formidable in this short sequence.

胡導演說：「這個電影還有一個特點就是沒有先寫劇本，我要他們先搭好佈景，然後根據已有的佈景，我再來構想設計戲裡的動作。」

「客棧樓下略圖」為胡導演精心設計的「客棧」之空間平面圖，圖中繪有演員、鏡頭場面調度的動線。黃色線條代表活動景片（胡導演口中的「活片」），是用於拍攝時的可移動牆面；圈圈代表鏡位。

According to King Hu: "There is something special about this film, the script was written after setting was built. I ask them to build up setting first, and I think and design the actions and plots later, based on the setting just built."

This drawing is titled "rough drawing of the ground floor of the inn." It shows how King Hu designed the mise-en-scene of the inn, movements of actors and cameras. The yellow lines indicate the movable walls, which could be moved during the shooting. The circles indicate the camera positions.

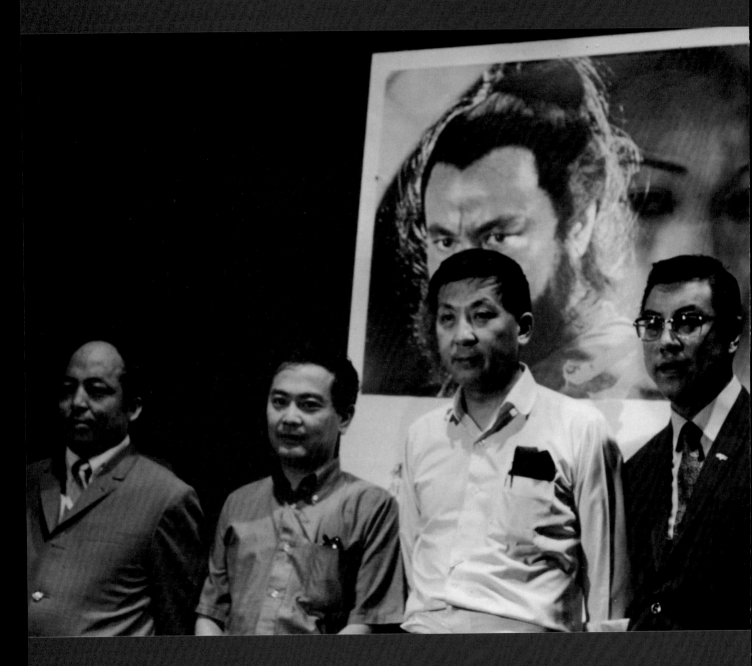

上圖 above
《喜怒哀樂》四位導演：白景瑞、胡金銓、李行、李翰祥
Four directors of *Four Moods*: Jingrui Bai, King Hu, Hsing Lee and Hanxiang Li.

右圖 right
《喜怒哀樂之怒》定裝照
Costume Fitting Photos of *Anger in Four Moods*

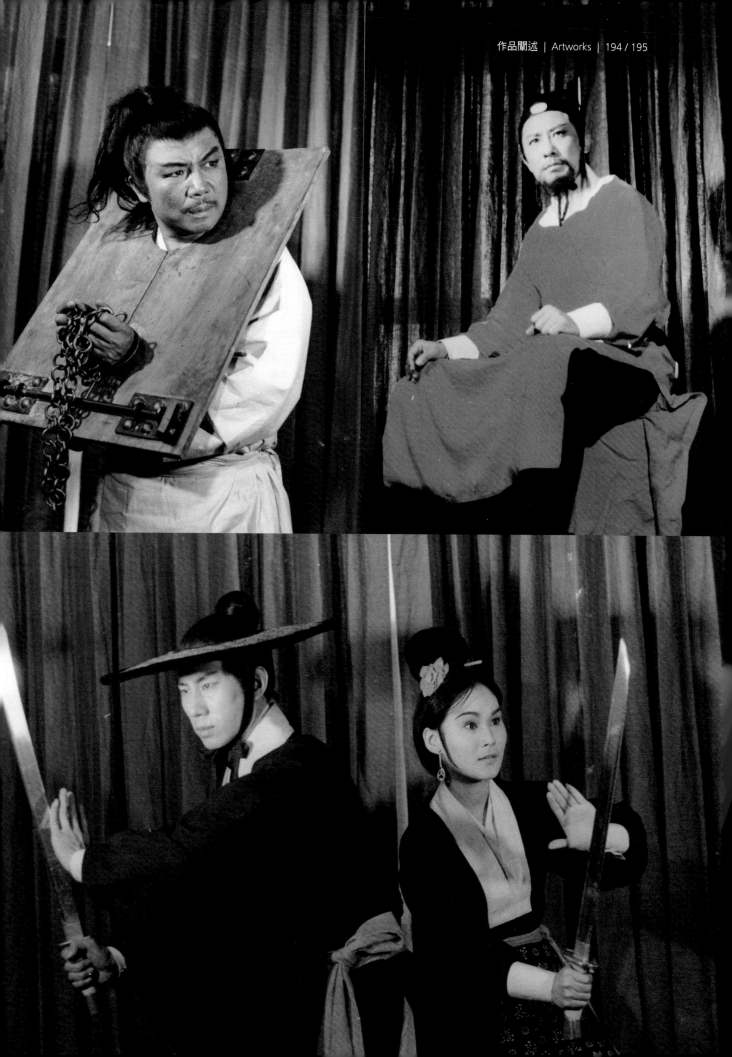

天下第一

1983／彩色／102 分鐘
出品／三一影視
編劇／胡金銓、小野、吳念真
演員／鄭佩佩、唐寶雲、崔苔菁、田豐、慕思成、曹健、華萱萱
攝影／周業興
美術／王童
服裝／胡金銓、王童
剪輯／汪晉臣
音樂／鄭思森

劇情摘要:
本片根據五代十國周世宗的史實重新改編。周世宗疑患有癲癇，長期服用道士丹藥，健康每況愈下，恍惚中口吐白荷之名。眼看北方軍事告急，南唐亦具威脅，宰相王樸及太監總管李長福命人潛入南唐走訪天下第一名醫張伯謹，展開層層相扣的連環套。張伯謹因邊關吃緊，出城不易，遂託守境友人放行，惟允以天下第一名家韋布衣的畫作相贈。韋布衣在寺中之壁作畫，獨缺畫中美女之貌，極思臨摹日前來寺參拜的天下第一美人白荷。白荷已成寡婦，算命師占卜白荷將再嫁與她玉珮成對之男子。王樸認出此乃皇帝身上的玉飾，只得再訪天下第一名盜丁。丁與其女在宴請契丹使者的酒宴上獻舞以偷玉飾，被白荷侍女懷疑、上前盤查，一陣慌亂的搶奪，丁女拋出樂器，正巧砸在皇帝的腦袋上，反解了天下第一的連環結。

All the King's Men

1983 / color / 102 mins
produced by Sunny Overseas Corporation
director / King Hu
screenplay / King Hu, Xiao Ye, Nianzhen Wu
actors / Peipei Zheng, Baoyu Tang, Taijing Cui, Feng Tian, Secheng Mu,
 Jian Cao, Xuanxuan Hua
cinematographer / Yexing Zhou
art director / Tong Wang
costume / King Hu, Tong Wang
editor / Jincheng Wang
music / Sesen Zheng

The film is based on a historical event in Five Dynasties and Ten Kingdoms period, in the 1st century. Shizong, the emperor of Later Zhou Dynasty, suffers from epilepsy and becomes addicted to the medicine prescribed by Daoshi Lee. His health is deteriorating. The loyal Prime Minister Pu Wang, worrying about the King's health, sends for the best physician Bojin Chang. Chang is blackmailed by the General who guards the gate. His condition to release Chang is that he will be rewarded with the painting by the most famous painter Buyi Wei. Unexpectedly Wei is confined in a temple to work on frescoes, and is unable to paint the angels without the most beautiful woman, Lotus, to inspire him. Lotus is a widow and told by a fortune teller that she will marry to the man who wears a jade circle similar to hers. The Prime Minister recognizes it's just like the Emperor's. To stop this from happening, he hires the most talented thief to steal Lotus' jade circle in the banquet. The banquet turns out chaotic. Then the daughter of the thief throws a musical instrument, hit the Emperor. All complication is resolved by this action.

本片是胡金銓睽違十多年後，再度為台灣的電影公司拍攝的古裝宮闈片，當年跟隨師父鄒志良搭建「龍門客棧」一景的王童導演，在此片擔任美術設計，並與胡導演共同負責服裝設計，師徒倆沒日沒夜的琢磨，讓此片雖沒有中影早期古裝片的氣派，卻更為精緻。兩人同年以此片獲得第二十屆金馬獎最佳服裝設計獎。

This film is a costume drama made by King Hu for a Taiwan film studio after more than 10 years. Tong Wang, who previously worked on building the sets of *Dragon Inn* with his mentor, Zhiliang Zhou, is artistic director for the film and also designed costumes with Hu. The two worked closely day and night. Though the film was not as grandeur as the early costumes dramas of CMPC, the result is more exquisite. They won the best costume awards of Golden Horse Awards in 1983.

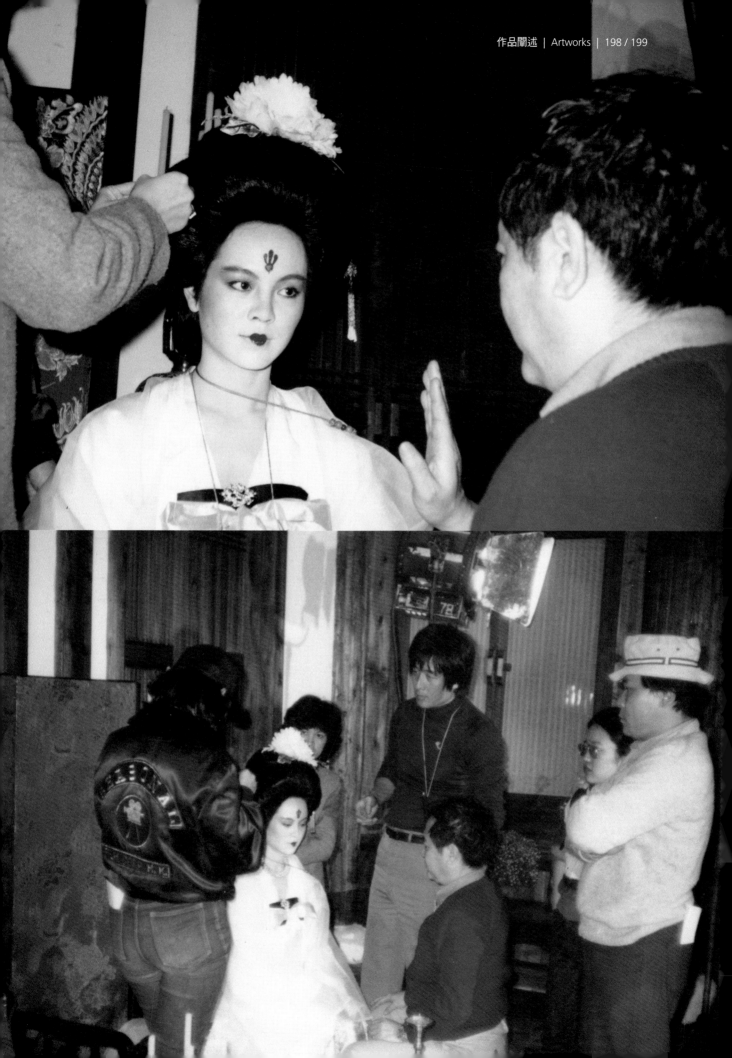

大輪迴

1983／彩色／103 分鐘
出品／台灣省電影製片廠
導演／胡金銓
原著／鍾玲
編劇／張永祥
演員／彭雪芬、石雋、姜厚任
攝影／林贊庭、周業興
美術／張季平
剪輯／周道淳、林善良
音樂／駱明道
武術／孫樹培

劇情摘要:
本片描述兩男一女的三世情緣,由胡金銓、李行、白景瑞三位導演合作,胡金銓所執導的是第一世。明朝,錦衣衛與宦官當道,把持朝政,阻絕諫路。馮瑞之父慘遭殺害,其未婚妻韓雪梅之父為求自保,將獨生愛女嫁給錦衣衛大官為侍妾。雪梅身懷祖傳魚腸劍,擬為國除害,錦衣衛隊長魯振一在路上迎接,途中逼迫雪梅交出寶劍,並欲侵擾;馮瑞率反抗義軍,屢次中途攔截;不料魯振一挾雪梅反向而行,前往探尋歸隱山中的師父、前義軍統帥盧子真。盧子真看穿魯振一想活捉他以換取賞金及兵力的詭計,服毒自盡前,交給魯振一塗有毒藥的義軍名冊,魯振一中毒眼瞎,馮瑞循跡趕至,雪梅為救馮瑞,擲出魚腸劍,卻誤中馮瑞,魯振一也同時將雪梅一劍穿心。

The Wheel of Life

1983 / color / 103min
produced by / Taiwan Film Studio
director / King Hu
story / Ling Chung
screenplay / Yongxiang Zhang
actors / Xufen Peng, Jun Shi, Houren Jiang
cinematographer / Zanting Lin, Yexing Zhou
art director / Jiping Zhang
editor / Taochun Zhou, Shanliang Lin
music / Mingtao Lou
action director / Shupei Sun

The three segments of the film are directed by King Hu, Hsing Lee and Jingrui Bai. The story is the love among two men and one woman crossing three generations. King Hu made the story of the first generation.

Feng's father is an upright official of Ming dynasty, and is killed by the powerful eunuchs and royal guards. Feng is engaged with Mei, a daughter of another official. Out of fear, Mei's father, offers her to the head of royal guards as his concubine in order to save his own life. Mei is on the road to marry, with a dagger, intending to kill the evil one. Mei is guarded by Lu, a captain of royal guard, to the capital. On the road, Lu forces Mei to hand in her dagger and tries to rape her. At this moment, Feng leads the resistance to rescue Mei. Lu abducts Mei and takes the opposite direction. They visit his master in the mountain. Lu's master sees through his treacherous plan and gives him a poisonous list of the resistance, then commits suicide. Lu is blind by the poison. Feng follows them and fights with Lu. Mei tries to save Feng but accidently kills him with the dagger. Lu manages to kill Mei at the same moment.

胡金銓東廠系列的最後一部，但胡導演武俠片中的重要元素仍盡情展現，只是女主角改由當時以學生電影走紅、氣質清新的彭雪芬擔任；書生轉為反抗義士，由當年的電視紅小生姜厚任擔綱；《龍門客棧》的俠客石雋成了錦衣衛，在片中演出大反派，總讓有情人不能成眷屬。石雋以本片獲得第二十八屆亞太影展最佳男主角。

This is the last of the Eastern Chamber series by King Hu, but the elements of Hu's martial art films are all present. The only difference is the female lead changed to the fresh and elegant Xuefen Peng, a popular star at the time. And the scholar character becomes an anti-communist patriot, played by Houren Jiang, a popular young actor. The swordsman in *Dragon Inn*, Jun Shi, played the royal guard, a villain who always prevents the lovers to unite. Jun Shi won the best actor award at the 28th Asia Pacific Film Festival.

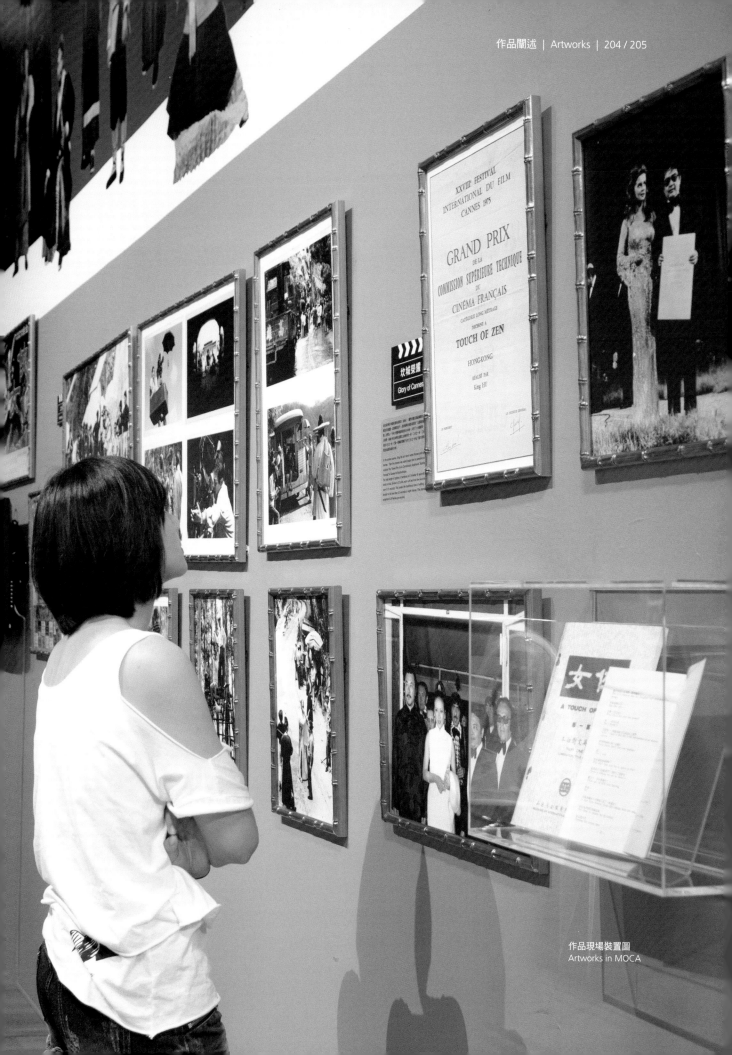

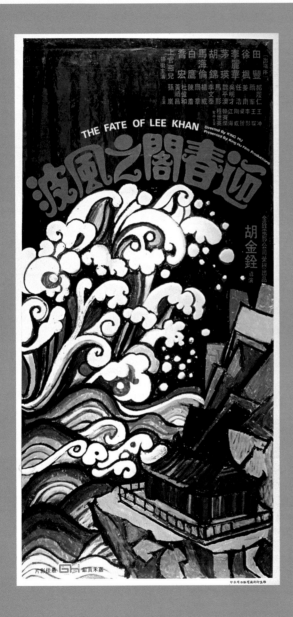

《迎春閣之風波》

1973／彩色／104 分鐘
出品／金銓電影公司
導演／胡金銓
編劇／胡金銓、王沖
演員／李麗華、徐楓、胡錦、茅瑛、喬宏、田豐、
　　　白鷹、韓英傑
攝影／陳朝鏞
剪輯／梁永燦
音樂／顧家輝
武術／朱元龍（即洪金寶）
© 獲星空華文傳媒電影有限公司授權

劇情摘要：
反元運動在朱元璋領導下日益高漲，但叛徒沈天松送信給河南王李察罕，說是可提供革命軍戰略圖。李察罕帶著妹妹李婉兒及衛兵曹玉昆等人踏上陝西之路，殊不知此行凶多吉少，所有陰謀、刺客全匯集於一行人即將落腳的客棧迎春閣，等候李察罕的到來。原來反元地下組織饅頭店的劉獲知此事後，聯絡迎春閣女掌櫃萬人迷，萬人迷先以美色設誘地方官都魯哈赤，又召來扒手黑牡丹、女騙子水蜜桃、藝人小辣椒及夜來香等老友喬裝婢女靜伺良機。客棧中敵我難辨，李察罕也派出文默齋一探虛實，反元志士王士誠與沙雲山亦混跡客棧，並以銅錢作為反元標記。在一陣取圖、搶圖的行徑中，李察罕對迎春閣的人起了疑心，揭發激戰的序幕，兩派人馬決戰荒野，黑牡丹等人相繼犧牲，婉兒和李察罕亦終於身亡倒地。

註：
《迎春閣之風波》為1970 年胡金銓回到香港自組「金銓電影公司」後，和嘉禾公司合作的首部影片。故事發生在各色人物交會的客棧，胡金銓在電影中喜歡用二層式布景，「因為這樣可以令畫面結構、動作處理，顯得有躍動感」，本片和《大醉俠》、《龍門客棧》合稱客棧三部曲。

The Fate of Lee Khan

1973 / color / 104 mins
produced by / King Hu Film Productions
director / King Hu
screenplay / King Hu, Chong Wang
actors / Lihua Li, Feng Xu, Jin Hu, Ying Mao, Roy Chiao, Feng Tian,
 Ying Bai, Yingjie Han
cinematographor / Chaoyu Chen
editor / Yongcan Liang
music / Joseph Koo
action director / Sammo Hung

In the late years of Yuan Dynasty, the anti Mongolia movement is led by
Yuan chang Zhu. Yet Zhu's staff, Tian song Shen , betrays and intends to
contribute the war map to the Mongolian Baron of Henan, Khan Lee. Lee
and his sister, Waner Lee, are on their way to pick up the map. The anti-
Mongolian organization knows about this, and tries to stop them. Wendy,
the innkeeper and the resistance fighter, invites her friends to disguise
as waitresses in Spring Pavillion. Other revolutionaries also come for the
map and use bronze coins as their sign. There are repeated attempts to
steal the map in the inn. It's hard to tell the good from the evil. Khan Lee
begins to suspect the people of Spring Pavilion and fighting erupts. In the
end, two sides have the finale fight in the wilderness. Wendy's friends fall
in succession and, finally, Waner and Khan Lee are also killed.

Note:
This film is regarded as one of "the Inn trilogy" of King Hu, along with
Come Drink with Me and *Dragon Inn*. It's the first film made by King Hu
after he returned to Hong Kong and founded King Hu Productions. The
story sets in the inn where all characters gather. King Hu likes to use two-
storey inn as his setting, which gives a jumping and lively sense to the
action and composition.

胡導演的服裝造型皆有所本,是經過縝密的考據,以寫實為基礎所設計出來的,有別於當年其他的武俠片,也因此胡導演認為他拍的是古裝動作片。

All costume designed by King Hu is based in detailed research and made in a realistic manner. This is different from other martial art film at that time, so Hu regards the films he made are costume action films.

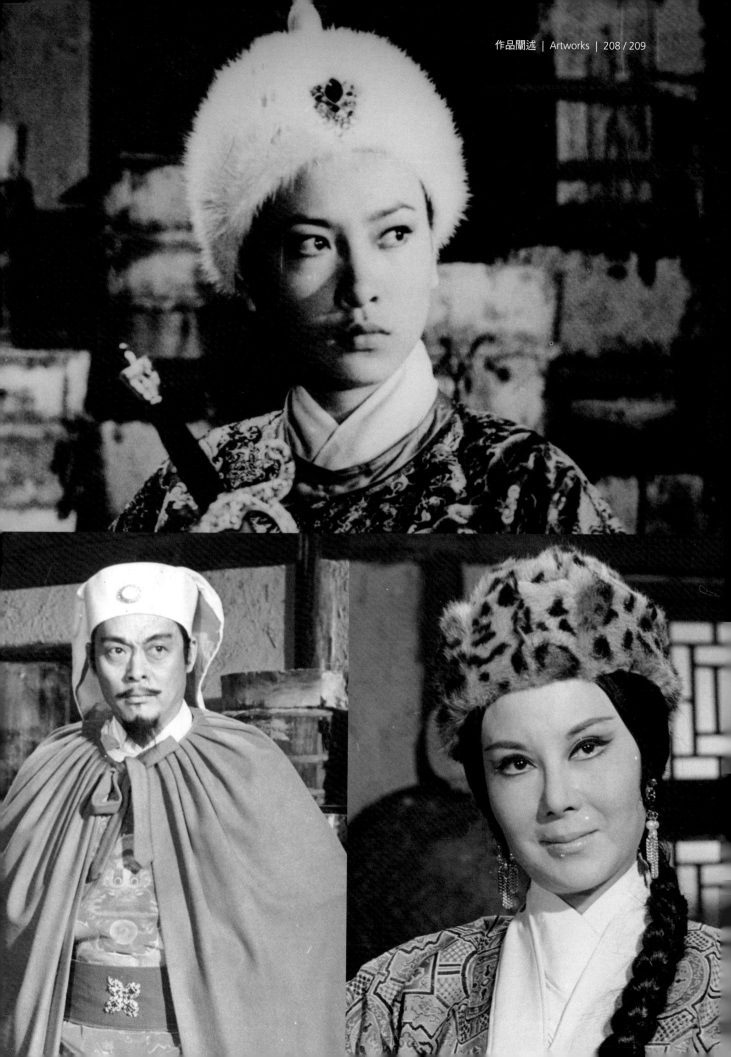

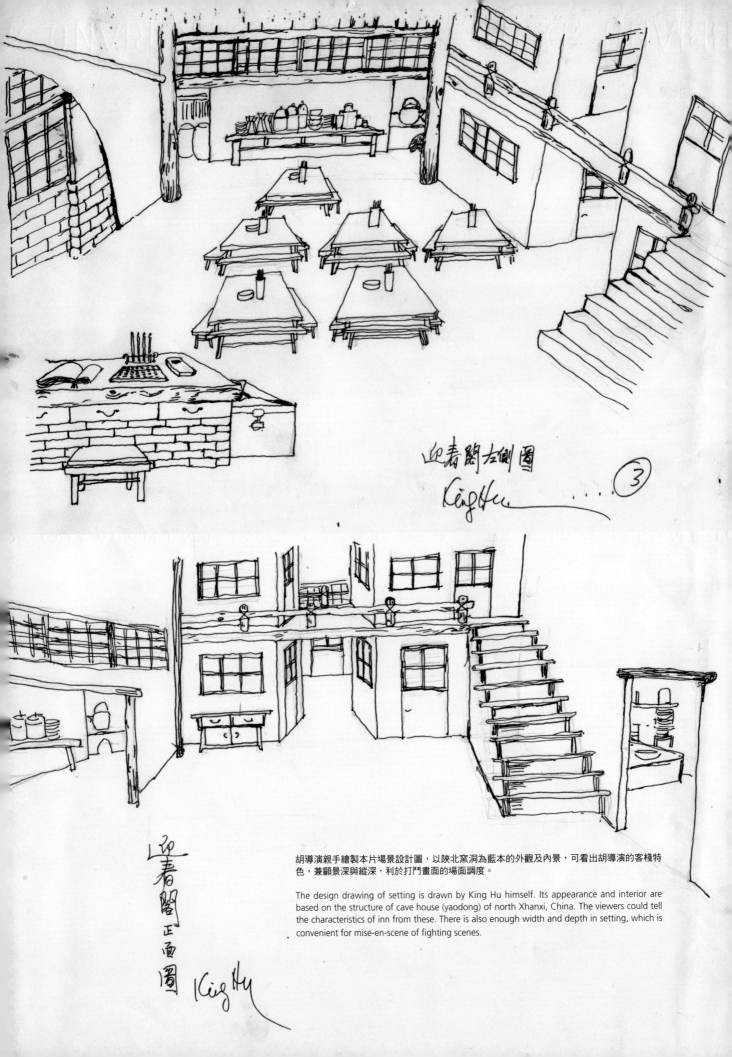

迎春閣左側圖

King Hu

③

迎春閣正面圖

King Hu

胡導演親手繪製本片場景設計圖，以陝北窯洞為藍本的外觀及內景，可看出胡導演的客棧特色，兼顧景深與縱深，利於打鬥畫面的場面調度。

The design drawing of setting is drawn by King Hu himself. Its appearance and interior are based on the structure of cave house (yaodong) of north Xhanxi, China. The viewers could tell the characteristics of inn from these. There is also enough width and depth in setting, which is convenient for mise-en-scene of fighting scenes.

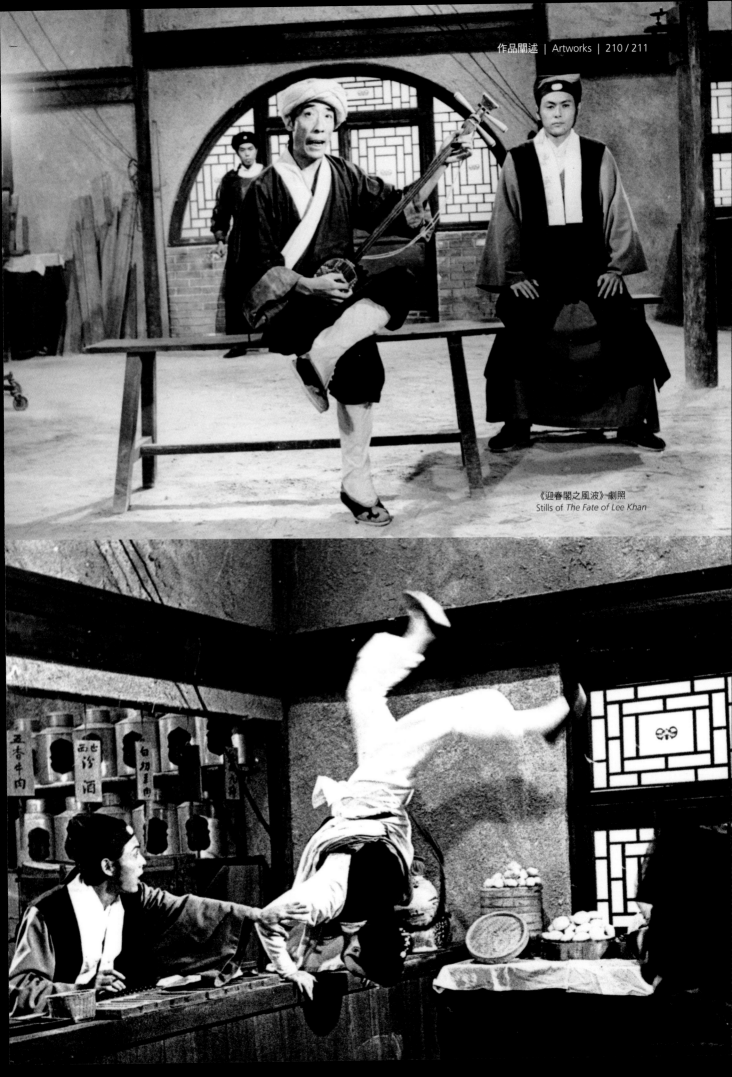

《迎春閣之風波》劇照
Stills of *The Fate of Lee Khan*

忠烈圖

1975／彩色／104 分鐘
出品／金銓電影公司
導演／胡金銓
編劇／胡金銓、王沖
演員／徐楓、白鷹、喬宏、吳家驤、韓英傑、
　　　朱元龍、吳明才
攝影／陳清渠
武術／朱元龍

劇情摘要:
明朝嘉靖年間，閩浙沿海一帶倭寇流竄，作惡多
端，尤以許棟及日人博多津為首的走私集團最烈。
因倭寇與地方官乃至朝廷官宦亦有所通，實難徹底
清除。皇上為清剿倭寇，遂命朱紈為浙江巡撫，朱
紈又找來機智權謀的俞大猷，委以重任。俞將軍召
集民間高手伍繼園夫婦、謀士湯克儉等一行七人，
喬裝商人設計誘敵。七人以笛聲傳訊，圍棋示意攻
略等計，成功截擊倭寇，後因地方官搶功攔截而前
功盡棄。伍氏夫婦設計誘出與倭寇勾結之官宦，又
偽裝投誠，勇入虎穴，並在賊巢小現身手略逞對方
高手，更假意欲殺俞大猷輸誠。最後，伍氏夫婦領
將士至倭寇之大本營，在島上決一死戰。

註:
《忠烈圖》展現胡金銓對軍事攻略的趣味。外景皆
在香港外海小島，卻拍出險峻偉岸之勢，其佈局、
取景、人物造型均可圈可點。借古諷今的劇情，更
讓人會心。

The Valiant Ones

1975 / color / 104 mins
produced by King Hu Film Productions
director / King Hu
screenplay / King Hu, Chong Wang
actors / Feng Xu, Ying Bai, Roy Chiao, Jiaxiang Wu, Yingjie Han,
 Sammo Hung, Mingcai Wu
cinematographor / Qingqu Chen
action director / Sammo Hung

The story sets in Ming dynasty. The Japanese and Chinese pirates attack
the South East coast area of China. The pirates bribe the local officials and
high rank officials in the court and so it's difficult to eradicate them. The
Emperor appoints Wan Zhu to eliminate the pirates. Zhu finds General
Yu to carry out the mission. Yu summons the valiant ones to attack the
pirates. Yet the local officials intercept and the action fails. The valiant
ones then disguise and set traps to lure the hidden corrupted officials.
They play with the pirates by pretending to surrender. Finally, the two
sides have intense fights on the island where the pirates hide.

Note:
This film shows King Hu's interest in military strategies. It's shot in
remote island of Hong Kong. Yet the images are just like shot in high
mountains. Its composition, camera positions, and costume are excellent.
Furthermore, King Hu also uses the plots of the ancient incident to
criticize the contemporary circumstances.

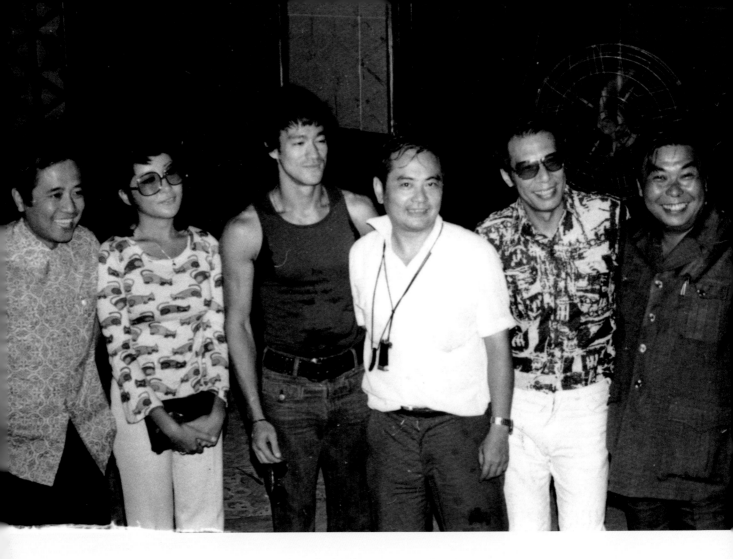

影片在香港離島拍攝期間，兩位導演老友
李翰祥、李行特去探班。在香港嘉禾片廠
拍攝時，知名功夫巨星李小龍、嘉禾總裁
鄒文懷也前往探視。

When *The Valiant Ones* was shooting in
a remote island in Hong Kong, King Hu's
old friends, directors Hanxiang Li and
Hsing Lee went to visit on location. When
Hu shot in Golden Harvest studio, the
famous star, Bruce Lee and the President
of Golden Harvest, Raymond Chow went
to visit Hu.

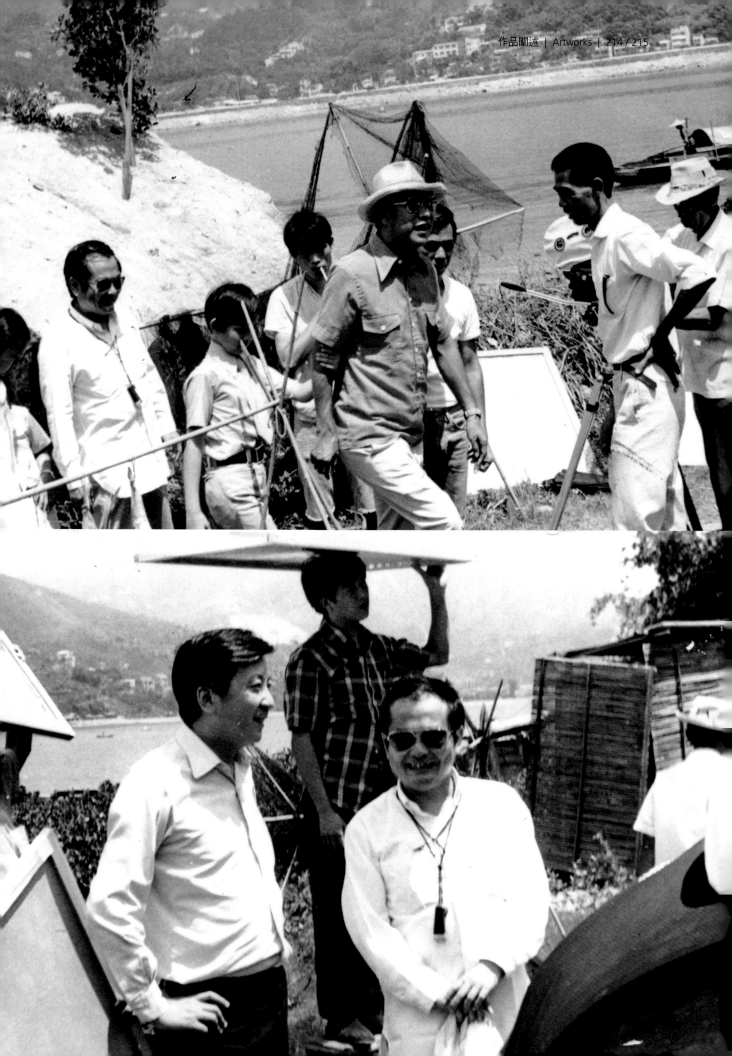

本片武術指導韓英傑、洪金寶師徒除協助武打動作設計外，也擔任大反派武功高強的倭寇角色，其功力來自彈簧床和胡導演的鏡頭與剪接技法。

The action directors are Yingjie Han, the master, and his disciple, Sammo Hung. Other than designing choreography of actions, they also played the villains, pirates with excellent Kung Fu. This illusion is created by the spring pad and King Hu's camera and editing techniques.

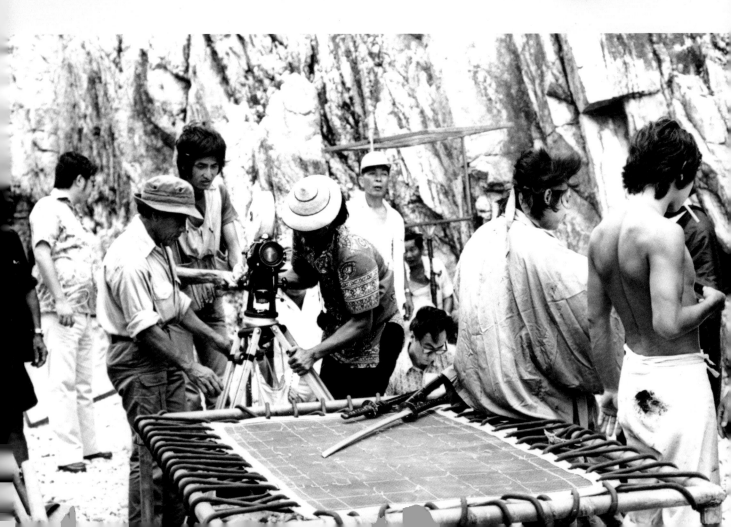

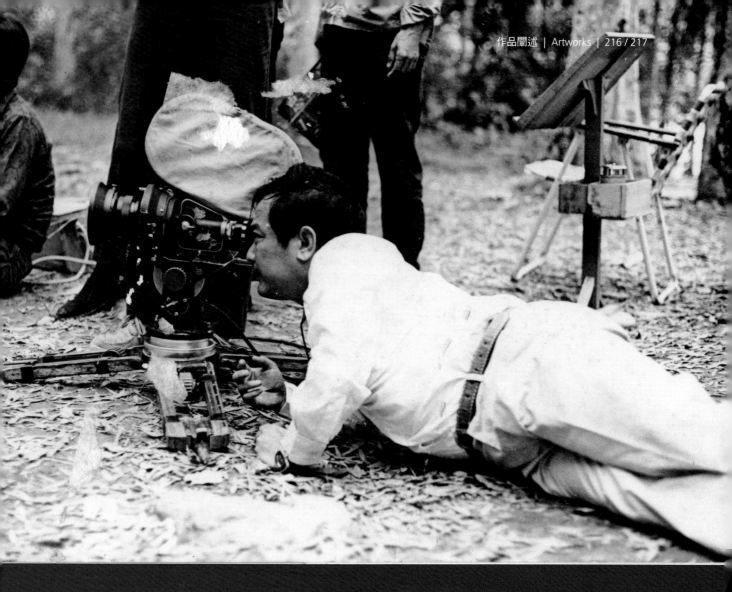

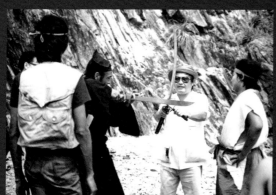

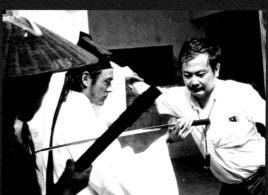

《忠烈圖》工作照
Working Shots of *The Valiant One*

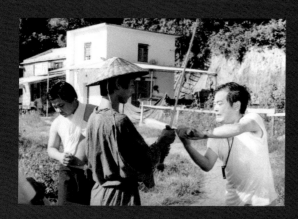

動畫手稿區

本區展出內容，包括史上首次完整公開的胡氏動畫創作手稿，以及策展團隊特別製作的動畫箱，除了讓觀眾瞭解動畫的視覺暫留原理，也希望引導觀者見識胡氏眾多手稿背後的原創與先鋒意義、人文與想像空間，和藝術與美學企圖。

胡金銓是多才多藝的人物典型，除了電影之外，他的繪畫才華與設計巧思同樣備受肯定。受母親的啟蒙，使他從小熱愛繪畫，並擅長將此興趣與事業和生活結合。早年他初入電影圈時所從事的工作就是場景設計、電影海報設計等美術相關工作。1950 年任職長城電影公司時，他的主任即是 1941 年製作中國第一部長篇動畫《鐵扇公主》導演之一的萬古蟾，他與萬籟鳴等四兄弟被譽為中國動畫創始人。後因胡金銓積極朝電影創作發展，把繪畫興趣和電影專長結合的動畫創作拍攝計畫，直到 1980 年以後才終於有了一些眉目和初步行動。

《張羽煮海》源自元人同名雜劇故事，描述人界書生與神界佳人突破困難與波折的愛情故事。胡金銓旅居美國時偶爾參觀海洋博物館，總是被各種長相奇特的魚類所吸引，又聯想到卡通片特別能夠表現神奇想像，便萌生將張羽煮海故事拍攝成卡通動畫片的強烈念頭。為此他多次回到美國聖地牙哥水族館寫生以採集素材，並著手揣摩戲中需要的各種角色，親自以素描、水彩、水墨繪出魚蝦原型和擬人化後之造型，從真實的海底世界去建構想像的龍宮場景，從中累積演化出了整部動畫的構想。在一次訪談中，胡金銓提到，他雖不懂動畫的技術，但是大約有十年的時間他陸續進行著這部動畫相關的角色設計和分鏡圖，說明了他對動畫製作是饒有企圖的。胡金銓一度與台灣宏廣公司洽商合作，將《張羽煮海》拍攝成院線版的 90 分鐘卡通長片。後因故計畫未現，他接受朋友建議將其改編成西洋版的劇本《深海傳奇》，又名《深海的戰爭與和平》，並重新繪製了劇中的各個角色造型。

Animation Drawings

This area exhibits the first ever complete King Hu's animation drawings on public display. The zoetrope is specially made to provide viewers with an understanding of the persistence of vision principle . It also contributes to an in-depth experience of the original creativity, imagination, and artistic design behind these drawings of King Hu.

King Hu was the classic example of a Renaissance man, a man of many talents. Besides making films, he was also recognized as a brilliant painter and an ingenious designer. Inspired by his mother, from a young age he was passionate about painting, and skillfully managed to integrate this interest into his work and life. In the early years when he entered film industry, his work comprised of designing sets, posters, and other art related works. In 1950, he served in the Great Wall Film Company, his manager Guchan Wan, was one of the directors responsible for producing the first animation of China, *Princess Iron Fan*, in 1941. Guchan Wan, Laiming Wan, and another two brothers were hailed as the pioneers of Chinese animation. Later on, due to his ambition in filmmaking, King Hu did not develop his interest in drawing and professional filmmaking skills any further. It wasn't till after 1980, that he finally gathered some ideas and started to take action to animation projects.

The original story is adapted from *Zhang Yu Boils the Sea*, a story of zaju, a form of poetry from the Yuan dynasty, and tells the story of a romance between a scholar from the human world and a beautiful woman from the world of the gods. When King Hu visited San Diego Sea World in USA, he was attracted by all the fishes with peculiar looks. In the meantime, he thought that animation could make one's imagination come true, so he came up with the idea of making an animated film of the sea world. Hu started to research the marine animals, making many visits to the aquarium, and picked the ones that would be suitable to be characters in the film. First he drew the sketches, watercolor drawings, and Chinese ink washings of the marine animals, then designed the characters. Based on the real undersea world he created the setting for Dragon Palace in his imagination and this evolved into the idea of making a full animated film. In an interview, Hu said that he was not familiar with animation techniques but he had worked on the characters and storyboards for this animation for over 10 years, showing how determined he was to complete this animated film.

Then, Hu worked with Wang Film Productions in Taiwan and intended to make a 90-minute animation feature of the story. Since the animation project with Wang Film was not successful. King Hu followed advices of friends and rewrote the story as *The Boiling Sea* and re-designed the characters in western style.

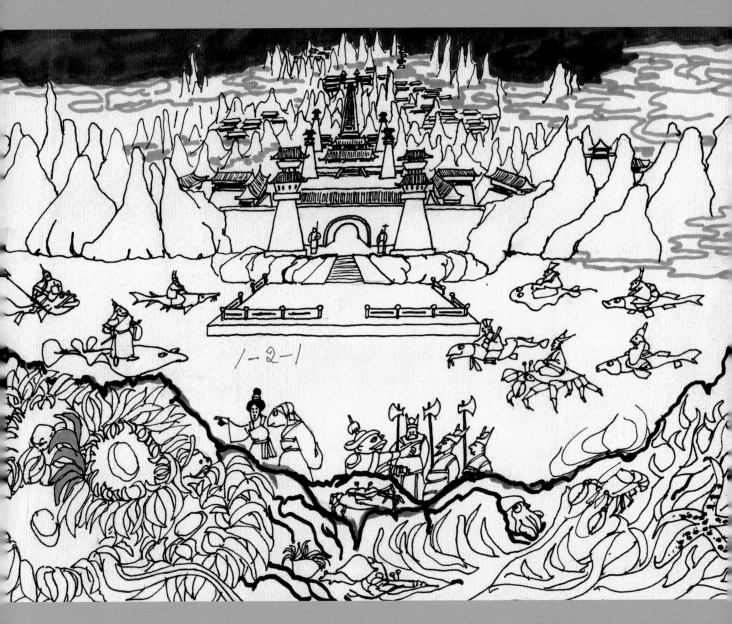

《張羽煮海》手稿
Drawings of *Zhang Yu Boils the Sea*

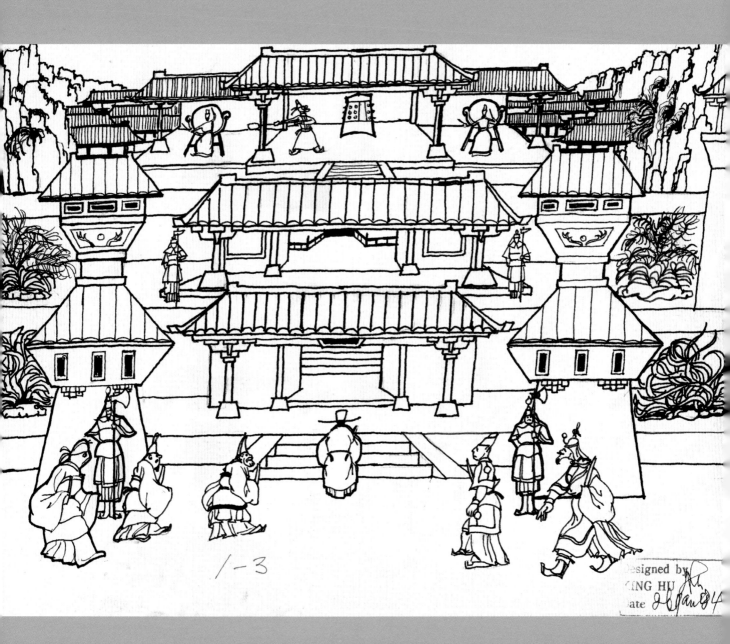

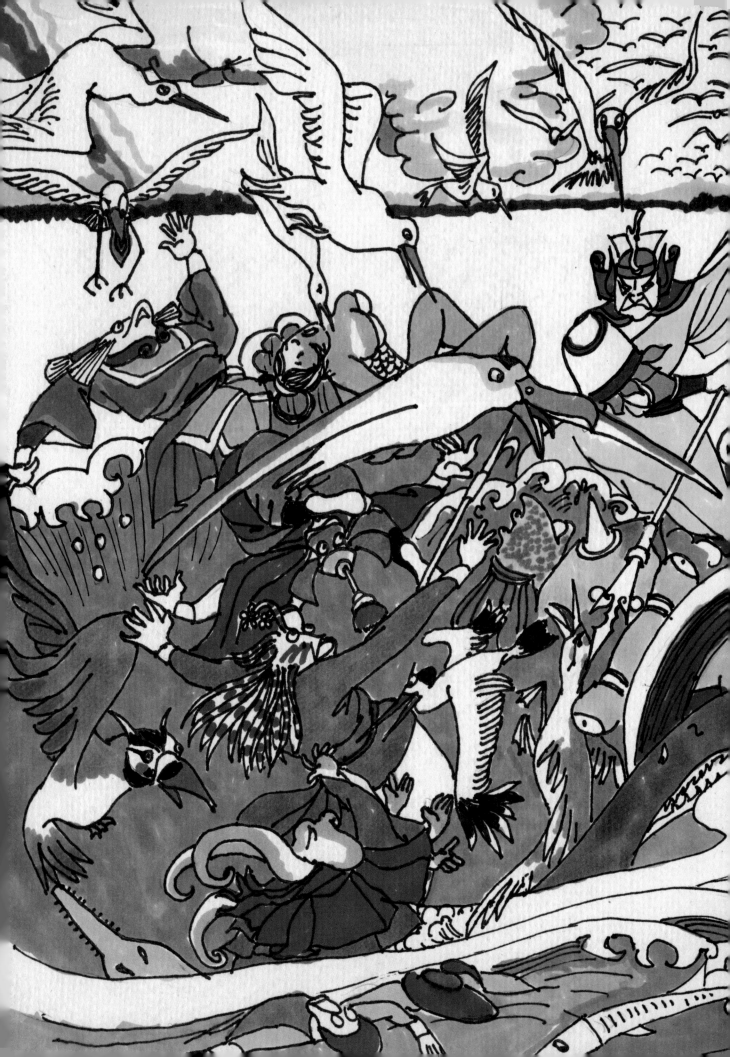

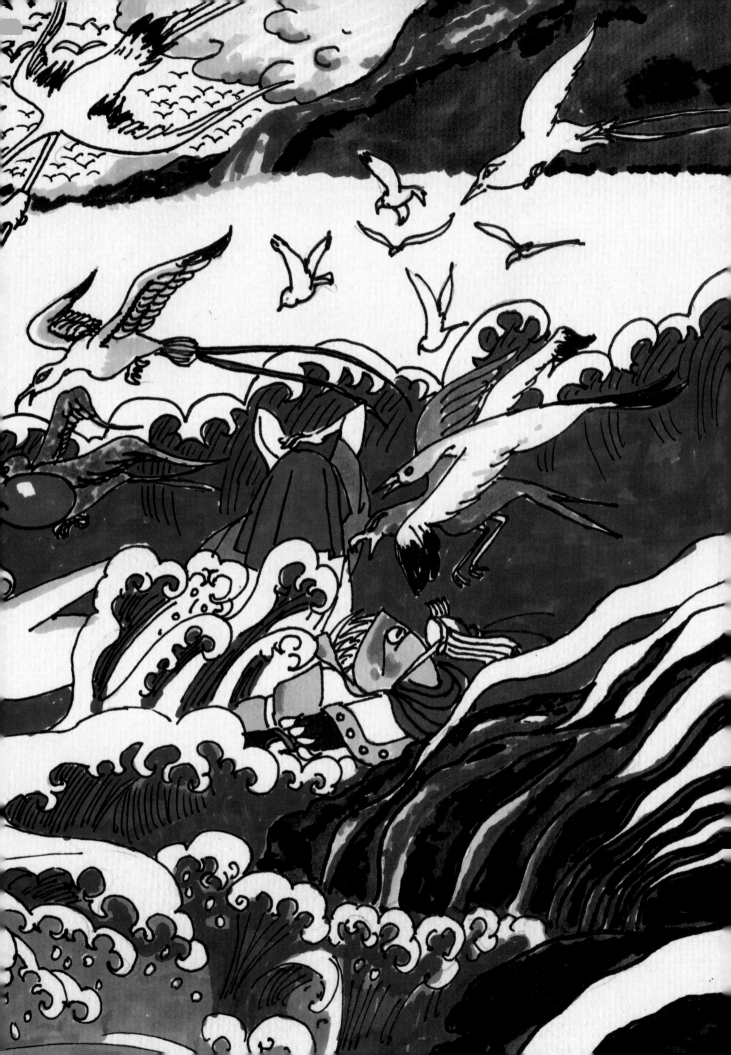

《張羽煮海》手稿
Drawings of *Zhang Yu Boils the Sea*

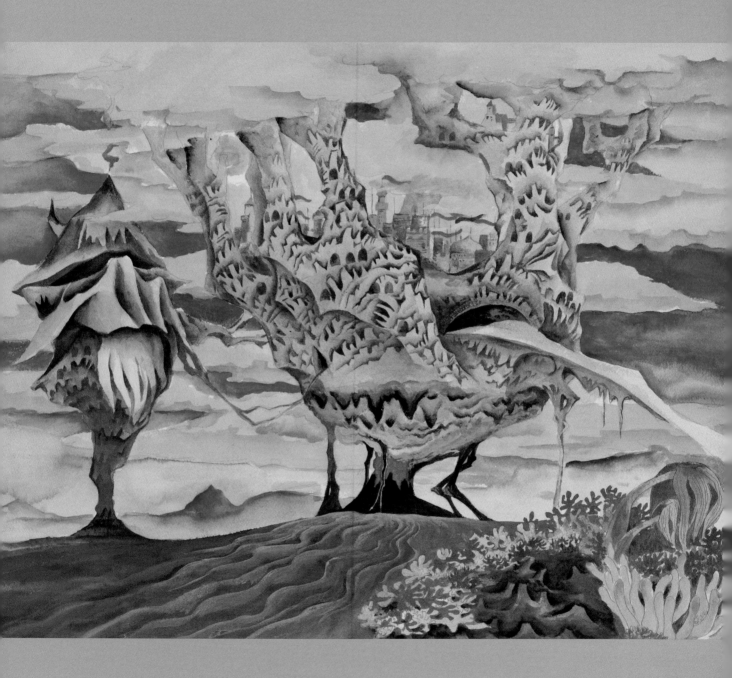

西遊記
The Golden Monkey

海底的戰爭與和平
The Boiling Sea

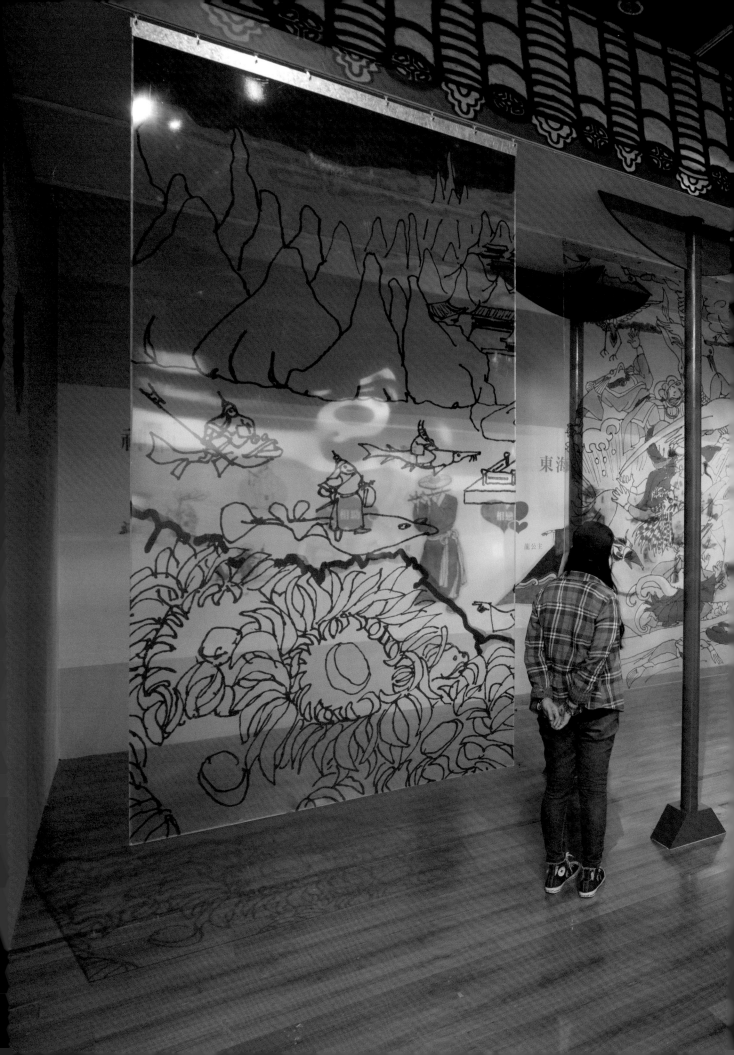

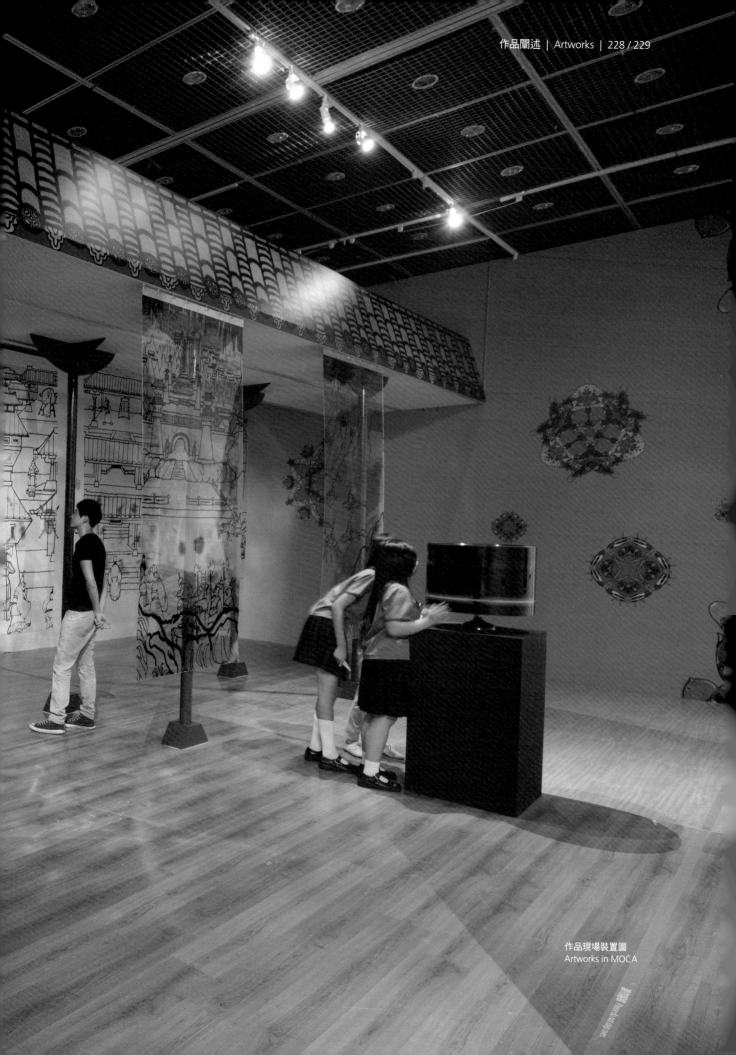

人類

張羽

相戀

龍公主

作品闡述 | Artworks | 230 / 231

作品現場裝置圖
Artworks in MOCA

漫畫再現區

本區展出的是胡金銓的漫畫創作，80年代以後，胡金銓沉潛定居於美國期間，基於對時代與社會的敏感以及個人無時不在繪畫熱情與幽默，陸續創作發表了這批人物與四格漫畫。透過這些以政治人物與社會現象為題材的作品，可以回看當年活躍於國際舞台的風雲人物如柯林頓總統、伊莉莎白女王、達賴喇嘛、葉爾欽……等人，在胡氏筆下賦予之什麼樣的造型風格，又給了什麼樣的春秋論斷。

胡金銓的漫畫風格線條簡潔、構圖俐落，看似談笑用筆，卻每每隱藏著或幽默調侃的機智，或嘲諷批判的寓意，從充滿政治意味的美國與北韓之間亦敵亦友的曖昧關係，抑或中共傀儡式的政治體系，乃至於美國與日本之間的經濟競爭，抑或是英國查爾斯王儲與卡蜜拉過往甚密的關係等等時事趣聞，都是胡金銓「畫」的對象，他的諷刺手法犀利卻不刻薄，頗有傳統文人磊落大方的風範，對此，其前妻作家鍾玲的評語：金銓的畫……畫筆所捕捉的，卻是人間的、閒適的、情趣洋溢的一剎那……不啻為最佳的註腳。

漫畫再現區作品特請國際政治專家，現聯合報副總編輯郭崇倫先生撰文導讀。

Caricatures and Comics

This area displays the caricatures and comics created by King Hu. After the eighties, King Hu retreated to settle in the US. Due to his awareness of the times and society, and his constant drawing with enthusiasm and humor, he created and published this batch of caricatures and comics. The themes he used were taken from current affairs relating to politicians and social phenomena. From these caricatures, it is possible to look back in time and see those playing big roles in the international arena, such as President Clinton, Queen Elizabeth, Dalai Lama, and Boris Yeltsin. King Hu endowed them with differing styling, and gave them a judgment.

In terms of style, the caricatures of King Hu had clean lines, tidy compositions, and seem as if they were drawn in laughter and jest. However, his various anecdotes often concealed wit, humorous ridicule, or implied criticism, they featured the politically charged and ambiguous relationship between the US and North Korea, the puppet like system of Chinese Communism, the economic competition between the US and Japan, as well as the close relationship that existed between Prince Charles and Camilla. King Hu used satire in a sharp but not in cruel way, he had an above broad and generous demeanor, rather like that of the traditional literati. As such, his ex-wife writer, Ling Chung made a statement of judgment, which is as good as the best of footnotes: "in the drawings of King Hu… all that his pen captures comes from human observation, he leisurely depicts individual moments filled with delight…"

The works featured in the caricatures and comics area are annotated by the international political analyst, Deputy Editor-in-chief, United Daily News Mr. Chen-Lung Kuo.

查爾斯王儲與黛安娜王妃1992年12月9日正式分居，之前兩人關係因為查爾斯與卡蜜拉過從甚密，已經出現裂痕，黛安娜後來接受訪問時，就表示婚姻之間出現第三者，「是有些擁擠」。此兩幅應為左右並列，顯示卡蜜拉1993年致電查爾斯，表示自己身上已刺繪了「威爾斯王子御用」徽章，查爾斯知道英國民意非常反對兩人在一起，聞訊嚇了一跳。

Prince Charles and Princess Diana officially separated on December 9th, 1992, and prior to the demise of their marriage, their relationship was already unstable due to intimacy between Prince Charles and Camilla. In an interview of Diana, she expressed that, "There were three of us in this marriage, so it was a bit crowded." These two pieces are to be juxtaposed next to each other, and show that in 1993 Camilla phoned Prince Charles and told him that she had gotten a tattoo of an emblem of "for the exclusive use of the Prince of Wales". Prince Charles was startled by this, as he was aware that the British public was very much against their affair.

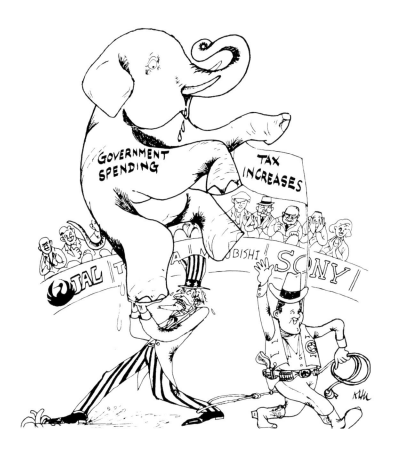

從八〇年代中期開始,日本經濟有逐漸超越美國的趨勢,尤其在柯林頓政府的第一任,預算超支,受赤字拖累,但是國會又受到反對黨共和黨所控制,不同意加稅,當時的美國雖想增加政府支出,促進經濟,但是受到國會扯後腿,日本公司則在旁訕笑圍觀。

Since the mid 80's, Japanese economy was gradually surpassing that of the U.S., and especially during Clinton's first term of presidency, the government's over expense caused increase in debts. However, the congress was overpowered by the opposing Republican Party, which was against tax increase. At that time, although the U.S. wanted to increase government spending to boost the economy, it was held back by its congress, whereby the onlookers of Japanese companies snickered in ridicule at the side.

這四幅漫畫雖然繪於不同時期，但是可以合在一起，看出美國與北韓打交道的歷程；美國（柯林頓）原本指責北韓（金正日）背後發展核武（1），結果發現他僅是唬人（2），大喜過望的華盛頓開始與平壤談判，希望能用援助換取北韓放棄發展核武（3），結果沒想到，北韓核武計畫竟然是真的（4）。

Although these four comic works were created at different times, however, they could be placed together to offer a narration of the exchanges between the U.S. and North Korea: The U.S. (Bill Clinton) accusing North Korea (Jong-il Kim) of developing nuclear weapons in secrecy（1）, and to discover later that he was only bluffing（2）; overjoyed by the discovery, Washington D.C. began negotiating with Pyongyang, with the hope of offering aid in exchange for North Korea's agreement to give up developing nuclear weapons（3）; to its surprise, North Korea's nuclear weapon program turned out to be active（4）.

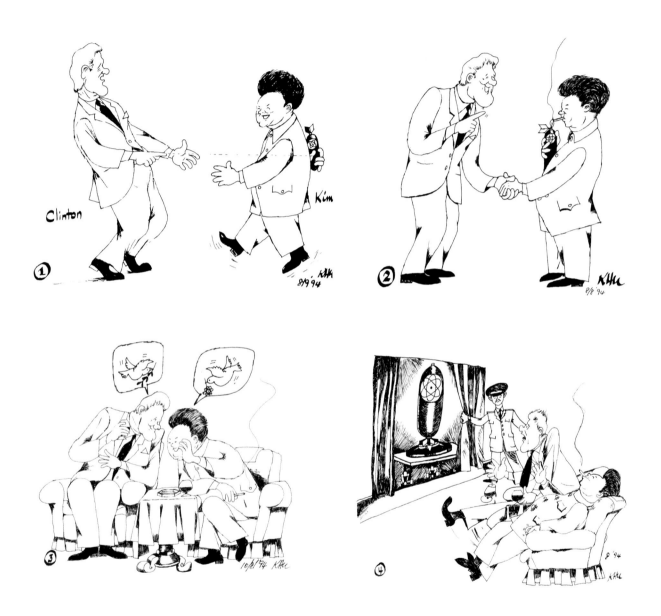

中共檯面上的人物，無論是國家主席江澤民，或是總理李鵬，事實上是由幕後的元老們，鄧小平、陳雲、姚依林等人所操控，上幅可以看到鄧雙手操線，其他有權操線的也只有陳雲而已，但是1992年十月召開的中共十四大，決定取消元老組成的中顧委，下幅即在傳達，沒有了操偶師之後，線偶們不知道該怎麼辦，有的仰頭仍然期待指示，有的則累累如喪家之犬，擔心被秋後算帳。

The distinguished figures of the Chinese Communist, whether being President Zemin Jiang or Premier Peng Li, were in fact all controlled and manipulated by the party's senior veterans behind the scene, such as Xiaoping Deng, Yun Chen and Yilin Yao. The top piece shows Deng's hands controlling the marionette strings, and there was only one other person, Yun Chen, who also had control of the strings. However, in October 1992 during the Fourteenth National Congress of the Central Advisory Commission, it was decided that the Central Committee of the Communist Party of China comprised of these veterans would be dismissed. The bottom piece shows that without these puppeteers, the puppets appear lost, with some looking up searching for instructions and others looking distraught like stray dogs, and they are filled with the fear of retaliation.

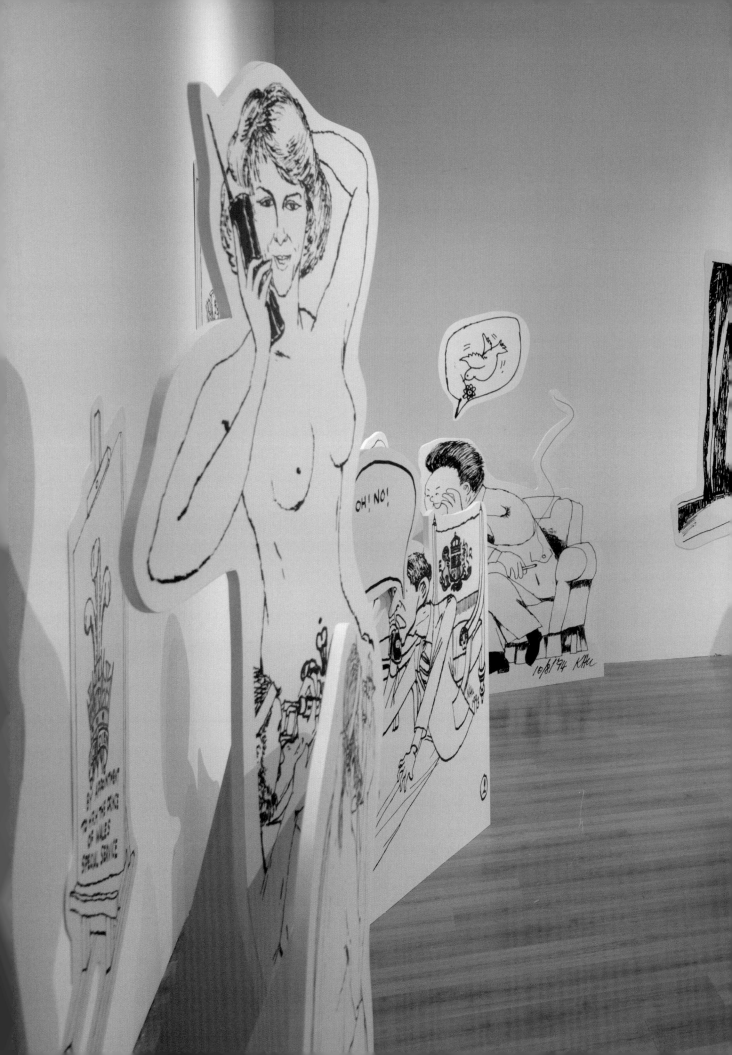

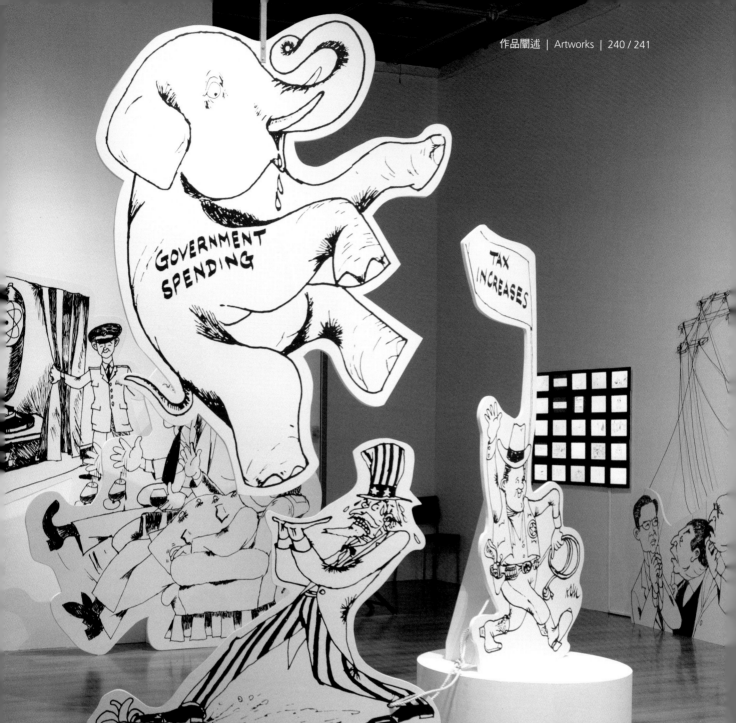

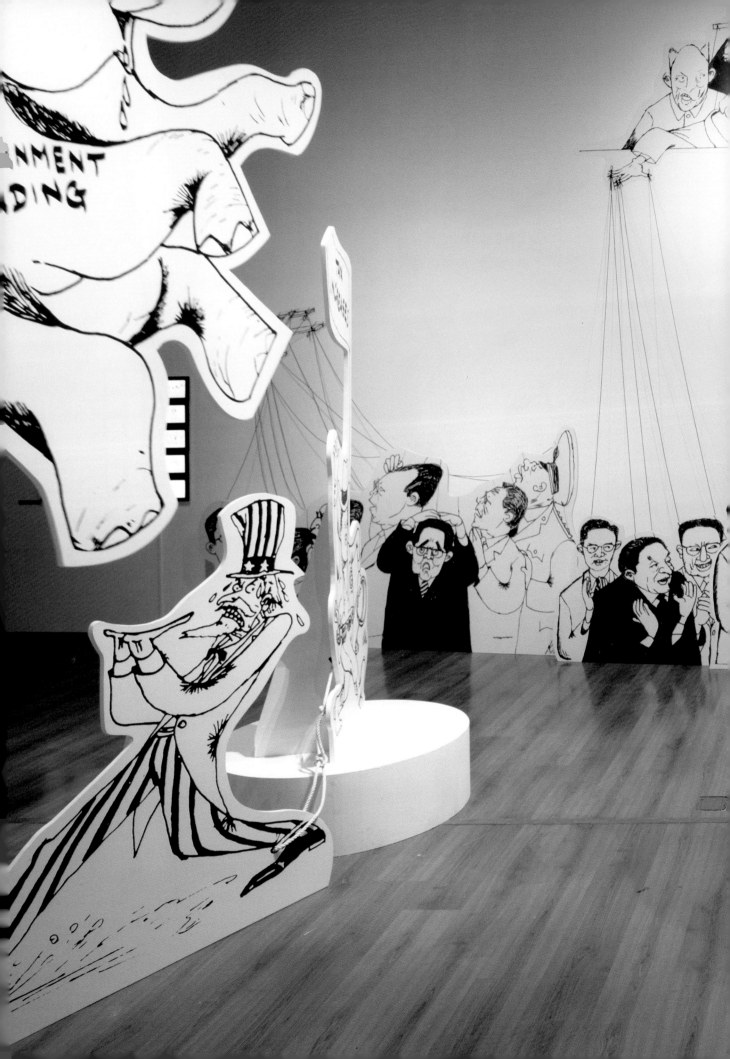

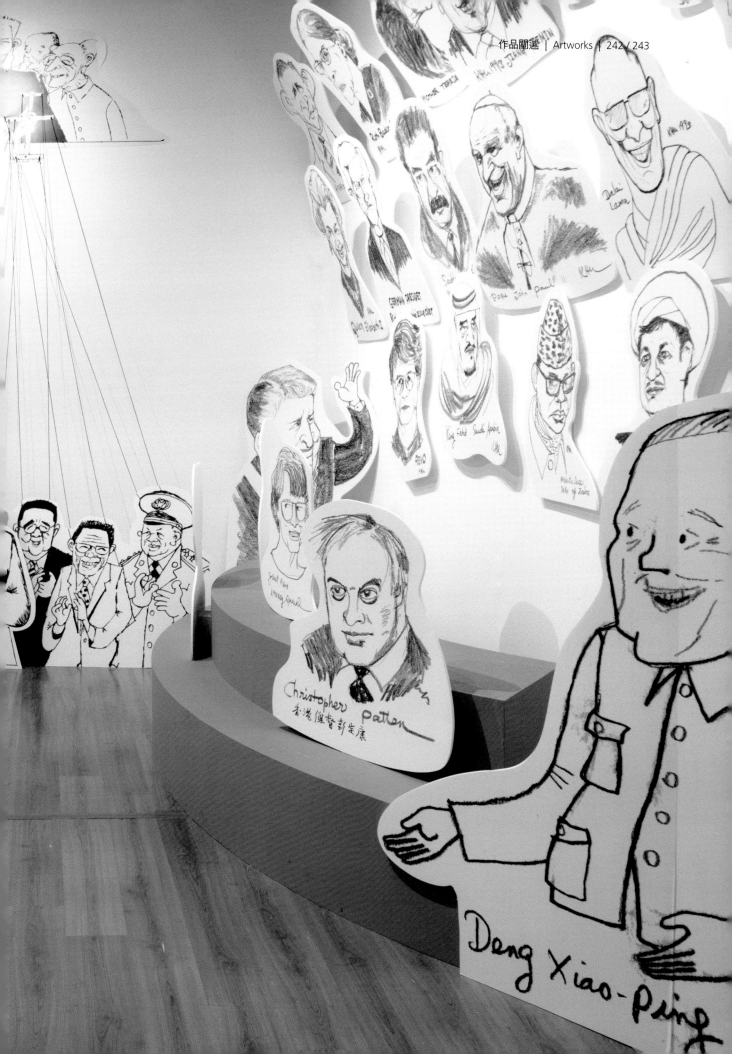

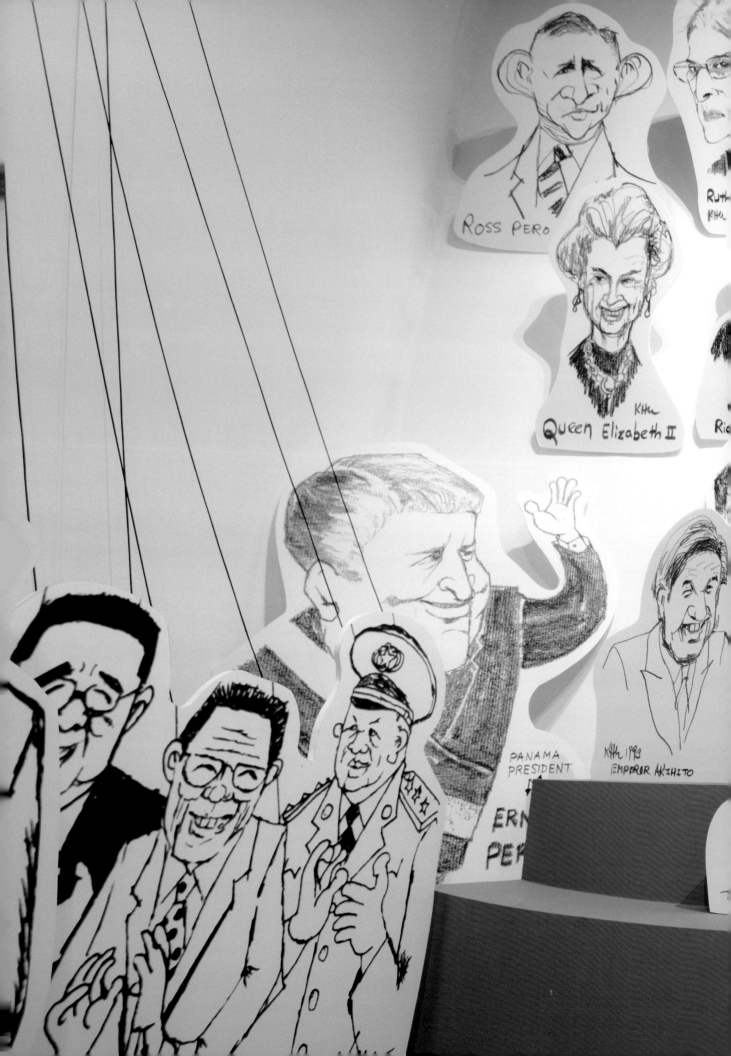

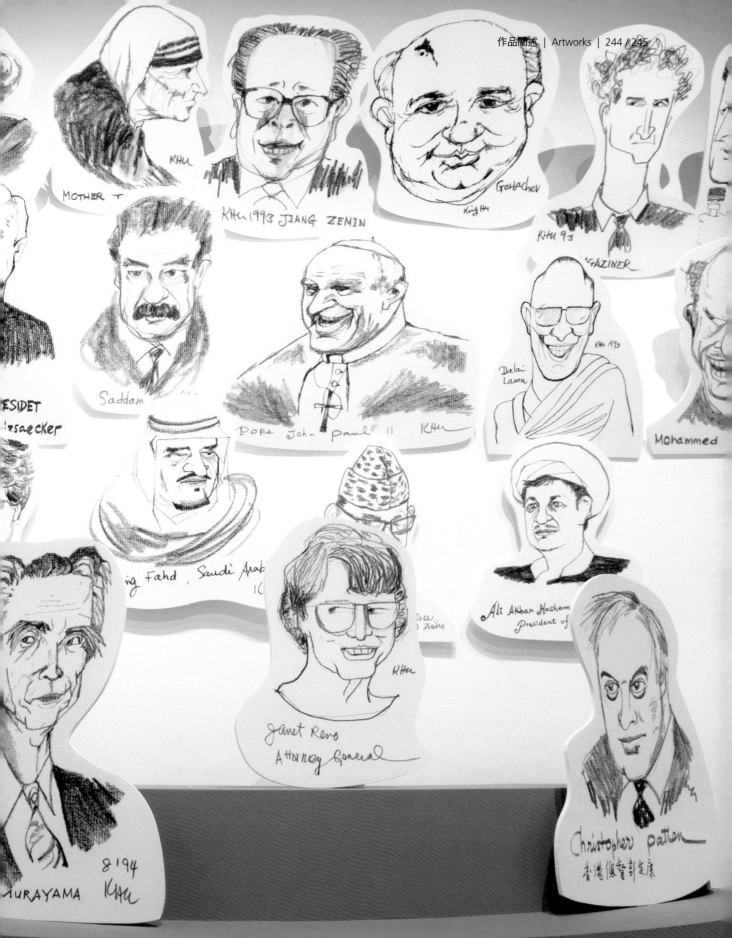

MOTHER T

KHu

KHu 1993 JIANG ZEMIN

Gorbachev

King Hu

KHu 93

GAZINER

ESIDET
izsaecker

Saddam

Pope John Paul II KHu

Delai
Lama

KHu 1993

Mohammed

ng Fahd, Saudi Arab
10

Sese
Zaire

Ali Akbar Hashem
President of

Janet Reno
Attorney General

KHu

Christopher patten
香港總督彭定康

URAYAMA 8194
KHu

未完成的故事
Unaccomplished Projects

胡金銓一生除了動畫片之外，還有兩部未完成的電影－《華工血淚史》和《無冕皇后》，這兩部片對其別具意義，因此，在展覽最後，策展團隊特別為胡導演佈置了一張空的導演椅，對望著《華工血淚史》相關的文獻資料，以及牆上刻著大大的「劇終」二字，彷彿曲終人散，回過頭卻看到胡金銓另一部未完成的作品《無冕皇后》的試拍片段，一旁女主角張艾嘉現身說法，述說著《無冕皇后》的故事情節和胡金銓的小故事，像是所有事情仍還在進行中。

《華工血淚史》是胡金銓於1982年開始策畫的大部頭電影，故事講述1870年代參與加利福尼亞州的「聯合太平洋鐵路建築工程」的華人移民故事，五位華人勞工被騙到那裡進行鐵路工程，卻得不到薪水，於是決定前往三藩市，希望可以籌到回中國的船費。途中經過金礦場便開始學著白人採金礦，因按照古法傳說流傳的方式挖掘，真的尋找到了金礦，卻被美國人趕走；之後他們來到了瑞典人的礦場，一樣找到了豐富的金礦，但當瑞典人要把他們趕走時，他們決心反抗，利用陷阱、圈套和投石器等古法，把持有槍枝機械的瑞典人趕走了，獲得最後的勝利。

然而《華工血淚史》因所需資金龐大，一直到1996年底才獲得英國Goldcrest公司同意投資一半資金，由張家振、吳宇森擔任執行製片，並獲周潤發同意擔任主角，仍須尋找另一家美國發行商再出資一半。原定於1997年四月開拍，一直到1997 年胡金銓因心臟導管氣球擴張手術失敗逝世，《華工血淚史》仍未來得及開拍。

As well as an animation, Hu left two film projects unaccomplished when he passed away: *The Battle of Ono* and *The Uncrowned Queen*, two films that meant a lot to him. So the curatorial team has placed an empty director's chair at the end of the exhibition that faces the *Battle of Ono* related literature, with "The End" in big letters on the wall, as if the film is over and the audience will leave. However when they turn, they see the test film of *The Uncrowned Queen* and Sylvia Chang gives the film's plot and tells stories about King Hu as if the film is still being made.

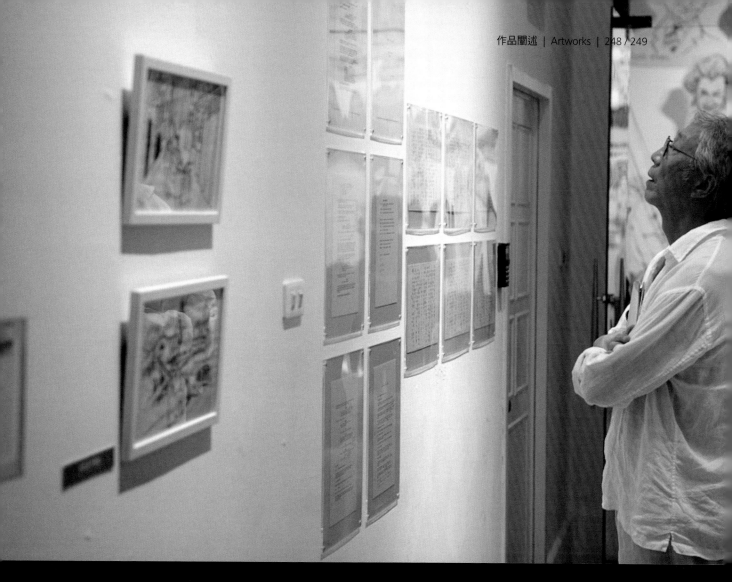

作品現場裝置圖
Artworks in MOCA

The Battle of Ono was a major project King Hu began planning in 1982. The film would have told the story of Chinese migrants workers who worked on the Union Pacific Railway in California. Five of these coolies are cheated and are not paid, they decide to make their way to San Francisco to try to make money to pay for their journey back to China. In their way they copy the white people and begin to look for gold, but use an ancient Chinese method and actually find gold. But they are forced away by the white people; they move to a mine run by Swedes and find a rich seam of gold again. But the Swedes also try to drive them away; this time they decide to resist and drive away the gun-toting Swedes, using traps and tricks and sling shots, achieving final victory.

Because of the large amount of capital needed to make *The Battle of Ono*, the funds weren't raised until 1996 when Goldcrest of the UK put up half the money. Terence Chang and John Woo came on board as executive producers and big HK star Chow yun-fat had agreed to play the male lead. But they still need to find a US distributor to cover the other half. Filming was first due to start in April 1997; when Hu's coronary angioplasty operation failed and he died on January 14, 1997. The project of *The Battle of Ono* remains unaccomplished.

張艾嘉談最後的《無冕皇后》

About the Last Work of King Hu,
The Uncrowned Queen
by Sylvia Chang

胡導演帶著我去維也納參加電影節，我們帶了一位攝影師，去拍了一個片段，他本想拍成電影，叫《無冕皇后》（又稱《維也納事件》），這部片子是他一直以來想拍的一個故事，是關於女記者的片子，他的藍圖是黃珊。但他加了個片段，是講這個女孩年輕的時候在大陸有一位對她影響很深的老師。可是文革的時候，她卻出來批鬥這位老師。

文革結束後，這個女孩到了香港，後來又輾轉去到國外。之後兩人都出現在維也納，這位老師是教文學、藝術的。兩人在維也納遇上。這個女孩很害怕，就逃；但這位老師就在後面一直追著她、一直跑著想要追上她。她以為這位老師是不是要報復？但老師其實不是要報復……。

胡導演就想拍這個《無冕皇后》。就在追逐當中，那位老師心臟病突發，於是這個女孩過去扶他，他就跟她說，這些事情都過去了，那是大時代的問題，跟個人沒有關係，只是時代把人也扭曲了。

他就想拍這個戲，我們在維也納拍了些外景，他演老師，我演無冕皇后。我是最後一個跟胡導演演戲的，回來以後，他還讓我看毛片，那個片子漂亮到……，因為維也納的空氣太好了，人的皮膚是透的。所以就想知道，那個片子現在在哪裡？如果可以找到這段片子，那真的是太好了，那個紀念性會有多大！

King Hu and I attended a film festival in Vienna. We went with a cinematographer to shoot a sequence. Hu wanted to make a feature out of this and titled "*The Uncrowned Queen.*" The story is based on the experience of a female reporter, Shan Huang, and Hu added some fictional part. It talks about when Huang is young, there is a teacher (played by King Hu) influences her deeply, yet she picks on her teacher during the Culture Revolution.

After the Culture Revolution, Huang goes abroad. Then they run into each other coincidentally in Vienna. She is terrified and runs away. But the teacher keeps chasing her, trying to get her. She thinks the teacher wants to get revenged. That, however, is not his intention. During the chase, the teacher has a heart attack, then Huang turns around and helps him. He said to her, let everything bygone be bygone, it's not her fault, it's the circumstance of the times. It's just the revolution has twisted the human mind.

Hu wanted to make this film and we shot several scenes on location in Vienna. Hu played the teacher and I, the female reporter. I am the last one who performed with the master. After we returned, he showed me the dailies. It was just beautiful, the air in Vienna is so clean and the skin looks like shining. Where is that test film? If we could find the reel, that will be just great. And it'll be something we could memorize Hu with.

特別活動
Special Events

開幕記者會—俠女俠客再現當代
Opening Press Conference – Swordswomen and Swordsmen in MOCA

「胡說：八道—胡金銓武藝新傳」於7月3日下午二點舉行開幕記者會，曾經與胡金銓導演合作的知名影視工作者鄭佩佩、石雋，以及胡金銓導演的姪女胡維堯女士特別遠道前來，共襄盛舉，暢談往昔情誼，參與本次展覽的藝術家陳昌仁、葉錦添也蒞臨現場，媒體出席踴躍，爭相採訪報導。

The opening press conference for *King Hu: the Renaissance Man* was held on July 3rd at 2:00pm. The event was graced by the presence of many renowned figures in the film industry who have worked with Director King Hu, including Peipei Zheng, Jun Shi, and Hu's niece, Weiyao Hu. They talked ardently about their past experiences and friendship with Hu, and were also joined by contributing artists of the exhibition, Leo Chanjen Chen and Tim Yip. It was an event with great turnout of the media.

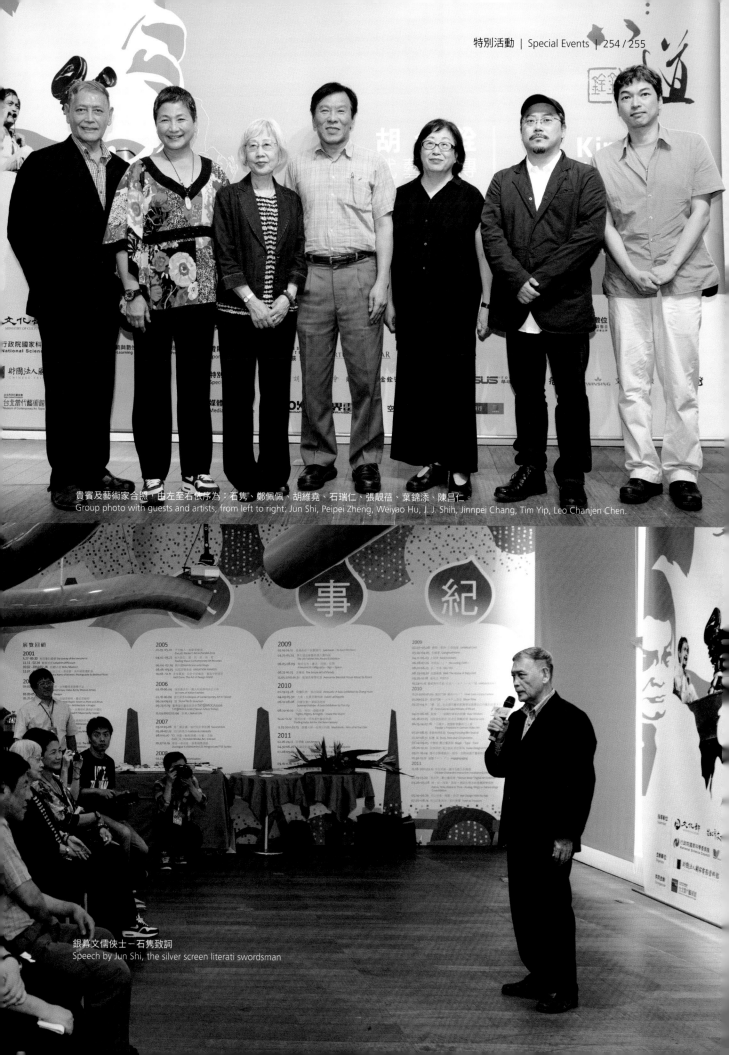

貴賓及藝術家合照，由左至右依序為：石雋、鄭佩佩、胡維堯、石瑞仁、張靚蓓、葉錦添、陳昌仁。
Group photo with guests and artists, from left to right: Jun Shi, Peipei Zheng, Weiyao Hu, J. J. Shih, Jinnpei Chang, Tim Yip, Leo Chanjen Chen.

銀幕文儒俠士－石雋致詞
Speech by Jun Shi, the silver screen literati swordsman

開幕晚會—仲夏星光熠熠思故人
Opening Night -
A Star-Studded Summer Memoriam

本展為搭配本次展覽濃濃的懷舊武俠風格，特地選於戶外廣場舉行開幕晚會，現場在《山中傳奇》悠揚的樂音中開啟晚會的序幕。胡金銓導演的弟子們更難能可貴於當代館齊聚一堂—鄭佩佩、岳華、徐楓、石雋、張艾嘉等人聯袂出席晚會，追念恩師提攜之情；胡金銓導演的姪女胡維堯和外甥郎雲，專程撥冗出席；文化部政務次長許秋煌、台北市文化局局長劉維公，以及胡導在港台的諸多友人，如作家舒國治、卜大中、資深攝影師華慧英、台北藝術大學戲劇系主任黃建業等人也到場觀禮，感懷故人，足見胡金銓導演一生影響力之深遠。晚會在貴賓們同齊揮舞木劍時達到最高潮，展覽於眾星破幕儀式後，隆重盛大開展。

In conjunction with the nostalgic martial arts ambience of this exhibition, the organizers held the opening night in its outdoor plaza, opened with the splendid music from the film, *Legend of the Mountain*. With the attendance of Peipei Zheng, Hua Yue, Feng Xu, Jun Shi, Sylvia Chang, amongst others, it was a rare occasion for Hu's disciples to gather together at MOCA Taipei, as they remembered and talked about their teacher's kindness in helping them thrive in the film industry. Hu's niece Weiyao Hu and nephew Yun Lang made a trip to Taipei just to attend the event. Additionally, George Chiu-huang Hsu, Administrative Deputy Minister, Ministry of Culture, Weigong Liu Commissioner, Department of Cultural Affairs, Taipei City, and many of Hu's friends from Taiwan and Hong Kong, such as writers Kuochih Shu, Dazhong Pu, veteran cinematographer Huiying Hua, Edmond Wong Professor of Department of Theatre Art, Taipei National University of the Arts, amongst others also attended the event to join others in remembering the master. The great turnout of the night showed the profound influence of Hu still imparts, and as the night progressed to the climax with the stars and guests swinging their wooden swords, the exhibition officially opened.

開幕晚會胡金銓弟子、家屬代表及藝術家
合照，前排左起依序為：岳華、張靚蓓、
張艾嘉、李志希、葉錦添，後排左起依序
為：郎雲、石瑞仁、徐楓、華慧英、胡維
堯、鄭佩佩、石雋、李長安、陳昌仁、葉█
怡利。
Group photo with King Hu's disciples█
family members, and artists; front row█
from left to right: Hua Yue, Jinnpei Chang█
Sylvia Chang, Ben Lee, Tim Yip; back row█
from left to right: Yun Lang, J.J. Shih, Feng█
Xu, Huiying Hua, Weiyao Hu, Peipei Zheng█
Jun Shi, Changan Li, Leo Chanjen Chen, Y█
Li Yeh.

開幕儀式，貴賓手持木劍，化身俠客█
女。由左至右依序為：許秋煌、朱文清█
岳華、徐楓、張艾嘉、鄭佩佩、劉維公█
華慧英、李志希、李長安、胡維堯、葉錦█
添。
Opening ceremony with guests holding█
wooden swords and transformed into█
swordswomen and swordsmen. From█
left to right: George Chiu-huang Hsu█
Wen-ching Chu, Hua Yue, Feng Xu█
Sylvia Chang, Peipei Zheng, Weigong Liu█
Huiying Hua, Ben Lee, Changan Li, Weiyao█
Hu, Tim Yip.

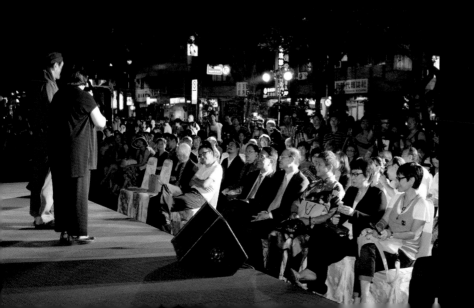

台北當代藝術館館長石瑞仁、電影資料館█
館長張靚蓓開幕致詞。
Speech by Executive Director of MOCA█
Taipei J.J. Shih and Director of Chinese█
Taipei Film Archive, Jinnpei Chang.

特別活動－
手繪電影看板畫師現地創作
Special Event –
Onsite Painting of Movie Billboards

配合本次展覽的懷舊風格，本展邀請著名的手繪電影看板畫師顏振發，特地從台南北上，於開幕前二天進行現地創作，連夜完成《俠女》、《大醉俠》、《空山靈雨》等三幅近兩公尺高的電影看板。

擁有四十年繪製經驗的顏振發師傅，先從圖稿開始丈量比例，以分割區塊的方式，將整張畫面用原子筆繪製出數個正方及三角形。第二步驟再將上好底色的畫布，精密地測量實際看板的尺寸，並用粉筆施作畫面的切割，依照圖稿的各個區塊和比例，細膩畫出電影角色的輪廓。

接著進入到油漆上色階段，講求作畫光線飽和度的顏師傅，不畏室外35度的高溫，堅持在陽光充足的當代館門口進行創作，此引起參觀民眾的興趣，驚喜地靜靜欣賞繪師的創作實況，甚至還有粉絲們體恤顏師傅的辛勞，特別分享飲品為他加油打氣，讓現場充滿歡笑和溫馨的氣氛。

上色完成之後，師傅再以勁拔的揮毫氣勢寫下電影片名一一完成三幅看板。顏振發師傅筆下唯妙唯肖的人物，喚起了民眾早期觀影的美好時光為觀眾帶來一場豐富的視覺饗宴。

To go along with the nostalgic style of this exhibition, the organizers invited renowned movie billboard painter Zhenfa Yan from Tainan to paint on-site two days prior the opening. He has completed three billboards, nearly two-meter high, dedicated to *A Touch of Zen*, *Come Drink with Me*, and *Raining in the Mountain*.

Yan has extensive forty-year experience in painting. He first measured the original poster and divided it into squares and triangles with a ballpoint pen. The next step was to take a primed canvas and carefully measured

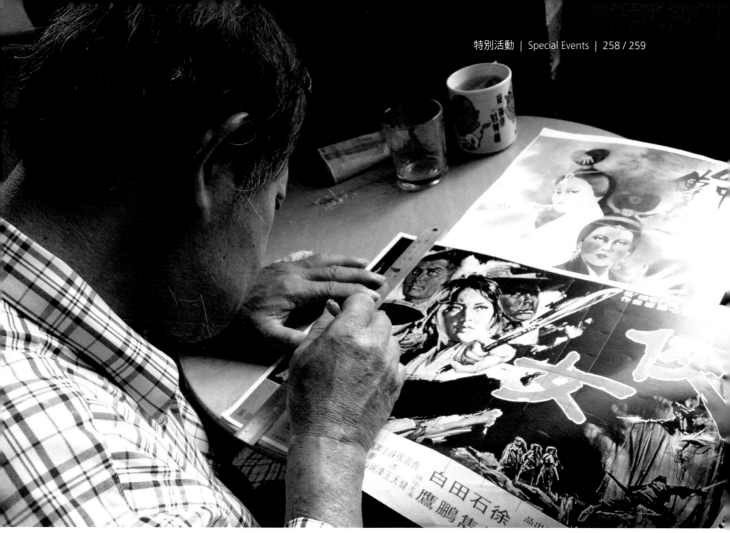

先在圖稿上以尺和筆將畫面分割為小區塊。
Begin with dividing the poster into small sections with a ruler and pen.

the actual size of the billboard and to draw out the dividing lines base on the sections and ratios of the poster, and then to proceed to paint out the details of the characters.

When coloring with paint, Yan is most particular with the brightness and saturation of his work; therefore, despite the 35 Celsius degree heat, he still insisted on painting by the gate of MOCA Taipei under the bright sunlight. Visitors of the museum were drawn by his creation and gathered in amazement and quietly observed his art creation on-site. There were also few fans appreciated his efforts, they offered the master drinks, and the painting process was filled with joy and warmth.

After the completion of coloring, Yan wrote down the title of the film with his remarkable brush work, and the same steps were taken until all three billboards were completed. The characters created by Yan were so vivid they brought to the public a visual feast, and brought a sense of nostalgia of seeing movies in old times.

40年的紮實功夫，兩三筆便畫出俠女銳利的眼神。
With his solid 40 years of experience, the sharpness in the swordswoman's eyes was effortlessly created.

畫師不畏室外高溫，一筆筆刷出俠女風姿。
Despite the scorching heat outside, the master created the magnificent swordswoman stroke by stroke.

現地創作過程引起眾人圍觀。
People were drawn by the live creation on-site.

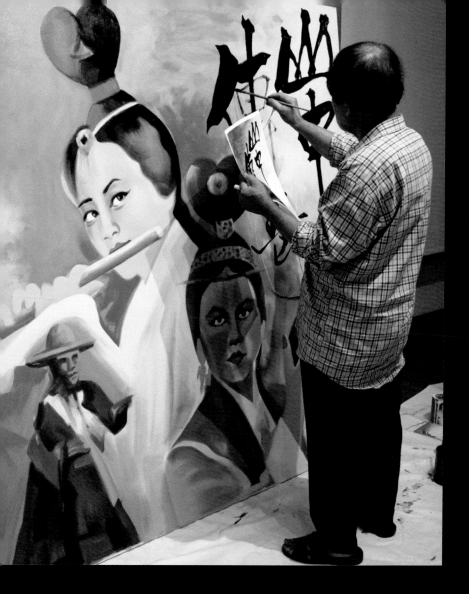

畫師最後在看板上寫下片名，創作大功告成。
The piece was completed after the master painter wrote down the title of the film.

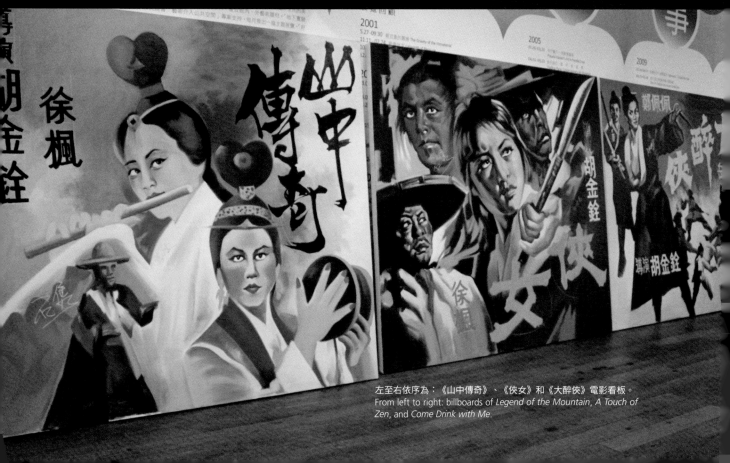

左至右依序為：《山中傳奇》、《俠女》和《大醉俠》電影看板。
From left to right: billboards of *Legend of the Mountain*, *A Touch of Zen*, and *Come Drink with Me*.

特別活動－魔卡電影院
Special Event – MOCA Movie Theater

本展特別在活動大廳，每日定時播放法國導演尼歐葛瑞（Hubert Niogret），於2011 年拍攝完成的一部48分鐘紀錄片《胡金銓》，片中邀請台灣電影學者焦雄屏、香港電影演員岳華（電影《大醉俠》男主角）、胡金銓弟子吳明才及明報月刊主編潘耀明等人，從各個角度談論胡金銓的電影美學、藝術特色、時代意義和後續影響。

胡金銓導演影響港台武俠電影至深，不僅聞名亞洲影壇，更在國際影展享有盛名。在紀錄片中，這些觀點不同的精彩言論，加上珍貴罕見的歷史畫面和電影片段，有助於觀眾全方位地瞭解胡金銓，及其源自東方傳統美學又富現代獨創精神的電影藝術成就。當代館與電影資料館於展覽期間盛大舉辦「魔卡電影院」，精選六部胡金銓代表之作，包括《大醉俠》、《俠女》、《迎春閣之風波》、《空山靈雨》、《龍門客棧》及《忠烈圖》，讓民眾重溫胡金銓導演各個時期的經典之作。

當代館另於戶外廣場舉辦兩場「武林星光之夜」，現場配合手作創藝市集與清新優質的樂團演出，吸引大批忠實影迷專程前往欣賞。

Daily showings of French director Hubert Niogret's documentary take place at the activity hall. Niogret completed a 48-minute documentary, *King Hu*, in 2011. Taiwan film scholar Peggy Chiao, Hong Kong movie actor Hua Yue (male lead of *Come Drink with Me*), King Hu's disciple Mingcai Wu, Director of Mingpao Monthly, Yiuming Poon, amongst others, talked and shared their views on King Hu's film aesthetics, artistic style, significance and impact.

Hu's impact in Hong Kong and Taiwan's martial arts film is very profound, and he was hailed not only in Asia, but also internationally renowned. In the documentary, the interviews of various perspectives along with rare historical footages and film clips help the audience to learn more comprehensively about King Hu and his cinematic achievements, which were inspired by traditional Asian aesthetics and rich with innovative spirits.

Furthermore, MOCA Taipei and Chinese Taipei Film Archive have joined together for this exhibition in launching the "MOCA Movie Theater". Six of King Hu's classical films were presented, including *Come Drink with Me*, *A Touch of Zen*, *The Fate of Lee Khan*, *Legend of the Mountain*, *Dragon Inn*, and *The Valiant Ones*. The public could revisit classical films made by Hu in different phases of his career.

MOCA Taipei has also organized two outdoor events at its plaza, aptly named the "Star-Studded Martial Arts Night". The events were held in conjunction with an outdoor arts and crafts fair and performances by exceptional live bands, and attracted the participations of many enthusiastic film buffs.

「魔卡電影院」
播放場次一覽表：
「MOCA Movie Theater」
Showing Times：

魔卡電影院

播映地點：當代館1樓活動大廳

07/05　16：00《大醉俠》1966/95min
07/07　14：00《俠女》1970/200min
07/28　16：00《迎春閣之風波》1973/104min
08/04　16：00《空山靈雨》1979/122min

武林星光之夜

播映地點：當代館戶外廣場

07/14　19：00《龍門客棧》1967/112min
08/18　19：00《忠烈圖》1975/104min

MOCA Movie Theater

Showing location:
1st floor activity hall of MOCA Taipei

07/05 16：00 *Come Drink with Me*, 1966/95min
07/07 14：00 *A Touch of Zen*, 1970/200min
07/28 16：00 *The Fate of Lee Khan*, 1973/104min
08/04 16：00 *Legend of the Mountain*, 1979/122min

Star-Studded Martial Arts Night.

Showing location：MOCA Taipei outdoor plaza

07/14　19：00 *Dragon Inn*, 1967/112min
08/18　19：00 *The Valiant Ones*, 1975/104min

在仲夏夜晚星光下，回味電影巨擘的傳奇。
Revisiting the legendary movie greats under the starry night in summer.

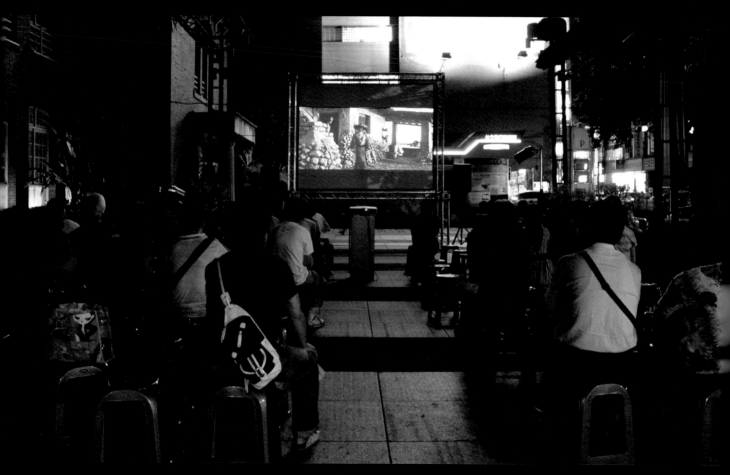

廣場播映《龍門客棧》，民眾一睹武俠經典之作。
Audience gathered at the plaza to see the classical martial arts film, *Dragon Inn*.

教育活動－藝術家面對面、MOCA講吧及專家導賞
Educational Events – Artist Talks, MOCA Lectures and Expert Guided Tours

本次展覽期間，配合參展藝術家在台時間，安排兩場藝術家面對面講座，第一場由葉錦添主講「胡導演的時間與空間之武俠氛圍」，活動時間安排在平日晚上，仍吸引許多喜愛胡金銓導演和葉錦添電影美術設計的觀眾參與；另一場由藝術家黃美清、王福瑞、陳昌仁、葉怡利共同分享本次展覽創作的精彩內容。MOCA講吧的主題規劃，則從胡導演的原創動畫《張羽煮海》、戲劇影評、電影美術設計和文學角度出發，分別邀請各領域的專家講師們主講，分享過去與胡金銓共事的點點滴滴和創作故事。7月4日及7月5日的MOCA講吧，特邀香港影評人舒琪、胡維堯和資深演員鄭佩佩、石雋主講，俠女與書生丰采不減當年，談起胡導演在電影創作的理想與執著，尤令人動容，讓現場影迷觀眾回味無窮。

During the exhibition and considering the times that the contributing artists were in Taiwan, two artist talks were arranged, one by Tim Yip on the subject of "King Hu's Martial Arts Ambiance in Relations to Time and Space". Despite the event being held in a weekday night, it still attracted many participants because of their love for Hu and also Tim Yip's artistic designs. Another artist talk was by contributing artists of the exhibition, including Meiching Huang, Fujui Wang, Leo Chanjen Chen, Yili Yeh, they shared their memorable experiences working for this exhibition with the audience.

The organization of MOCA lecture series was focused on *Zhang Yu Boils the Sea*, and King Hu's achievements from film criticism, artistic direction, and also literary perspectives. Experts from various fields were invited to talk about their experiences and details working with the master.

For MOCA lectures held on July 4th and 5th, Kei Su, a film critic from Hong Kong , Weiyao Hu, and actors Peipei Zheng and Jun Shi were invited to speak. Their talks about King Hu's ideals and perseverance with filmmaking were vivid and touching, and kept the audience focused and interested the entire time.

藝術家面對面 Artist Talks

07/04 向大師致敬之一：
胡金銓導演的「時間與空間之武俠氛圍」
主持人：王玉齡／蔚龍藝術總經理
主講人：葉錦添／參展藝術家

07/04 Homage to the Master I:
King Hu's Martial Arts Ambiance
in Relations to Time and Space
Moderator： Yulin Wang／General Manager,
Blue Dragon Art Company
Speaker：Tim Yip／Contributing artist

葉錦添主講《胡金銓導演的時間與空間之武俠氛圍》
Tim Yip's talk on "King Hu's Martial Arts Ambiance in Relations to Time and Space"

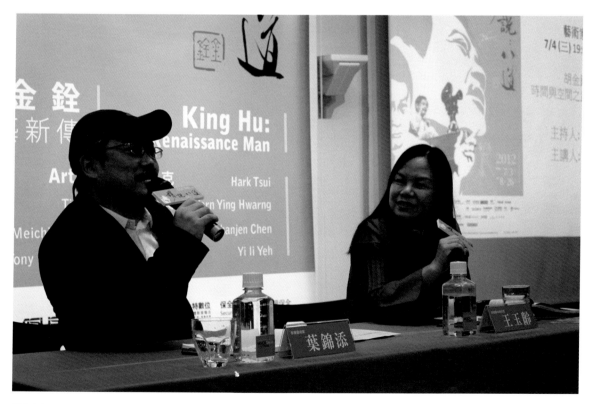

葉錦添侃侃而談胡金銓在其電影美術生涯中的影響，右為蔚龍藝術總經理王玉齡。
Tim Yip on King Hu's influence on his career in art direction, to the right is Yulin Wang, General Manager, Blue Dragon Art Company

07/21 向大師致敬之二：
關於武俠之迷霧傳說—胡金銓的電影美學
主持人：張靚蓓／國家電影資料館館長
主講人：黃美清、陳昌仁、王福瑞、葉怡利／參展
　　　　藝術家

07/21 Homage to the Master Ⅱ：
On Legend of Martial Arts—
King Hu's Film Aesthetics
Moderator: Jinnpei Chang／Director, Chinese Taipei
　　　　　　Film Archive
Speakers: Meiching Huang, Fujui Wang, Leo Chanjen
　　　　　Chen, Yili Yeh／Contributing artists

藝術家面對面現場，現場吸引許多民眾聆聽。
Participants of the Artist Talk.

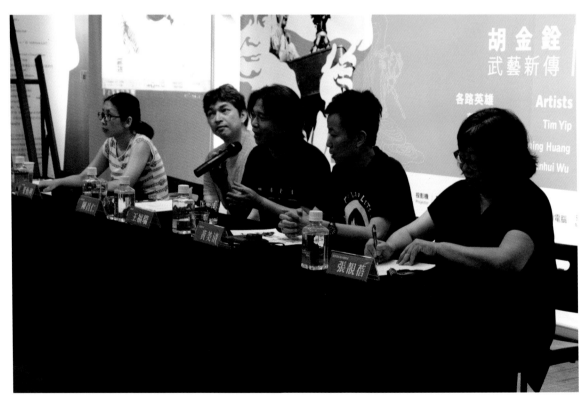

左起依序為：藝術家葉怡利、陳昌仁、王福瑞、黃美清及電影資料館館長張靚蓓。
From left to right: artists Yili Yeh, Leo Chanjen Chen, Furui Wang, Meiching Huang, and Jinnpei Chang, Director, Chinese Taipei Film Archive.

MOCA講吧 MOCA Lectures

07/04 胡金銓電影裡的動與靜
主持人：張靚蓓／國家電影資料館館長
主講人：舒琪／影評人、香港演藝學院電影電視學院院長

07/04 Movements and Stillness in King Hu's Films
Moderator: Jinnpei Chang／Director, Chinese Taipei Film Archive
Speaker: Kei Su／film critic, Dean, School of Film and Television, Hong Kong Academy for Performing Arts

07/05 不朽傳奇之俠客聚首─胡金銓導演與我
主持人：張靚蓓／國家電影資料館館長
主講人：鄭佩佩／美國胡金銓基金會會長
　　　　石雋／財團法人胡金銓導演文化藝術基金會執行長
　　　　胡維堯／香港語文現代化學會會長

07/05 The Immortal Legendary Gathering of Swordsmen – Director King Hu and Me
Moderator: Jinnpei Chang／Director, Chinese Taipei Film Archive
Speakers: Peipei Zheng／President, King Hu Foundation,
　　　　 Jun Shi／CEO, King Hu Cultural and Art Foundation
　　　　 Weiyao Hu／Director, Hong Kong Society for Chinese Language Modernization

07/14 《張羽煮海》，跟隨胡金銓導演工作的那段日子
主持人：林盈志／國家電影資料館出版組組長
主講人：馮毓嵩／杭州師範大學創意設計藝術分院院長

07/14 *Zhang Yu Boils the Sea*, Days of working with Director Hu
Moderator: Yingzhi Lin ／ Head of publishing department, Chinese Taipei Film Archive
Speaker: Yusong Feng／Director, Creative Arts Design Department, Hangzhou Normal University

07/28 武俠電影一代宗師─胡金銓的電影世界
主講人：黃建業／台北藝術大學戲劇學系專任副教授

07/28 Master of Martial Arts Film ─King Hu's World of Cinema
Speaker: Edmond Wong／Associate professor, Department of Theatre Art, Taipei National University of the Arts

08/04 筆鋒有情話武藝—胡金銓的文化世界
主持人：張靚蓓／國家電影資料館館長
主講人：李歐梵／知名作家、文化研究學者

08/04 Martial Arts in Writing – King Hu's Cultural World
Moderator: Jinnpei Chang／Director, Chinese Taipei Film Archive
Speaker: Leo Ou-fan Lee／writer, cultural studies scholar

08/18 叱吒影壇的武俠本色—胡金銓導演的電影和美術
主持人：石瑞仁／台北當代藝術館館長
主講人：曲德益／北藝大美術學院教授

08/18 Martial Arts Characters in Films —King Hu's Film and Art
Moderator: Jinnpei Chang／Director, Chinese Taipei Film Archive, J.J. Shih／Executive Director, MOCA Taipei
Speakers: Tong Wang／Director, Department of Filmmaking, Taipei National University of the Arts,
 Deyi Qu／Professor, School of Fine Arts, Taipei National University of the Arts

MOCA講吧《筆鋒有情話武藝—胡金銓的文化世界》，李歐梵主講。
" Martial Arts in Writing—King Hu's Culural World" by Le0 Ou-fan Lee

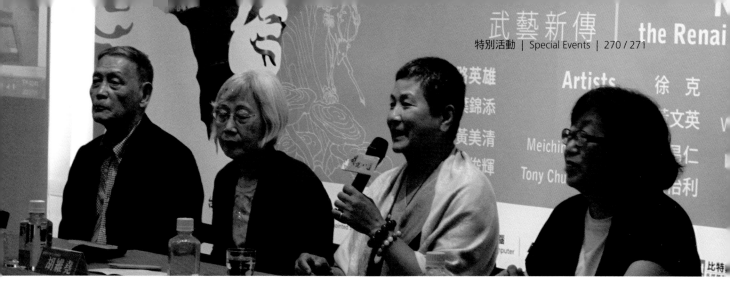

《不朽傳奇之俠客聚首》講座，左起依序為：石雋、胡維堯及鄭佩佩。
"The Immortal Legendary Gathering of Swordsmen" lecture; from left to right: Jun Shi, Weiyao Hu, and Peipei Zheng.

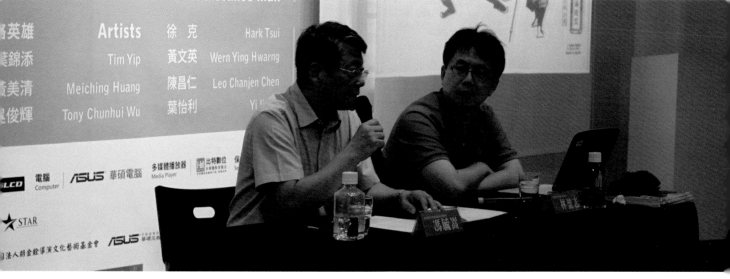

MOCA講吧《張羽煮海》，馮毓嵩教授主講。
"Zhang Yu Boils the Sea" by Yusong Feng.

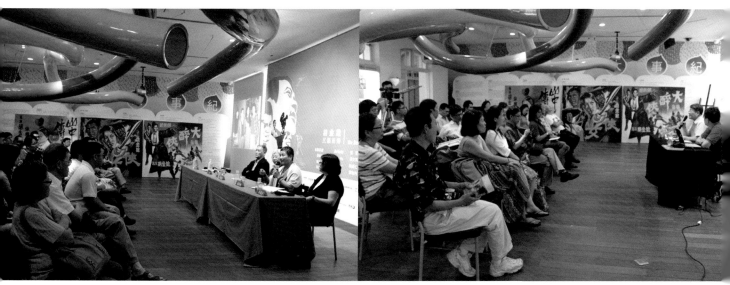

MOCA講吧《不朽傳奇之俠客聚首》現場，觀眾發問熱絡。
Participants enthusiastically asking questions during "The Immortal Legendary Gathering of Swordsmen" lecture.

MOCA講吧《張羽煮海》，主講人精彩分享與胡金銓導演共事的時光。
The speaker of "Zhang Yu Boils the Sea" lecture sharing of exciting times working with King Hu.

週日專家導賞 Sunday Expert Guided Tour

07/08林羽婕／台北當代藝術館副館長
07/15顏忠賢／實踐大學建築設計學系副教授
07/22陳昌仁／參展藝術家
07/29石雋／資深演員、亞太影帝
08/05黃美清／電影美術指導、參展藝術家
08/12張靚蓓／國家電影資料館館長
08/19塗翔文／影評人、台北電影節策展人

07/08 Yuchieh Lin／Deputy Executive Director, MOCA Taipei
07/15 Zhongxian Yan／Associate Professor, Architecture Department, Shih Chien University
07/22 Leo Chanjen Chen／contributing artist
07/29 Jun Shi／actor, winner of Asia Pacific Film Festival best actor award
08/05 Meiching Huang／art director, contributing artist
08/12 Jinnpei Chang／Director, Chinese Taipei Film Archive
08/19 Steven Tu／Film critic, programmer, Taipei Film Festival

週末工作坊 Weekend Workshop

08/11武俠小劇場─我的獨門功夫偶
講師：洪瑞霞／無獨有偶劇團工作室

08/11 Martial Arts Mini Theater ─My Unique Martial Arts Puppet
Lecturer: Ruixia Hong／The Puppet & Its Double Theater

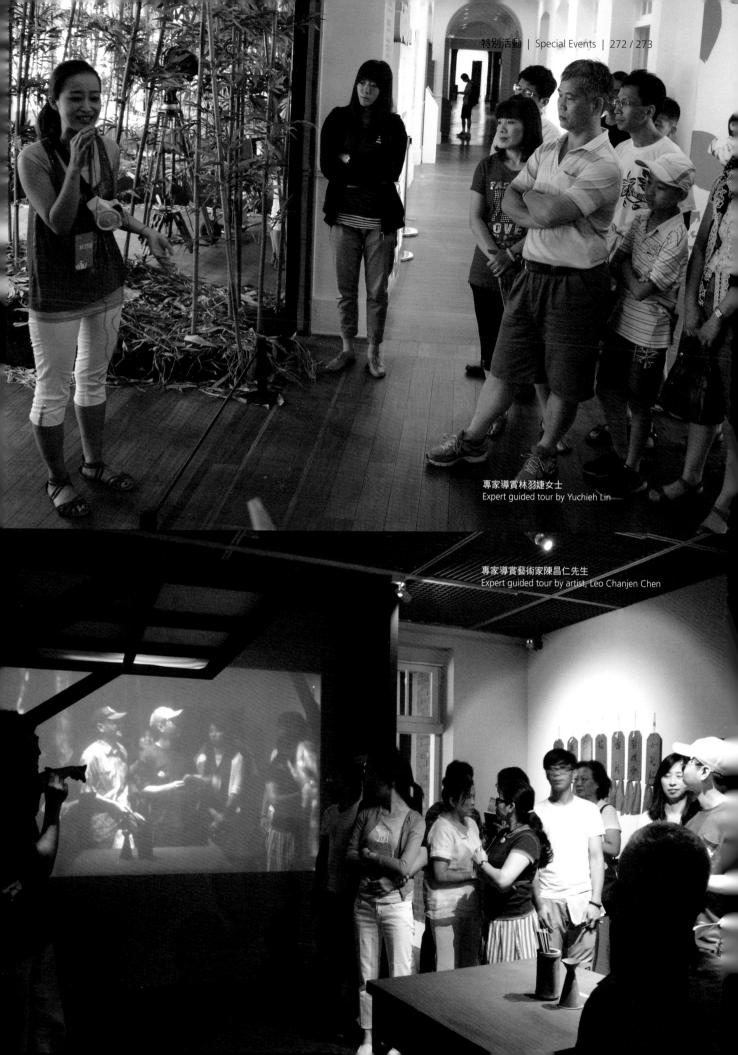

專家導賞林羽婕女士
Expert guided tour by Yuchieh Lin

專家導賞藝術家陳昌仁先生
Expert guided tour by artist, Leo Chanjen Chen

MOCA兒童藝術夏令營

今年暑假，配合「胡說：八道—胡金銓・武藝新傳」展覽，本館邀請多位藝術家，從影像與表演藝術的角度出發，用藝教於樂的方式，帶小朋友認識胡金銓導演的武藝世界。

第一梯次的「輕功・光影・大挪移—影像創作營」，是以停格動畫的概念，運用身邊輕易取得的數位相機，拍攝屬於自己的武俠電影，從角色發想、道具製作到影片拍攝，體驗電影攝製的樂趣。此外，也透過認識電影的基本原理、電影配樂與海報設計，讓小朋友藉由創作個人專屬的電影海報，領略胡導演電影的視覺藝術之美。

第二梯次的「大俠・女俠・小飛俠—表演藝術營」，以胡導演的武俠精神出發，透過肢體遊戲的引導，讓小朋友玩出十八般武藝，運用創造力戲劇（Creative Drama）活動，做一系列包含肢體、聲音、想像、節奏、專注力等練習，認識戲劇編、導、演的過程及魅力。

MOCA Summer Camp

In conjunction with the summer exhibition, *King Hu: the Renaissance Man*, MOCA Taipei has invited several artists to create diverse visual and performing arts events for children. The objective of these education activities is to guide children to learn more about King Hu's world of martial arts in fun.

The first session, "Qinggong, Light and Shadow, The Great Shift - The Visual Creative Camp", incorporated the concepts of stop-motion animation. By utilizing readily accessible digital cameras, the participants took part in shooting their own martial arts films by creating the characters, making props, and taking shots. They are able to enjoy producing a movie in the process. Furthermore, through the learning of basic principles of filmmaking, scores and poster designs, children also created their own movie posters and learned about the visual aesthetics employed in Hu's films.

The second session, "Swordsmen, Swordswomen, Little Flying Fighters- Performing Art Camp", was based on Hu's martial arts spirits. Children were able to express themselves with various martial arts movements by playing games. Furthermore, the series of creative drama activities led the participants in learning and practicing movements, sounds, rhythms, and how to optimize their imagination and concentration. They were able to learn and experience the charm of drama in the processes of creating the story, direction, and acting.

「輕功 ‧ 光影 ‧ 大挪移－影像創作營」展覽導賞
" Qinggong, Light and Shadow, The Great Shift - The Visual Creative
Camp" exhibition guided tour

「輕功 ‧ 光影 ‧ 大挪移－影像創作營」利用各種材質,設計電影
主角的服裝和道具
" Qinggong, Light and Shadow, The Great Shift - The Visual Creative
Camp" - utilizing various materials to design costumes and props.

「輕功 ‧ 光影 ‧ 大挪移－影像創作營」
展覽導賞
" Qinggong, Light and Shadow, The
Great Shift - The Visual Creative Camp" -
exhibition guided tour

「輕功 ‧ 光影 ‧ 大挪移－影像創作營」利
用各種材質,設計電影主角的服裝和道具
" Qinggong, Light and Shadow, The
Great Shift - The Visual Creative Camp"
- utilizing various materials to design
costumes and props.

「輕功 ‧ 光影 ‧ 大挪移－影像創作營」利
用各種材質,設計電影主角的服裝和道具
" Qinggong, Light and Shadow, The
Great Shift - The Visual Creative Camp"
- utilizing various materials to design
costumes and props.

1|2
3|4

1、2.「輕功‧光影‧大挪移－影像創作營」運用停格動畫概念，拍攝自己的第一部武俠電影
" Qinggong, Light and Shadow, The Great Shift - The Visual Creative Camp" - utilizing stop-motion animation concepts to create one's first martial arts film

3.「輕功‧光影‧大挪移－影像創作營」製作旋轉幻影座，了解視覺暫留的原理
" Qinggong, Light and Shadow, The Great Shift - The Visual Creative Camp" - learning about the theory of vision of persistence with hands-on making of zoetrope.

4.「輕功‧光影‧大挪移－影像創作營」手翻書繪製
" Qinggong, Light and Shadow, The Great Shift - The Visual Creative Camp" - making of flip books

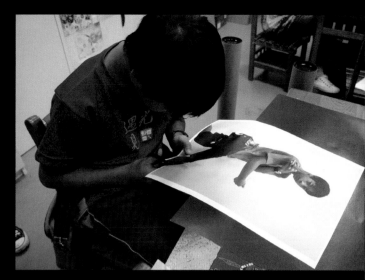
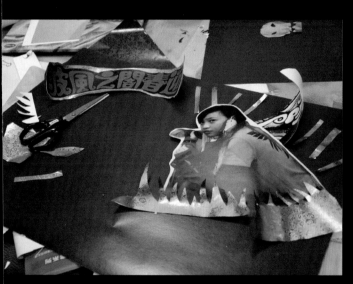

1|2
3|4

1.「輕功 ‧ 光影 ‧ 大挪移－影像創作營」小朋友繪製的手翻書成品
" Qinggong, Light and Shadow, The Great Shift - The Visual Creative Camp" - flip books created by participating children

2、3.「輕功 ‧ 光影 ‧ 大挪移－影像創作營」電影海報設計製作
" Qinggong, Light and Shadow, The Great Shift - The Visual Creative Camp' - movie poster design and production

4.「輕功 ‧ 光影 ‧ 大挪移－影像創作營」藝術家蕭輔吹與小朋友們合影留念
" Qinggong, Light and Shadow, The Great Shift - The Visual Creative Camp' - artist Fuchui Xiao and participating children.

藝術家簡歷
Biographies

吳俊輝 / Tony Chunhui Wu

吳俊輝，美國紐約巴德學院米爾頓‧艾佛利藝術研究所藝術碩士，主修電影製作。作品曾於法國巴黎龐畢度中心、美國紐約現代美術館、舊金山電影中心、紐約「勞勃‧畢克紀念電影」實驗電影中心放映。其中《感傷之旅》與《諾亞諾亞》連續兩屆獲第2003與2004年台北電影節台北電影獎最佳實驗片獎等。其他重要展出尚有2006年台北雙年展及2007年國立台灣美術館亞洲藝術雙年展等，並曾策畫許多重要藝術活動，如第二屆牯嶺街國際小劇場藝術節、2010台灣國際紀錄片雙年展、EX!T 2010台灣國際實驗媒體藝術展策展人等。現任世新大學專任助理教授。

Tony Chun-Hui Wu received his MFA in Film/Video at Milton Avery Graduate School of the Arts of Bard College, New York. His films have been shown at the Museum of Modern Art in New York, Centre Pompidou in Paris, San Francisco Cinematheque, and Robert Beck Memorial Cinema in New York etc. Among others, his film *Sentimental Journey* (2003) and *Noah, Noah* (2004) was named the Best Experimental Film at Taipei Film Festival. Additionally, he has been involved with many important exhibitions and festivals as curator, jury and consultant, 2009 Taipei Film Festival, 2010 Kaohsiung Film Festival etc. He is a program director for EXiT -Experimental Media Art Festival in Taiwan, and an assistant professor, Department of Radio, Television and Film, at Shih Hsin University.

陳昌仁 / Leo Chanjen Chen

陳昌仁目前任教於日本京都造型藝術大學電影學系，曾任教於美國明尼蘇達大學、加州大學聖地亞哥分校、日本成蹊大學。臺大外文系畢業、美國加州大學洛杉磯分校（UCLA）電影博士。電影學術論文外，著作包括攝影及當代藝術評論，散見於《新左評論》、《中國時報》等國際及國內出版期刊。教學寫作外亦從事電影創作攝製，影像作品如紀錄片《見好就吃》，曾參與楊德昌導演之《一一》、《恐怖分子》，美國Gus van Sant 導演之Psycho，及日本林海象導演等國際電影製作。

Leo Chanjen Chen teaches film production at Kyoto University of Art & Design, Japan. He has taught film at the University of Minnesota, University of California, Seikei University and National Tainan University of Arts. His research interests include comparative aesthetics, visual arts culture and cinema studies. In addition to his publications on cinema, Leo Chen has written on photography, sculpture and various visual arts and has published in *New Left Review* and other international journals. Besides his academic engagements of research and teaching, Leo Chen also makes films, such as *Good Enough to Eat* (1990), and produces media arts projects. He has participated in film productions on both shores of the Pacific, including *Yi Yi / A One and a Two* (2000) and *Psycho* (1998).

黃文英 / Wern Ying Hwarng

黃文英為美國卡內基美倫大學藝術碩士，與匹茲堡大學戲劇製作碩士。1990-1996年間於美國紐約從事歌劇、百老匯劇場服裝設計與美術設計工作，近年常與侯孝賢導演合作，如正在拍攝中的《聶隱娘》，也參與了蘭陵劇場、優劇場、當代傳奇劇場等舞台設計工作，並協助成立「台灣電影文化協會」，目前擔任該協會理事長。

Graduated from MFA, Carnegie Mellon University and MA, University of Pittsburgh, Wern Ying Hwarng had worked at Opera and Broadway as costume designer, as well as the TV art director in New York during 1990 to 1996. She has collaborated with Hsiao Hsien Hou in recent years, such as the upcoming film, Assassin. Furthermore, she has also worked on the costume design for various famed theater companies, including Lan Ling Theatre 30, Utheatre, Contemporary Legend Theater and so forth. Hwarng co-founded the Taiwan Film & Culture Association, and is currently the general manager.

黃美清、王福瑞 / Meiching Huang + Fujui Wang

黃美清畢業於法國巴黎賈克樂寇國際戲劇學校劇場設計系，國內著名的電影與舞台空間設計師，常與許多知名的導演合作，如德國導演溫德斯、台灣導演鈕承澤、蔡岳勳等，其設計風格富有強烈的哲學思維、及多元文化的特性。曾以電影《艋舺》榮獲臺北電影節最佳美術設計、第54屆亞太影展最佳藝術指導等，並多次入圍金馬獎最佳美術設計。

王福瑞為台北藝術大學「藝術與科技中心(Center of Art and Technology)」未來聲響實驗室主持人，主要從事數位互動聲音藝術的實驗，同時是許多重要聲音藝術節如「台北數位藝術節」、「超響/2010」聲音藝術展演等活動之策展人。

Graduated from the École Internationale du Théâter Jacques Lecoq in Paris. Since 1996, she has worked as the art director in commercial films, stage design, scenography. Presently worked as the production designer in film industry. Huang's philosophical and multi-cultural background reflected on the aesthetics of her work. She has received the awards for Best Art Direction for the film Monga in Asia Pacific Film Festival and Taipei Film Festival 2010 and has been nominated many times by Golden Horse Award.

Fujui Wang, Head of the Trans-Sonic Lab in center for art and techology of Taipei National University of the Arts, specializes in sound art and Interactive art. Fujui Wang is the pioneer of sound art in Taiwan, who has been engaged with sound art experiments and many important festivals as Digital Art Festival Taipei and TranSonic Sound Art Festival.

葉怡利 / Yili Yeh

葉怡利畢業於國立台南藝術學院應用藝術研究所，是一位創作力豐沛、國際展演經驗豐富的年輕藝術家。她的創作融合錄像、偶發、扮裝與表演的元素，並透過錄影與攝影留下行動的紀錄，看似無厘頭的表面其實探討了全球化底下的次文化現象。葉怡利曾於留尼旺、法國、美國、韓國、日本、中國等地駐村創作，並曾獲得澳洲黃金海岸國際陶藝競賽優選獎、臺北市立美術館「臺北獎」美術類入選獎等，並獲得多項公共藝術獎項等。

Graduated from Tainan National College of the Arts. Yeh is a young artist with abundant creativity and rich experience in holding exhibitions in many countries. Her works combine the elements of video installation, happening, cosplay and performing art. She recorded the performance with video and photography. Her Kuso art works actually explore the sub-culture phenomena in globalization. Yeh was invited as residence artist by France, USA, Korea, Japan and China. She received awards of Gold Coast International Ceramic Art Award, Taipei Arts Awards and also many awards of public art.

葉錦添 / Tim Yip

葉錦添畢業於香港理工學院的攝影系，之後先後從事舞臺佈景繪製、攝影師等工作；1986擔任徐克電影《英雄本色》美術設計，1992年以電影《誘僧》獲得金馬獎最佳美術設計，至2001以《臥虎藏龍》獲得奧斯卡金像獎藝術指導獎，是首位獲得此獎的華人藝術家。2002年起，葉錦添陸續於臺北、荷蘭、法國、美國、西班牙、北京、香港、上海等地舉行個展，展出內容多以服裝設計為主。2010年則於台北當代藝術館展出《仲夏狂歡》，為個人創作生涯中最大型、最完整的個人創作展。

Graduated from Photography Department, Hong Kong Polytechnic. After that, he has been worked as stage setting designer and photographer. In 1986, he was the Art Executive of *A Better Tomorrow*. He was awarded Best Production Designer, Golden Horse Award in1992, for *Temptation of a Monk*. In 2001, he received Best Art Direction, Oscar Academy Award for *Crouching Tiger, Hidden Dragon*. He was the first Chinese artist receiving this award. Yep held solo exhibitions of costume design in Taipei, Netherland, France, USA, Spain, Beijing, Hong Kong, Shanghai and other places since 2002. In 2010, Tim Yip held solo exhibition, *Summer Holidays*, in MOCA, Taipei.

專輯執行

發行人：丁庭宇、張崇仁
總編輯：石瑞仁、張靚蓓
副總編輯：林羽婕、鍾國華、林盈志
執行編輯：陳志芳、黃翔、王雪妮、徐慧娟、劉宇彬、 薛惠玲、王志欽、王祖珮、黃庭輔
英文編輯：黃慧敏
美術編輯：李秉軍、王景銘
特約攝影：陳文榮
特約翻譯：廖蕙芬、凱勁中翻英服務有限公司、何美瑜、陳逸軒、Geof Aberhart

發行所：
財團法人台北市文化基金會 台北當代藝術館
地址：103台北市大同區長安西路39號
電話：+886-2-2552-3721
傳真：+886-2-2559-3874
網址：www.mocataipei.org.tw/blog

財團法人國家電影資料館
地址：100台北市中正區青島東路7號4樓
電話：+886-2-2392-4243
傳真：+886-2-2396-0760
網址：www.ctfa.org.tw

印刷：圓彩國際企業有限公司
定價：新台幣 599元
初版一刷 2012年12月
ISBN：978-986-88674-0-6

展覽執行

台北當代藝術館團隊

執行總監：石瑞仁
展覽統籌規劃：林羽婕

展覽組團隊成員
副組長：陳志芳
專員：黃翔、周文婷、許格元、張瀞尹、徐慧娟、
許翼翔、王雪妮、黃俊瑋、賴佳良、游聖寅
視覺設計：林婉筠、李秉軍、王景銘

發展行銷與推廣教育組團隊成員
副組長：劉宇彬、張文瑜
專員：呂易穎、劉逸萱、周璟筠、王健任、趙沁琬

行政組團隊成員
副組長：曾清琪
專員：陳貞蓉、郭宜茵、陳忠成、郭湘媛、葉芷伶

國家電影資料館團隊

執行總監：張靚蓓
顧問：黃建業、王童
行政統籌：鍾國華
企劃執行：薛惠玲
版權洽談、英文翻譯：黃慧敏
影音統籌：黃庭輔
公關統籌：蔡菁菁

行政支援團隊
黃金濠、陳玫孜、林志遠、廖翠貞

資料協力團隊
薛惠玲、黃庭輔、徐昌業、王祖珮、賴永仁、蔡敏
政、謝麗華、張嘉和、吳恬安、廖璜華

藝術家協力團隊
葉錦添、黃文英（藝術家協調：蔡菁菁）
陳昌仁、吳俊輝（藝術家協調：黃慧敏、孫如杰、
郭榮平）
黃美清（藝術家協調：薛惠玲）

影音剪接團隊
黃庭輔、潘琇菱

攝影記錄團隊
徐昌業、張嘉和、邱繼諺、林家豪、楊杰麟、
孫如杰

公關團隊
蔡菁菁、陳瑩潔、劉欣玫、蔡耀云、俞姵伊、陳偉
熙、林姵菁、胡延凱、朱思怡

周邊活動執行
王少華、蕭明達、葉聰利

Production Team of Catalog

Publisher: Tin-Yu Ting, Chung-Jen Chang
Chief Editor: Jui-Jen Shih, Jinn-pei Chang
Vice- Editor: Maple Yu-Chieh Lin, Kuohua Chung, Ying-chih Lin
Executive Editors: Casper Chen, Hsiang Huang, Shirney Wong, Louise Hsu, Edward Liu, Hui Lin Hsueh,
 Chih-chin Wang, Tsu-pei Wang, Ting-fu Huang
English Editor: Teresa Huang
Catalog Designer: Vic Li, Jing-Ming Wang
Photography: Weng-Rong Chen
Translator: Anna Hui-Fen Liao, Kevin' s Chinese-English Translation Service, Isabella Ho, Yihsuan Chen,
 Geof Aberhart

Published by
Taipei Culture Foundation/Museum of Contemporary Art, Taipei
Address: 39 Chang- An West Road, Taipei 103, Taiwan, ROC
Telephone:+886 2 25523721 Fax：+886 2 25593874
Website: www.mocataipei.org.tw/blog

Chinese Taipei Film Archive
Address: 4F, No. 7, Ching-Tao East Road, Taipei 100, ROC
Telephone:+886 2 23924243 Fax：+886 2 23926359
Website: www.ctfa.org.tw

Printed by: Corona Technics Co., Ltd.
Price: TWD.599
First Published in December 2012
ISBN：978-986-88674-0-6

Working Team of Exhibition

Museum of Contemporary Art, Taipei

Executive Director: Jui-Jen Shih
Deputy Director: Maple Yu-Chieh Lin

Department of Exhibition
Deputy Supervisor: Casper Chen
Specialists: Hsiang Huang, Dwadi Chou,
 Ge-Yuan Syu, Chin-Yin Chong ,
 Louise Hsu, Ian Hsu, Shirney Wong,
 Gino Huang, Chia-Liang Lai, Simon Yu
Visual Design: Wan-Yun Lin, Vic Li, Jing-Ming Wang

Department of Communications & Education
Deputy Supervisor: Edward Liu, Phoebe Chang
Specialists: Yi-Ying Lu, Yi-Hsuan Liu, Ching-Yun
Chou, Johnny Wang, Tiffany Chao

Department of Administration
Deputy Supervisor: Kate Tseng
Specialists: Anita Chen, Vivian Kuo, Ryan Chen,
 Ivy Kuo, Tsz Ling Ip

Chinese Taipei Film Archive

Executive Director: Jinn-pei Chang
Consultants: Edmond Wong, Toon Wang
Administration Supervisor: Kuohua Chung
Planning : Hui Lin Hsueh
Licensing / English Translation: Teresa Huang
Editing Supervisor: Ting-fu Huang
Publicity Supervisor: Jing-jing Tsai

Administration Supporting Team
Ching-hao Huang, Maggie Chen, Jyh-yuan Lin,
Tsuei-Jen Liao,

Documentation Supporting Team
Hui Lin Hsueh, Ting-fu Huang, Chang-yeh Hsu,
Tsu-pei Wang, Yung-jen Lai, Min-Cheng Tsai,
Li-hua Hsieh, Jia-he Chang, Tien-An Wu,
Huang-hua Liao

Artist coordinating Team
artists Tim Yip, Wern Ying Hwarng: Jing-jing Tsai
artists Leo Chen, Tony Wu: Teresa Huang, Jason Sun,
Jung-ping Kuo
artist Meiching Huang: Hui Lin Hsueh

Editing Team
Ting-fu Huang, Hsiu-ling Pan

Recording-photography Team
Chang-yeh Hsu, Jia-he Chang, Jerry Chiu,
Chia-hao Lin, Chieh-lin Yang, Jason Sun

Publicity Team
Jing-jing Tsai, Ying-jie Chen, Hsin-mei Liu,
Yao-yun Tsai, Pei-yi Yu, Wei-shi Chen, Pei-jing Lin,
Steven Hu, Janine Ju

Activity Team
Shanti Wang, Mingdar Shaw, Tsung-li Yeh

國家圖書館出版品預行編目(CIP)資料

胡說：八道：胡金銓武藝新傳 /
石瑞仁、張靚蓓總編輯. -- 初版. --
台北市：台北當代藝術館,
2012.12
288 面；21 x 28公分　中英對照
ISBN 978-986-88674-0-6(精裝)
1. 胡金銓　2.電影導演　3.電影美學

987.31　101016131